(INSIDE THE CURVE)

ALONE · TOGETHER

Manuela Aguilar, four, began
early education in a private
school in Quito, Ecuador, in 2020.
Since the onset of the COVID-19
pandemic, she has attended
school remotely. Although
Manuela has the resources to
study from home, the isolation
has changed the way she
connects with others.

DAVID DIAZ ARCOS/FLUXUS FOTO
QUITO, ECUADOR | JUNE 2020

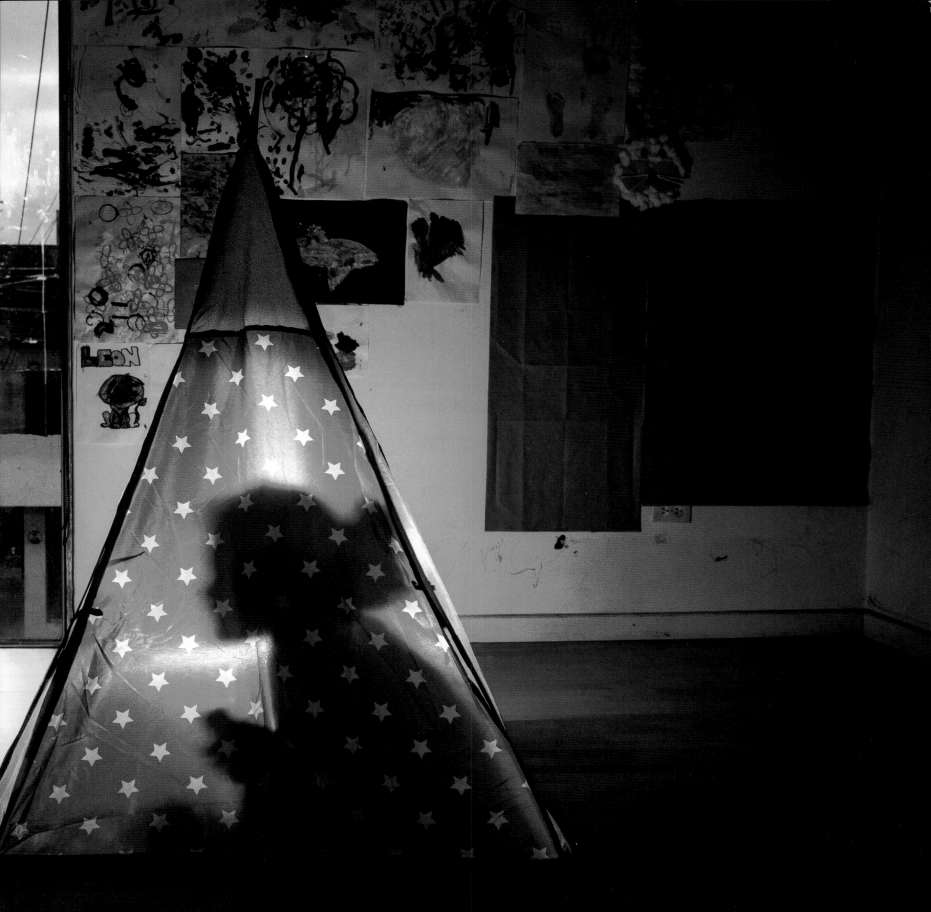

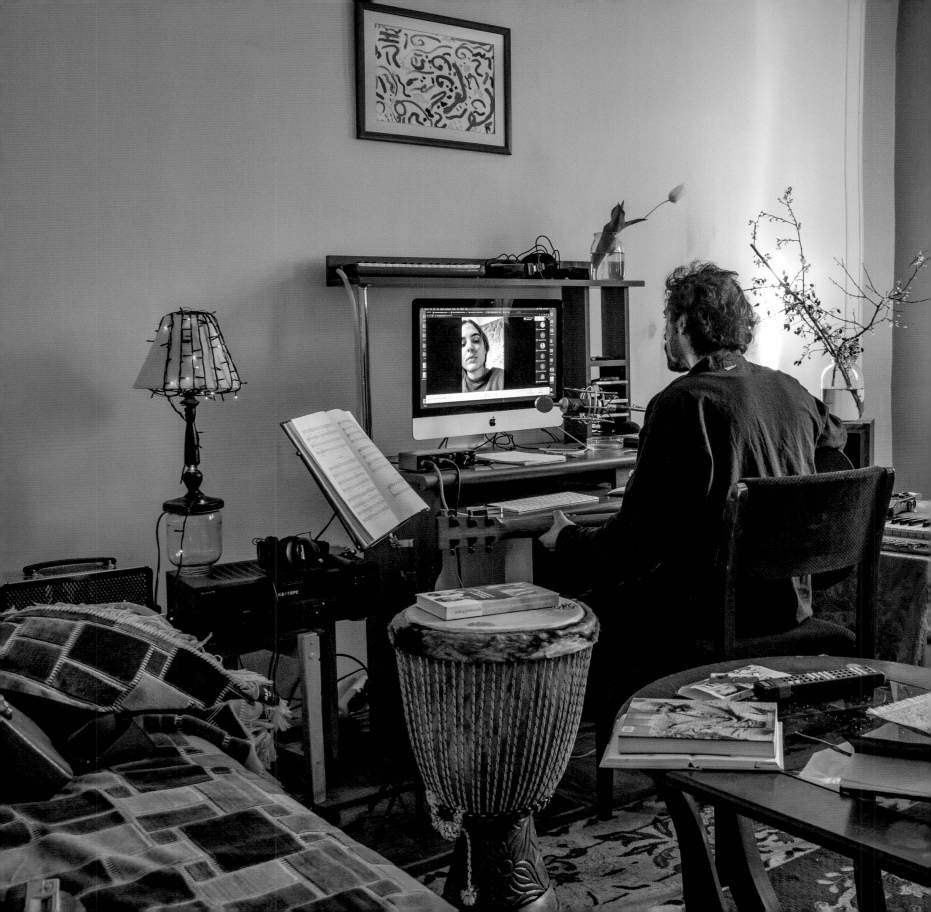

WORK · HOME

Arik Grigoryan, 36, teaches an online music class from his home in Yerevan, Armenia. As in-person classes were suspended to counter the spread of COVID-19, Grigoryan experienced the challenges of education in isolation alongside his students.

ANUSH BABAJANYAN | YEREVAN, ARMENIA
APRIL 2020

EXPLOIT · PROTECT

People create distance between themselves as they wait for a bus in front of the closed and emptied CentralWorld department store in downtown Bangkok. Above them, the building's screen projects the vigilant glare of a leopard wearing a face mask—a watchful reminder to adhere to COVID-19-related safety measures.

SIRACHAI ARUNRUGSTICHAI
BANGKOK, THAILAND | MAY 2020

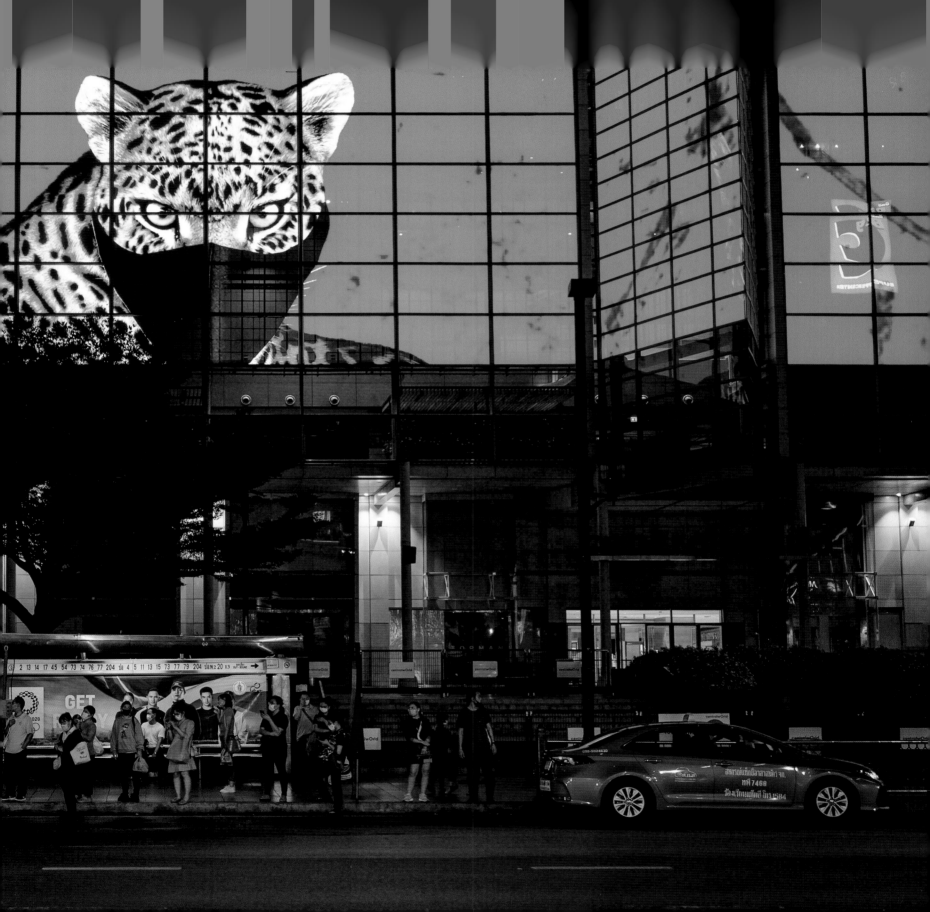

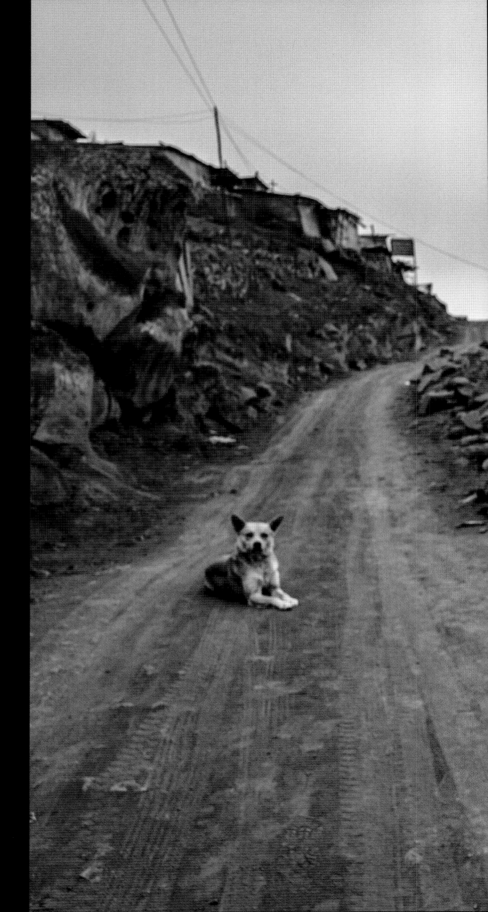

URBAN · RURAL

Herineo Arontico and his daughter walk down a road in the low-income settlement of Villa María del Triunfo, located on the arid outer boundaries of Lima. The family's home has no running water, and because of difficult terrain, it cannot be reached by water trucks. To obtain water—and to help prevent the spread of COVID-19 through proper hygiene—the family must carry it home in buckets from the nearest access point.

MUSUK NOLTE | LIMA, PERU | JULY 2020

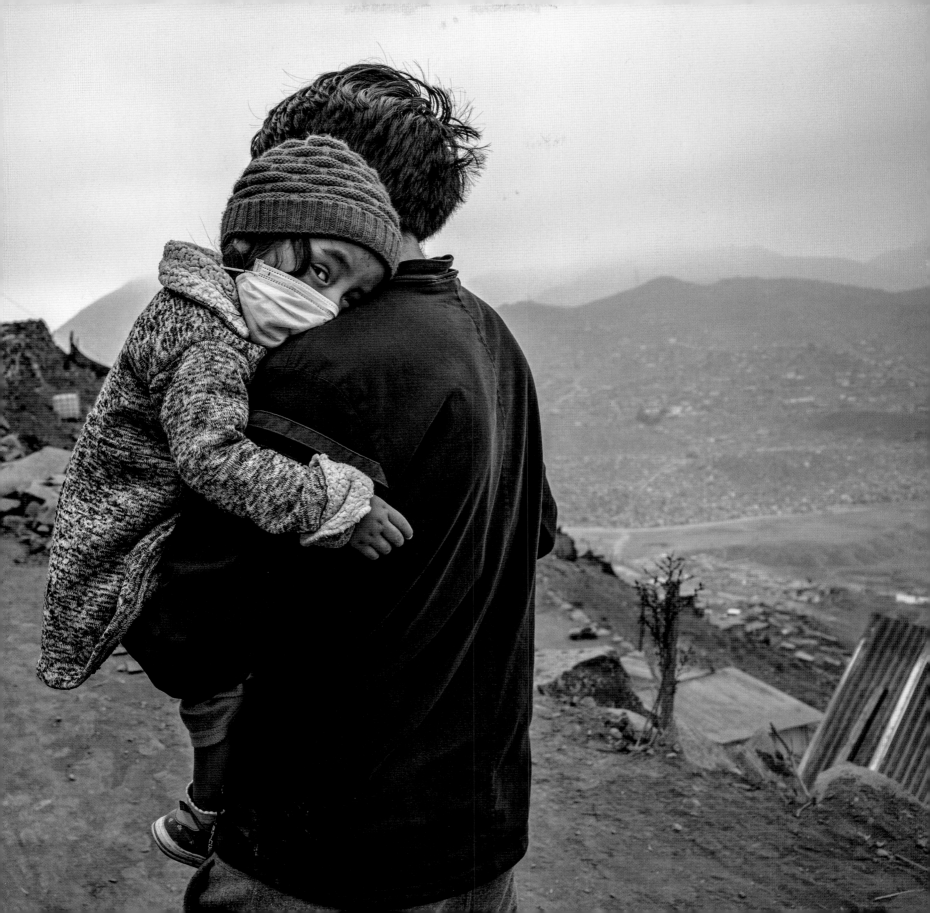

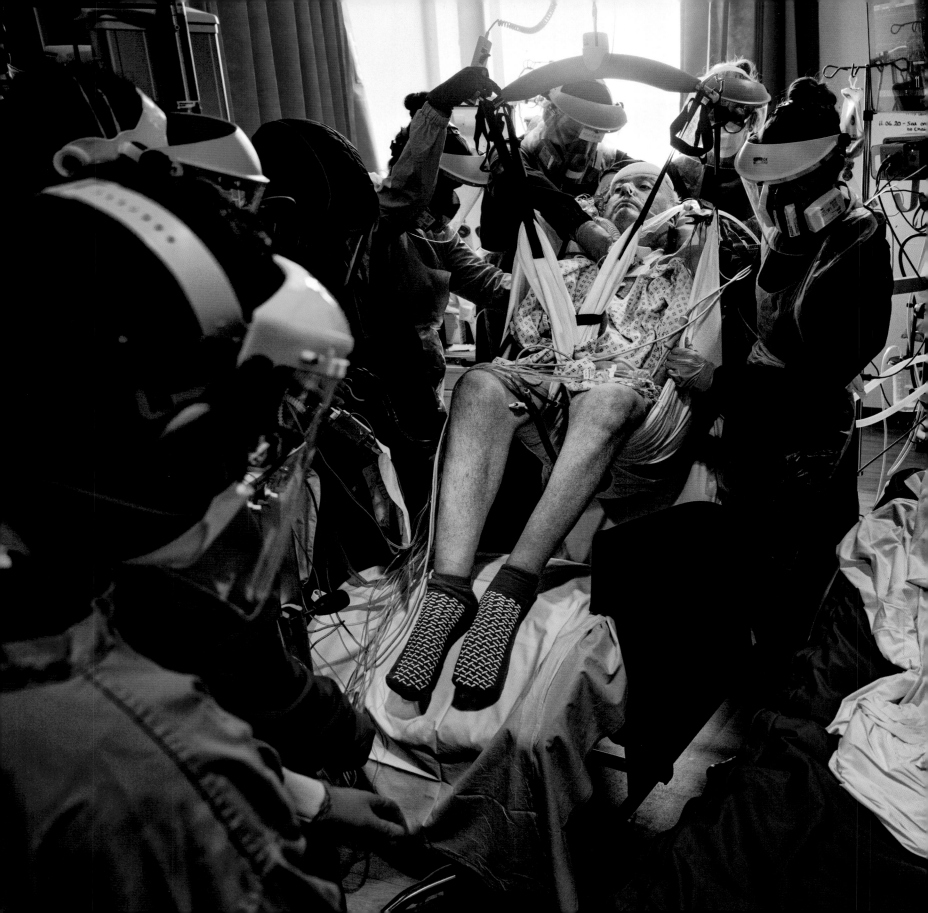

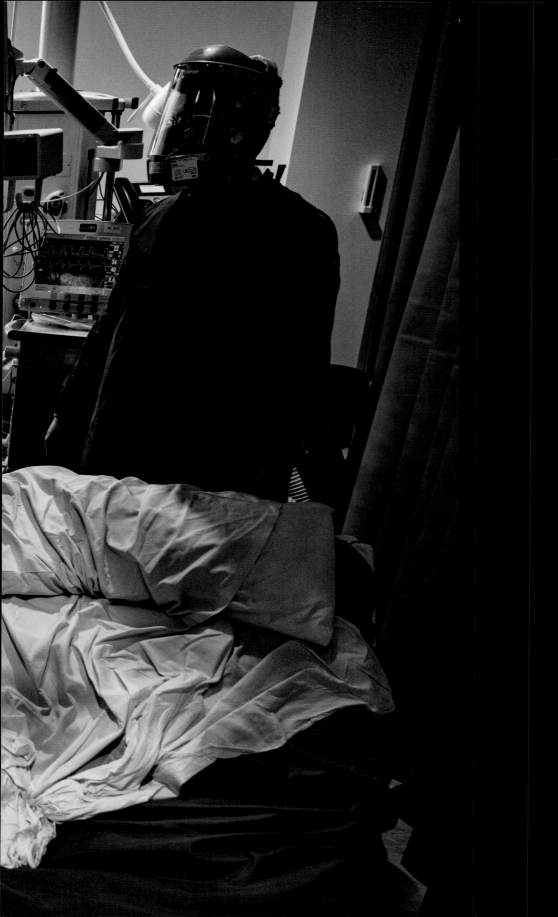

THREAT · RESILIENCE

Medical staff at the Royal
Papworth Hospital in Cambridge,
England, prepare to lift William,
50, into a seated position to help
him exercise his muscles. A
resident of the intensive care unit
for three months, he was one of
the longest-running COVID-19
patients on extracorporeal
membrane oxygenation (ECMO)
support, a process that pumps
and oxygenates a patient's blood
outside of the body—essentially
doing the job of the lungs.

LYNSEY ADDARIO | CAMBRIDGE, ENGLAND
JUNE 2020

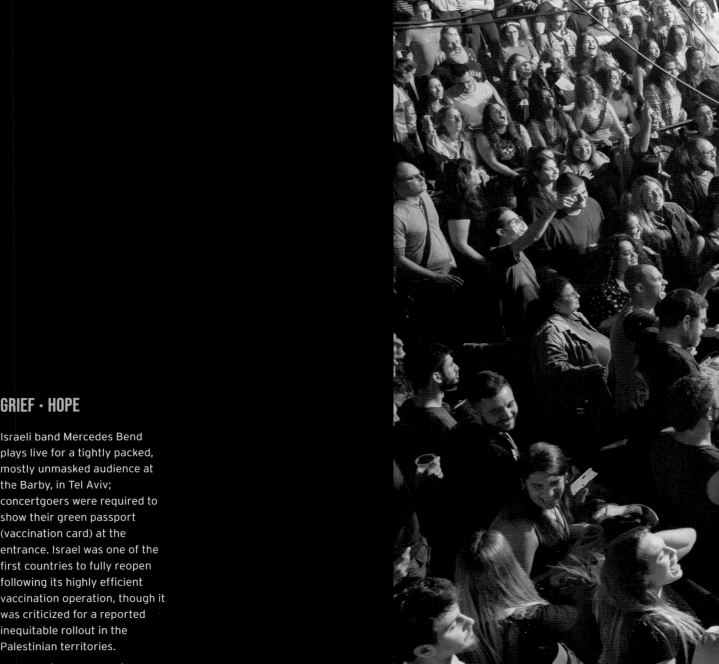

GRIEF · HOPE

Israeli band Mercedes Bend
plays live for a tightly packed,
mostly unmasked audience at
the Barby, in Tel Aviv;
concertgoers were required to
show their green passport
(vaccination card) at the
entrance. Israel was one of the
first countries to fully reopen
following its highly efficient
vaccination operation, though it
was criticized for a reported
inequitable rollout in the
Palestinian territories.

DAN BALILTY | TEL AVIV, ISRAEL | MARCH 2021

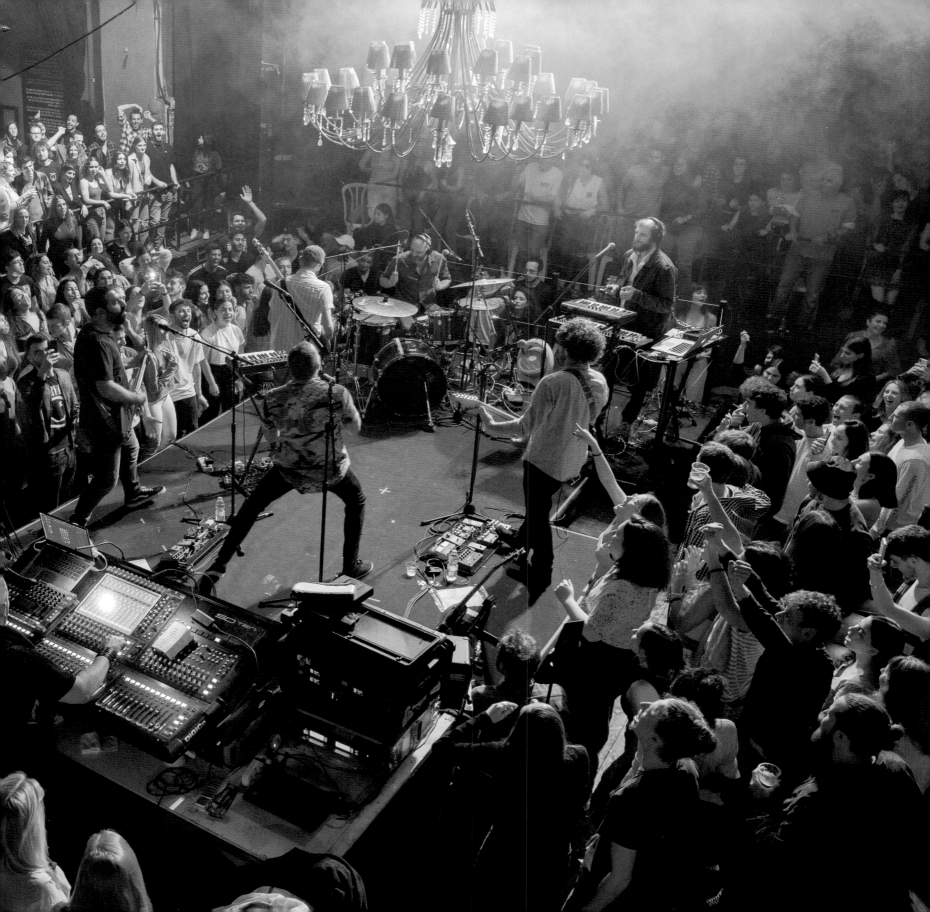

(INSIDE TH

HE CURVE)

STORIES FROM THE PANDEMIC

CURATED BY CLAUDI CARRERAS

NATIONAL
GEOGRAPHIC

WASHINGTON, D.C.

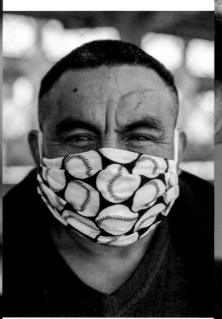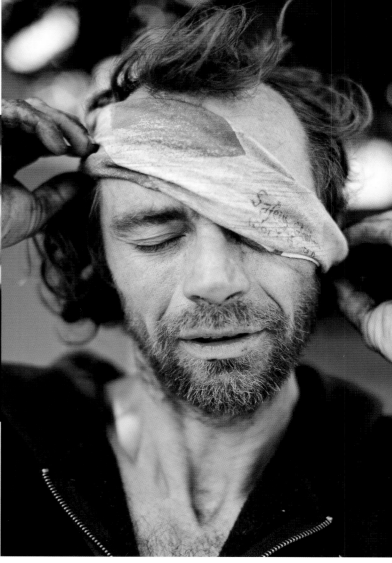

LACK OF HOUSING IN A TIME OF CRISIS: As the majority of California's citizens sheltered at home during the COVID-19 pandemic, the San Francisco Bay Area's considerable unhoused population faced the health and economic crisis without shelter, hygienic infrastructure, or equitable access to health care. *From left:* Ray, Juan, and Erin are experiencing a lack of housing; *far right:* Audrey, a political activist with *Poor* magazine

MARK LEONG | CALIFORNIA, UNITED STATES | MAY–SEPTEMBER 2020

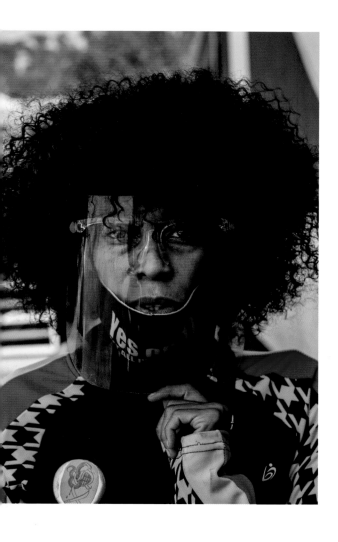

CONTENTS

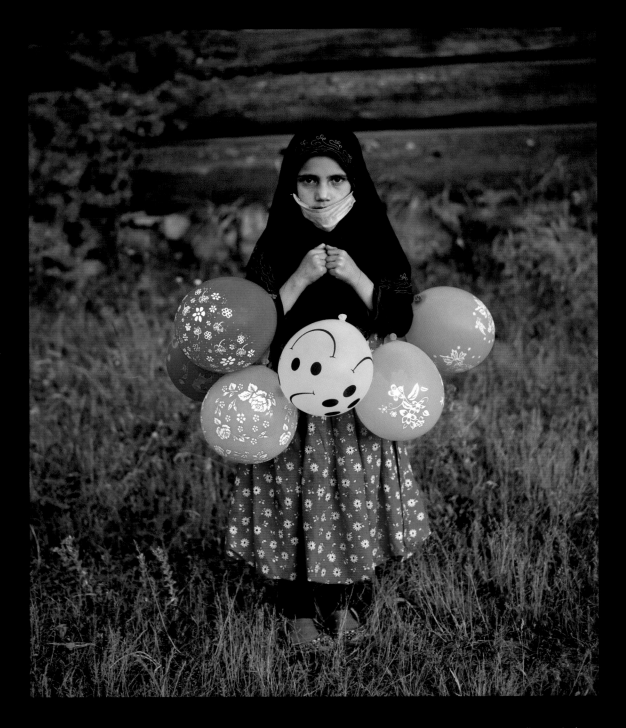

LIFE WITHOUT SCHOOL: Tayyiba, an eight-year-old girl in north Kashmir's Rafiabad region, plays with balloons during Eid Al-Adha. Schools in the disputed region have been closed since August 2019, first due to a military lockdown and then to the COVID-19 pandemic. Psychiatrists report that the overlapping crises have led to "hopelessly" high levels of youths with mental health issues, including depression and post-traumatic stress disorder.

SHOWKAT NANDA | RAFIABAD, KASHMIR | AUGUST 2020

FOREWORD

The COVID-19 pandemic changed the world. Newsrooms around the globe navigated countless disruptions. For local journalism, the impact was particularly profound, as the pandemic accelerated the downward slide of an already struggling industry. At the same time, the public turned to local news sources for information—anything to protect themselves and their loved ones.

Soon, a gap emerged: Vital information wasn't always available, since there were too few journalists to cover the stories that communities needed most. This was especially true of underserved communities that didn't have access to reliable information about the virus but were disproportionately impacted by it. As the COVID-19 pandemic unfolded, the vital importance of evidence-based reporting became abundantly clear.

This deeply resonated with us at the National Geographic Society, since storytelling is fundamental to our mission. The Society funds world-class journalists, photographers, filmmakers, and documentarians, and is one of the largest funders of independent reporting today. Stories raise our awareness about important issues, offer context and nuance, spark dialogue, encourage empathy, and move people to act. We believe in the power of storytellers to illuminate and protect the wonder of our world. And so we chose to act.

We launched the COVID-19 Emergency Fund for Journalists in March 2020 to support individuals who wanted to report on the impacts of the virus in their communities. The response was overwhelming. We received thousands of applications and ultimately funded 324 projects, representing storytellers from more than 70 countries. Through their lenses, we saw the social, emotional, economic, educational, and equity issues threatening livelihoods all over the world. In Indonesia, Joshua Irwandi was shadowing hospital workers when he captured a haunting image of a suspected COVID-19 victim's body wrapped in plastic. Published in *National Geographic* magazine and on its celebrated Instagram account, the photo ignited a worldwide conversation about the devastating human cost of the virus.

Inside the Curve is a curated collection of these poignant stories—an honest and in-depth visual chronicle of our time. Told by dedicated individuals at the forefront of a global crisis, it's a story of the resilience and tenderness of the human spirit. And it's a story of hope—of journalism as a catalyst for positive change. The fund set in motion a series of transformative responses, big and small: Food for a mother to feed her child. Donations. Relief efforts. Policy change.

At the National Geographic Society, we are proud to invest in storytellers. Their narratives shape our understanding of the world, our place in it, and our ability to change it. They are flashes of light in a time of darkness. We hope they inspire you the way they have inspired all of us.

Jill Tiefenthaler
Chief Executive Officer
National Geographic Society

PREFACE

ABOUT THE COVID-19 EMERGENCY FUND FOR JOURNALISTS

As we launched the National Geographic Society's COVID-19 Emergency Fund for Journalists, the world began to shut down. From the safety of our homes, we watched a mysterious disease make its way across the globe, and we immediately felt a need to support those on the front lines who were telling its story.

In the beginning we ran at a breakneck speed. We traded ideas and built a new initiative across computer screens. At times there were 30 people in one virtual meeting, a cacophony of voices focused on the fund. At other times children, suddenly sent home from childcare, crawled across our colleagues' laps as we discussed how to ensure our grants would reach those in need of our support.

When we opened the fund, it was as if we'd opened the floodgates. Hundreds of applications streamed in during the first week. While it was daunting, our purpose was clear: to give these storytellers the support they urgently needed. While reviewing applications, we would send messages to one another into the night: *"Go to bed!"* *"No, you go to bed!"* The next day we would compare notes, recognizing the sometimes-impossible choices bound up with limited funding, along with seemingly limitless talent and need.

As we pored through applications, something remarkable started to come into focus. Where we were once bombarded with news of dark, sobering statistics and amorphous grief—the magnitude of which was difficult to comprehend—we were now replete with stories rich in color and detail, layers and dimension. They helped to center the gravity of an omnipresent virus in experiences that were personal, nuanced, and often universally felt.

There were heartbreaking stories, yes. But there were many uplifting stories too, of resilience and beauty. We highlighted stories of graffiti artists in Kenya who sprayed evidence-based messages on shop walls to encourage social distancing; a community radio station in Gabon that commissioned original, educational songs with local musicians; American Indian podcasters and doctors who joined together to share the latest and best information with their communities. These storytellers looked beyond traditional publishing methods in print and online outlets and found creative ways, in multiple languages, to reach the underserved and marginalized who may not have access to digital media or the ability to read.

We funded hard-hitting, on-the-ground reporting, such as by those who documented the impact of the virus on migrant worker communities and incarcerated people. The latter series explored a lack of protections against exposure to COVID-19, ranging from limited access to safety equipment to the federal lawsuits over prison conditions. These storytellers championed the overlooked and forgotten.

Collectively, their work told a much broader story about the pandemic in a strikingly intimate way. One recipient documented his pregnant wife's preparations to give birth at home. Another examined how children continued their education without access to electricity. Another revealed how countries like Syria, in the midst of other collective trauma, simultaneously grappled with the deadly virus. These stories were individual yet universal; they captured the human condition in all its many facets.

In the time since we launched the fund, I've had the enormous privilege of getting to know some of the journalists and photographers you will learn about in this book. As we followed their journeys, they shared the impacts of their reporting. Visual artist Júlia Pontés, who reported on mining communities in Brazil, described it as "the most intense, challenging, and satisfying work experience I have ever had." Journalist Ankita Mukhopadhyay, who investigated women's access to health care in India, wrote, "The past few weeks have changed my life. The women who shared their story of struggle will get a platform,

THESE STORIES WERE INDIVIDUAL YET UNIVERSAL; THEY CAPTURED THE HUMAN CONDITION IN ALL ITS MANY FACETS.

and it wouldn't have been possible to do this work without the help of funding from the National Geographic Society." This book is full of stories just like these, of people coming together to help their neighbors, and of generosity in the face of limited resources.

Inside the Curve reiterates that journalists are eager to tell the stories of their communities. And their stories highlight our mutual interconnectedness. In the work that we funded, we often saw our own experiences reflected as we attempted to parent and teach and do our jobs. And we felt a little less alone.

Storytelling is a hallmark of our work at the National Geographic Society because it helps us understand our human journey and our world. That's also true of the accounts in this book: They create a record of shared humanity that will echo around the globe for generations.

Kaitlin Yarnall
Chief Storytelling Officer
National Geographic Society

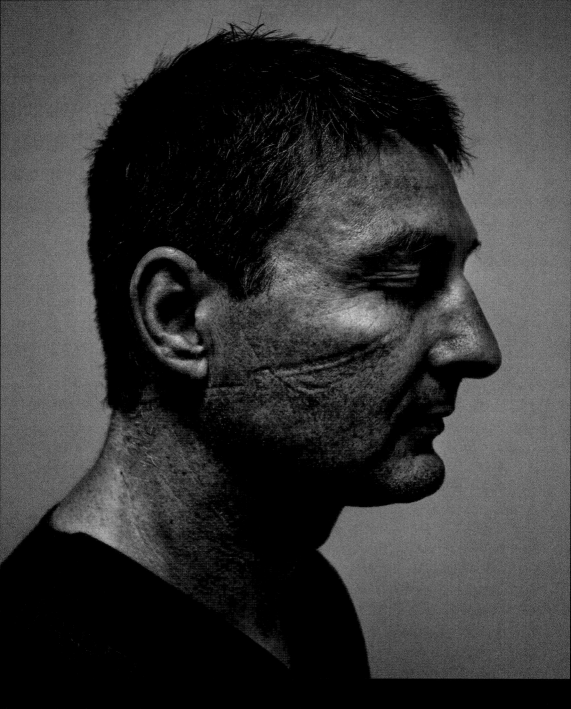

ANGLE OF REPOSE: Yves Bouckaert, chief physician of intensive care at Tivoli Hospital in La Louvière, Belgium, removes his mask after several hours spent inside the COVID-19 intensive care unit.

CÉDRIC GERBEHAYE | LA LOUVIÈRE, BELGIUM | MARCH 2020

INTRODUCTION

DOCUMENTING A GLOBAL PANDEMIC IN ALL ITS COMPLEXITY

COVID-19 was a nefarious stranger that infiltrated the world overnight and changed us forever. From the first moment it arrived, with contradictory information flowing from all sides, it was immediately clear that the role of journalists would be more important than ever. But by necessity, thousands were confined, unable to do their jobs and without stable funding sources to ensure their survival.

The National Geographic Society sprang into action. The COVID-19 Emergency Fund for Journalists was opened on March 27, 2020, with the purpose of supporting local stories about the pandemic, particularly the most vulnerable populations around the world. For many, this was an opportunity to produce, in record time, essential material documenting multiple facets of a global crisis. And thanks to digital platforms, social media, and the 24-hour news cycle, we could see that work transmitted live.

It may be impossible to fully comprehend the nuance of the projects the Emergency Fund supported. The program provides an intimate yet wide-ranging glimpse of this pandemic in all its complexity. The stories that converge in *Inside the Curve* are produced by creators from all over the world; together, they form an unprecedented constellation of authentic experiences. From local narratives told by reporters close to the action, we were able to draw a global map of the epidemic from the perspective of its own protagonists. And unlike the coverage commissioned by other media, the Emergency Fund allowed these storytellers to work on projects of their own choosing.

The work supported by these grants underscores patriarchal patterns found in some mainstream outlets in the representation of different communities around the globe. Many groups no longer feel represented by the media; there is a need to diversify the narratives and to center previously underrepresented voices. The Emergency Fund has been especially attuned to this situation, making it possible for hundreds of professionals to document the pandemic from their own perspective. This close and immediate view constitutes a unique and unprecedented visual corpus.

As COVID replicated around the world, we were all vulnerable to the same disease for the first time in a century—although some were more exposed than others as they risked their lives

to perform essential jobs. The journalists who appear in these pages are part of the group that put their physical integrity at risk, and I had the privilege of supporting them on the journey of their projects. The process has been moving, as it has allowed me to learn through the eyes of the storytellers about the different effects of the pandemic and the consequences of mitigation efforts implemented around the world.

And those effects were searing. Through the eyes of these storytellers, I was able to witness them from the perspectives of Indigenous communities in the Amazon rainforest, farmers in rural Portugal, migrants on the U.S.-Mexico border, and owners of shuttered shops and restaurants in San Francisco. I saw the havoc of COVID on families fleeing Middle East wars, Ecuadorian children without a home digital connection to remotely attend school, and marginalized neighborhoods in Kenya.

The first grants of the Emergency Fund were awarded at the end of March 2020; the last were administered in August 2021. Thanks to the extension and dimension of these endowments, we can better understand the different stages of the pandemic and how it affected different countries. While we could never tell the entire story of the crisis, we instead present deeply personal views that reveal how it was experienced around the world.

This book contains six chapters that explore different aspects of COVID-19.

"Alone / Together" illuminates a society that is more connected than ever, able to share similar

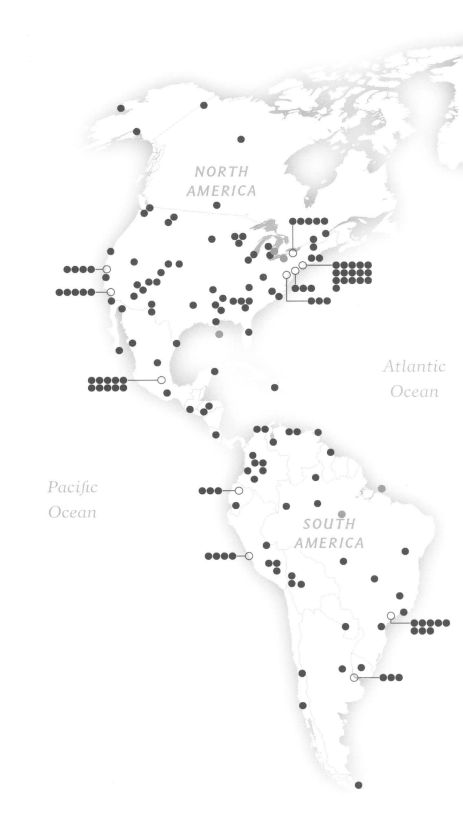

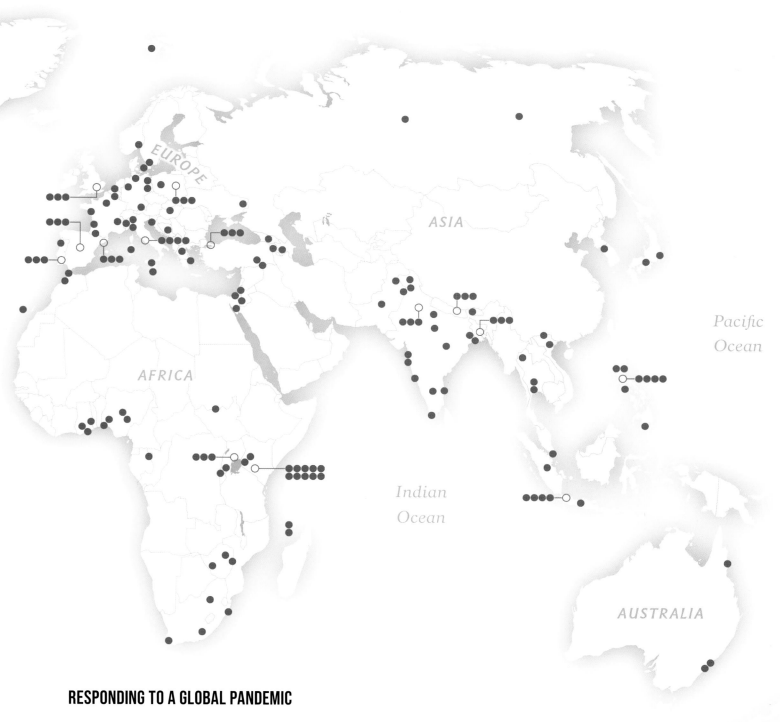

RESPONDING TO A GLOBAL PANDEMIC

As uncertainty, fear, and conflicting information kept pace with the COVID-19 virus as it spread across the globe, the National Geographic Society launched the COVID-19 Emergency Fund for Journalists to help journalists tell emerging stories of dire need and inequity, and to spread critical public health information. From March 13, 2020, through August 15, 2021, the fund awarded 324 projects in more than 70 countries.

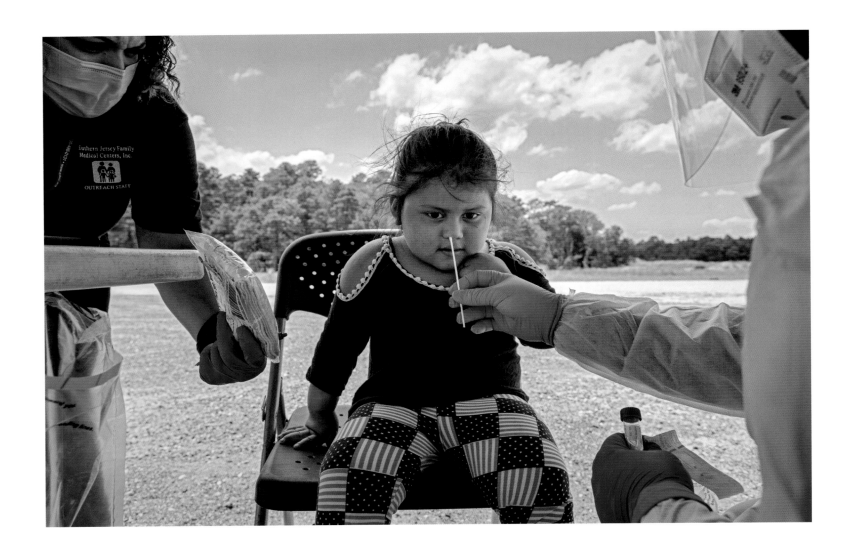

THE RISK OF WORK: The daughter of a farmworker at Atlantic Blueberry in Mays Landing, New Jersey, receives a COVID-19 test. Every year an estimated 6,000 migrant farmworkers, primarily from Mexico, Haiti, and Central America, arrive at blueberry farms in southern New Jersey for an intensive eight-week harvest. During this time, most workers and their families live in crowded camps, sharing bathrooms and dormitory-style sleeping quarters, which makes them particularly vulnerable to COVID-19. At the height of mandatory stay-at-home orders, essential workers helped meet the demands of everyday life, including supplying transportation, providing medical care, and maintaining food supplies and distribution.

KATIE ORLINSKY | NEW JERSEY, UNITED STATES | JULY 2020

fears and feelings despite the forced isolation and social distance imposed by public health requirements.

"Work / Home" reveals how some workers who have not always been valued are now recognized as fundamental gears in our shared society. Remote work, the adaptations of the educational system, and the teaching of our children have become part of our daily lives, throwing inequalities and structural differences into sharp relief.

"Exploit / Protect" manifests the profound interconnection between nature and humanity. During the lockdown, many of us have felt the need to reconnect with the natural world. Yet in too many parts of the world, deforestation, illegal fishing, and the loss of biodiversity have increased significantly, with an impact yet to be assessed.

"Urban / Rural" shows how quarantine has manifested the disconnection and inequalities between the cities and the countryside. This chapter magnifies the immense differences in the realities of those who inhabit urban and rural spaces.

"Threat / Resilience" confronts the structural failures of our social and economic system while highlighting the inherent strength of many communities—and the importance of such values as solidarity, cohesion, and transparency.

Finally, "Grief / Hope" addresses one of the most important aspects of the pandemic (and certainly one of the most difficult to photograph): the psychology of the experience. So many of us have

THE STORIES THAT CONVERGE IN *INSIDE THE CURVE* ARE PRODUCED BY CREATORS FROM ALL OVER THE WORLD; TOGETHER, THEY FORM AN UNPRECEDENTED CONSTELLATION OF AUTHENTIC EXPERIENCES.

grappled with the fear and vulnerability stemming from the extreme disruption of our everyday lives. This has profoundly and radically affected our communities, awakening a collective feeling of hope—essential in overcoming this private and global traumatic experience.

Although the images in this book have been curated for their documentary value, we have avoided publishing the harshest of them in the hopes of building a vision that will help us to discern a shared future in which no one is left behind; in so doing, we can perceive our world as the diverse, inclusive, and equitable home it should be.

While it has revealed the differences that separate us, the COVID-19 pandemic has also granted us a global empathy. In this brave new world, we are no longer strangers.

Claudi Carreras
Curator, Inside the Curve

ALONE

TOGETHER

WORLDS APART. Throughout our evolution, humans have thrived by banding together. So what do we do when the spread of a virus forces us apart? Thankfully, technology has provided people with new ways to connect. Although video calls are a poor substitute for in-person interaction, they have allowed work, education, and socialization to continue during the pandemic in a way that would have been impossible just a few years ago. The projects in these pages deal with being alone, as well as the shared experiences that have brought us closer together.

ALONE

Eleden Suarez, 80, poses for a drone portrait inside her small garden at her home in Santa Lucía, Uruguay. Suarez had been living alone since her husband's death 15 years prior; though she asserted that she was not afraid of being alone and could distract herself, she experienced severe isolation throughout the COVID-19 pandemic. The elderly have been one of the most vulnerable groups throughout this crisis—not just to the virus but also to the isolating effects of quarantine.

SANTIAGO BARREIRO | SANTA LUCÍA, URUGUAY
APRIL 2020

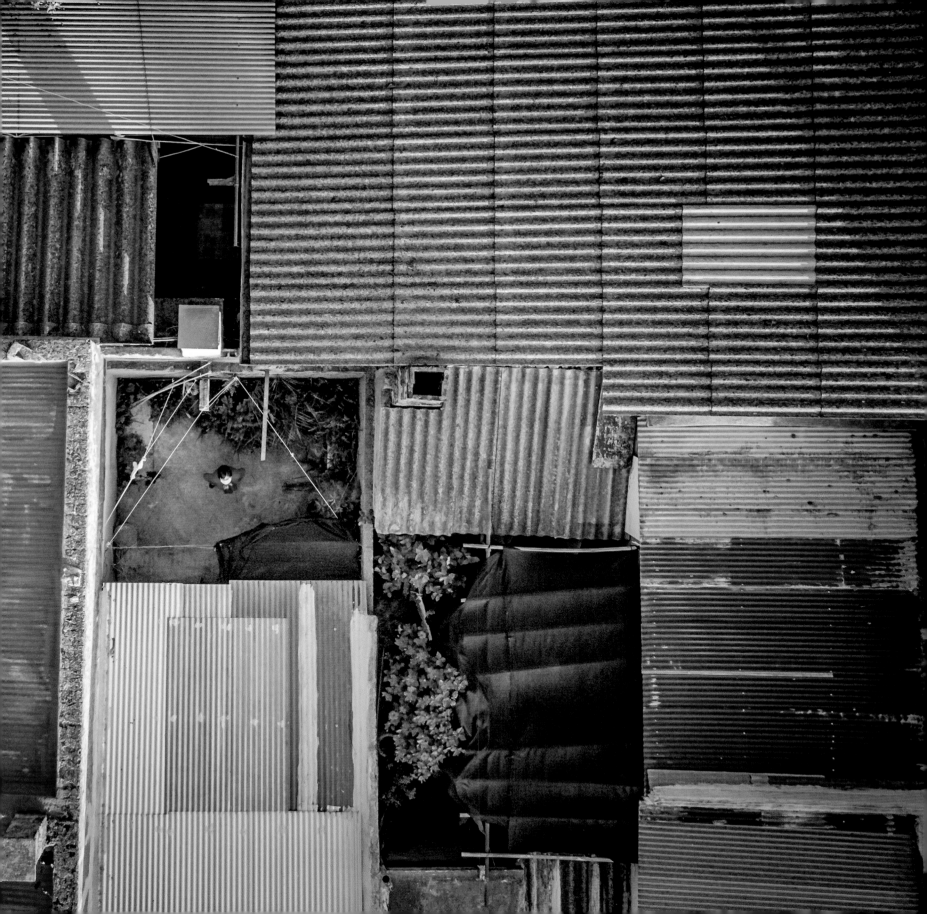

TOGETHER

The parents and sisters of Jose (not pictured) connect with him on FaceTime on the day he met his two-month-old baby, Manu, for the first time. Residents of Argentina, Jose and his partner, Flavia, had planned to travel to the Ukrainian capital, Kyiv, where their son was born in March 2020 via gestational surrogacy. But shortly before his birth, Argentina closed its borders as part of its COVID-19 travel restrictions, so the couple couldn't be present for this life-changing event.

IRINA WERNING | BUENOS AIRES, ARGENTINA
MAY 2020

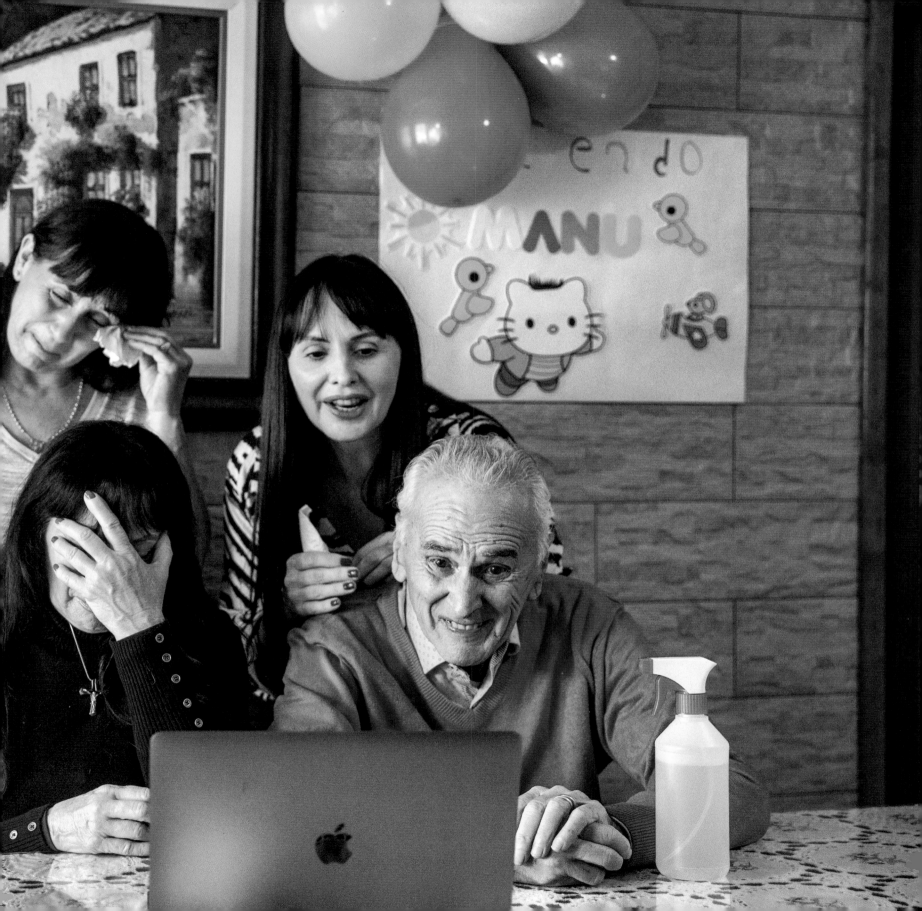

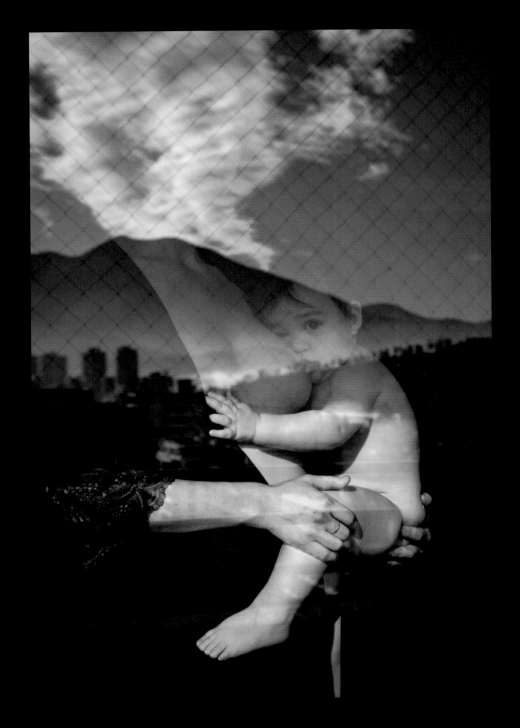

SEEKING SHELTER: Tamara Merino breastfeeds her son, Ikal, in a self-portrait taken during mandatory quarantine. Merino explored the connection between mother, child, and nature during COVID-19.

TAMARA MERINO/AYÜN FOTÓGRAFAS | SANTIAGO, CHILE | JUNE 2020

ESSAY

COMFORT IN CRISIS

BY TAMARA MERINO

Tamara Merino is a documentary photographer and visual storyteller based in Santiago, Chile. Her Emergency Fund-supported project explored the connection between mother, child, and nature while being in lockdown because of the COVID-19 pandemic.

The world today has given us a pause: a life without haste, without pressures, and without excuses. For more than 365 days we were locked in a confined space due to government-mandated quarantine restrictions. During those days, the world stood still, and life in my house froze into a hug.

Suddenly stuck in one place, I had the opportunity to turn the camera inward and portray my own life. Thus, my "quarantine diary" was born. It records my relationship with my son and my mother, as well as the symbiosis created between the three of us during isolation. Quarantine gave us the opportunity to deeply share a life that we would never have lived together if not for the pandemic.

Deep down, I feel that quarantine is like motherhood: an endless spiral of loneliness, isolation, unanswered questions, anxiety, reflections, and hope. These emotions are neither negative nor positive; they are simply new. But quarantined or not—inside or outside—freedom is a state of mind. It is a philosophy, a decision.

During quarantine I wondered, What happens when humans are deprived of their connection to nature? So I decided to explore this issue during our isolation period, to help make sense of how my son was growing up behind concrete walls.

One way to cope was to embody nature for him. I am the earth that contains him, I am the wind that lulls him, I am the fire that motivates him to explore, and I am the water that calms him. Maybe he didn't miss the soil and the sun, as I do, because he had been locked up half of his life.

We have learned so much, lost so much, and gained so much in this pandemic. And I believe that even though we have felt like caged animals, the quarantine has made us reconnect with our inner animal. We depend on nature, yet it grew and flourished in our absence.

Today we are the ones who must inhabit the world in a different way.

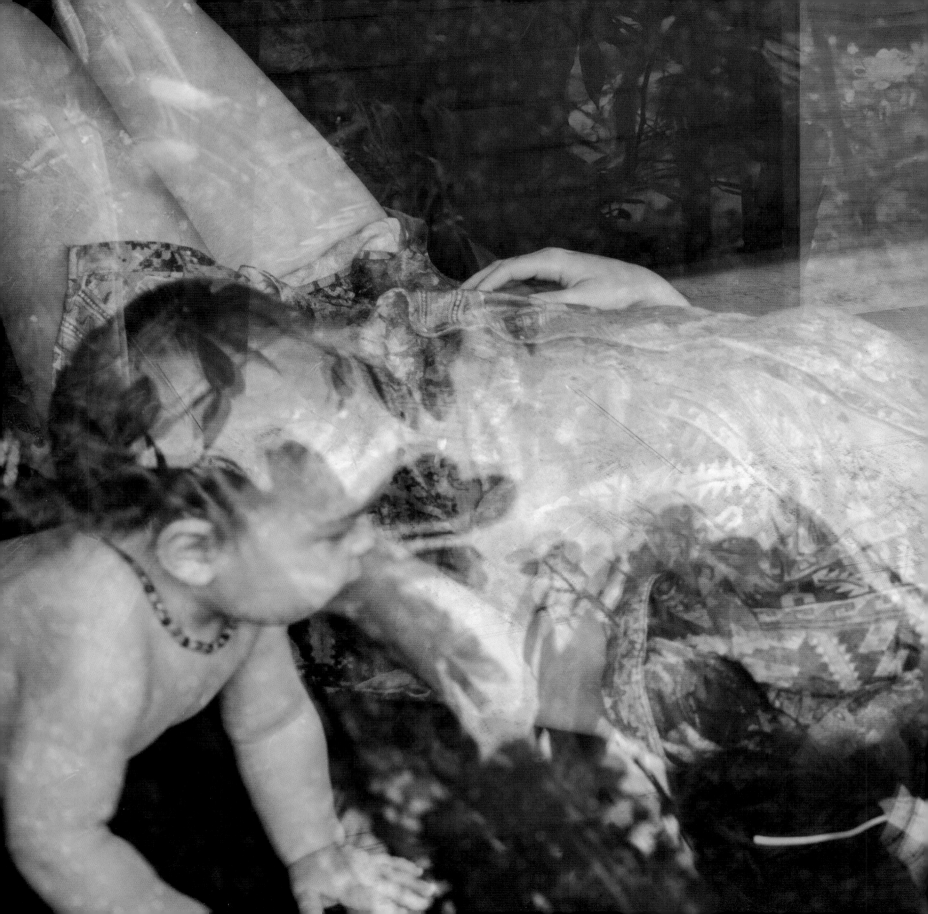

APART FROM NATURE

TAMARA MERINO/AYÜN FOTÓGRAFAS
SANTIAGO, CHILE | APRIL 2020

In a self-portrait with her son, Ikal, Tamara Merino documents her window as a physical manifestation of the barrier between them and the natural world. During 140 days of mandatory quarantine in Santiago, Chile, with limited exposure to the outdoors, she discovered the environment's enormous impact on our collective well-being.

APART FROM NATURE CONTINUED

TAMARA MERINO/AYÜN FOTÓGRAFAS | SANTIAGO, CHILE | JULY 2020

Tamara Merino's son, Ikal, looks through a window that is stained with body grease and handprints. During months of a mandatory stay-at-home order to counter the spread of COVID-19, Merino turned her camera on herself and her family to explore the effects of being kept apart from nature.

BIRTH IN QUARANTINE

ESPEN RASMUSSEN/VII | NESODDEN, NORWAY | APRIL 2020

Espen Rasmussen's pregnant partner, Julia, takes a moment outdoors during a mandatory stay-at-home order. Rasmussen began documenting Julia's pregnancy on March 13, 2020, the first day that Norway went into lockdown to stem the outbreak of COVID-19. With Julia's delivery expected just two days after this photo was taken, the family took careful precautions, including shopping early in the morning, barring their children from connecting in person with friends, and leaving the house only when necessary.

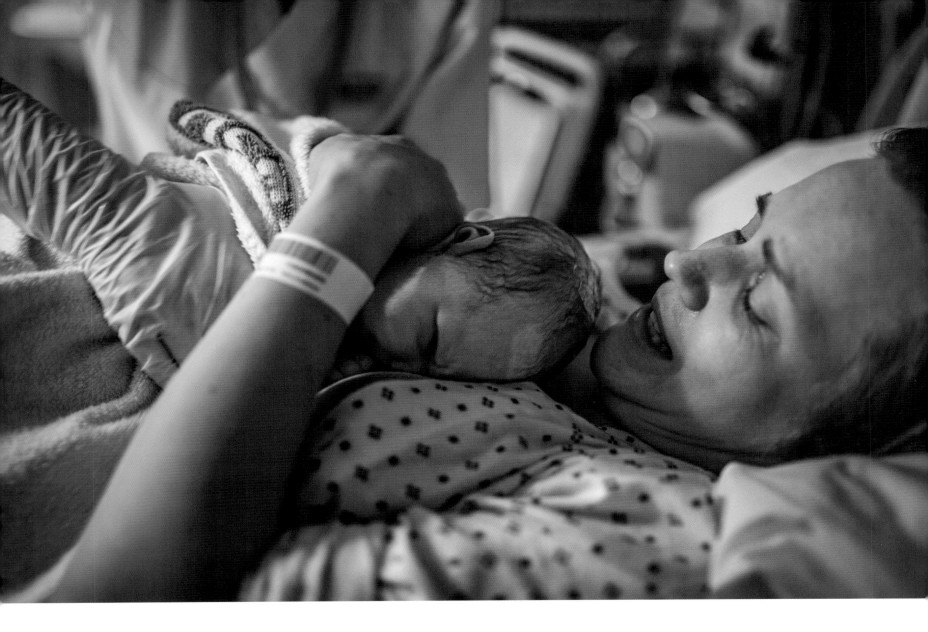

BIRTH IN QUARANTINE CONTINUED

ESPER RASMUSSEN/VII | AKERSHUS UNIVERSITY HOSPITAL, NORWAY | APRIL 2020

Left: Stella is born at the outset of the COVID-19 pandemic. *Right:* Following the delivery, in a hospital filled with COVID-19 patients, the baby can be seen by her father only via video chat.

Amid the isolation and uncertainty of the pandemic, Espen Rasmussen chronicled his partner Julia's pregnancy and his youngest child's birth; his work highlights the challenges of pregnancy and delivery and of family life in a time of crisis.

SINGLE MOTHERS CONFRONT COVID-19

SHAI ANDRADE | AREMBEPE, BAHIA, BRAZIL
NOVEMBER 2020

Stephanie and her son swim in
the river in front of their house.
Throughout the COVID-19
pandemic, she crossed it each
day to reach the butcher, where
she worked as an attendant.
Swimming provided her and her
son with moments of leisure
and affection.

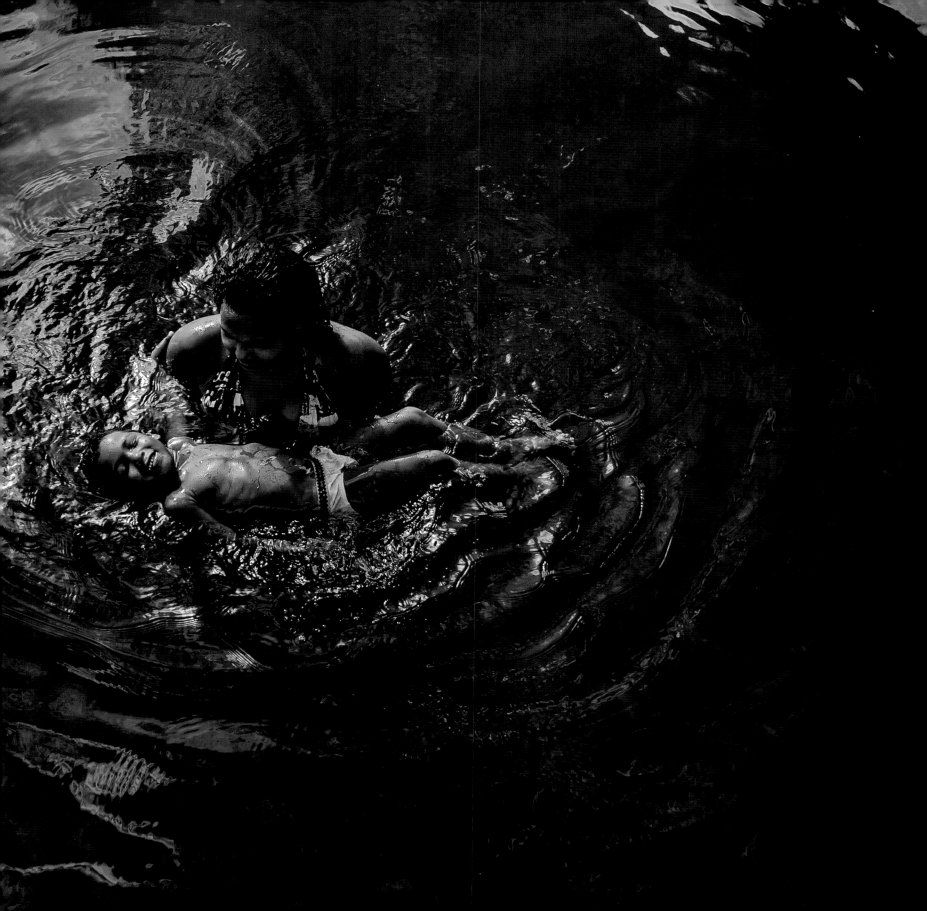

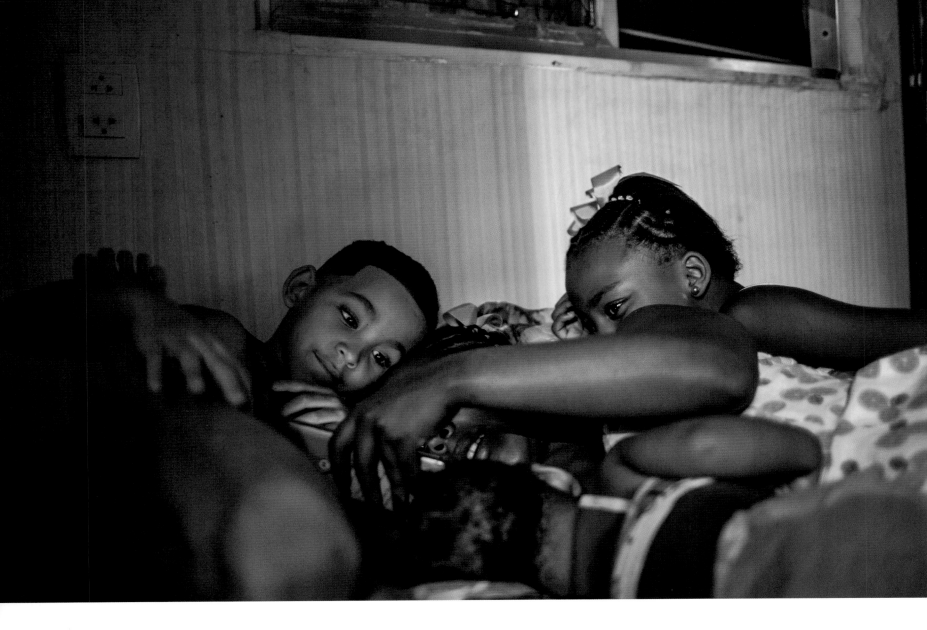

SINGLE MOTHERS CONFRONT COVID-19 CONTINUED

MARÍA MAGDALENA ARRÉLLAGA AND PATRÍCIA MONTEIRO | BRAZIL | JUNE–SEPTEMBER 2020

Left: Rafaela Machado, 29, a mother of four, watches a video with her children before bedtime.
Right: Aru, five, reacts to his mom, Luisa, 27, while choosing the best hiking trail.

With the closure of daycare centers and schools to prevent the spread of COVID-19, many of Brazil's single mothers were forced to forfeit work to supply full-time childcare or to rely on social networks for daycare while working in essential positions to provide for their families. As the pandemic tightened its grip on Brazil, women regularly came to bear the most weight in the social chain, often working outside the home while managing domestic responsibilities, education, and childcare.

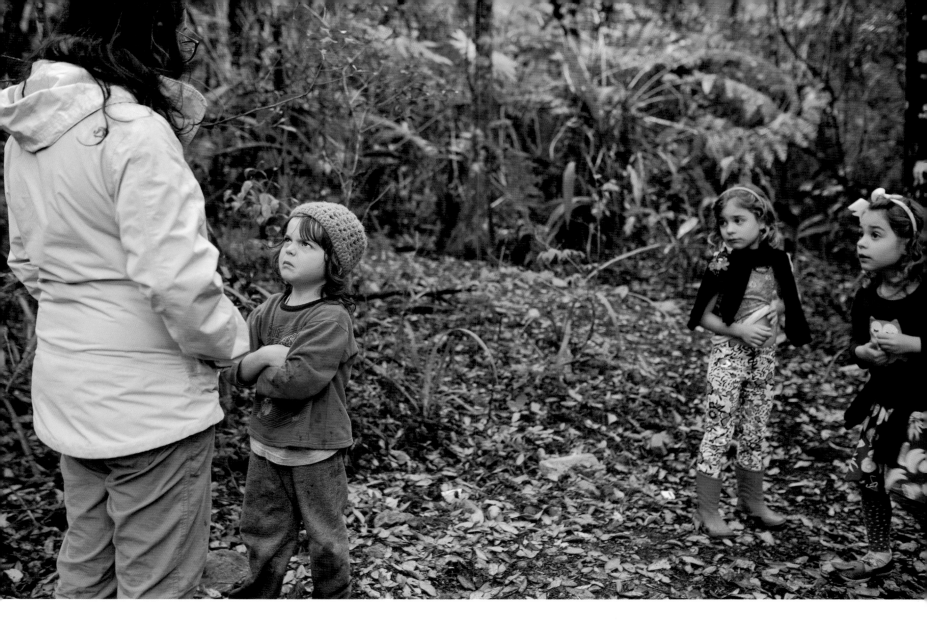

FAULT LINES EXPOSED

MOHAMMAD FAHIM AHAMED RIYAD | DHAKA, BANGLADESH | APRIL 2020

Below: Spaces to enforce social distancing are drawn on Bailey Road, one of Dhaka's busiest shopping and restaurant districts. *Right:* Visitors eagerly await entry to Baitul Mukarram mosque to return to in-person prayers.

In Dhaka, Bangladesh's capital and most densely populated city, the COVID-19 pandemic created fault lines that ruptured almost all aspects of life, exposing stark socioeconomic disparities in how residents were able to prepare and quarantine.

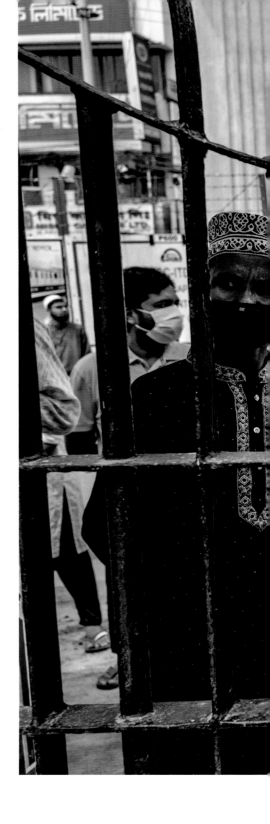

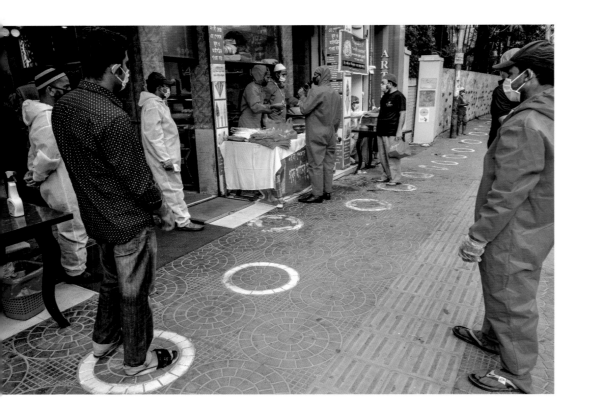

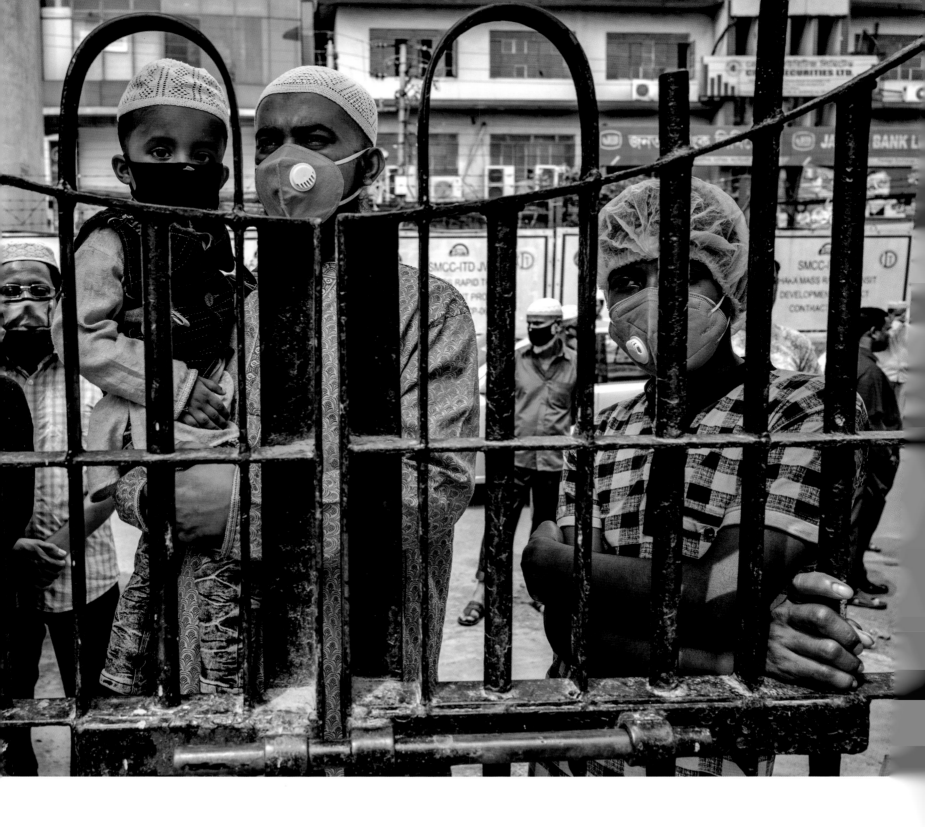

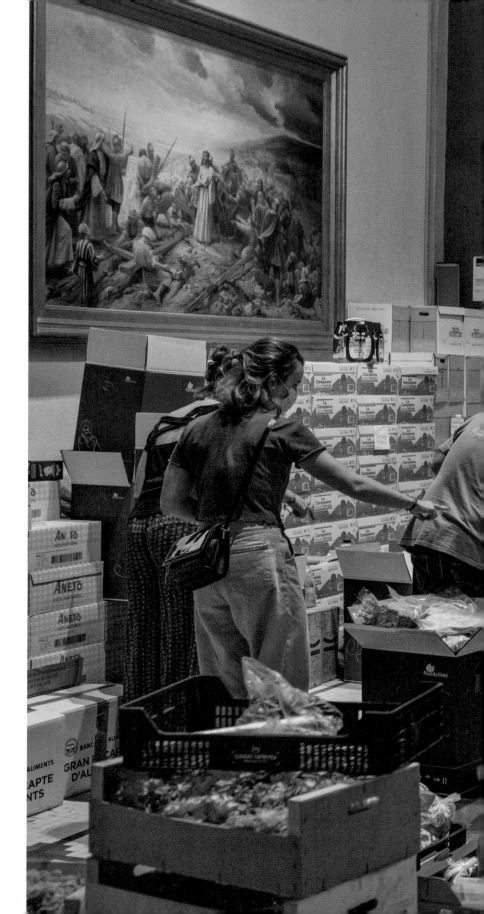

COMMUNITY AID LENDS STRENGTH

MARIA CONTRERAS COLL
BARCELONA, SPAIN | JUNE 2020

Volunteers prepare food for families inside Santa Anna, a 12th-century monastery turned church converted amid the COVID-19 pandemic to the site of a community-aid operation. During Barcelona's state of emergency and lockdown, volunteers here distributed food supplies and more than 200 meals daily to the most socially and economically affected families.

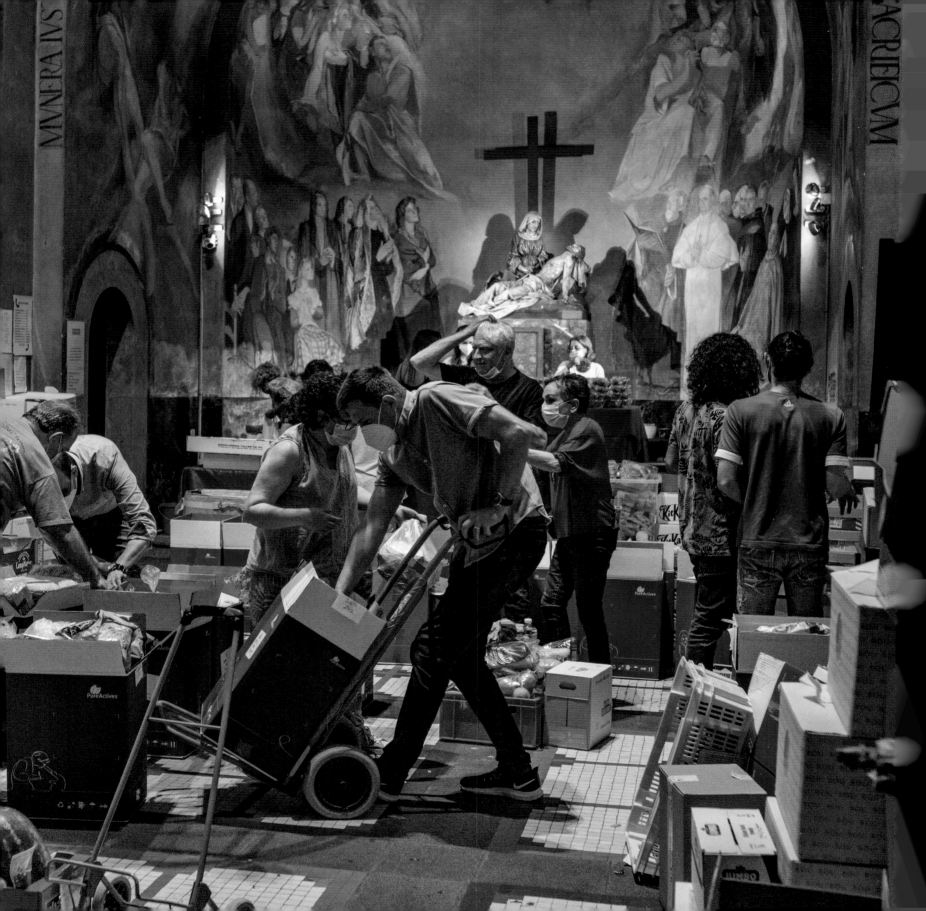

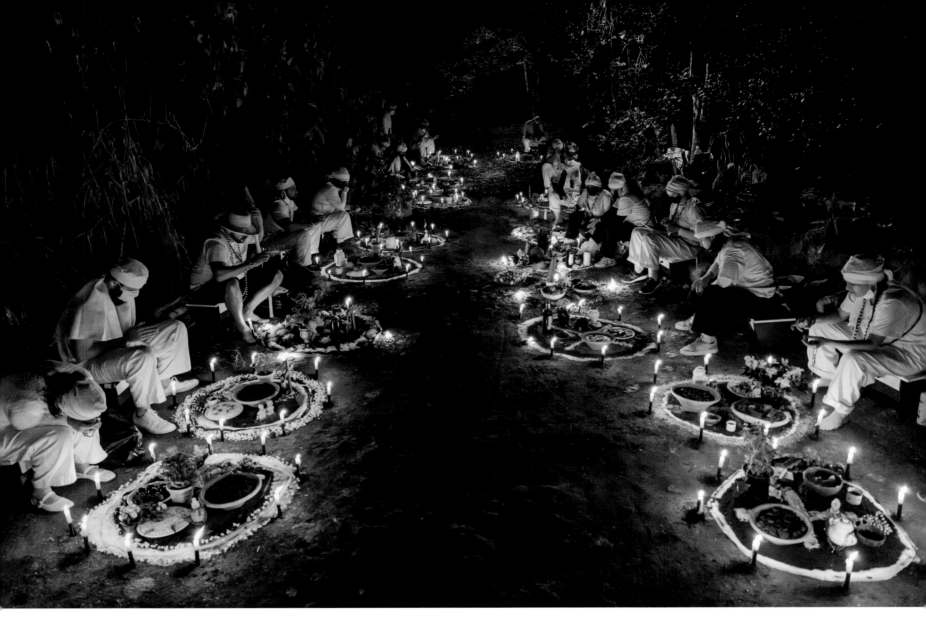

REDEFINING RELIGIOUS COMMUNITY

GUILHERME CHRIST | SÃO PAULO, BRAZIL | MAY-JUNE 2021

Left: Attendees of Umbanda temple Casa do Pai Benedito perform a ritual dedicated to African ancestors' spirits and Obaluaê, the Yoruba deity of sickness and cure. The ritual was carried out in the woods to conform with restrictions on gatherings in closed areas amid the COVID-19 pandemic. *Right:* After his temple closed in the face of lockdowns, Umbanda priest David Dias broadcasts a Preto-Velhos ritual online.

During the pandemic, many of Brazil's Afro-Indigenous religions, deeply rooted in community life, had to reinvent their practices, often using new technologies to reach their members.

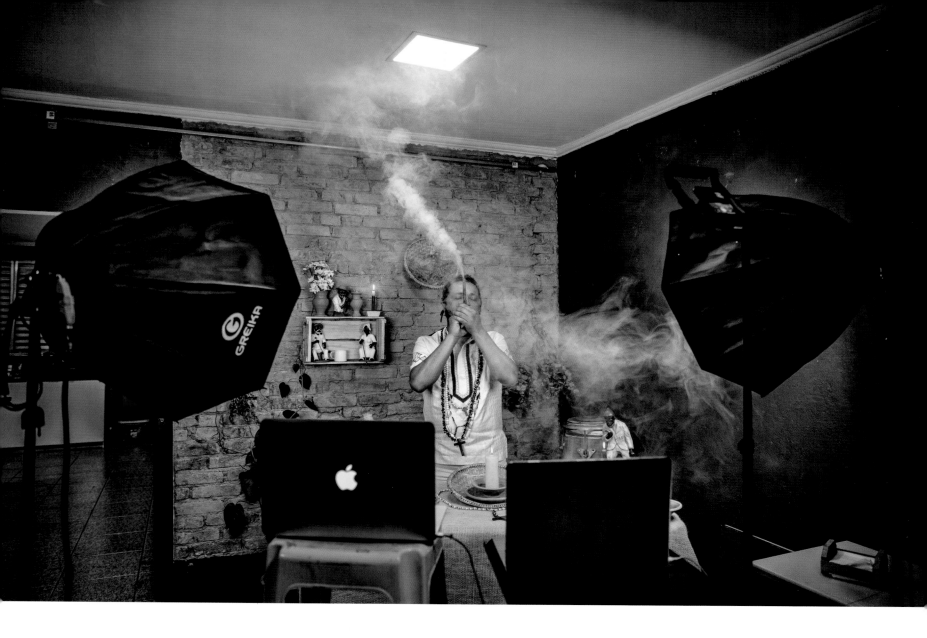

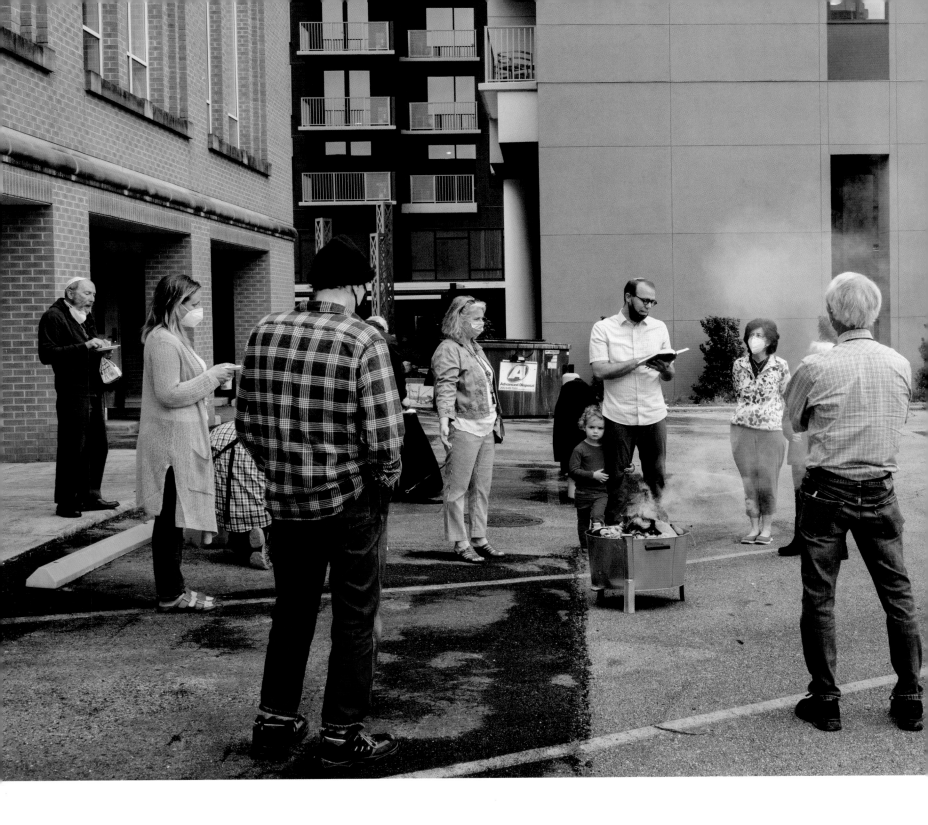

FAITH AMID COVID-19

NATALIE KEYSSAR | ALABAMA, UNITED STATES | MARCH 2021

Left: Members of Temple Beth-El in Birmingham, Alabama, gather in the parking lot for the ritual burning of leavened bread products in observance of Passover. *Below:* Doctor Nauman Qureshi, a longtime member of the Huntsville Islamic Center mosque, reads the Quran with his 14-year-old granddaughter on FaceTime while his wife, Mussarat Qureshi, the principal of the center's Islamic Academy, relaxes nearby.

As COVID-19 began to change lives and take lives in Alabama, the state's diverse religious groups provided food aid, spiritual balm, and a sense of community amid increasing isolation, economic hardship, fear, and grief.

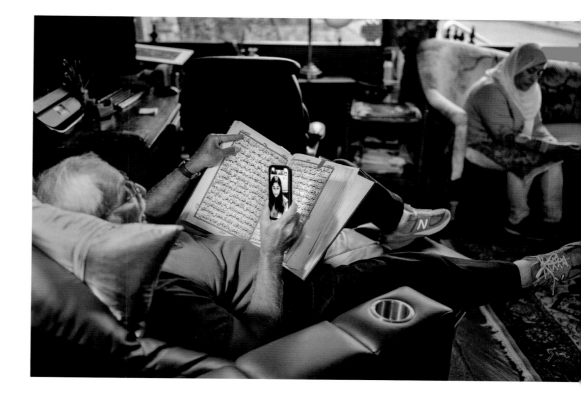

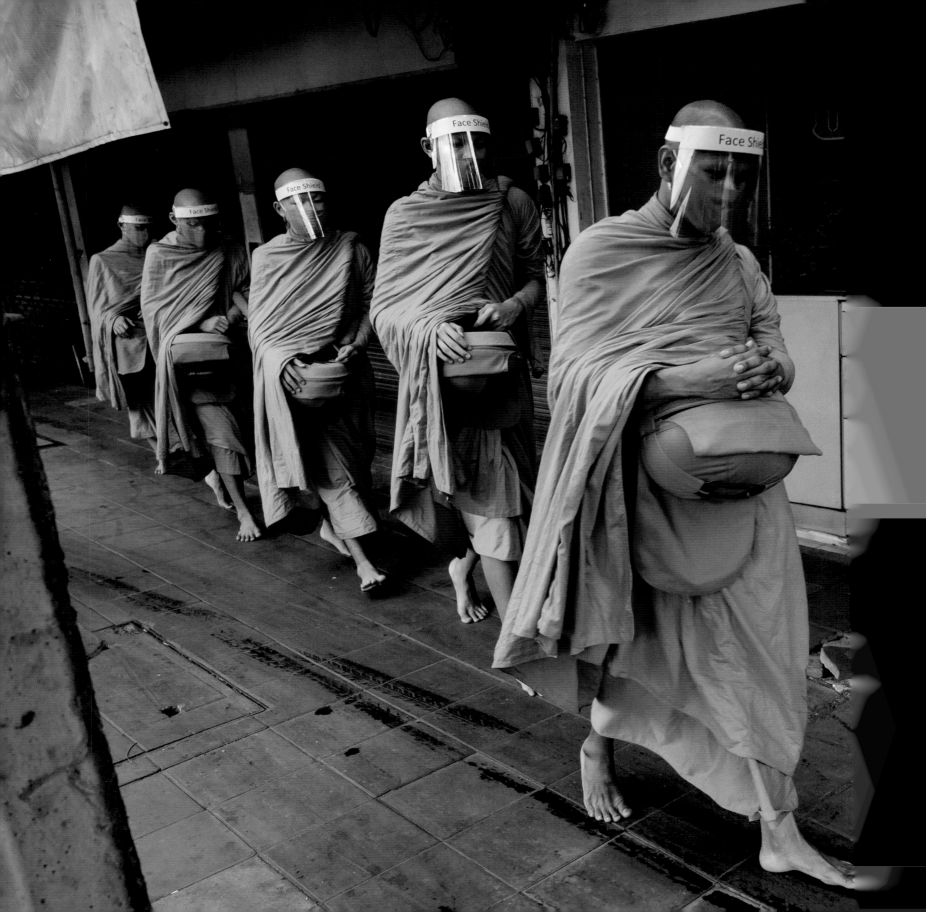

SOCIOECONOMIC DISPARITIES LOOM LARGE

SIRACHAI ARUNRUGSTICHAI
BANGKOK, THAILAND | APRIL 2020

Buddhist monks from Wat Matchanthikaram walk the streets of Bangkok during their daily alms rounds, collecting food donations and giving blessings in return. To reduce the risk of infection by the COVID-19 virus during this traditional practice, they made their own face shields using designs found on a video-sharing platform.

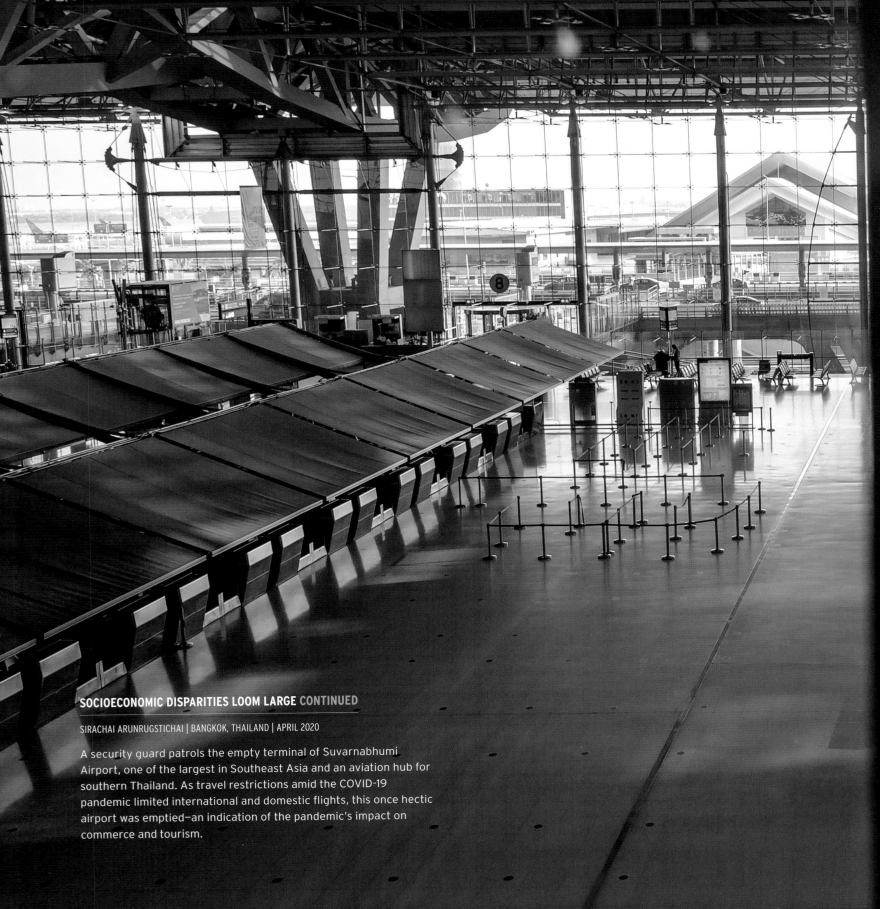

SOCIOECONOMIC DISPARITIES LOOM LARGE CONTINUED

SIRACHAI ARUNRUGSTICHAI | BANGKOK, THAILAND | APRIL 2020

A security guard patrols the empty terminal of Suvarnabhumi Airport, one of the largest in Southeast Asia and an aviation hub for southern Thailand. As travel restrictions amid the COVID-19 pandemic limited international and domestic flights, this once hectic airport was emptied—an indication of the pandemic's impact on commerce and tourism.

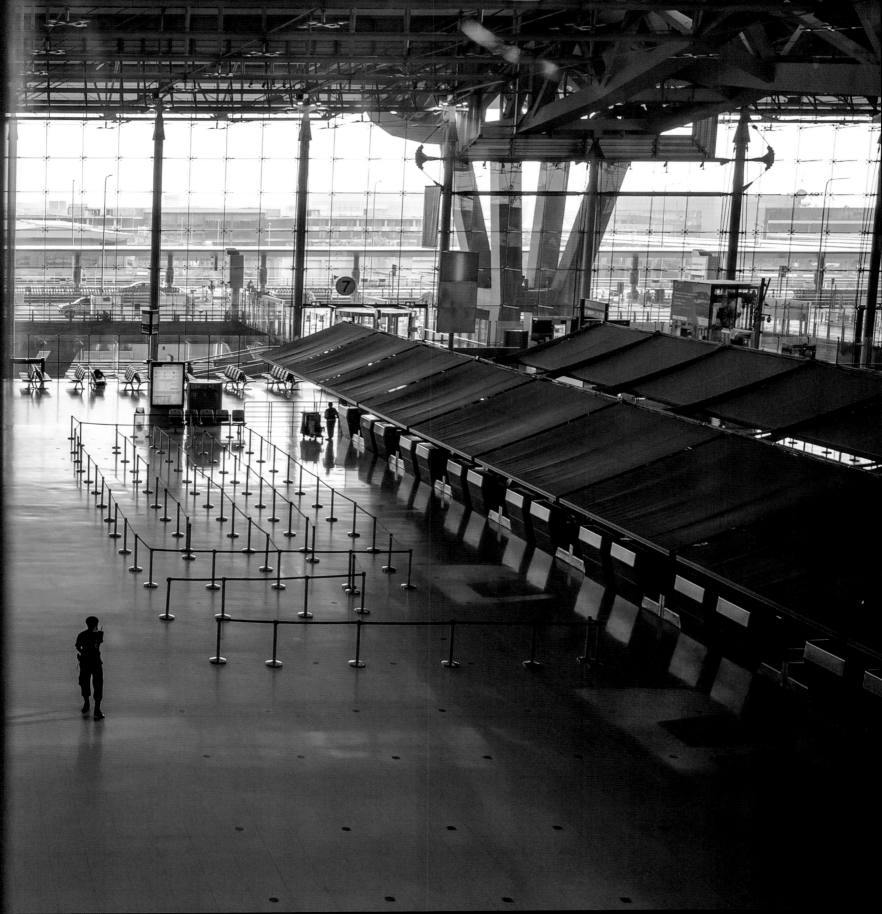

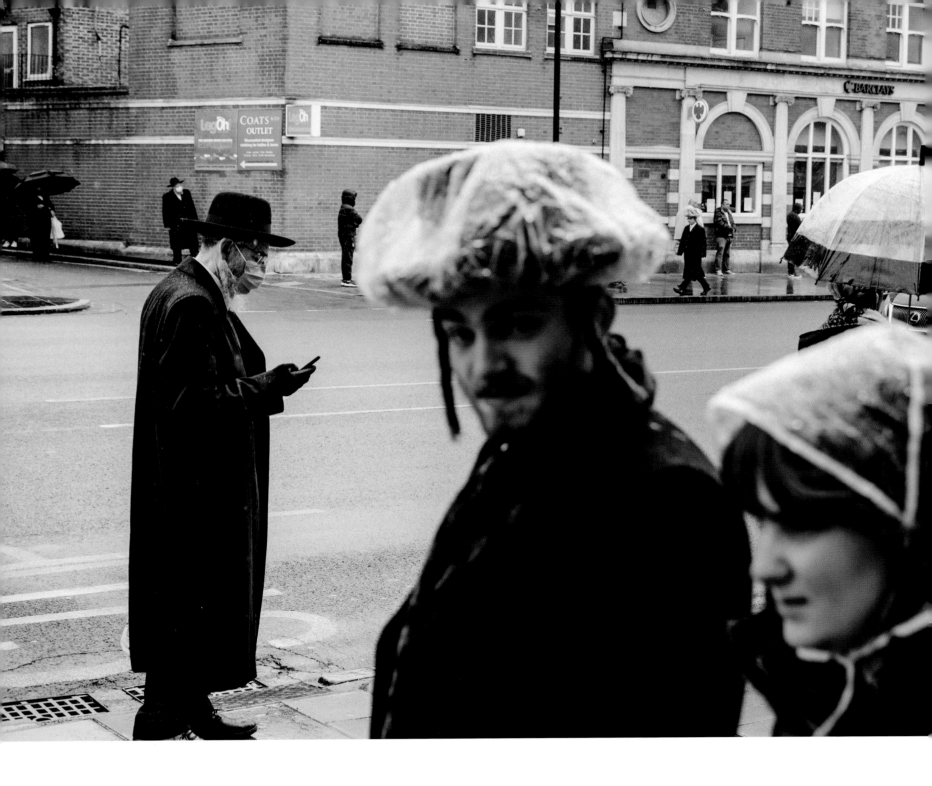

COMMUNITY-BASED LIFELINES

GREY HUTTON | LONDON, ENGLAND
APRIL 2020

Left: A man checks his phone while a socially distanced queue snakes its way around a bank.
Right: Sahra Adan, who fled Somalia during a civil war, peers from behind her mask.

Hackney is one of the most diverse and underserved neighborhoods in the United Kingdom; COVID-19 devastated its close-knit communities, which are often home to multigenerational households. Informal networks including food hubs, support organizations, and translators of health and safety information became its residents' lifelines.

COMMUNITIES FIND STRENGTH IN SOLIDARITY

BRIAN OTIENO | NAIROBI, KENYA
APRIL 2020

Information on preventing the spread of COVID-19 is painted on a street in Kibera, Kenya, thanks to Maasai Mbili, an art collective group. As the pandemic bore down on this neighborhood–Africa's largest informal settlement–a network of volunteers, including local organizations, artists, and even a budding fashion designer distributing face masks, coalesced to help keep the community safe.

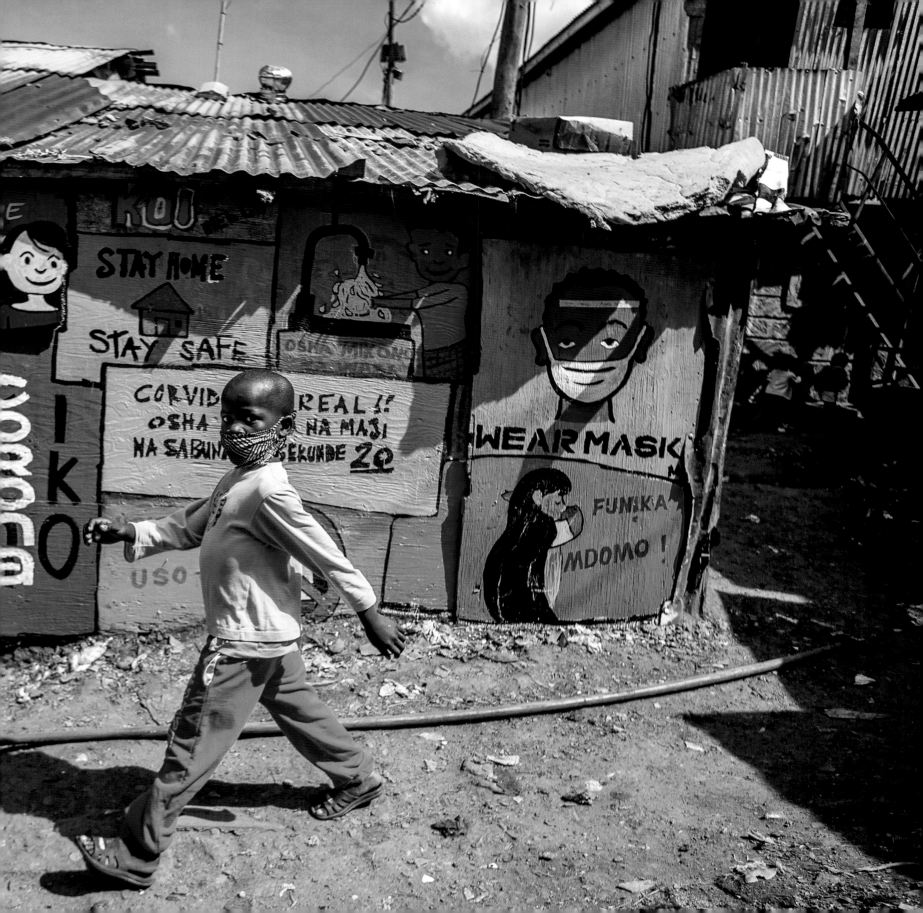

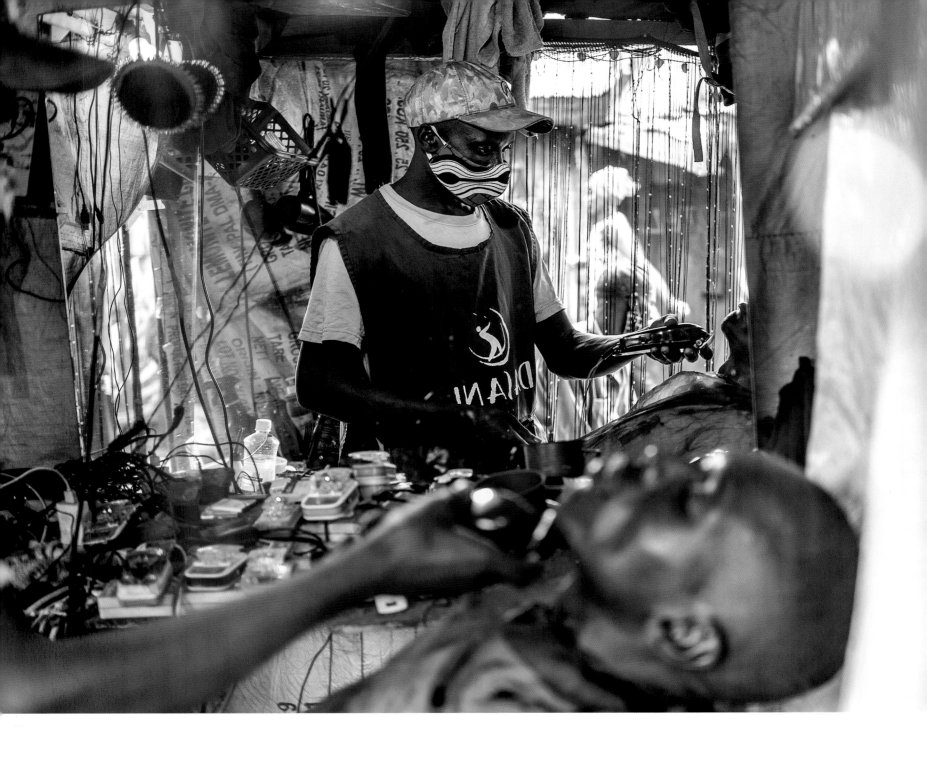

COMMUNITIES FIND STRENGTH
IN SOLIDARITY CONTINUED

BRIAN OTIENO | NAIROBI, KENYA
APRIL–MAY 2020

Left: Joshua Okoth, a barber, tends
to a client. *Top right:* Public health
officers disinfect a path used by a
family suspected of having COVID-19.
Bottom right: A man stands next to
graffiti containing information on
social distancing.

Kibera struggles with a lack of
hygienic products and infrastructure,
crowded living conditions, and
residents' inability to work from
home, which left them immensely
vulnerable to the spread of
COVID-19.

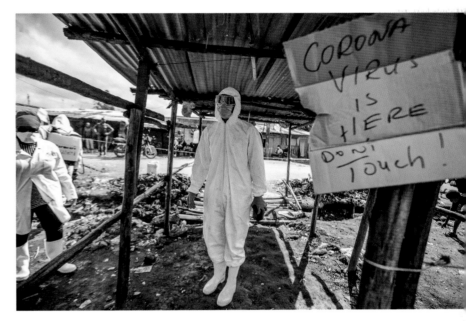

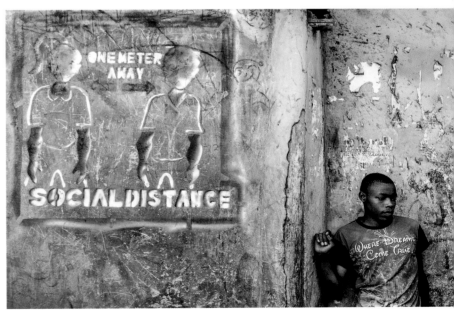

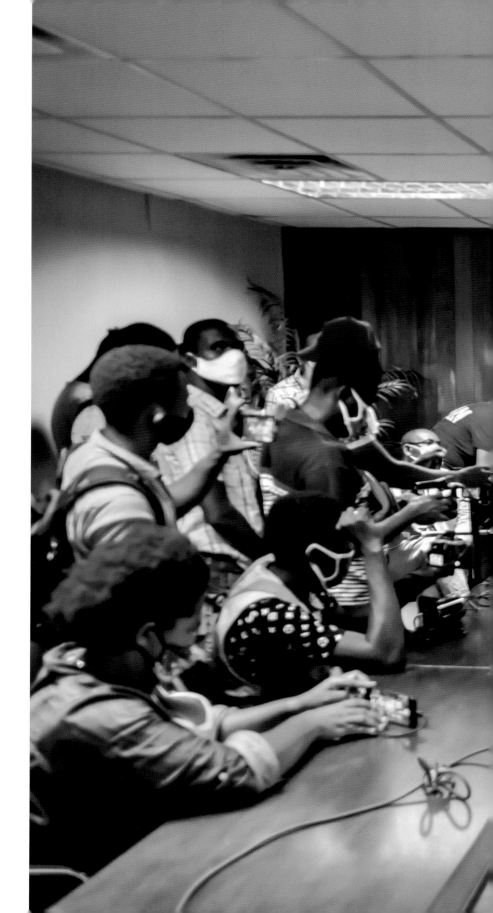

COVID-19 SAFETY IN AN ISLAND NATION

RÉGINALD LOUISSAINT, JR./KOLEKTIF 2D
PORT-AU-PRINCE, HAITI | JUNE 2020

In a conference room crowded with journalists, officials of Toussaint Louverture airport answer questions on suspended air travel in the wake of COVID-19. The Haitian government barred air traffic, other than flights related to health care, in an attempt to limit the spread of the virus to the country.

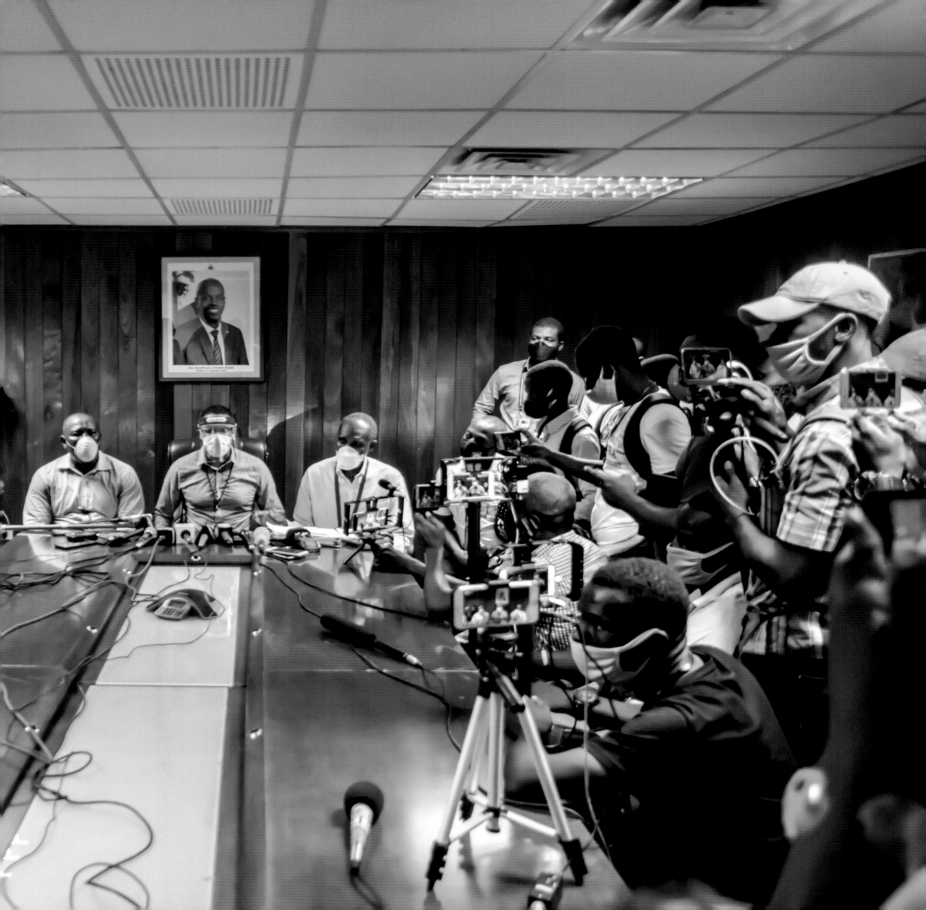

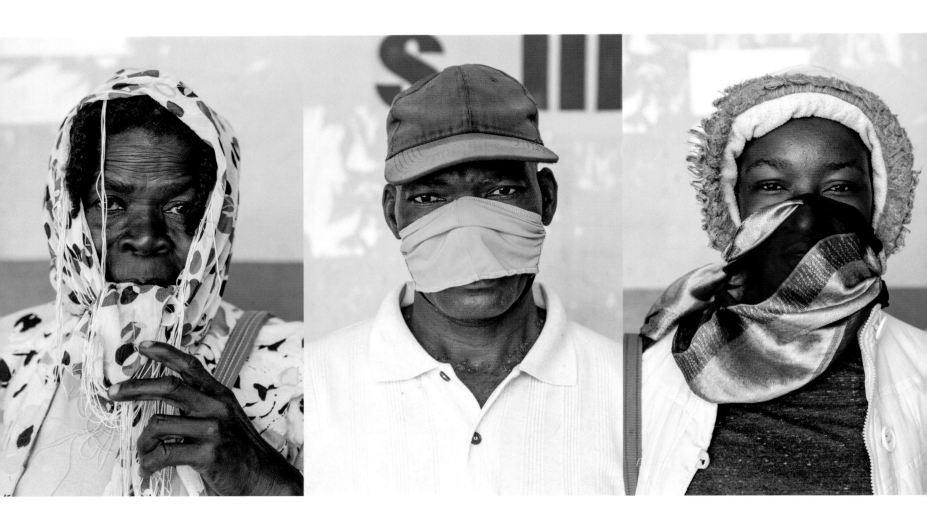

COVID-19 SAFETY IN AN ISLAND NATION CONTINUED

RÉGINALD LOUISSAINT, JR./KOLEKTIF 2D | GROS-MORNE, HAITI | DECEMBER 2020

Haitians show off their ingenuity in creating face masks using limited resources. With the onset of the pandemic, masks became necessary to receive crucial food distributions and other support from nongovernmental organizations. The lack of health and sanitary infrastructure in Haiti created dire conditions for the spread of COVID-19, while the pandemic compounded successive economic, political, and social crises.

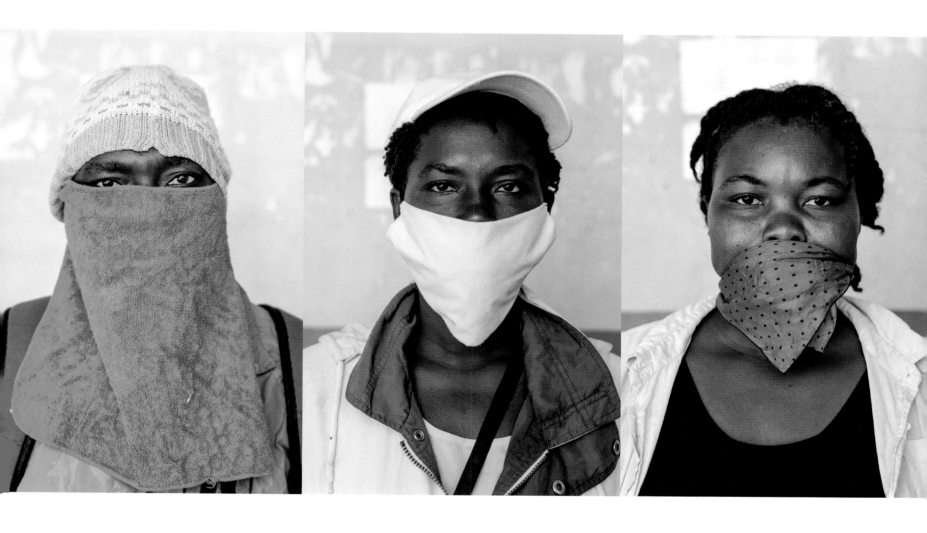

COVID-19 SHAPES RELIGIOUS FESTIVALS

ARKO DATTO | KOLKATA, INDIA | SEPTEMBER-NOVEMBER 2020

Below: As part of the dual Hindu celebrations of Mahalaya and Vishwakarma Puja—which in 2020 uncharacteristically fell on the same day—devotees make offerings and wade in the Ganges River. *Right:* A family walks through a sudden downpour just before dawn breaks during the Hindu festival of Chhath Puja.

The Hindu religious festival season of 2020 arrived amid spiking COVID-19 infections, stringent pandemic lockdowns, and a faltering economy in India. The festivities happened despite pervading fears, uncertainty, and tensions related to the pandemic, as well as rising nationalistic sentiments and legislation widely perceived as anti-Muslim.

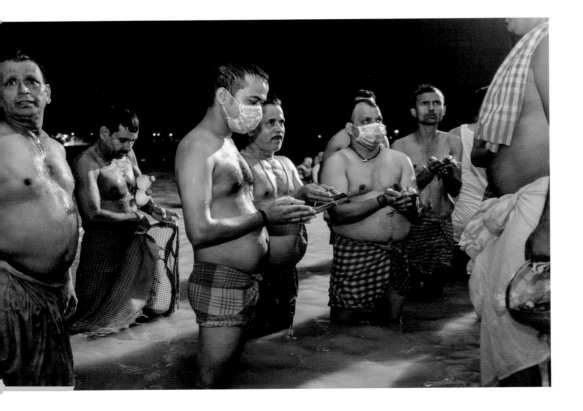

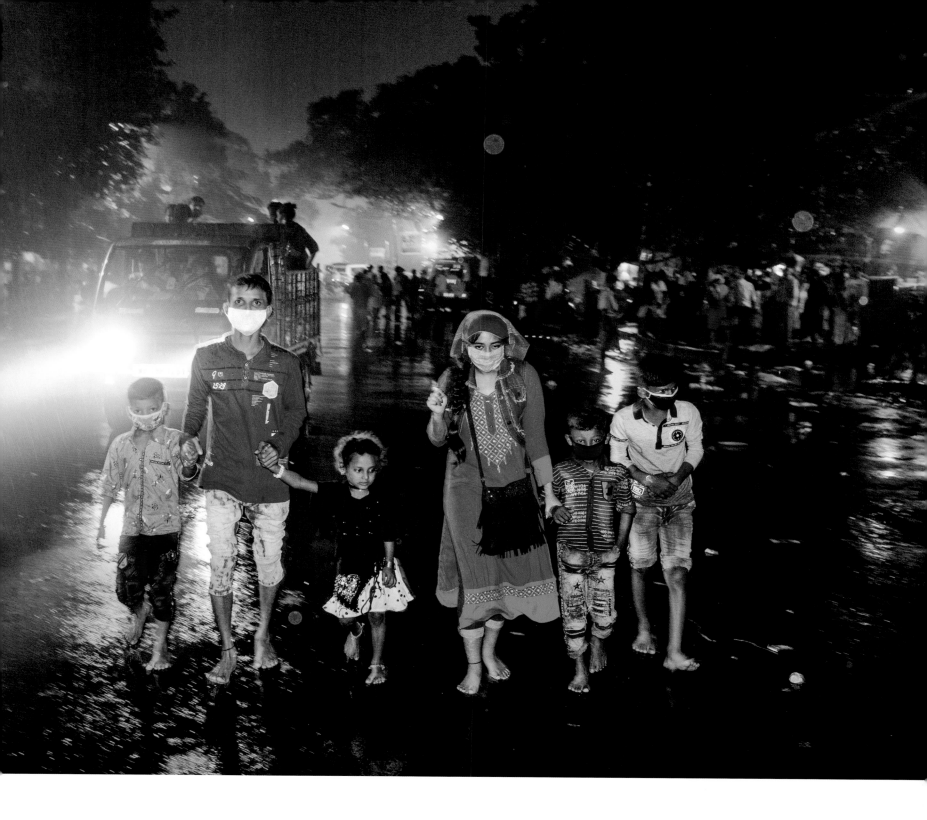

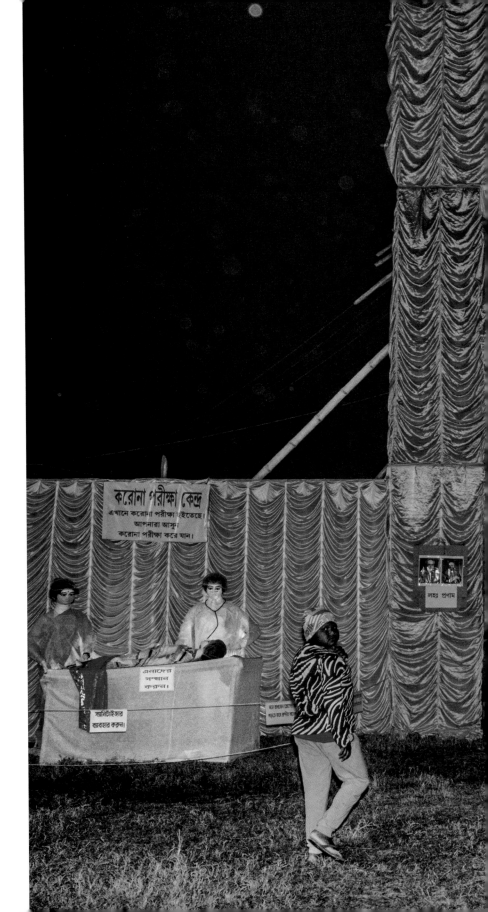

COVID-19 SHAPES RELIGIOUS
FESTIVALS CONTINUED

ARKO DATTO | CHANDANNAGAR, INDIA
NOVEMBER 2020

A COVID-19-themed installation is
displayed during Jagaddhatri Puja,
a Hindu religious festival. As India
recorded an increasing number of
COVID-19 infections in 2020, the
Hindu religious festival season,
which runs from September to early
December, reflected not only the
pandemic's cultural and economic
fallout but also trends of
nationalism and social unrest
sweeping the country.

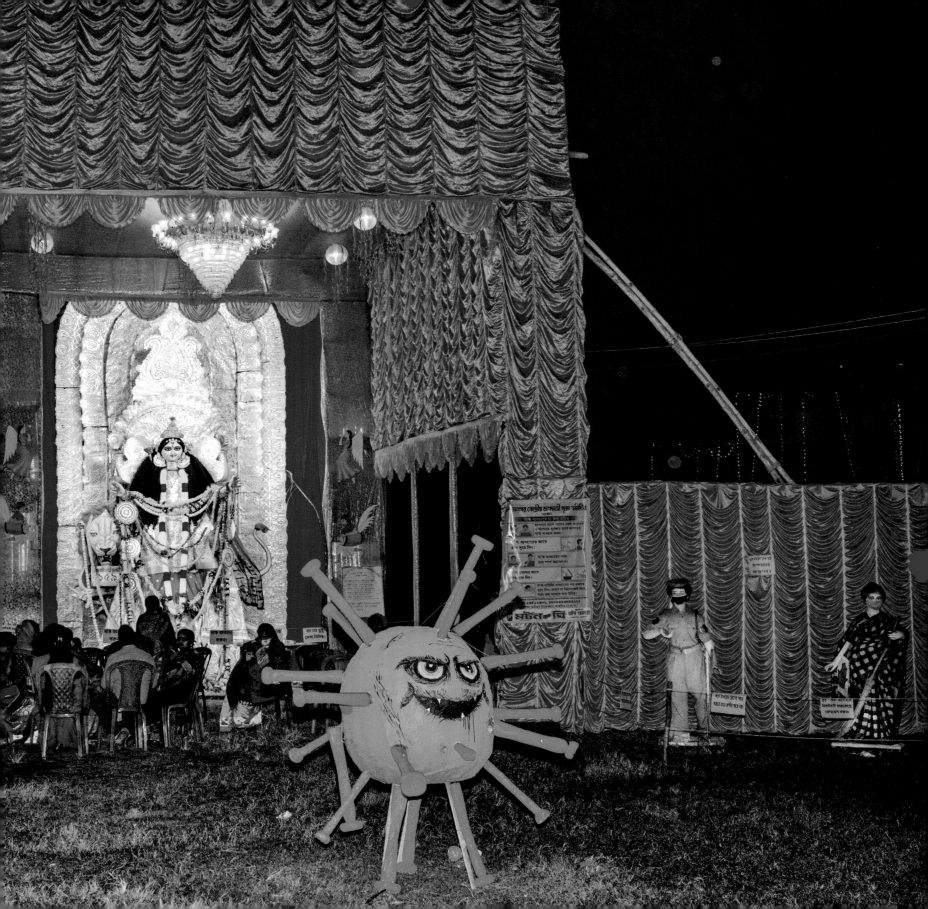

AN ISLAND COMMUNITY IN THE TIME OF COVID

GIULIA FRIGIERI | AEOLIAN ISLANDS, ITALY | FEBRUARY 2021

Left: Sisters Ilana and Chiara, accompanied by their friends Melo and Nicolò, hike to Monte Fossa Delle Felici, the highest peak of the Aeolian archipelago. *Below:* Best friends Melo and Daniel take a nap on the hydrofoil, the main and quickest means of transport around the Aeolian Islands.

While the COVID-19 pandemic compounded the sense of isolation and loneliness typical during winter in a community that thrives on seasonal tourism, it inspired some to appreciate and explore the natural beauty of their home.

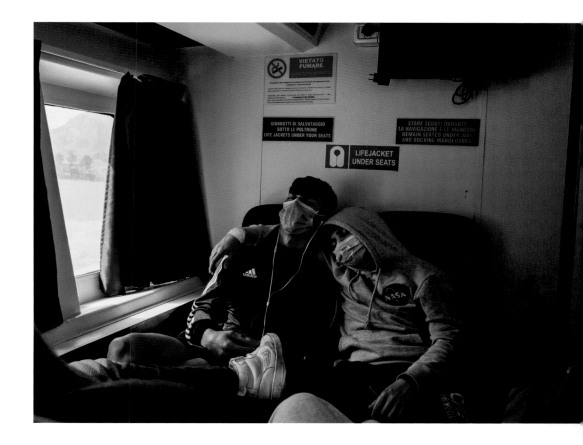

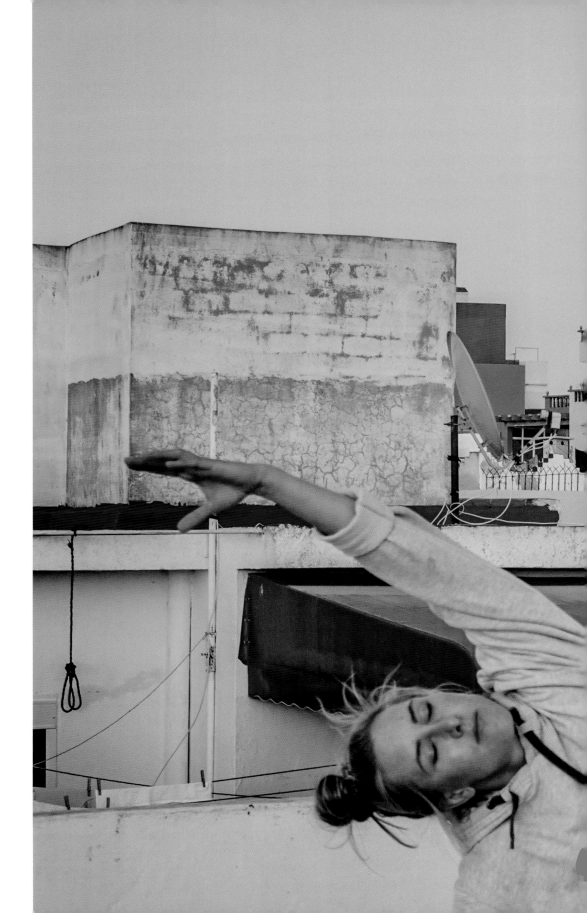

SUPPORT THROUGH COMMUNITY BONDS

YORIYAS YASSINE ALAOUI
ASILAH, MOROCCO | MAY 2020

The photographer's wife practices yoga while a young girl on a neighboring rooftop learns by mimicking her movements. Amid curfews and lockdowns during the COVID-19 pandemic, rooftops became the default meeting points in the small Moroccan holiday town of Asilah. As restaurants and small businesses closed in a city that relies largely on tourism, residents stayed safe and supported one another in this unique, close-knit community.

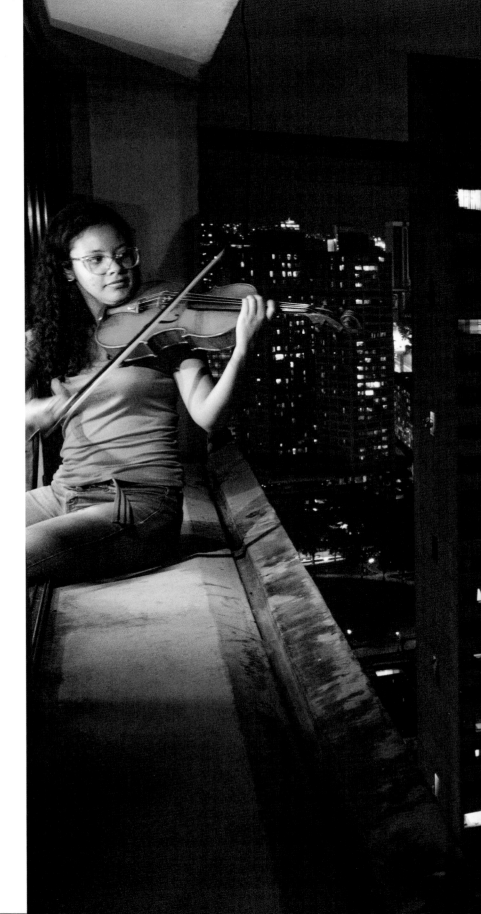

PANDEMIC ORCHESTRATION

ANA MARÍA ARÉVALO GOSEN/AYÜN FOTÓGRAFAS
CARACAS, VENEZUELA | AUGUST 2021

Katherine Cedeño, 25, poses for a portrait at her home in Caracas. Along with maintaining her career as a professional violist, Cedeño started a pastry-making venture in the face of the economic troubles fueled by the COVID-19 pandemic. She also contributed a viola track to *Sinfonía Desordenada (Jumbled Symphony)*, a unique album recorded separately by members of the Venezuelan Orchestra while quarantined in their homes.

PANDEMIC ORCHESTRATION CONTINUED

ANA MARÍA ARÉVALO GOSEN/AYÜN FOTÓGRAFAS | CARACAS, VENEZUELA | AUGUST 2021

Anthony Palacios, 21, plays drums in his living room in Caracas while his parents relax at the table and his sister attends to the family dog, Princess. Anthony recorded a drum track from his home for *Sinfonía Desordenada,* an album recorded separately by members of the Venezuelan Orchestra while quarantined in their homes.

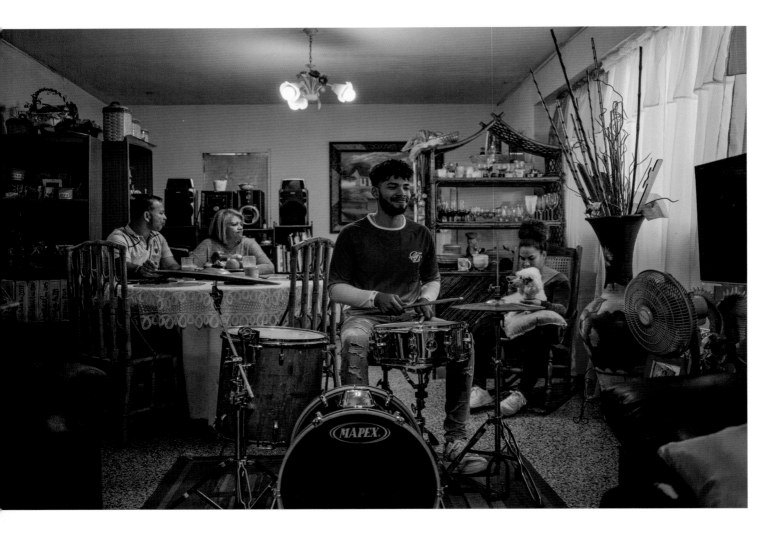

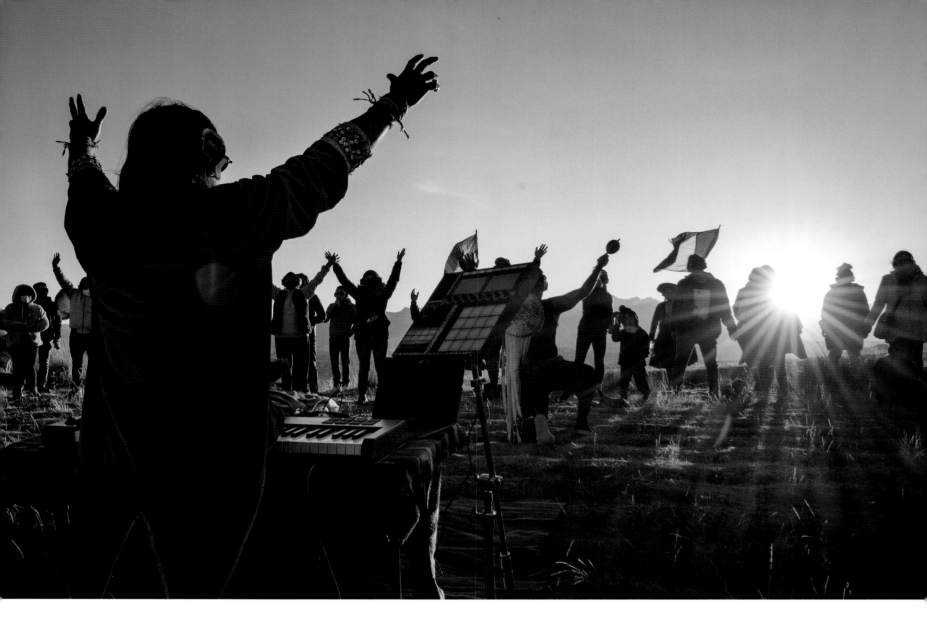

TRADITION THROUGH TECHNOLOGY

SHARON CASTELLANOS | CUSCO, PERU | JULY 2021

Edwin Carrasco, aka Tayta Bird, performs a silent concert in the highlands of Chinchero, Peru. In this outdoor space, the audience can hear the live music only via headphones, representing both a unique way for artists to connect with audiences and a nontraditional concert platform that helps prevent COVID-19 transmission. As events and concerts were canceled during the pandemic, musicians sought new ways to connect with audiences, including virtual concerts and outdoor settings.

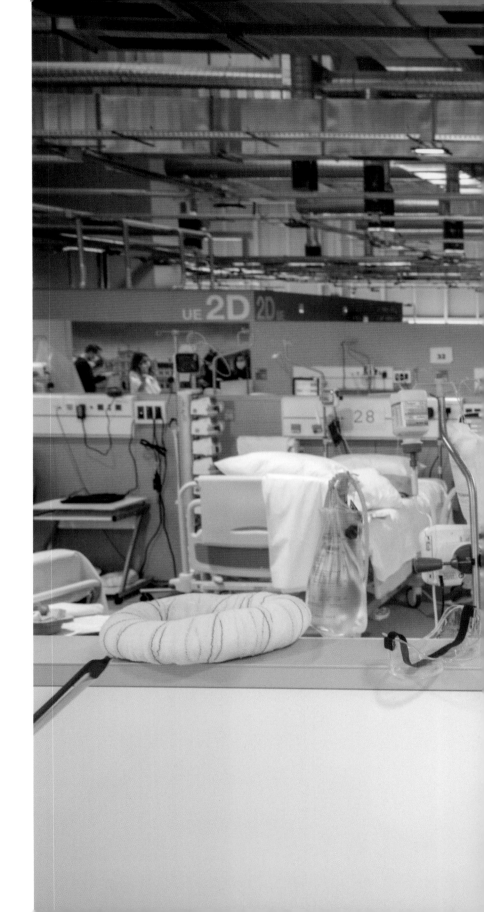

HEALING WITH MUSIC

ANA PALACIOS | MADRID, SPAIN
MARCH 2021

Albert Skuratov, violinist and conductor, plays Mozart in the intensive care unit of El Hospital de Emergencias Enfermera Isabel Zendal. Skuratov is a volunteer at the Músicos por la Salud foundation, which organizes micro-concerts to provide moments of happiness and well-being for patients and hospital staff. This hospital was built during the pandemic to exclusively care for COVID-19 patients.

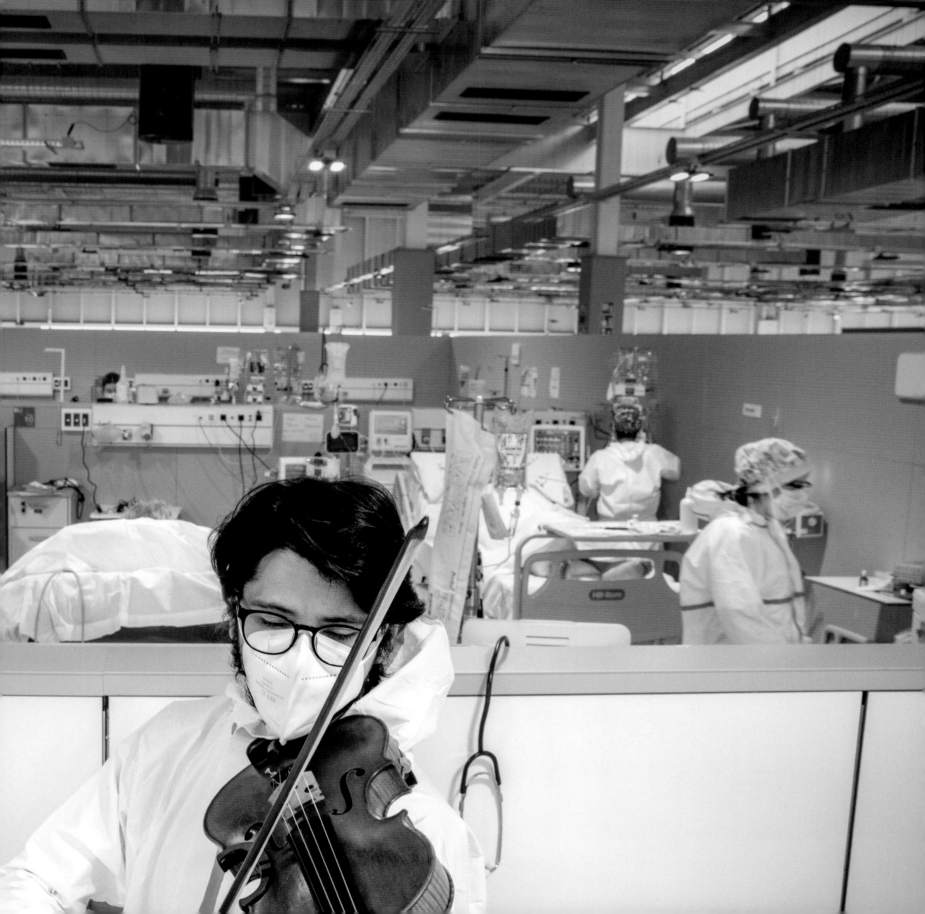

HEALING WITH MUSIC CONTINUED

ANA PALACIOS | MADRID, SPAIN | MARCH 2021

Hemodialysis patient José Silvio Cebrián, 73, takes a video as nurse Ana Briz dances with musician Juanjo Pérez while Gabriela Castillo sings a bolero. Pérez and Castillo collaborate with the Músicos por la Salud foundation. Because of COVID-19 restrictions, this hospital did not allow patients' family members or friends to visit, making the private concert extremely special.

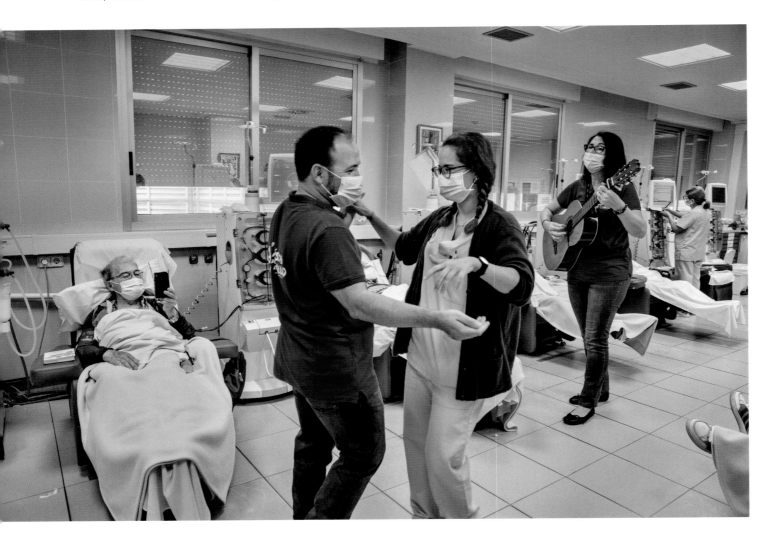

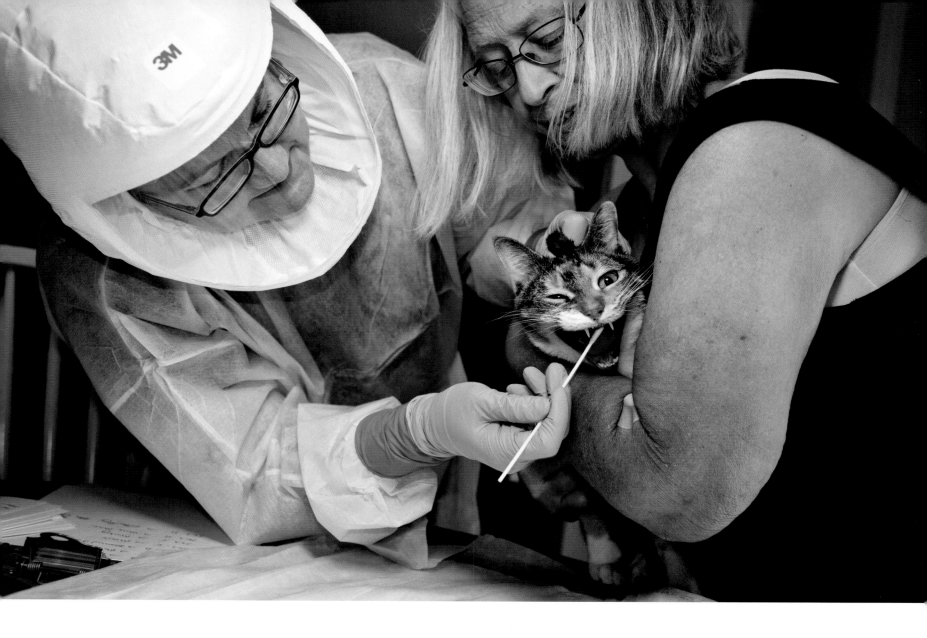

PETS AND PATHOGENS

PETE KIEHART | NORTH CAROLINA, UNITED STATES | SEPTEMBER 2020

Dr. Liz Petzold (left) swabs a cat belonging to COVID-19-positive patient Peggy Smith.

As part of Duke University's Molecular and Epidemiological Study of Suspected Infection, Petzold tested infected and recovering COVID-19 patients and their pets to learn more about the virus and its transmission within households.

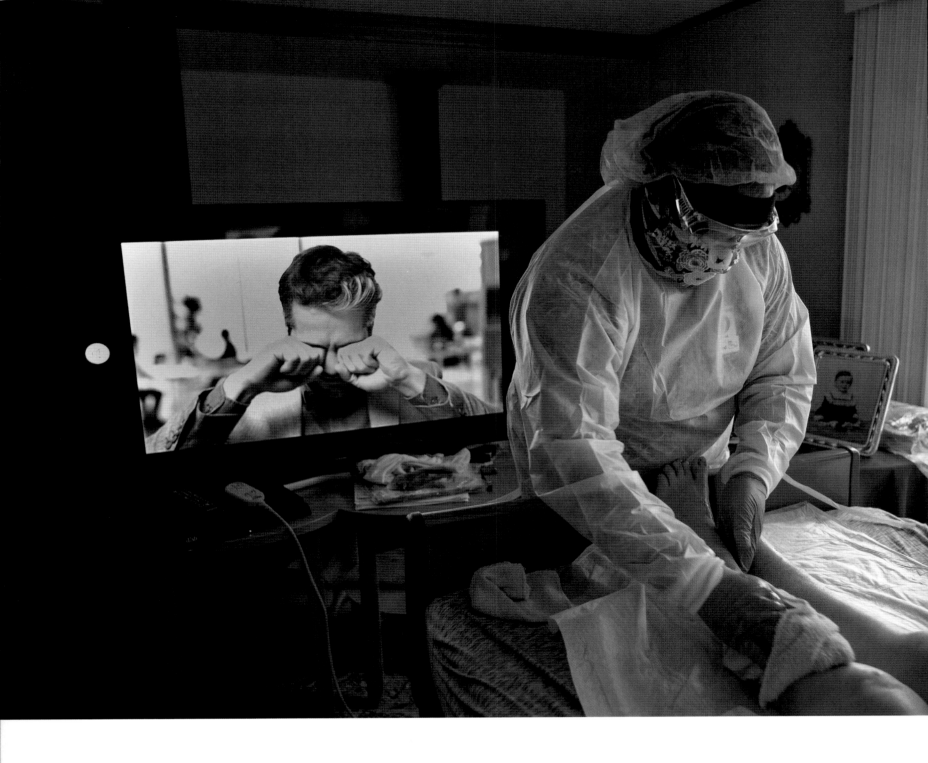

AGING AMID COVID-19

LYNN JOHNSON
WASHINGTON, UNITED STATES
APRIL-JUNE 2020

Left: Caregiver Delores Jetton attends to a patient. *Top right:* Hospice nurse Janine cares for patient L. J. Kaik. *Bottom right:* Nurse Tabitha Sierra administers one of the thousands of COVID-19 tests that she will conduct through the pandemic.

In ways both subtle and profound, COVID-19 changed how medical staff cared for the elderly. Work increased, caregivers feared contracting or spreading the virus, and personal protective equipment became an emotional and psychological barrier to empathetic treatment.

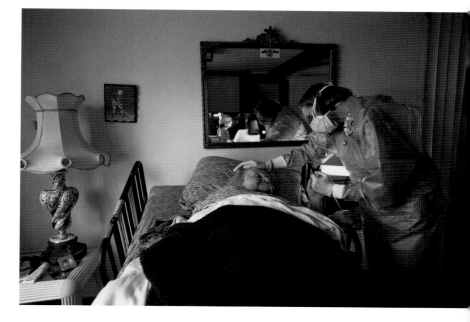

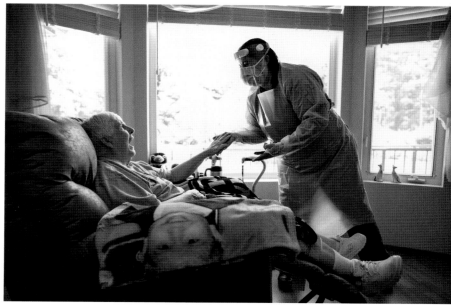

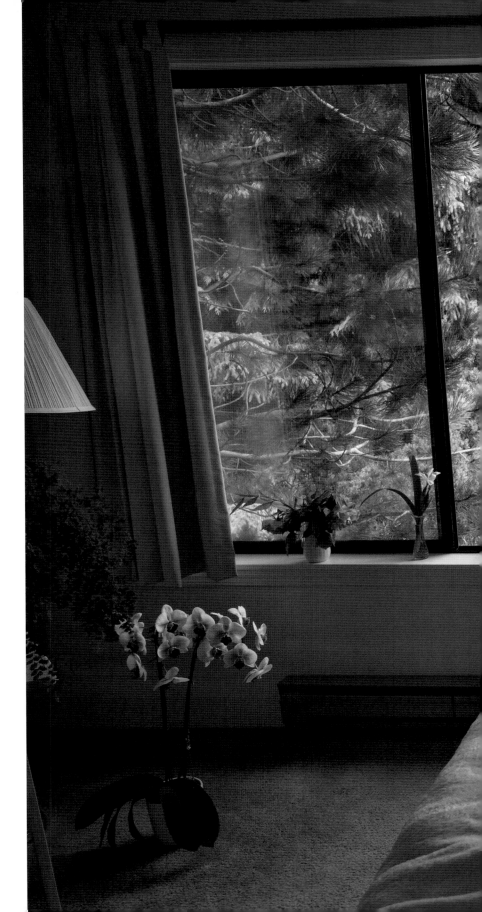

AGING AMID COVID-19 CONTINUED

LYNN JOHNSON | WASHINGTON, UNITED STATES
APRIL-JUNE 2020

An elderly woman nearing the end
of her life is visited by her
grandsons, both perched on ladders
to reach her second-floor window.
The woman is a resident of Enso
House, a nursing home providing
hospice care and spiritual support
rooted in Zen Buddhism. Due to
visiting restrictions in hospitals and
retirement communities during the
COVID-19 pandemic, dying became a
lonely passage all too often. This
family found a way to be together
for their grandmother's final hours.

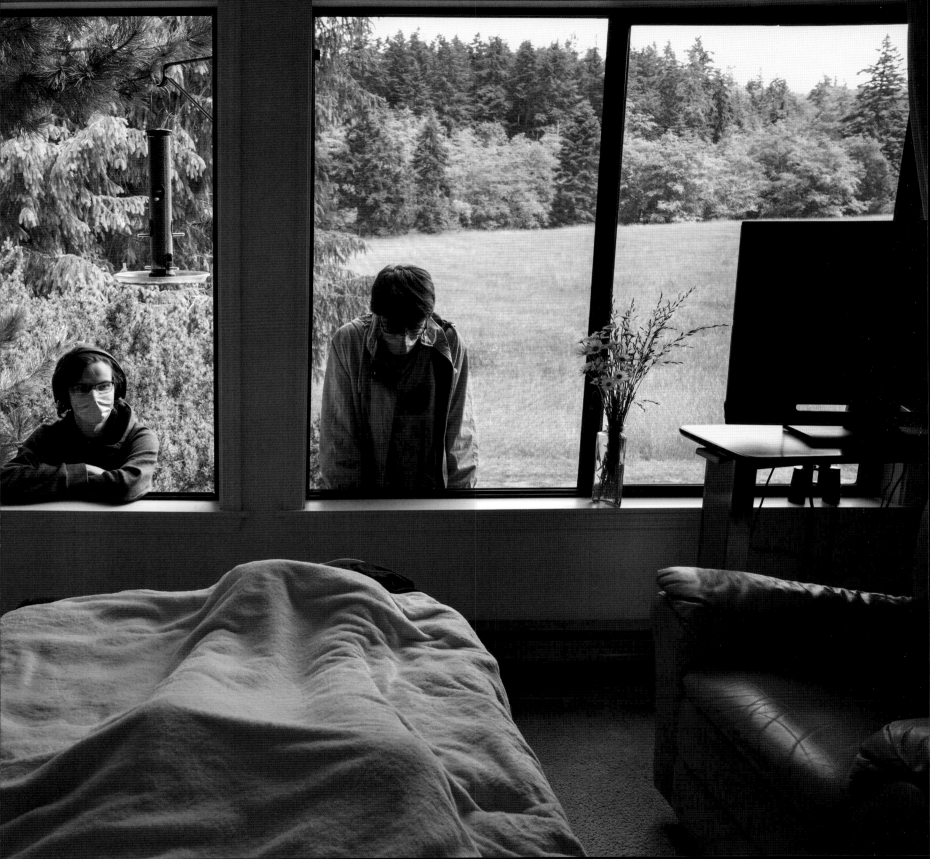

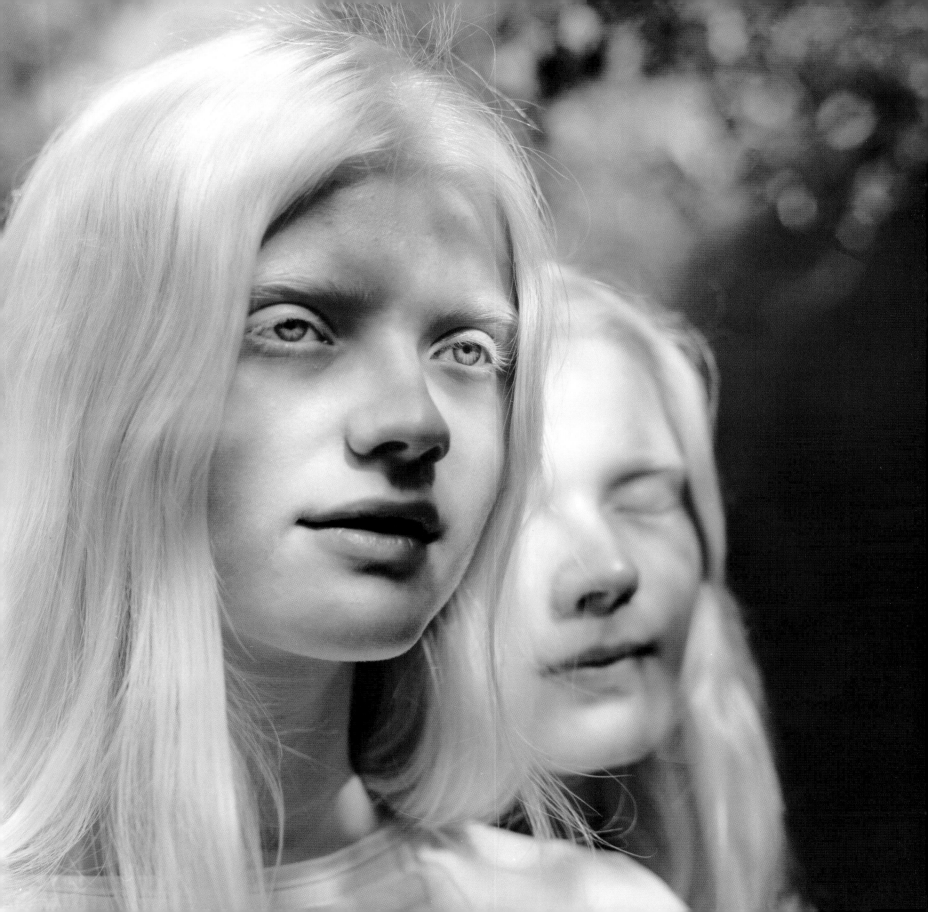

COMBATING COVID-19 WITH SISTERHOOD

DEBSUDDHA | KOLKATA, INDIA | JULY 2021

Swati and Gayatri pause to take in the evening sky on their rooftop in Kolkata. Quarantine and social distancing measures amid the COVID-19 pandemic compounded the isolation and psychological struggles of these unmarried sisters, who have faced discrimination as people with albinism. Through their unique bond, they found the strength and resilience to weather a time of crisis.

FIRST SEPARATION

CÉCILE SMETANA BAUDIER
FUNEN, DENMARK

Anna and Thea, 16-year-old identical twins, stand outside their parents' home in Funen, Denmark. The girls' first year of boarding school was disrupted by the COVID-19 pandemic. Growing up inseparable, they were kept apart for the first time by quarantine requirements, which prohibited them from even visiting each other's dorm rooms—a poignant example of how the pandemic fragmented the coming-of-age experience for young people around the world.

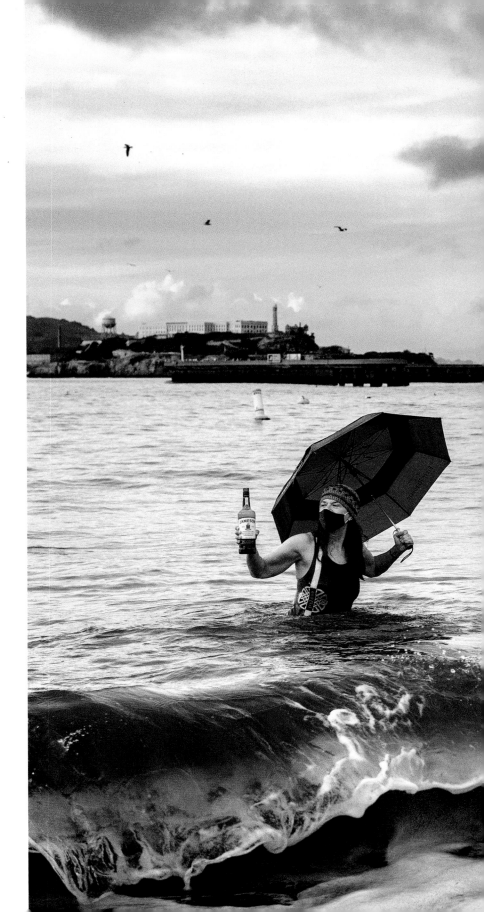

TOURISM FOR LOCALS
AMID COVID-19

LAURA MORTON
CALIFORNIA, UNITED STATES | JANUARY 2021

Holding bottles of whiskey,
Suzanne Greva (left) and Erika
Gliebe—both members of the
South End Rowing Club—run into
the water at San Francisco's
Aquatic Park Cove. Because the
historic rowing and swimming
club could not hold its annual
party for members amid
COVID-19 restrictions, members
were encouraged to take
humorous photos to be shared
at a virtual meeting.

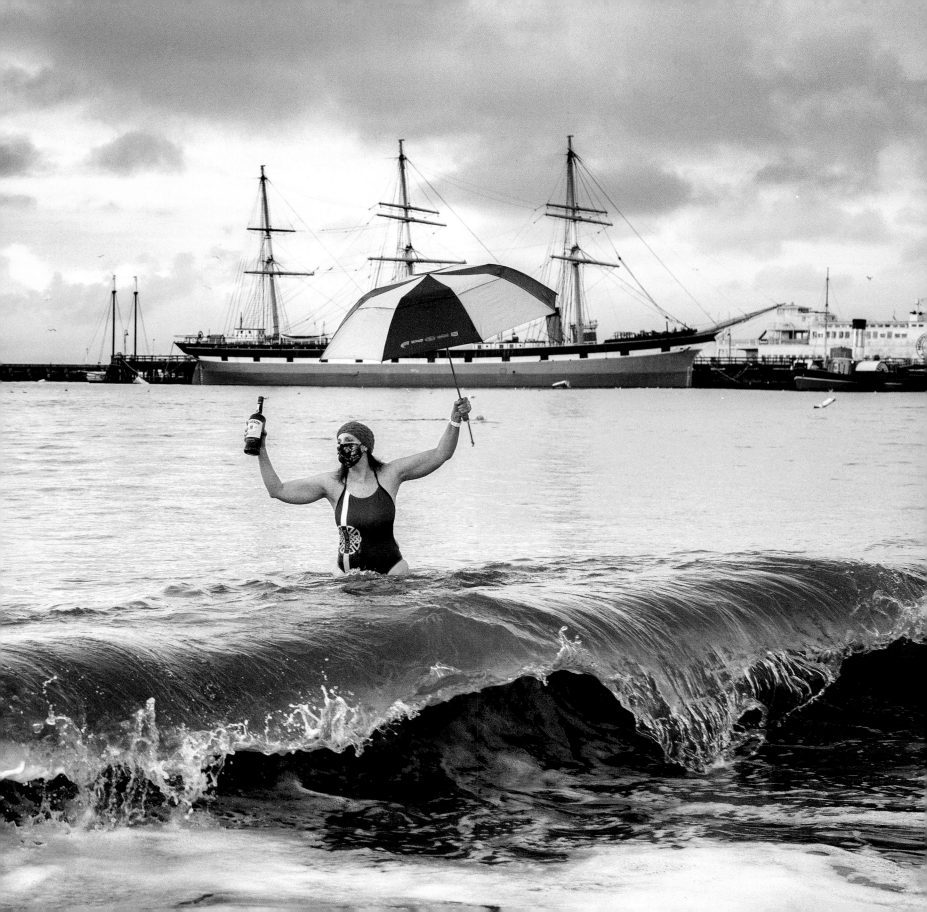

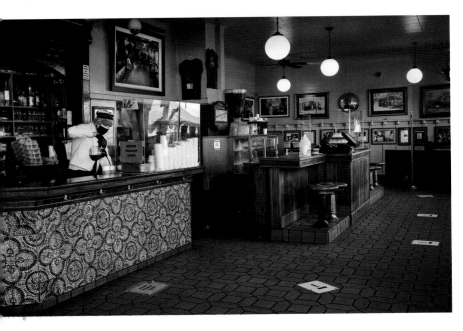

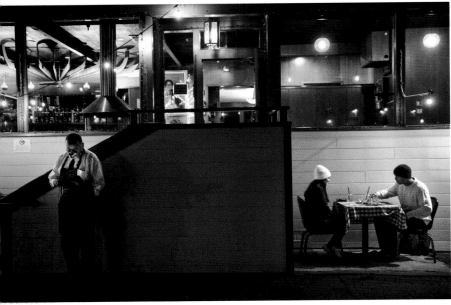

TOURISM FOR LOCALS AMID COVID-19 CONTINUED

LAURA MORTON
CALIFORNIA, UNITED STATES | JANUARY 2021

Top left: At the Buena Vista café, a Fisherman's Wharf staple since 1916, bartender Darcy Parsons makes Irish coffees to go. *Bottom left:* Server Simon Torres closes out a check while waiting on outdoor tables at Scoma's Restaurant. *Right:* Matt Meyers and Debbie Fontaine drink Irish coffees under an umbrella.

As Fisherman's Wharf, the center of San Francisco's tourism industry, was emptied of its sustaining flow of visitors amid COVID-19, locals began to reconnect with this unique neighborhood.

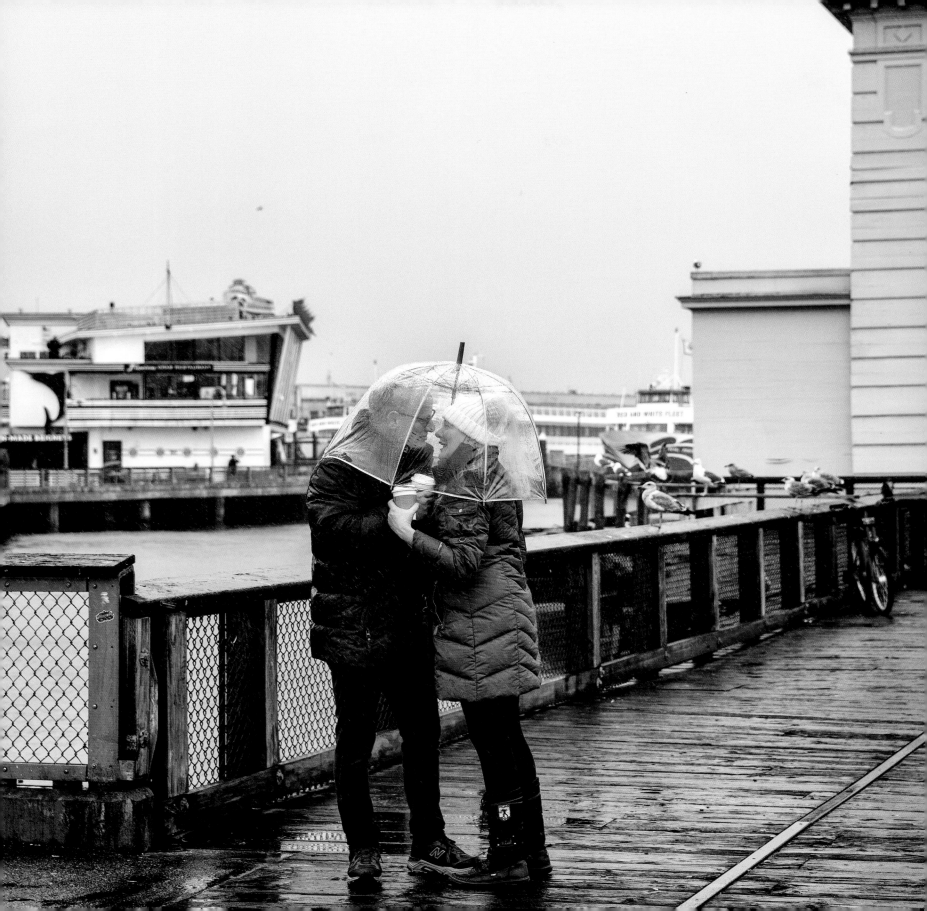

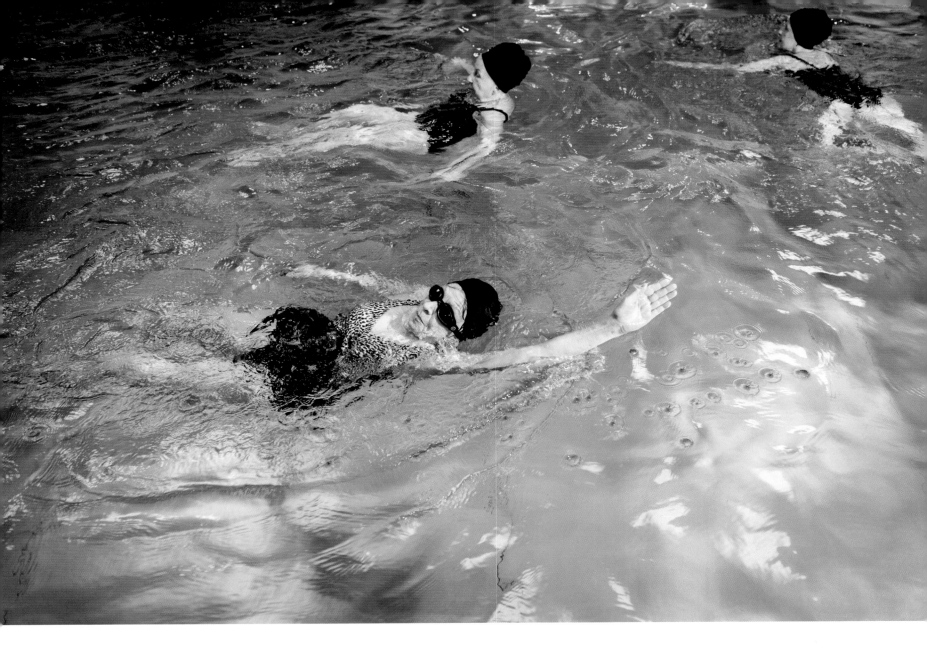

FIGHTING ELDERLY ISOLATION

JACOBIA DAHM | BERLIN, GERMANY | JULY 2021

Left: Doris Engel, 79, swims the backstroke in the company of other bathers. *Right:* Longtime friends Doris Engel and Monika Perlow, 83, exercise together in a swimming pool.

Often experiencing limited mobility, barriers to accessing technology, and increased vulnerability to COVID-19, the elderly were poised to suffer disproportionately from the devastating mental and physical consequences of loneliness during the pandemic. Female members of this Berlin care facility were greatly relieved when dancing, swimming, and gymnastics were able to resume in relative safety.

FOLLOWING PAGES

JOINING TOGETHER

ANA E. SOTELO | LIMA, PERU | JULY 2021

Las Truchas, a women's open-water swimming group formed during the COVID-19 pandemic, swims in the Pacific Ocean wearing the colors of the rainbow to symbolize peace and love. Amid the global crisis, a foundering health-care system, social and political turbulence, and alarming rates of violence against women, Las Truchas provides women with a community promoting physical and mental health that complies with social distancing protocols.

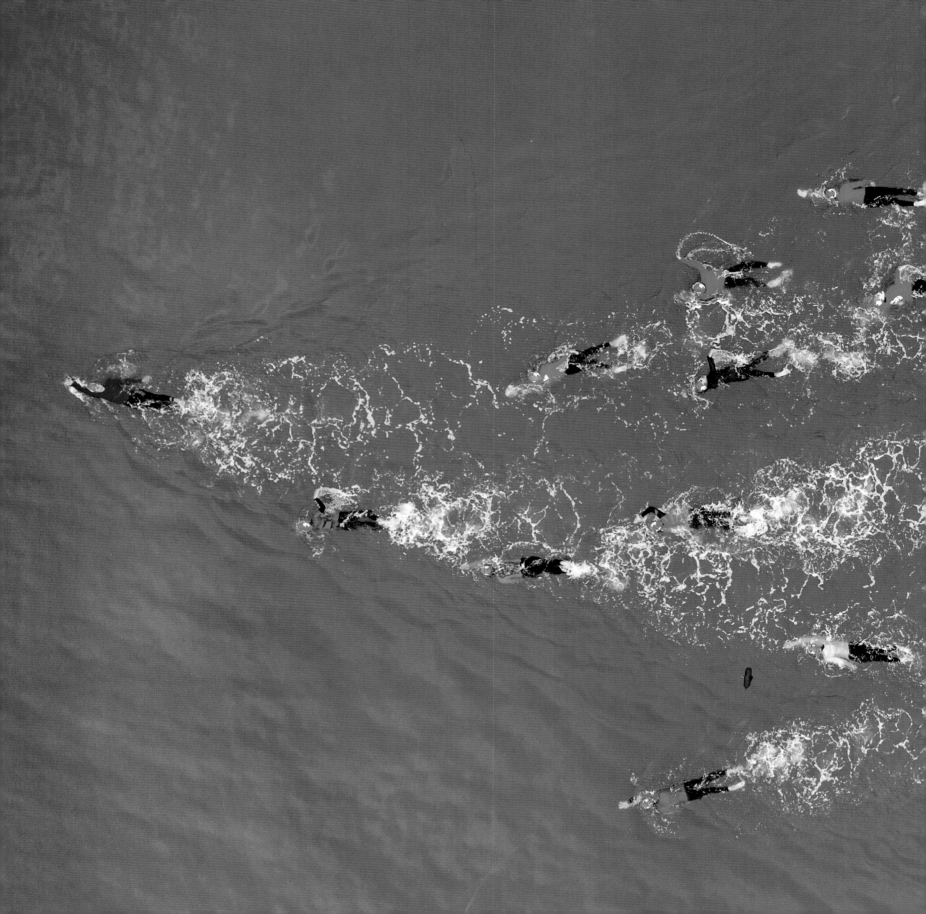

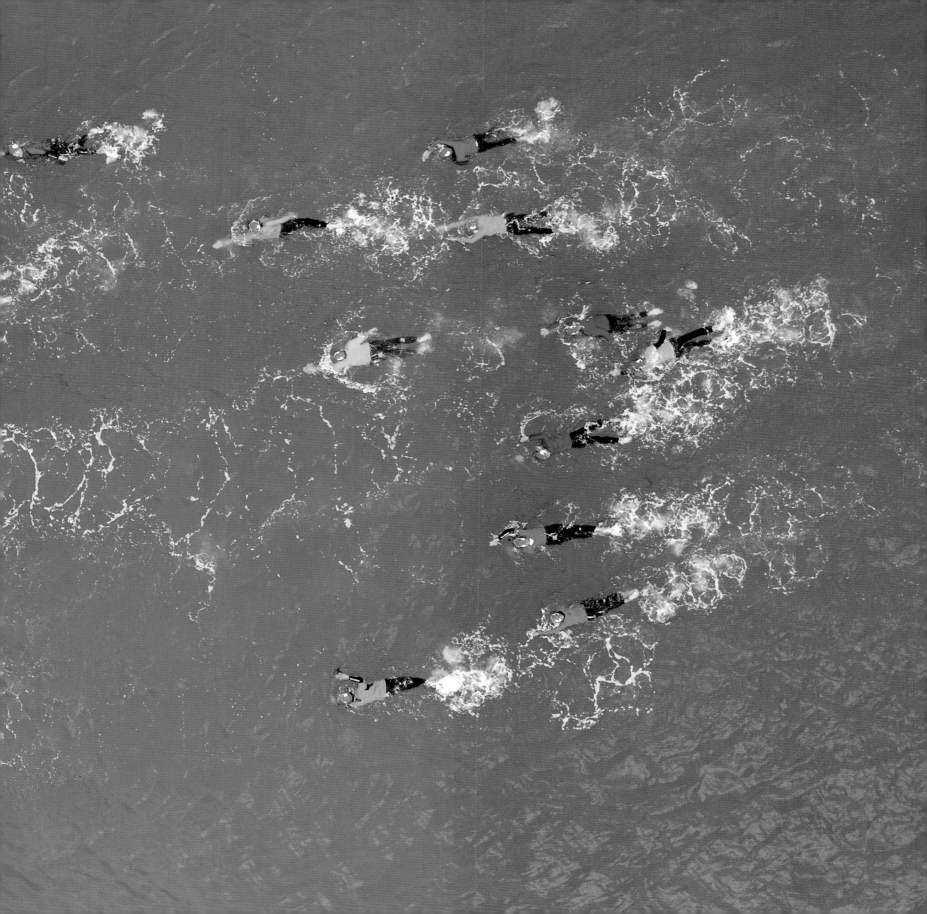

THE IMPORTANCE OF BEING CONNECTED

PAUL GAMBIN AND ALEJANDRA OROSCO | WORLDWIDE | AUGUST 2020-JANUARY 2021

Couples separated by thousands of miles connect via online video chats or in person for the first time in months. As the pandemic raced across the globe, binational couples around the world were abruptly forced to live separately. As uncertainty replaced plans for the future, relationships broke apart, families split, mothers gave birth alone, weddings were postponed or canceled, and the strains on mental and emotional health were significant.

EXILED BUT CONNECTED

MUNMUN DHALARIA | HIMACHAL PRADESH, INDIA | JULY 2020

The 14th Dalai Lama gives an online sermon to mark the beginning of his 85th birthday celebrations. While this occasion is typically marked by large in-person celebrations, in 2020 the Central Tibetan Administration planned only small-group gatherings and a series of virtual events, as Tibetans and global supporters celebrated in isolation or virtually.

MAINTAINING TRADITIONS ONLINE

DANIELLA ZALCMAN | NEVADA, UNITED STATES | APRIL 2020

Rabbi Ally Resnik Jacobson leads a virtual seder for her extended family at the outset of the COVID-19 pandemic. The virus may have rendered the large communal gatherings that typically mark Jewish holidays impossible, but with the help of videoconferencing, communities and families were still able to connect with loved ones to sing "Dayenu," eat matzos and haroseth, and parse the holiday's celebrated "Four Questions."

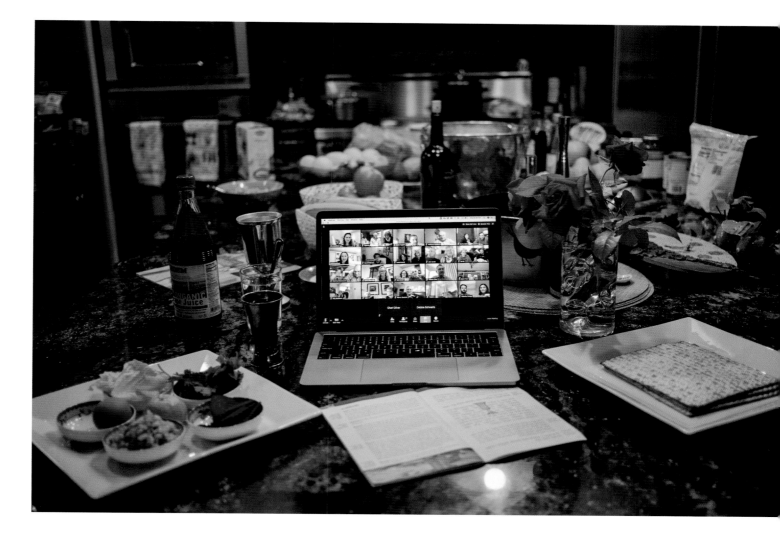

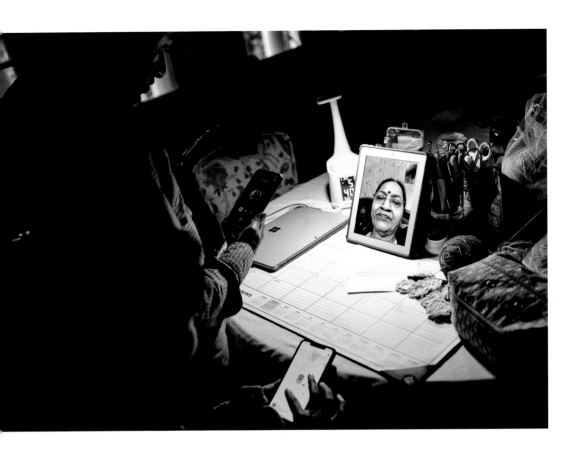

STAYING CONNECTED ACROSS DISTANCES

FABIAN MUIR | SYDNEY, AUSTRALIA | FEBRUARY–APRIL 2021

Above: From Sydney, Atul and Payal Bhargava speak to Atul's mother, Meena, in New Delhi while preparing to call Atul's father, Pradeep, who is in the hospital following a near-fatal kidney failure. *Right:* Riccardo Pasto, also in Sydney, speaks to his wife, Li, in Beijing.

When Australia closed its borders to international travel to help control the spread of COVID-19, many citizens, including the considerable migrant population, suddenly found themselves unable to visit family members who lived in other countries and were resigned to connect only virtually.

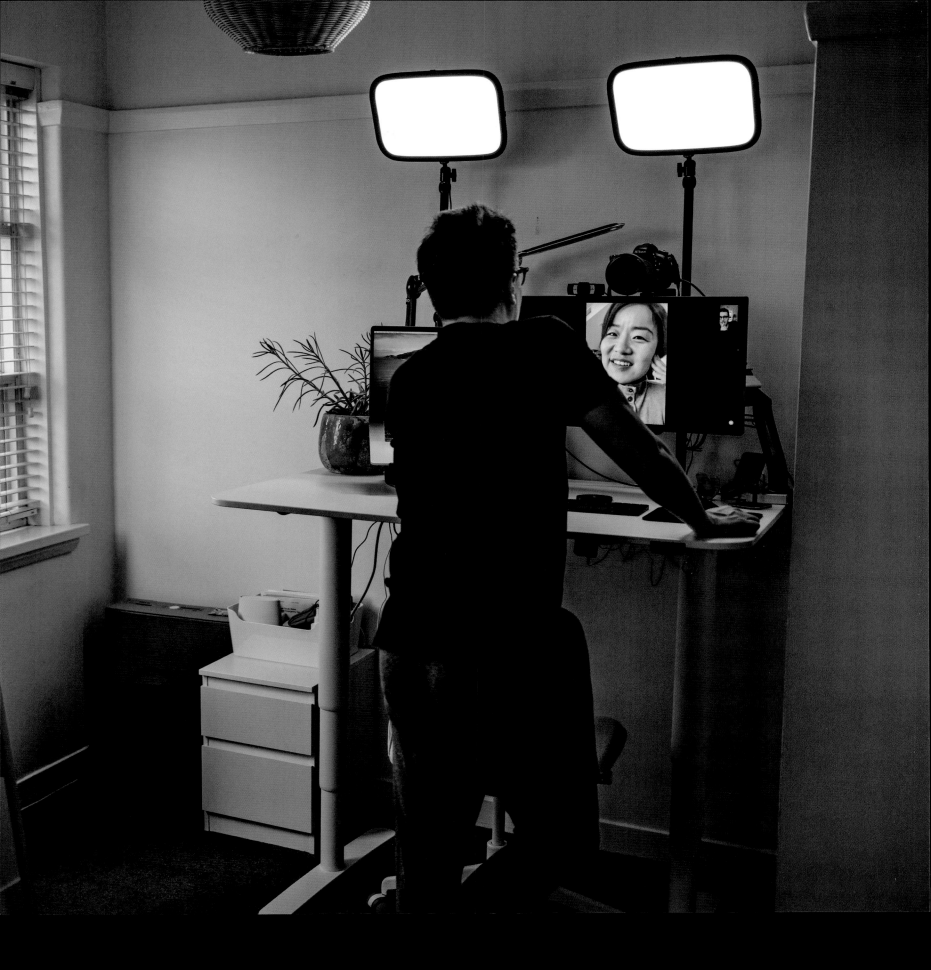

A FAMILY'S GROWTH

FAUSTO PODAVINI | ROME, ITALY
APRIL 2021

Though the pandemic disrupted lives around the world, it also provided an unforeseen opportunity to strengthen relationships among families. Here, Pier Francesco checks his smartphone before spending time on his computer. During the quarantine necessitated by the COVID-19 pandemic, he spent much of his time online, both to attend school and to keep in touch with friends. He assembled the computer with the help of his stepfather, Fausto Podavini: a unique bonding experience.

Behind the story: Faced with the COVID-19 pandemic, photographer Fausto Podavini and his partner, Anna, began living together earlier than they had planned. As a result, he abruptly became a stepfather figure to her two sons, Pier Francesco and Riccardo.

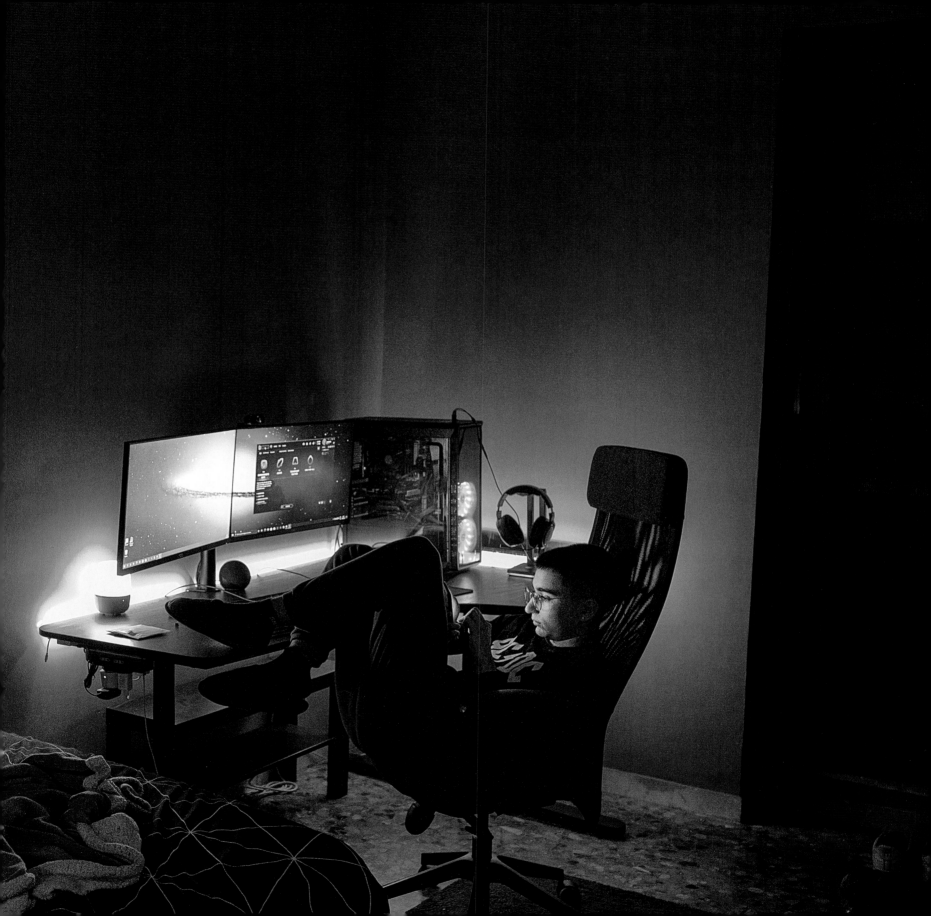

WORK WORK WORK WORK WORK WORK WORK WORK WORK HOME HOME HOME HOME HOME HOME HOME HOME HOME

BLURRED LINES. When the novel coronavirus began its sinister sweep across the world, lockdowns and stay-at-home orders soon followed. Suddenly, many were spending 24 hours a day at home. The lines around our personal lives and spaces quickly blurred, as our dwellings became offices, classrooms, restaurants, entertainment venues, and more. The projects shown here examine the new overlapping lines between work and home, bearing witness to the overwhelming shifts in our perspectives and our ways of life.

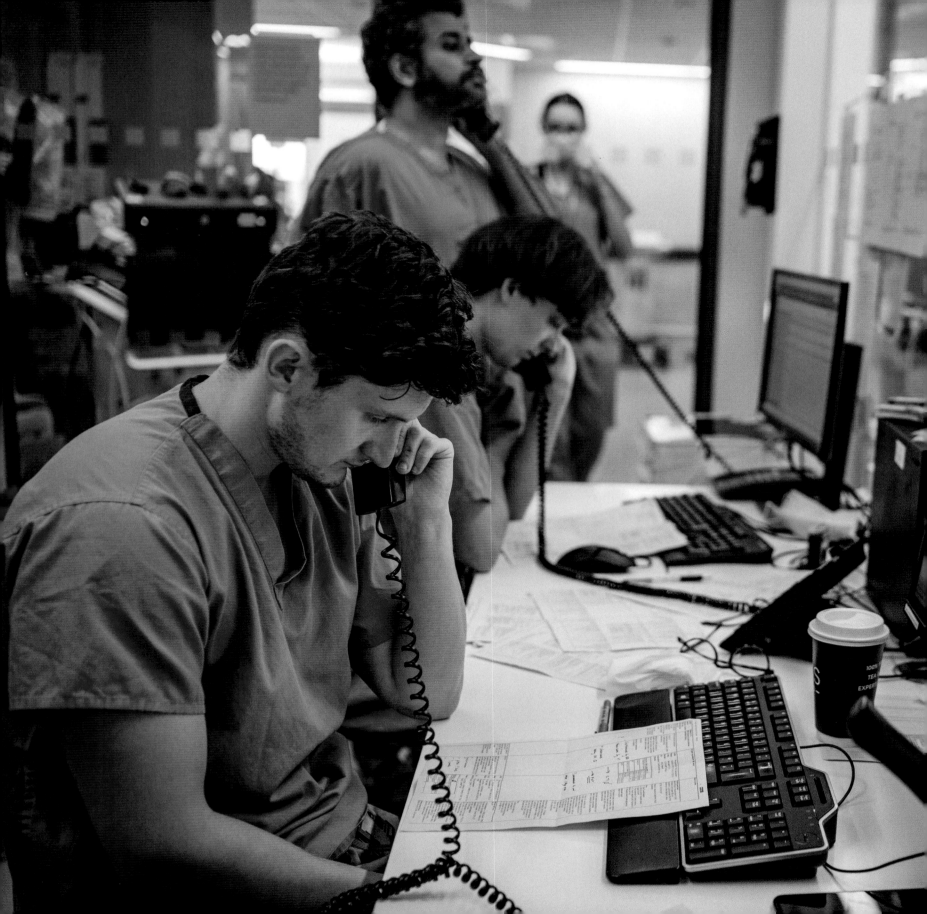

Please ensure
office area remains
clean. Wipe down hard
surfaces between use.
Clinell wipes supplied.
NO FOOD PLEASE.

Thank you all.

WORK

From a London hospital,
Dr. Andrew Fahey joins other
doctors as they update families
on the conditions of COVID-19
patients in intensive care.

LYNSEY ADDARIO | LONDON, ENGLAND
JUNE 2020

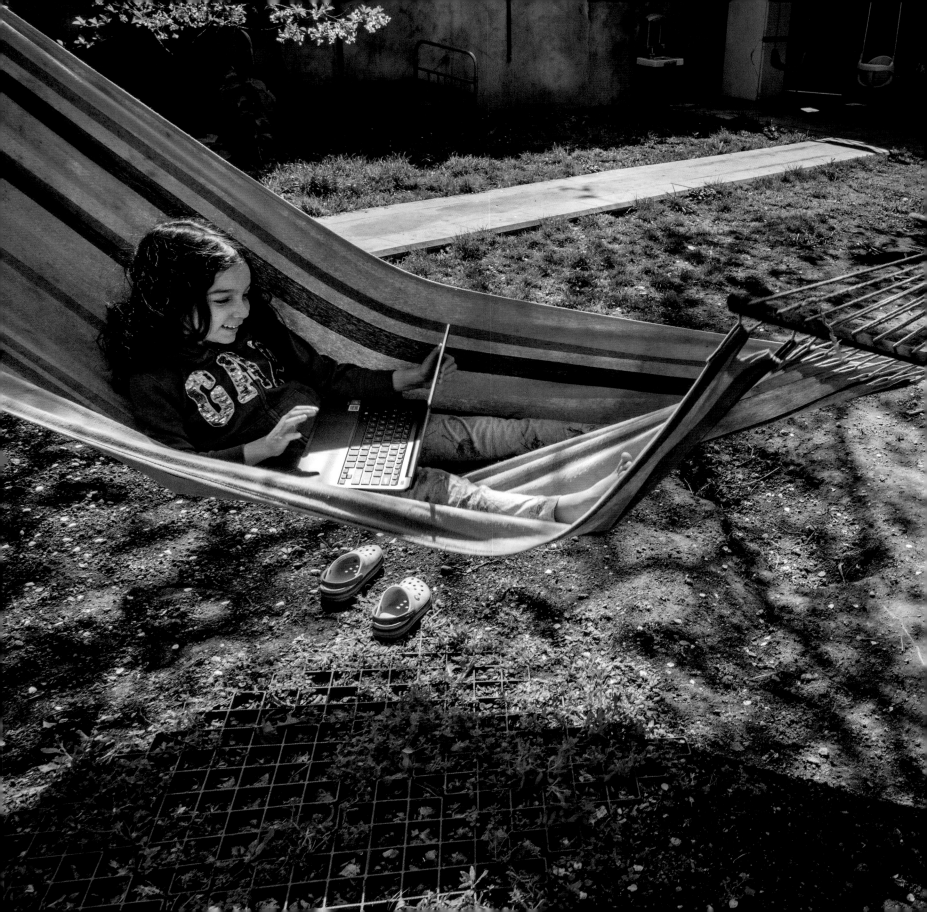

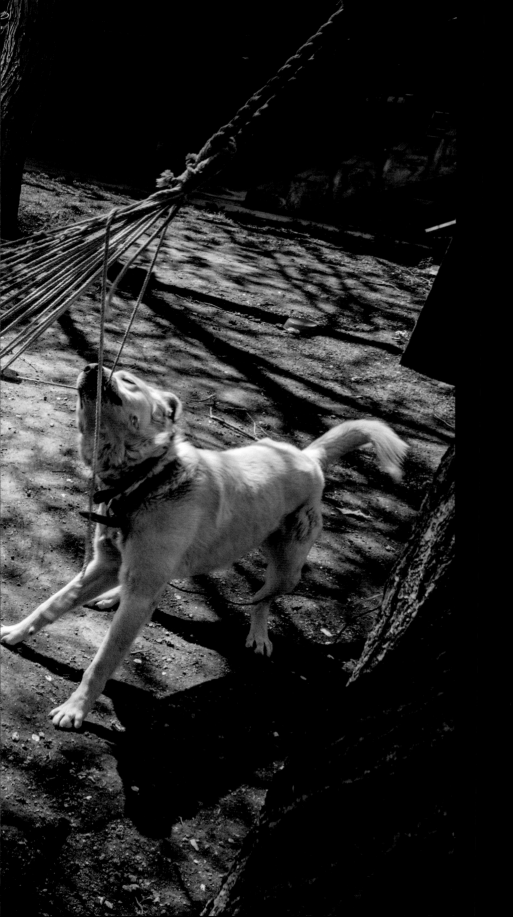

HOME

Ella Grigoryan, eight, attends school online in the backyard of her home in Yerevan, Armenia, while her dog, Apricot, plays nearby.

ANUSH BABAJANYAN | YEREVAN, ARMENIA
APRIL 2020

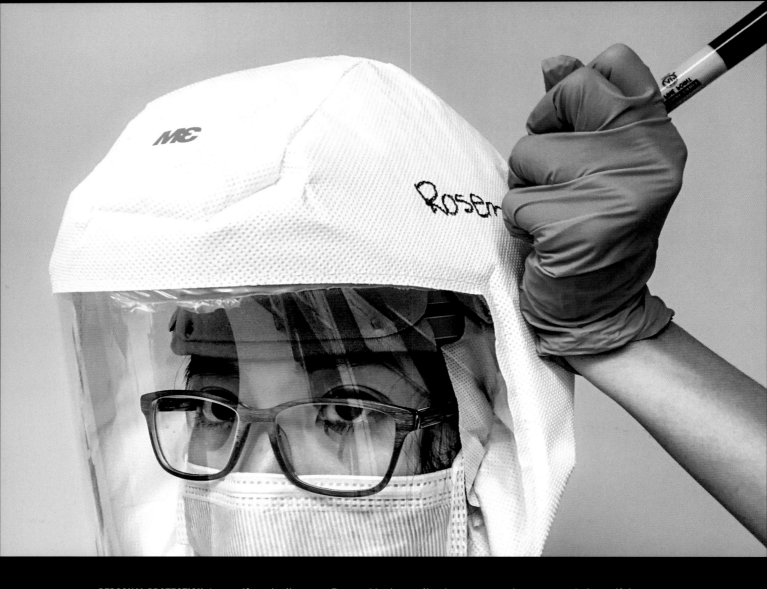

PERSONAL PROTECTION: In a self-portrait, nurse Rosem Morton writes her name on her powered air-purifying respirator hood, which connects to a battery-operated breathing apparatus shared among the staff at her Baltimore, Maryland, hospital. Facing a limited availability of personal protective equipment, Morton wiped clean and reused this hood, designed to be disposable, for the duration of the pandemic.

ESSAY

DISPATCH FROM THE FRONT LINES

BY ROSEM MORTON

Rosem Morton is a documentary photographer and nurse based in Baltimore, Maryland, United States. With the support of the Emergency Fund, she chronicled her journey as a nurse, highlighting the conditions inside the hospital and the fears that followed her home.

On March 17, 2020, six days after the first known coronavirus patient was admitted to my hospital, I started documenting this journey. I wrote, "Today is one of the last days I would call 'business as usual.' While much of the administrative staff has moved to working remotely, everyone else is still here."

These sentences evoke such a powerful response from me today. They bring me back to the beginning of having to go to work without any assurance of safety for myself, for my colleagues, or for my family. They also remind me of the divide—that the rest of the world got to stay home while frontline workers faced the unknown.

Amid rising case counts, I found comfort in documenting my experiences. But what began as a way for me to make sense of the pandemic became a testament to the battles being waged by health-care workers—battles fought behind hospital walls, out of sight for most people.

In the face of this crisis, it also felt crucial to examine peace. What do safe spaces look like after a weary day fighting an invisible enemy?

I found comfort pounding on dough during particularly stressful weeks; the smell of freshly baked bread soothed some of my worries. In our prolonged quarantine, I cut my partner's hair: the buzzing sounds, our quiet breaths, offered a different form of intimacy. These moments, magnified by the simplicity of isolation, grounded me during the hardest days.

Documenting myself professionally as a nurse was a challenging duality. My patients always take priority, and the demands of my job mean that I normally can't carry a camera. But despite my feelings of uncertainty, I felt a responsibility to inform others of frontline experiences.

So much of this time feels like a blur. But in hindsight, the opportunity to pause and preserve these moments through visuals and text has been a blessing. Through this project, I have been able to examine my past self and reflect on what we have all endured.

I am honored to have served as a nurse and as a documentarian to events that remind us all of the resilience of humanity.

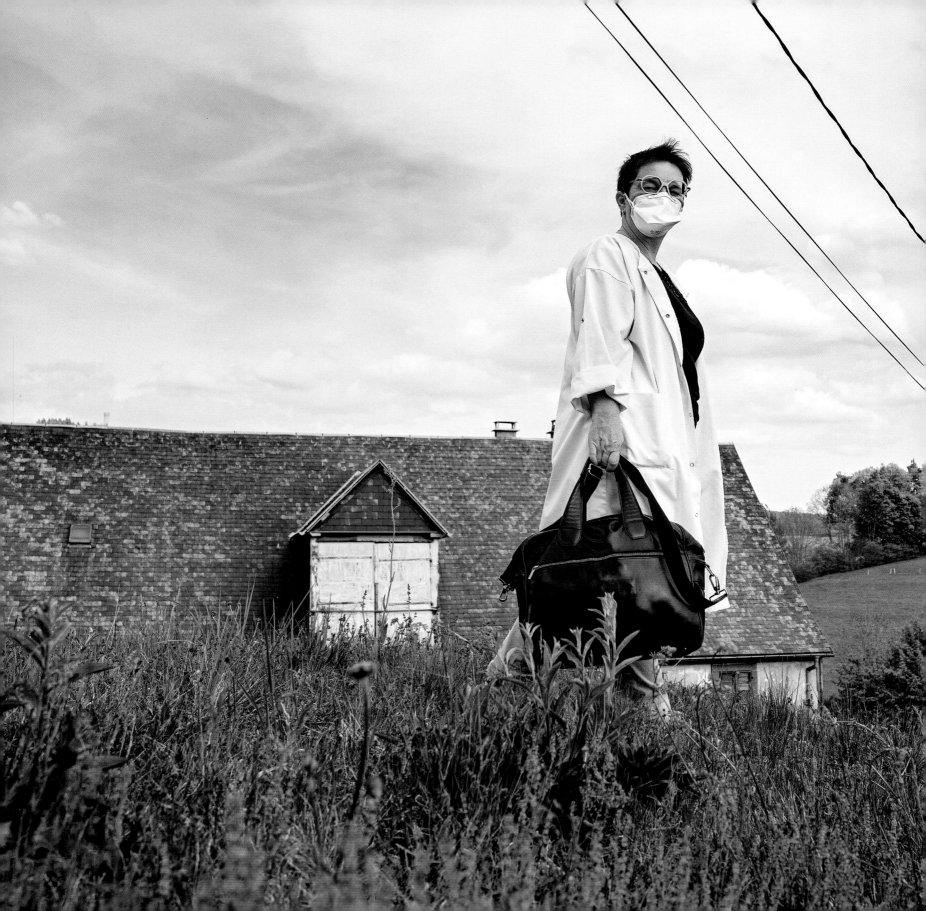

THE DOCTOR IS IN

MÉLANIE WENGER/INLAND
HACHIMETTE, FRANCE | APRIL 2020

Local doctor Dominique Spihlmann leaves one of her morning house calls. As the tiny rural French department of Haut-Rhin became a COVID-19 hot spot, Spihlmann became the first responder in the remote community of 10,000. Each day she saw up to 10 COVID-19 patients, along with her regular patients, in five villages spread across three small valleys. She also managed the COVID-19 unit of a nursing home she oversees, constantly consulting with nurses and caregivers, treating the patients, and testing the staff. After long days, Spihlmann entered her home and rejoined her family through an improvised decontamination area in her garage. At times, she forgot to take off her mask, even while at home.

Behind the story: To report this story, photographer Mélanie Wenger wore a protective jumpsut, an FFP2 mask, and shoe covers—as did her subject.

THE DOCTOR IS IN CONTINUED

MÉLANIE WENGER/INLAND | HACHIMETTE, FRANCE | APRIL 2020

Left: Dr. Dominique Spihlmann drives to visit a patient in her home after she may have been exposed to COVID-19. *Right:* Nurse Magali Riette reassures Mme Masson, a nursing home resident who was inconsolable while isolated in a COVID-19 unit after testing positive two weeks prior.

As the primary caregiver for a number of villages dotted throughout the rural department of Haut-Rhin, Spihlmann delicately balanced being a first responder to those with COVID-19 and attending to her regular patients.

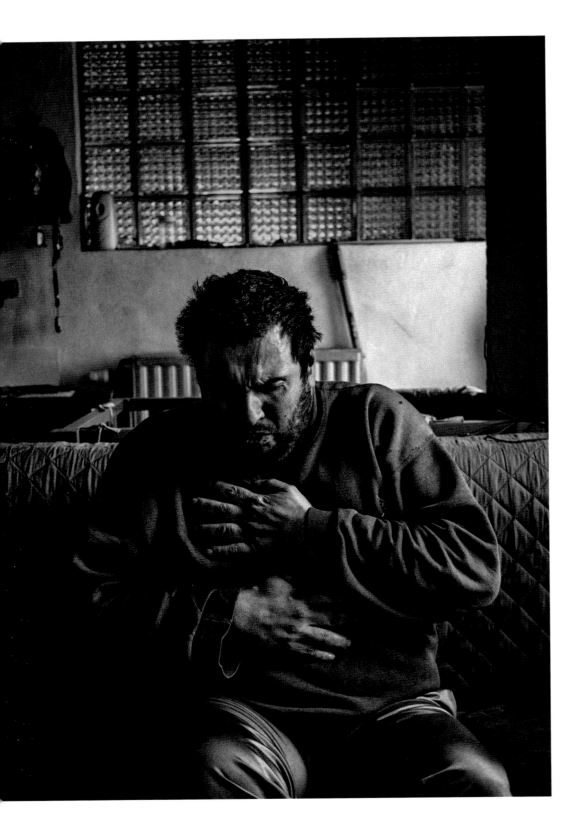

LOCAL HEROES PROTECT THEIR OWN

CÉDRIC GERBEHAYE | LA LOUVIÈRE, BELGIUM
MARCH–JULY 2020

Left: A man exhibits symptoms of COVID-19 during an intervention by the Mobile Emergency and Resuscitation Service of Tivoli University Hospital. *Right:* Dr. Romain Parlante explains the need for COVID-19 testing to a patient who refuses to be assessed at Résidence Le Laetare, a nursing home for the elderly.

As Belgium's rate of COVID-19 deaths soared to the highest in the world during spring 2020, doctors, nurses, and medical staff in the small town of La Louvière began the fight for their neighbors' lives.

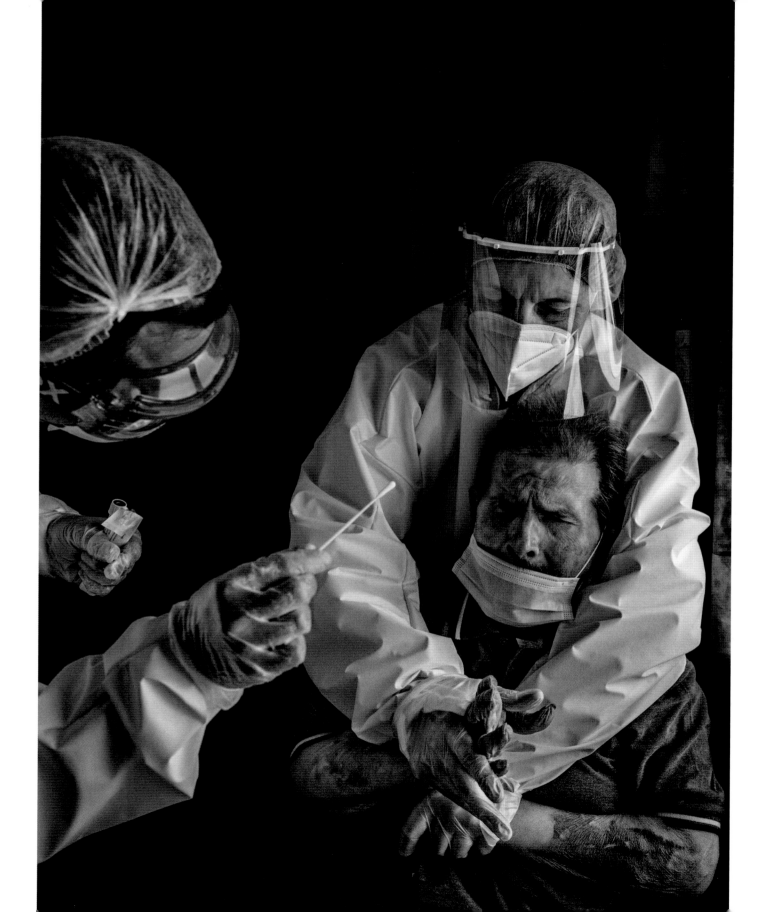

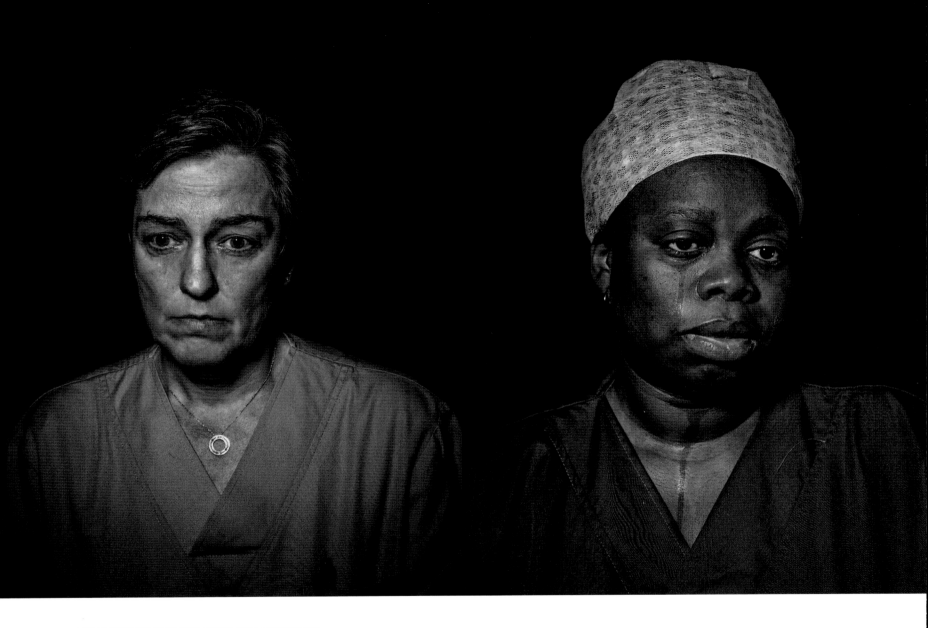

LOCAL HEROES PROTECT THEIR OWN CONTINUED

CÉDRIC GERBEHAYE | LA LOUVIÈRE, BELGIUM | APRIL–MAY 2020

Doctors and nurses of Tivoli University Hospital Center; in spring 2020, Belgium faced surging COVID-19 rates. *From left*: Cynthia, gynecologist; Ghislaine, geriatric services nurse; Julien, emergency department doctor; and Melanie, intensive care unit nurse

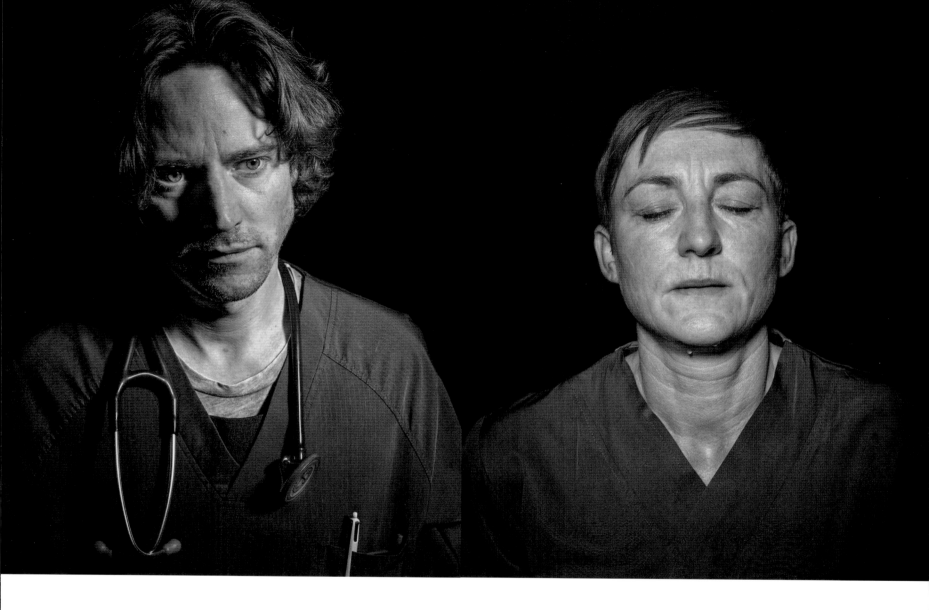

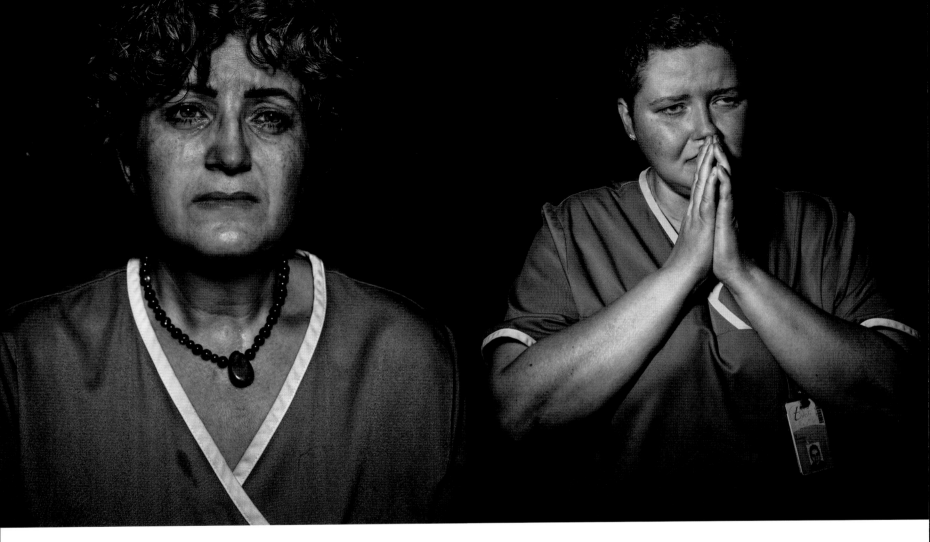

LOCAL HEROES PROTECT THEIR OWN CONTINUED

CÉDRIC GERBEHAYE | LA LOUVIÈRE, BELGIUM | APRIL–MAY 2020

Doctors, nurses, and medical staff of Tivoli University Hospital Center in La Louvière, Belgium.
From left: Hatice, emergency department logistics assistant; Florence, palliative care nurse; Manu, emergency department nurse; and Vanessa, mobile-team care assistant

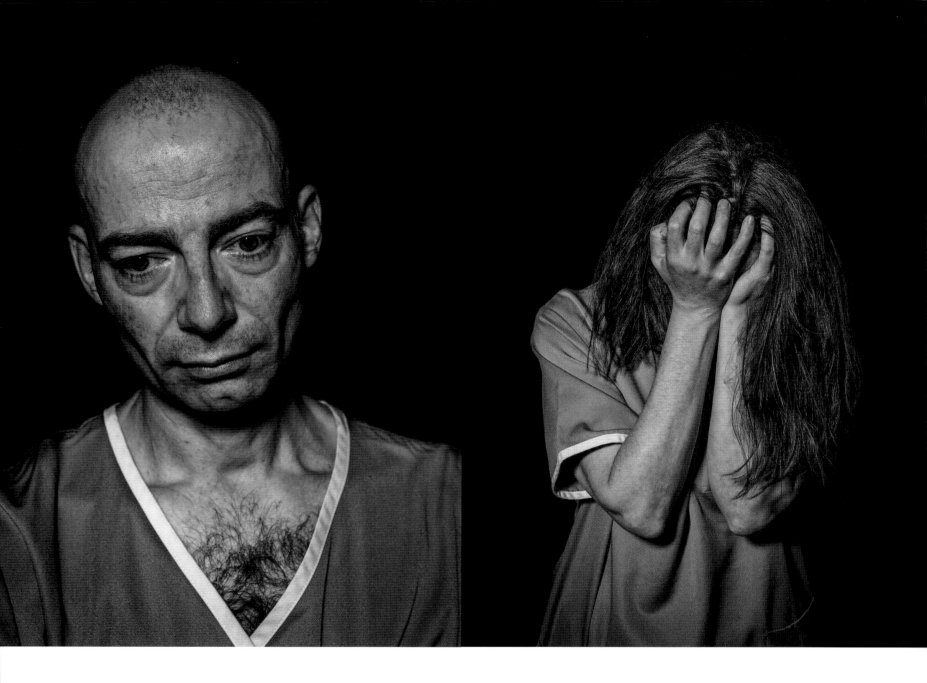

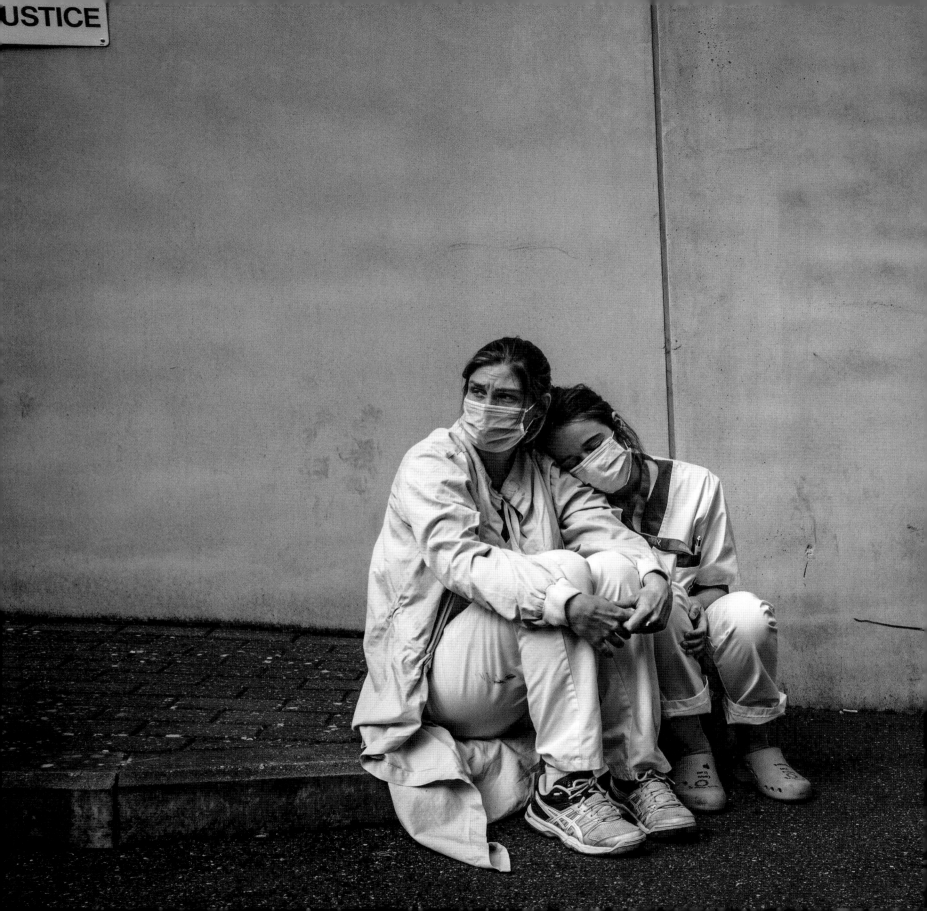

LOCAL HEROES PROTECT THEIR OWN CONTINUED

CÉDRIC GERBEHAYE | MONS, BELGIUM
MARCH 2020

Medical workers Caroline (left) and Yasmina, who arrived as reinforcements in Ambroise Paré Hospital's intensive care unit, take a brief rest.

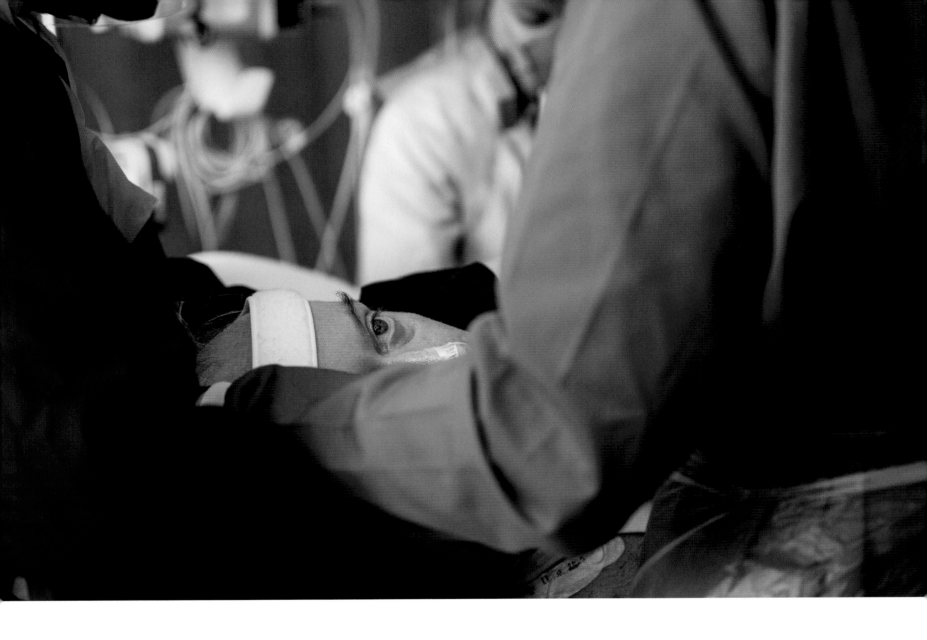

HOSPITALS CONFRONT COVID-19

LYNSEY ADDARIO | COVENTRY, ENGLAND | MAY-JUNE 2020

Left: ICU nurses and doctors prepare to turn and lift William, a COVID-19 patient, so that he can sit upright in a chair for several hours to rebuild his strength after months in intensive care.
Right: The passage between University Hospital Coventry's Emergency Department and its reception area is taped shut to stem the flow of air potentially contaminated by COVID-19.

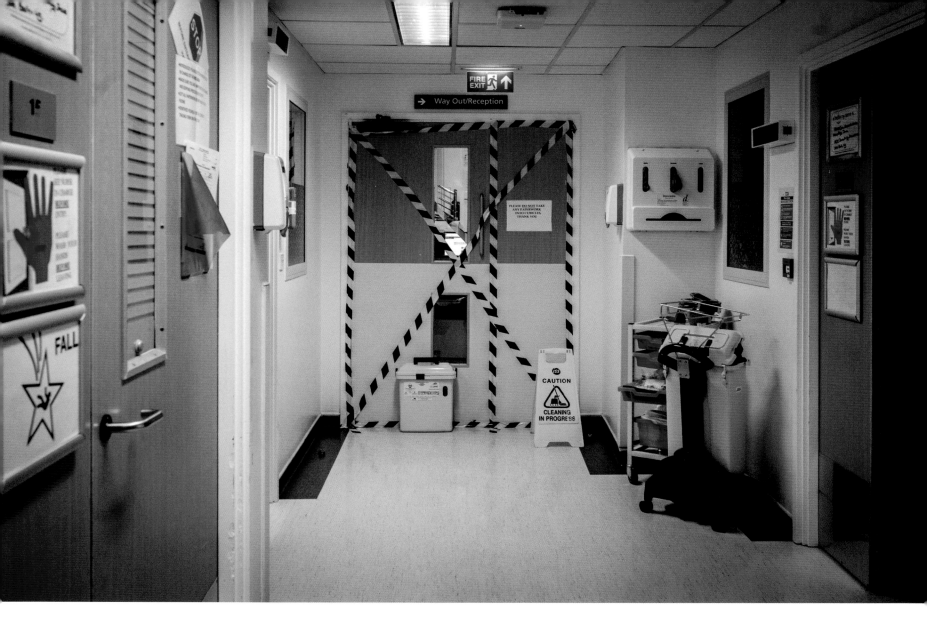

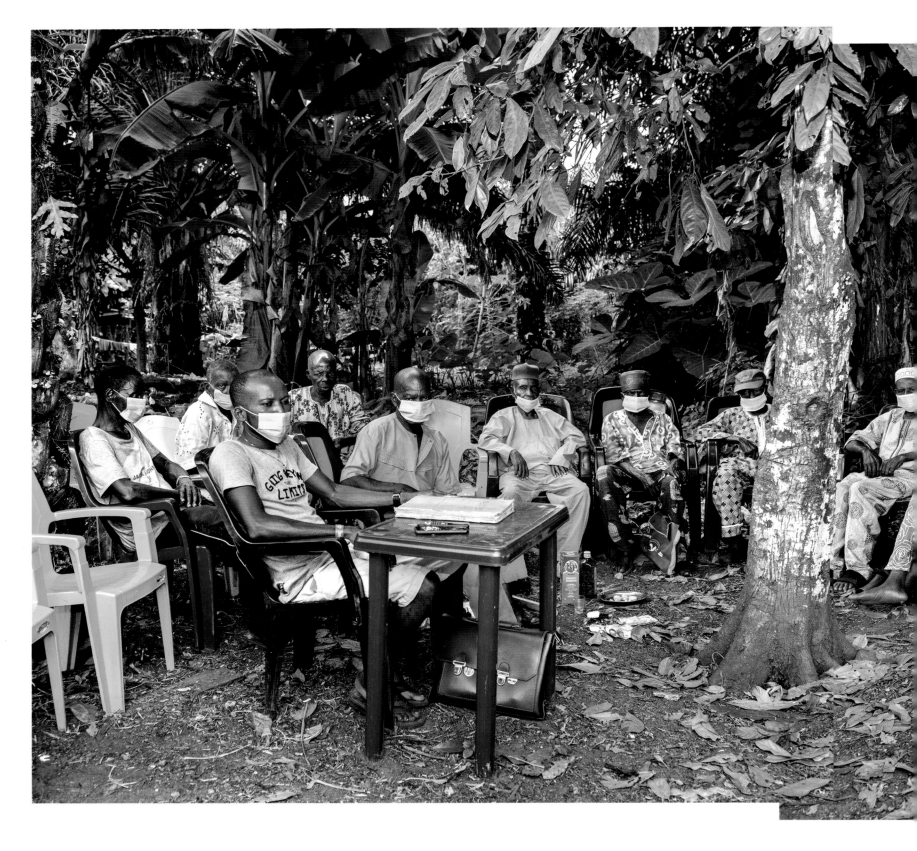

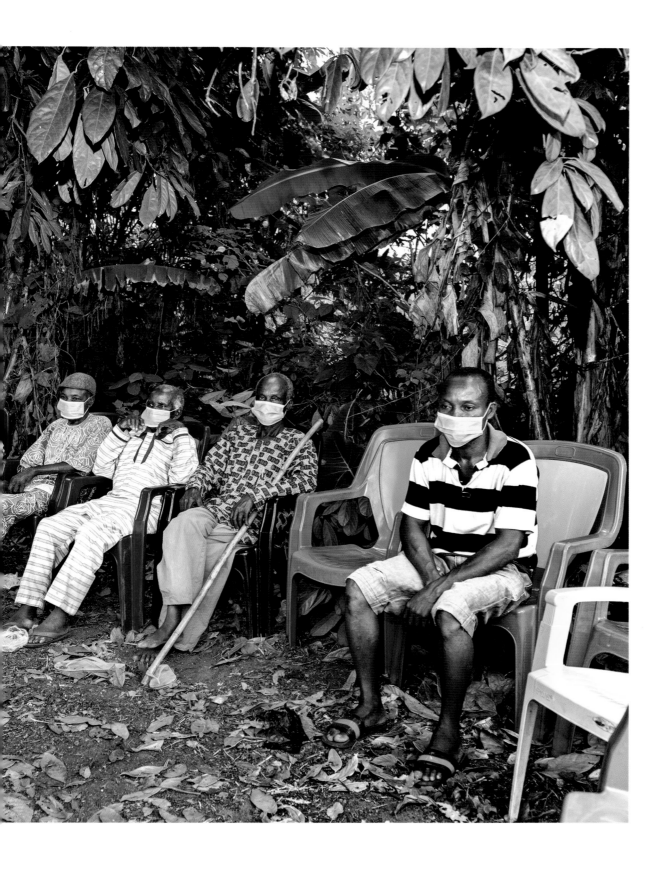

FIGHTING ON MULTIPLE FRONTS

BÉNÉDICTE KURZEN | DELTA STATE, NIGERIA
NOVEMBER 2020

A traditional council in Nigeria's Delta State receives a briefing from state officials about the transmission of yellow fever. Along with COVID-19, the region also experienced an outbreak of this viral infection spread by mosquitoes, causing the deaths of at least 300 people. Nigeria is a priority country for the World Health Organization's global strategy to eliminate yellow fever epidemics.

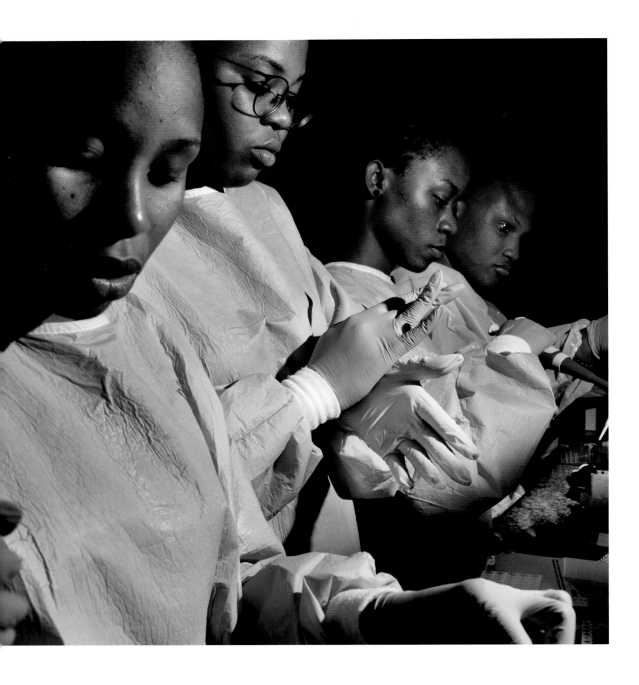

FIGHTING ON MULTIPLE FRONTS CONTINUED

BÉNÉDICTE KURZEN | OSUN STATE, NIGERIA
DECEMBER 2020

Left: Pictured from left to right, Ph.D. research fellows Jessica Uwanibe and Victoria Fehintola Ajogbasile and interns Shobi Otitoola and Iyanu Fred-Akintuwa prepare COVID-19 samples for sequencing at the African Center of Excellence for Genomics of Infectious Diseases (ACEGID). *Right:* Habeed Adekunle, 24, is tested for COVID-19 at the Asubiaro State Hospital in Osogbo as a prerequisite for submitting a job application.

Though supplies of COVID-19 tests were low in Nigeria, most samples were sent to ACEGID, the first institution in Africa to successfully sequence genomes for SARS-CoV-2. ACEGID identified 55 COVID-19 variants, including B.1.1.7, commonly known as the United Kingdom variant.

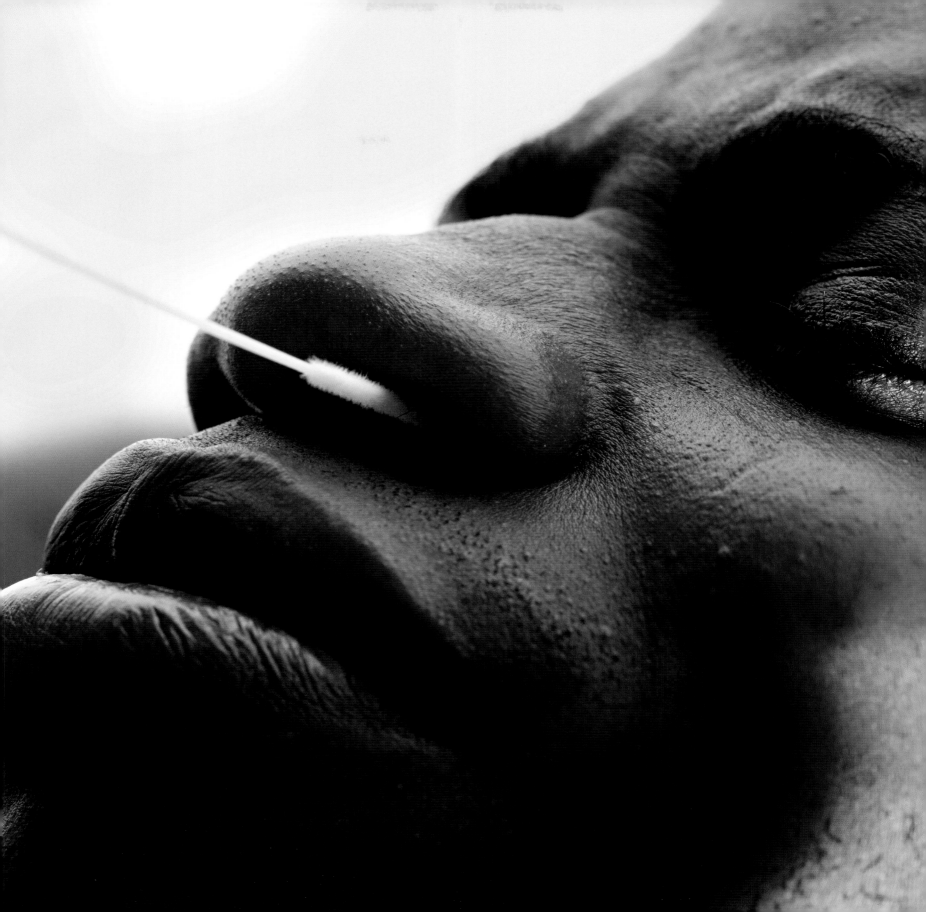

COVID COMPLICATIONS
——————————————

HARSHA VADLAMANI | AMBIKAPUR, INDIA
MAY 2021

Staff of the Government Medical
College Hospital tend to Suhanu
Das, 46, who fainted as she
watched a sample being taken
from the nose of her husband,
Anand Das, 51, to be tested for
mucormycosis. The disease, a
fungal infection that can cause
blindness and death, was
discovered in a startling number
of recovering COVID-19 patients
in India. When the pandemic
struck here, lockdown measures
made it virtually impossible for
residents from remote villages to
travel for treatment. Given the
already insufficient rural health-
care infrastructure, treating other
illnesses amid COVID-19 became a
dangerously low priority.

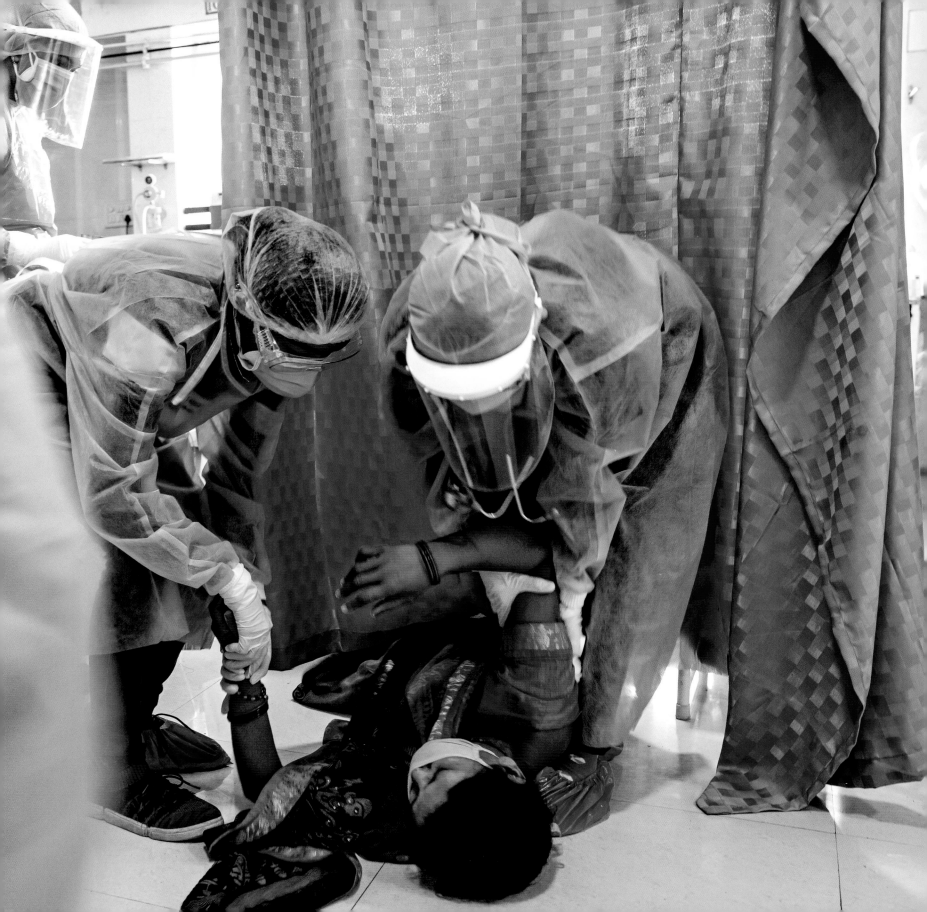

COVID COMPLICATIONS CONTINUED

HARSHA VADLAMANI | UTAVALI, INDIA | MAY 2021

Wearing three masks, Dr. Ashish Satav, 49, attends to a patient who tested positive for COVID-19 at the Meditation, Addiction, Health, AIDS, Nutrition charitable trust's Mahatma Gandhi Tribal Hospital in India's remote Melghat region. Satav was the only M.D.-qualified doctor among the region's 300 villages. As COVID-19 devastated the region, networks of volunteer doctors and nonprofit organizations rushed to treat the burgeoning number of patients, as well as those with other ailments that became neglected amid the pandemic.

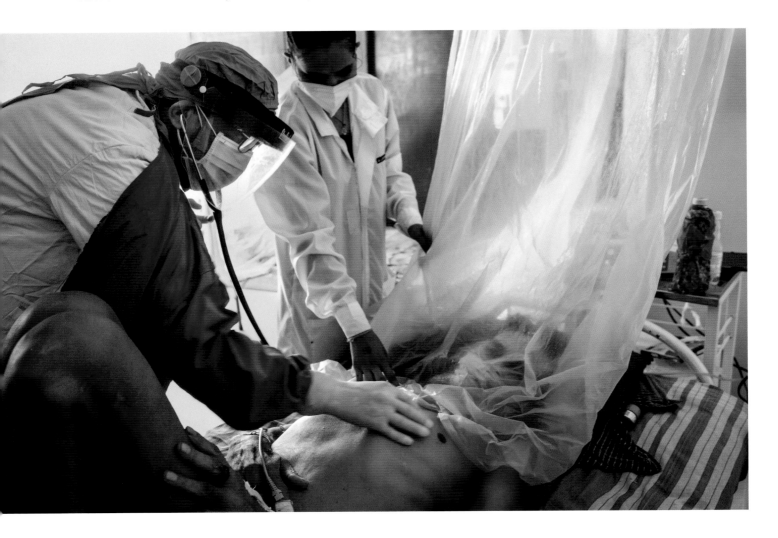

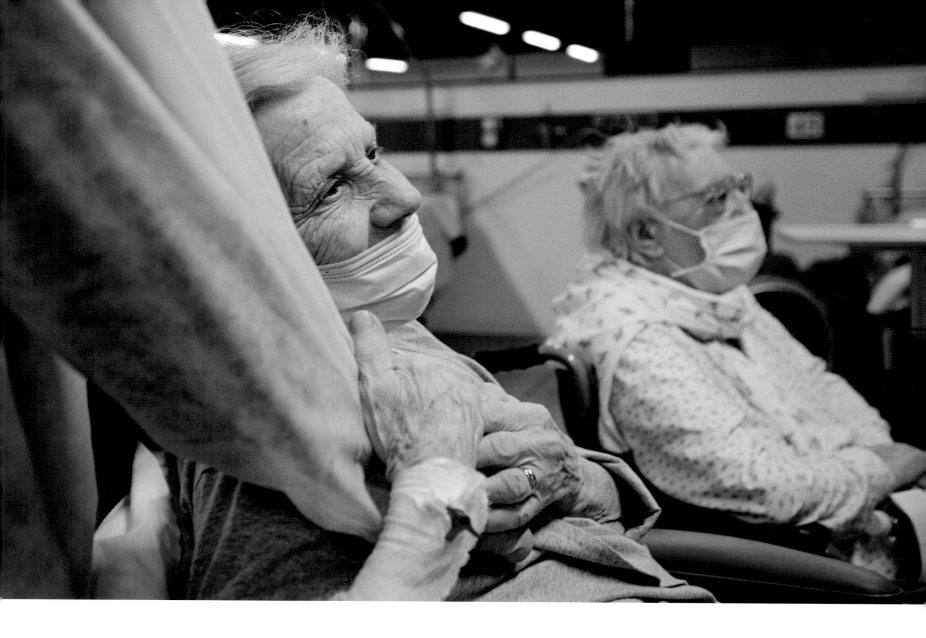

INTERNATIONAL SUPPORT

DIANA BAGNOLI | TURIN, ITALY | JUNE 2020

An elderly woman is attended to by Silvio, 48, a family doctor from Havana. In April 2020 members of the Henry Reeve International Medical Brigade, a humanitarian medical group based in Cuba, arrived in Turin, Italy, to assist with the outbreak of COVID-19. The brigade supported the overwhelmed local medical system, operating out of the Officine Grandi Riparazioni, a cultural event space converted into a makeshift hospital.

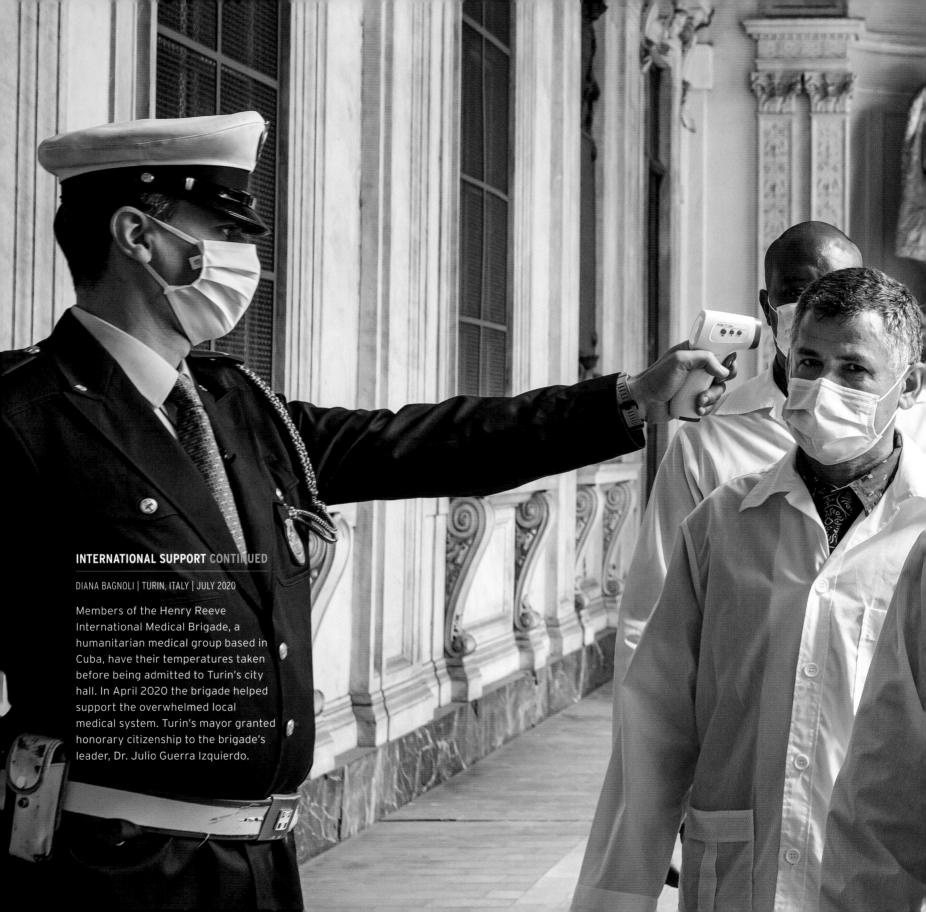

INTERNATIONAL SUPPORT CONTINUED

DIANA BAGNOLI | TURIN, ITALY | JULY 2020

Members of the Henry Reeve International Medical Brigade, a humanitarian medical group based in Cuba, have their temperatures taken before being admitted to Turin's city hall. In April 2020 the brigade helped support the overwhelmed local medical system. Turin's mayor granted honorary citizenship to the brigade's leader, Dr. Julio Guerra Izquierdo.

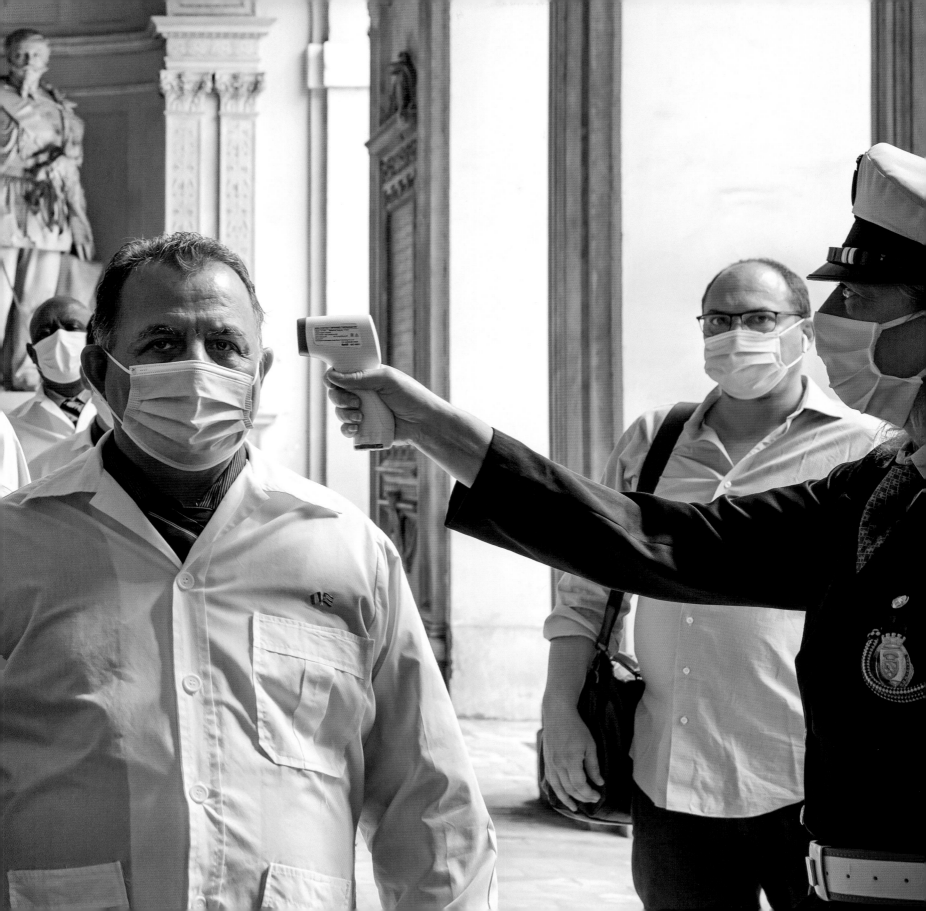

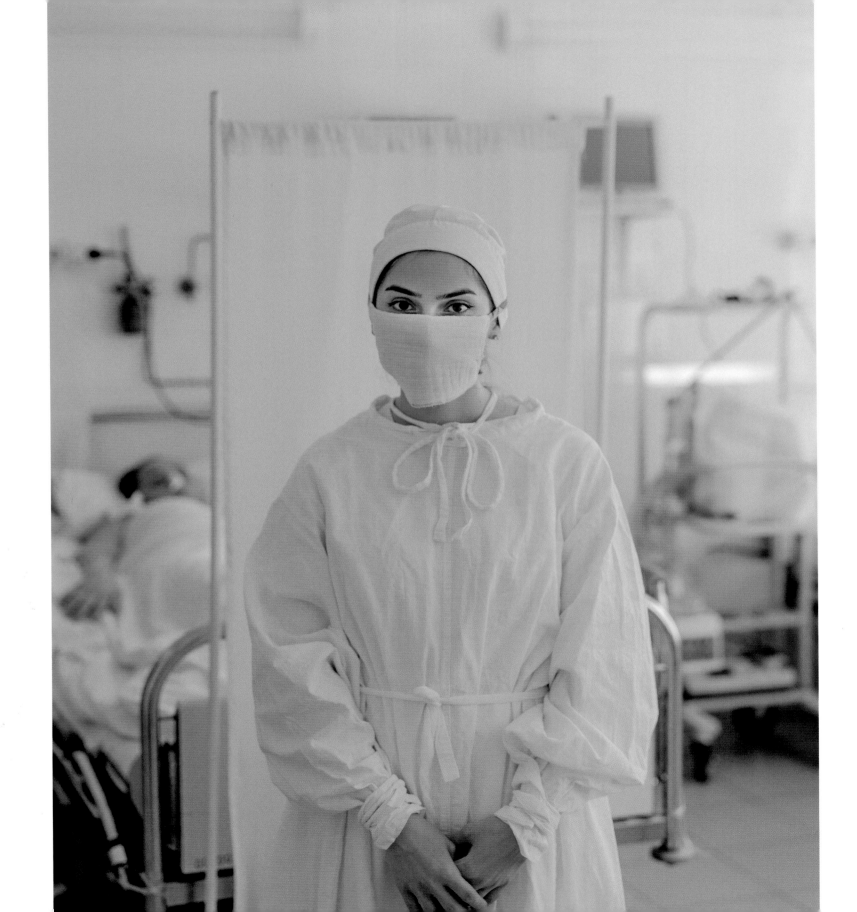

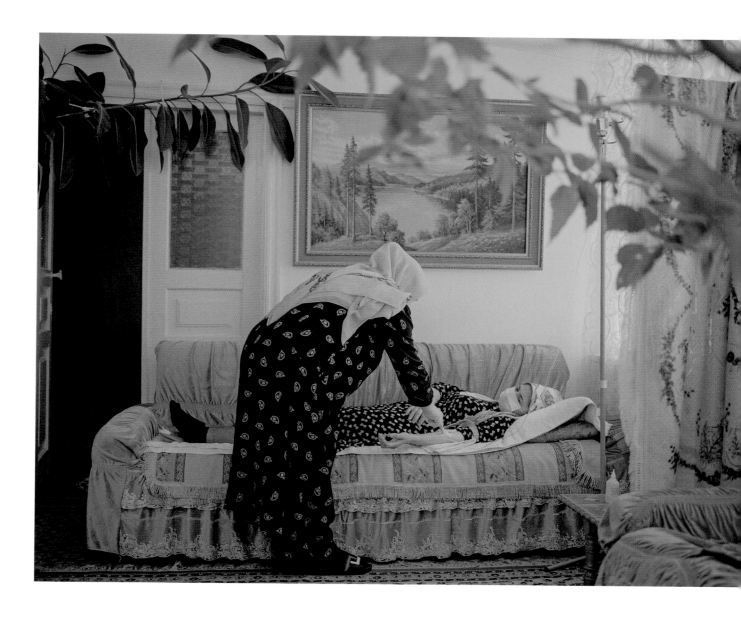

COMMUNITY SURVIVAL

NANNA HEITMANN | DAGESTAN, RUSSIA | JUNE 2020

Left: Patimat, an ICU nurse, pauses while caring for patients. *Above:* Paramedic Raziat Magamedova treats a COVID-19 patient recently released from the hospital.

In the villages of rural Dagestan, paramedics traditionally open their own homes to treat patients; at the height of the COVID-19 pandemic, almost every corner of Magamedova's house was filled with patients from her community.

DIGNIFIED BURIALS
AMID A PANDEMIC

TURJOY CHOWDHURY | DHAKA, BANGLADESH
OCTOBER 2020

Farid, 55, a member of volunteer
group Al-Markazul, conducts a
janazah (funeral prayer) for a man
who died of COVID-19. Testing
positive for the virus carried such
a heavy stigma in Bangladesh and
other places that many families
made the agonizing decision to
prioritize safety over traditional
burials. Al-Markazul, composed of
Muslim scholars and teachers,
stepped up to conduct dignified
funerals and burials for COVID-19
victims, a commitment that
forced them to stay away from
their own families for months and
to risk their own lives.

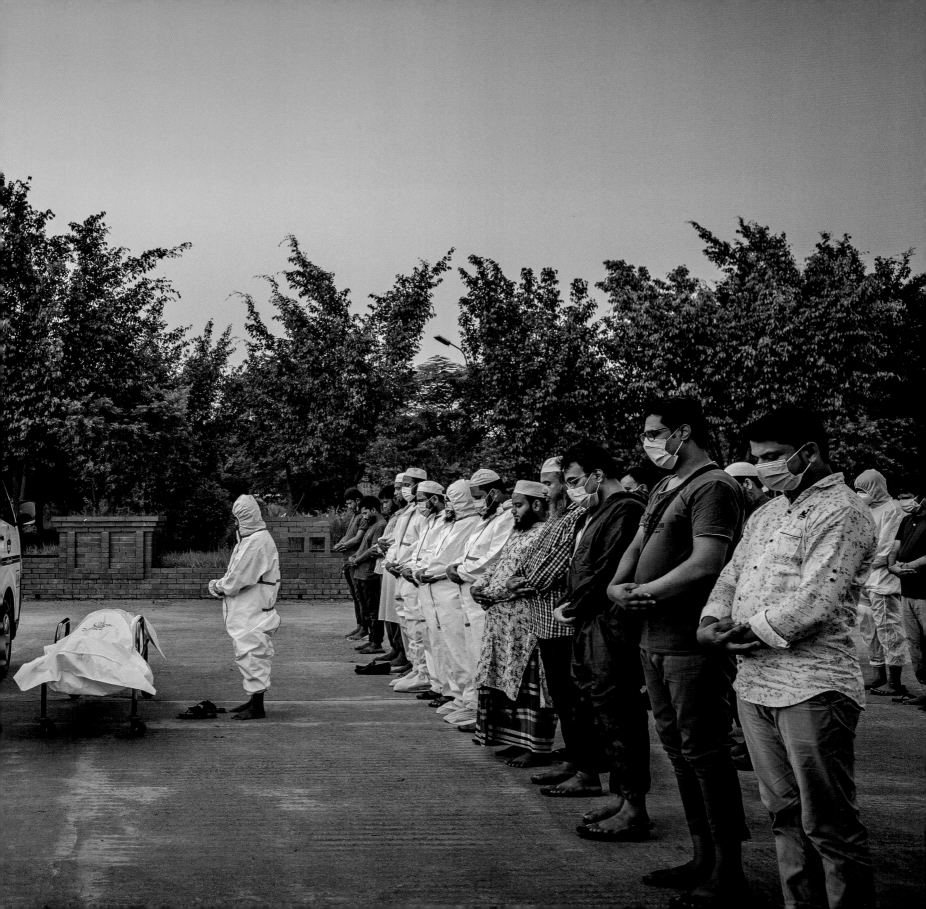

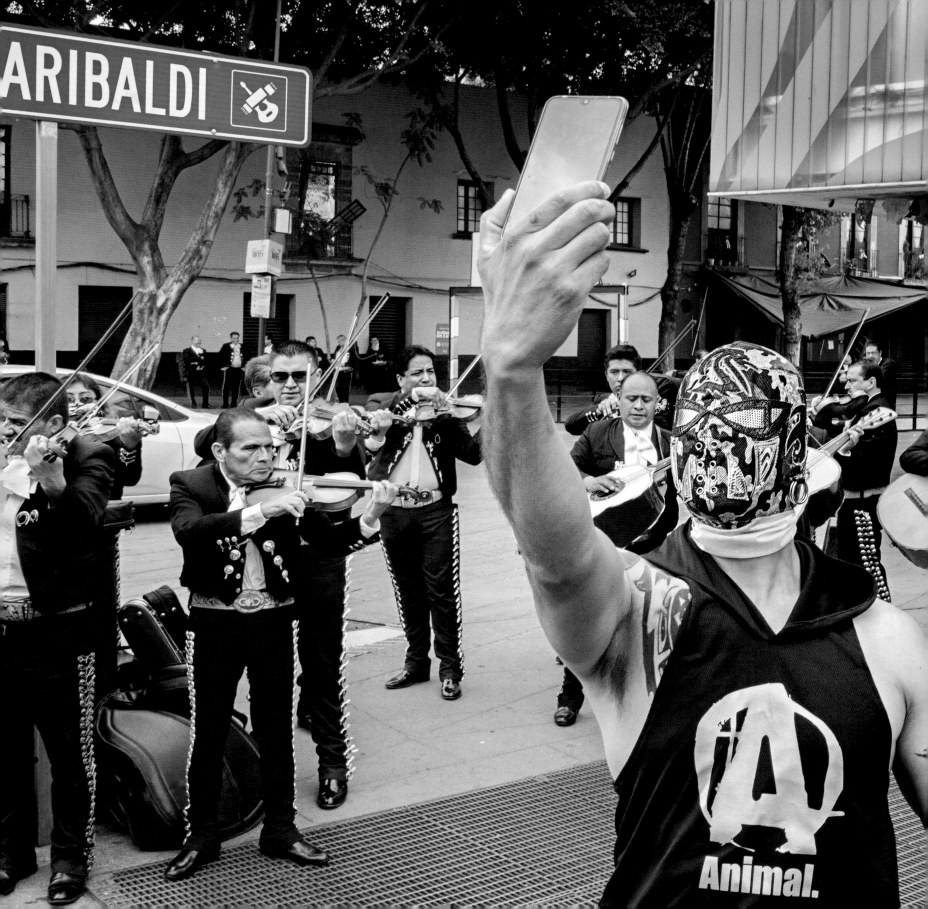

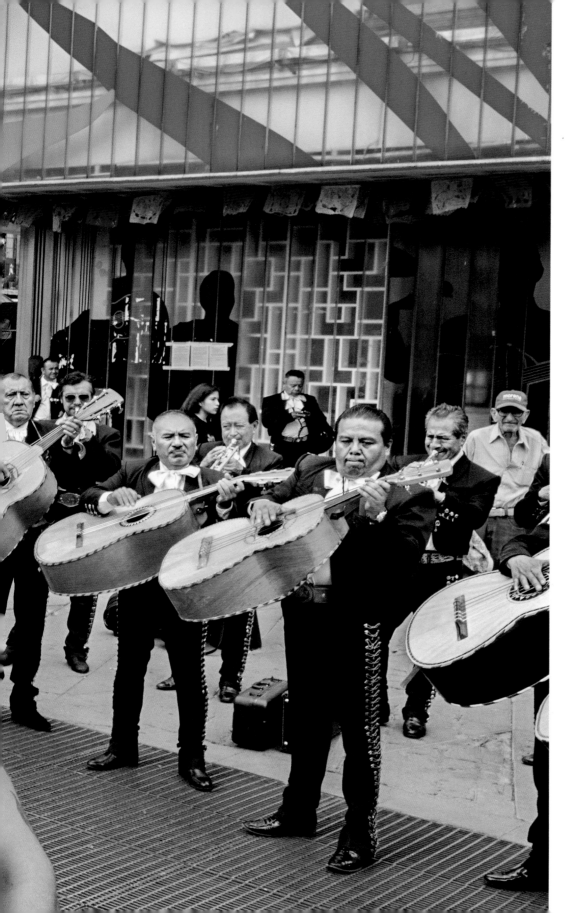

CULTURAL RESILIENCE

RUBÉN SALGADO ESCUDERO
MEXICO CITY, MEXICO | APRIL 2020

Cobra Extreme, a *luchador* (or masked Mexican wrestler), takes a selfie in front of mariachi musicians at Mexico City's Plaza Garibaldi. In exchange for donating supplies to a volunteer organization supporting the musicians amid COVID-19, he received a serenade.

With travel at a standstill during the pandemic, Plaza Garibaldi, known as Mexico City's Mariachi Mecca, fell silent, emptied of its usual throngs of tourists. Many musicians here, who rely on the bustling crowds for income, were suddenly unable to provide for themselves and their families. Some turned to the digital space, giving unique performances and sharing their culture through serenades commissioned online.

CULTURAL RESILIENCE CONTINUED

RUBÉN SALGADO ESCUDERO | MEXICO CITY, MEXICO | MAY 2020

Mariachi musicians record a televised Mother's Day special at the empty National Theater, viewed by millions across the country. In normal times, Mother's Day would attract large crowds to Plaza Garibaldi to hear the mariachi musicians live; during the pandemic, the plaza stood empty.

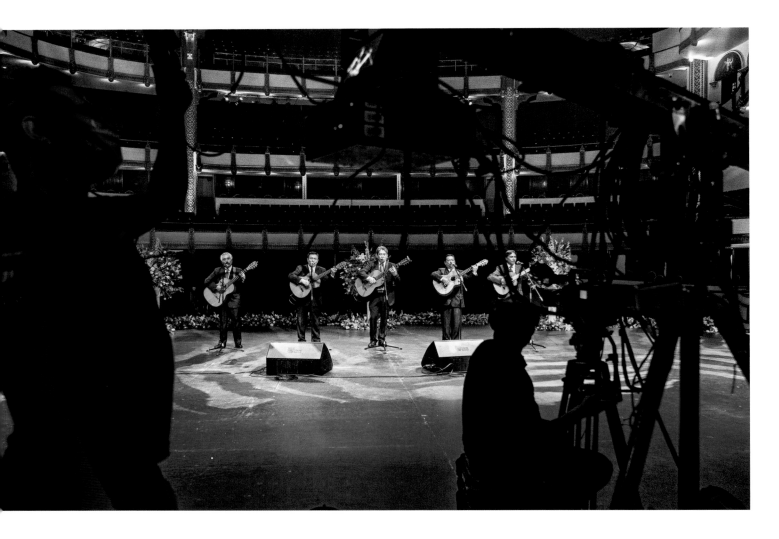

A COMMUNITY MAINSTAY

RORY DOYLE | MISSISSIPPI, UNITED STATES | DECEMBER 2020

Tracy Harden, owner of Chuck's Dairy Bar, hangs a sheet of plastic to serve as protection against COVID-19. Chuck's is an iconic eatery that has been a mainstay for generations in the lower Mississippi Delta, feeding farming families and operating as a meeting place where locals stay connected. Although it did not close during the pandemic, it operated temporarily as a takeout-only restaurant, causing a significant decrease in revenue.

FOOD INSECURITY
AMID COVID-19

RAFAEL VILELA | SÃO PAULO, BRAZIL
JULY 2020

Thousands of cyclists and motorbikes flood the streets of São Paulo during a delivery workers' strike. Amid COVID-19, this group faced worsening conditions, including exposure to the virus and lower pay as many (including those newly unemployed due to the pandemic) joined their ranks. In Brazil, the economic downturn in the wake of the pandemic pushed previously stable population segments toward food insecurity and poverty.

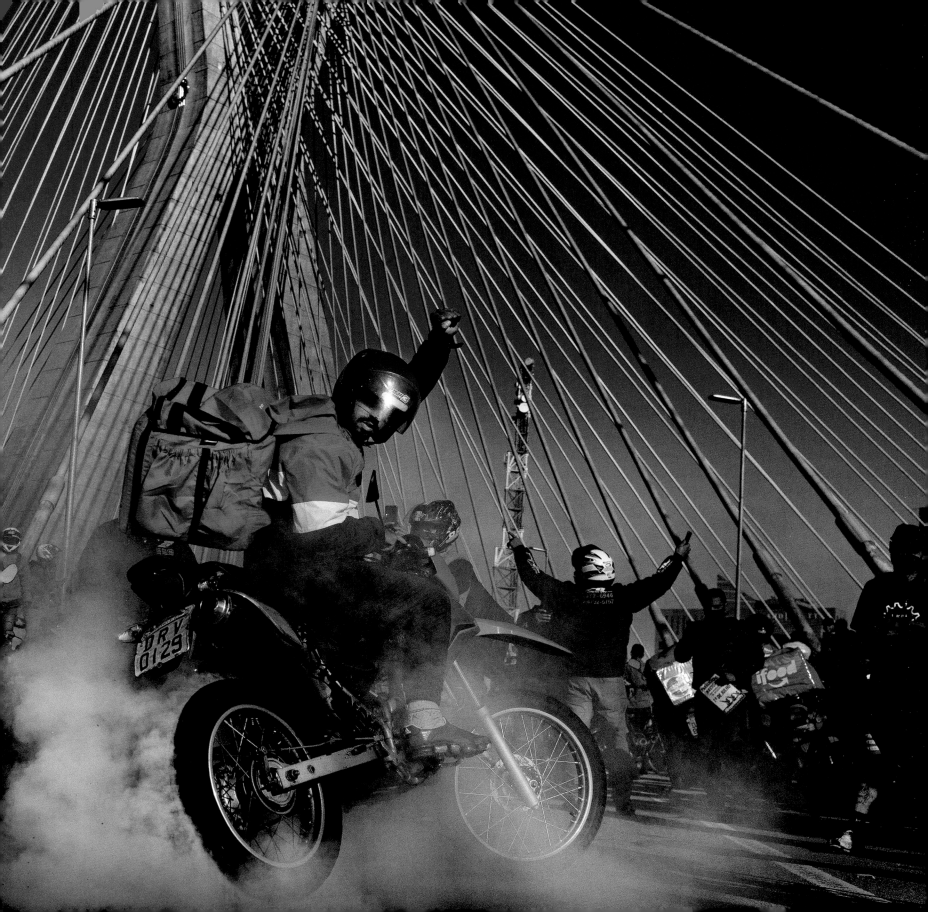

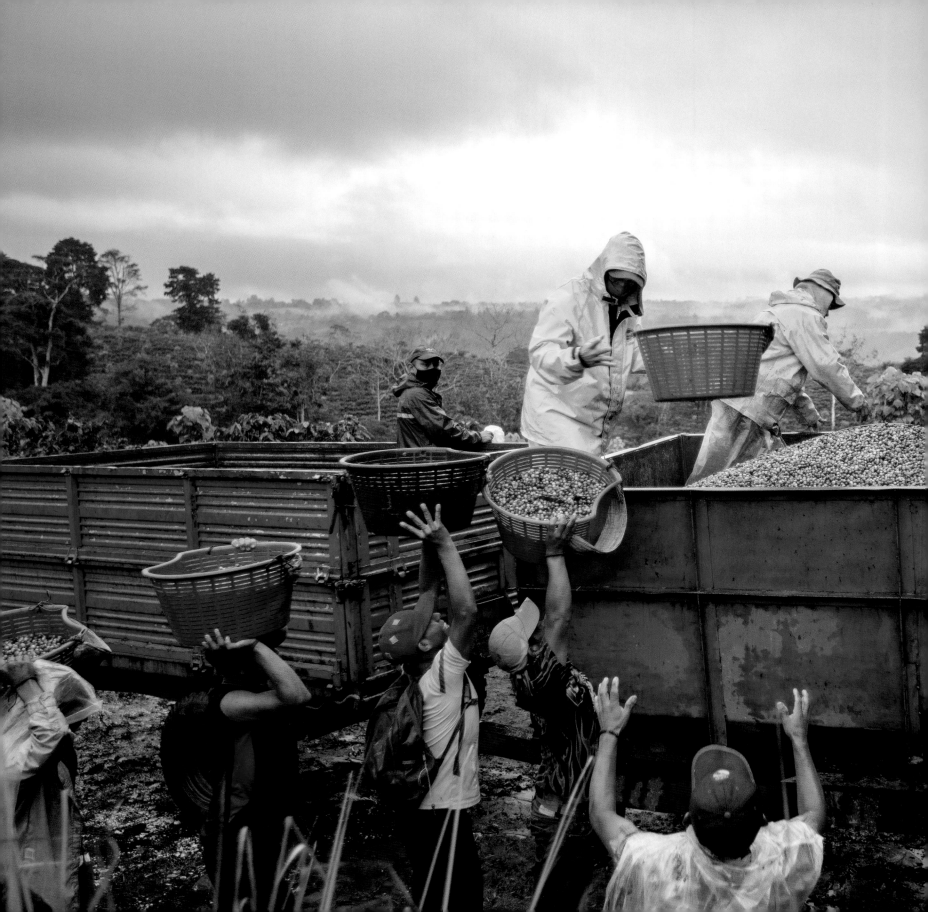

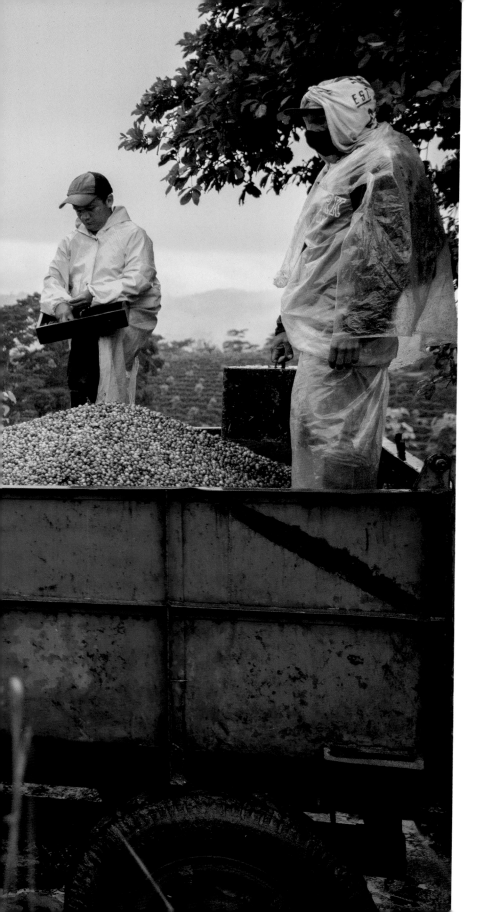

HEALTH CHALLENGES VS. ECONOMIC DRIVERS

MÓNICA QUESADA CORDERO
PUNTARENAS, COSTA RICA | NOVEMBER 2020

Indigenous Ngöbe-Buglé migrant workers from Panama exchange baskets of coffee cherries for the equivalent of two U.S. dollars. Coffee plantations in this part of Costa Rica depend on Ngöbe-Buglé immigrants to pick 95 percent of the crop. As international borders closed amid COVID-19, Costa Rica's migrant coffee workers were seen as both an essential economic force and a public health liability, forcing Costa Rican and Panamanian public and private sectors to work together to facilitate safe migration.

ESSENTIAL WORK AMID COVID-19

KARLA GACHET/RUNA PHOTOS /AYÜN FOTÓGRAFAS | CALIFORNIA, UNITED STATES | JUNE 2020

Below: Noraney Ocampo, 38, a Deferred Action for Childhood Arrivals (DACA) recipient and middle school teacher, watches her students' graduation online. *Right:* Jesica Garcia Garcia, 22, a DACA recipient, works in an essential position at a grocery store.

DACA is a U.S. immigration policy that allows some undocumented immigrants who arrived as children to receive deferred legal action and become eligible for an authorized work permit. More than 200,000 DACA recipients risked their health and safety in essential positions during the COVID-19 pandemic, even as legal challenges to the policy were being heard in the Supreme Court to decide the fate of these "Dreamers."

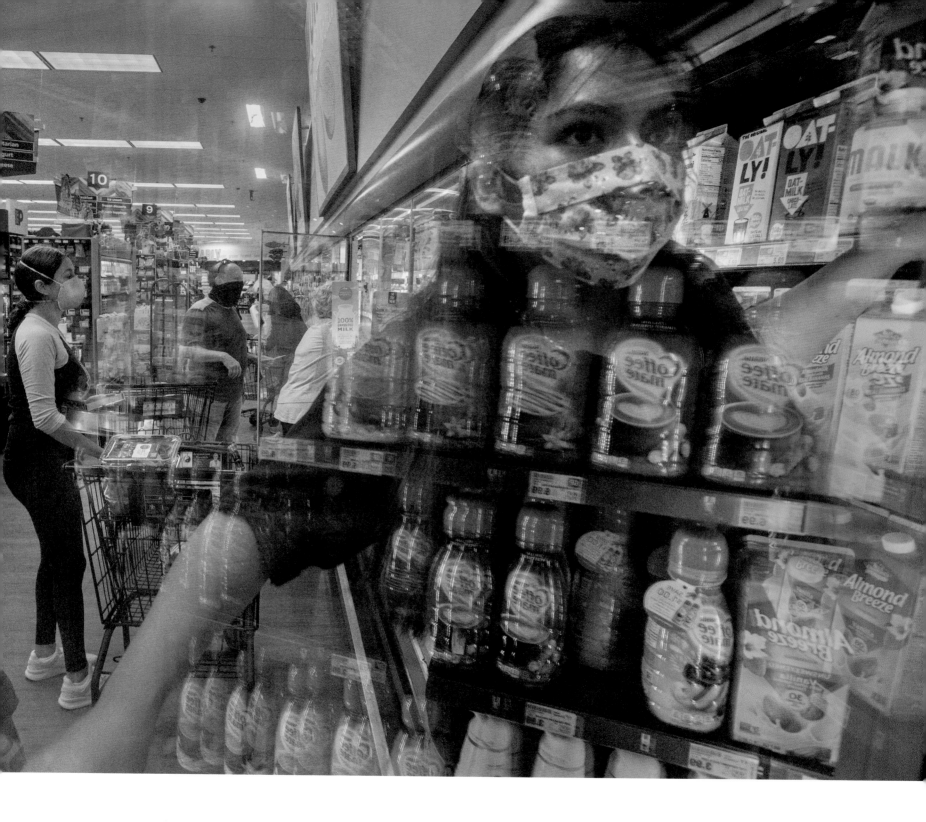

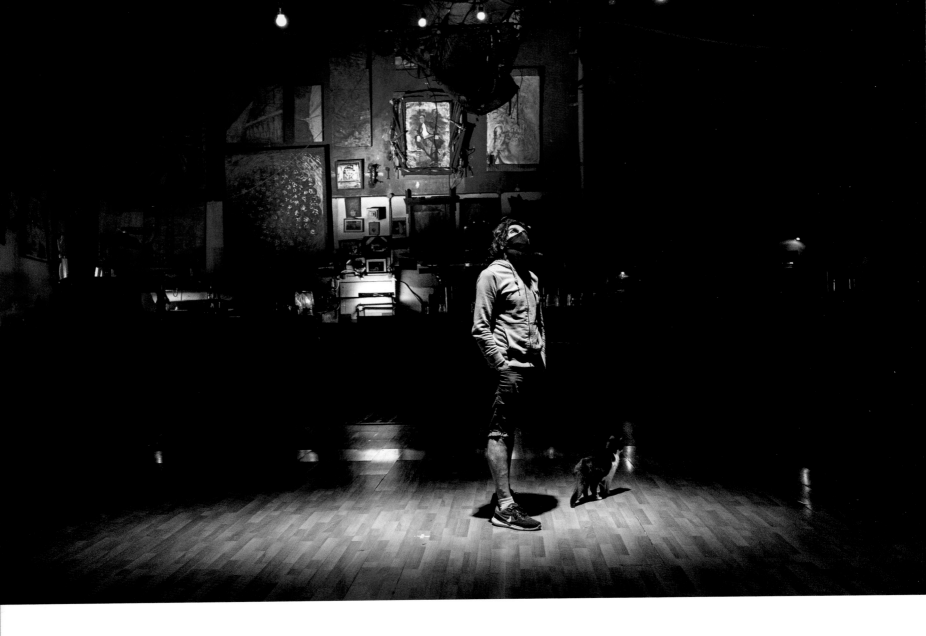

KEEPING CULTURE ALIVE

ANITA POUCHARD SERRA | BUENOS AIRES, ARGENTINA | OCTOBER 2020

Mario Bulacio, one of the Catedral Club's approximately 50 employees, pauses to reflect on an empty dance floor. A Milonga hot spot in Buenos Aires's iconic Almagro neighborhood, the Catedral had hosted tourists and local dancers for 22 years before closing indefinitely amid COVID-19. Dance is not only a cultural passion in Argentina but also a multibillion-dollar industry—and for many, the primary source of income.

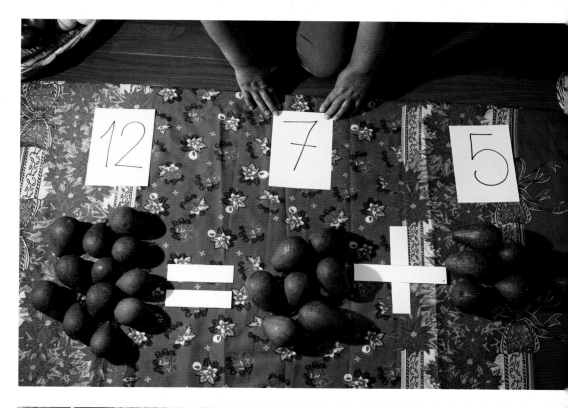

EDUCATION ONLINE

DAVID DIAZ ARCOS AND ANA MARÍA
BUITRÓN/FLUXUS FOTO
QUITO, ECUADOR | MAY-JUNE 2020

Top: Violeta Proaño, 53, uses
avocados as a teaching aid for
online primary education.
Throughout the COVID-19
pandemic, she and fellow teacher
Karla Jiménez, 36, taught online
classes out of their homes;
despite their best effort, only half
of their enrolled students were
able to continue studying.
Bottom: Laura Santillan, director
of the Yachay Wasi school,
records a video demonstrating
medicinal plants growing in the
school's garden to share with her
students virtually.

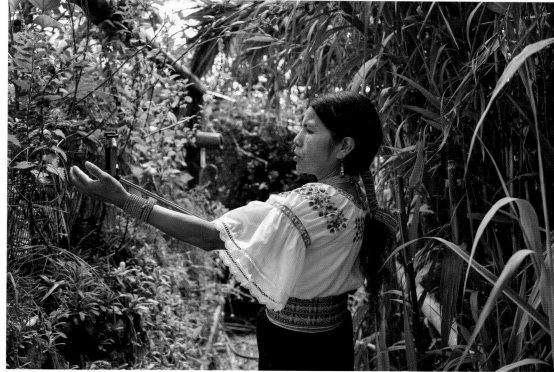

EDUCATION ONLINE CONTINUED

JOSUÉ ARAUJO/FLUXUS FOTO
QUITO, ECUADOR | MAY 2020

A young student who suffers from attention deficit hyperactivity disorder takes a much needed break during online classes. As education moved online to prevent the spread of COVID-19 in classrooms, many families facing socioeconomic inequities and students with different abilities were presented with limited or no opportunities to continue attending school.

CHANGING MILESTONES

ANDREA BRUCE | NORTH CAROLINA, UNITED STATES | JUNE 2020

Below: Participants in one of Pamlico County High School's graduation ceremonies line up to take the stage. Separate, socially distanced ceremonies were arranged, 20 students at a time, for the class of 2020.
Right: Attendees of Pamlico County High School's "Senior Night" take a photo of a senior portrait. To protect students from COVID-19, the school held the event on its track to celebrate the class of 2020, which had spent the majority of its senior year at home.

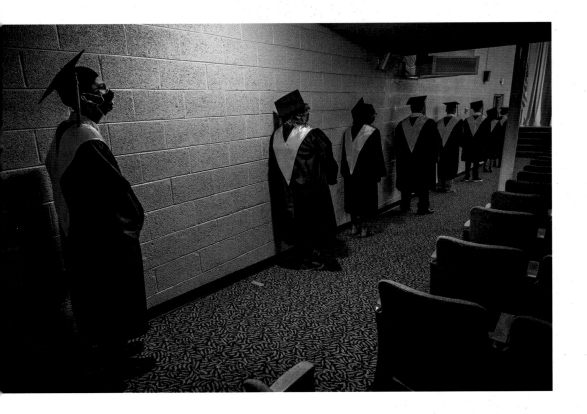

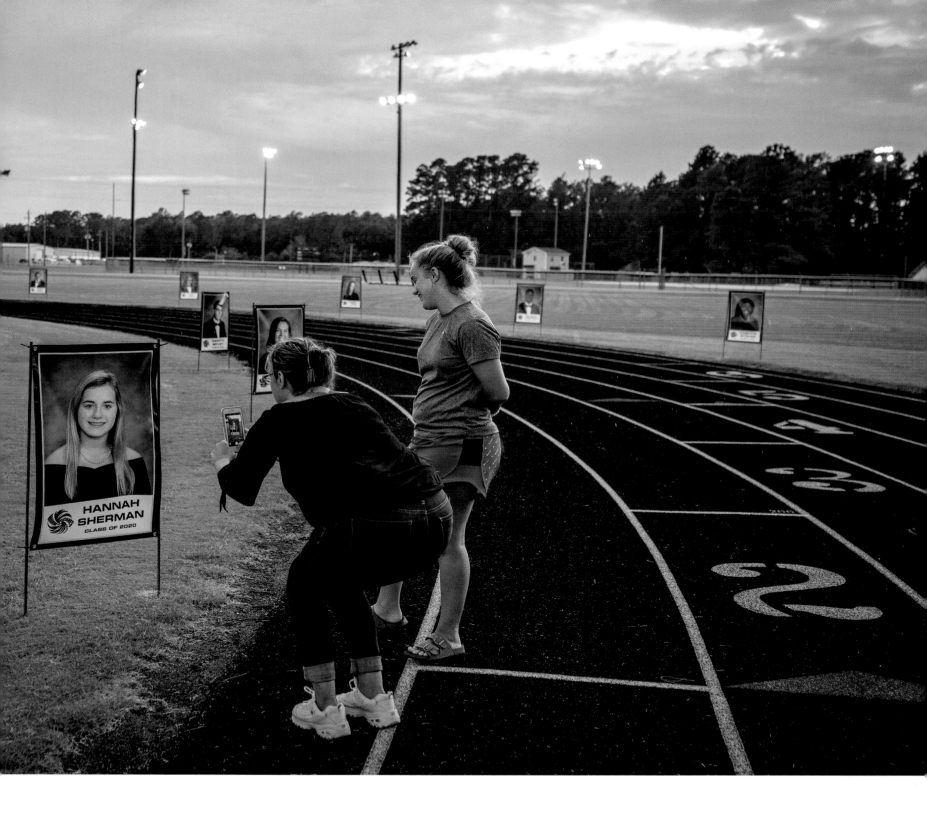

NATURAL EDUCATION

ANDREA FRAZZETTA | RAPALLO, ITALY | MAY 2021

Children from L'Albero Maestro ("the master tree"), a school based in nature, attend a lesson on the beach of San Michele di Pagana. The COVID-19 pandemic highlighted the need for new educational safe spaces and a rethinking of teaching methods. Outdoor schools allow children to spend their time in nature, accompanied by their educators. The process reduces stress, stimulates intellectual and health benefits, and reduces COVID-19 transmission.

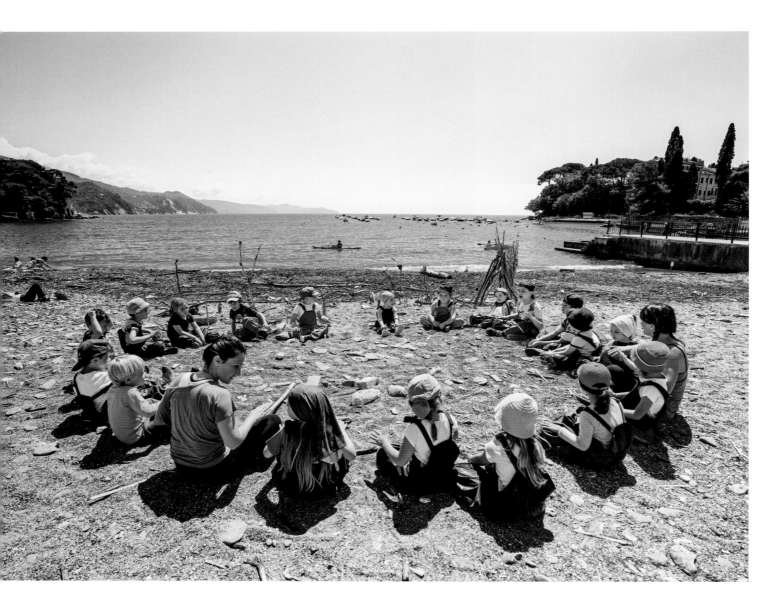

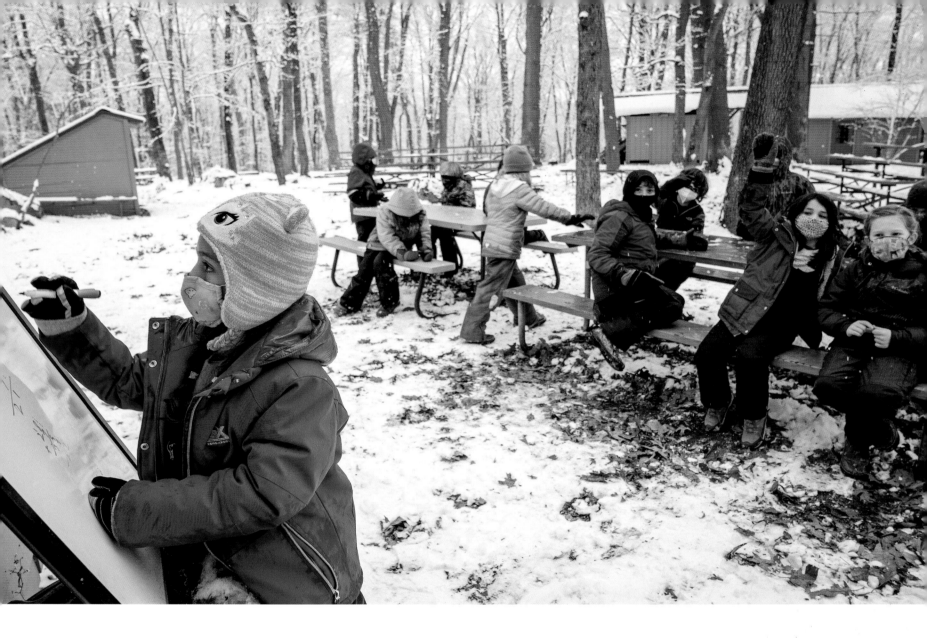

FINDING NEW EDUCATIONAL APPROACHES

JODI HILTON | MASSACHUSETTS, UNITED STATES | JANUARY 2021

Kyli Sierra, eight, works out a math problem at Home Base Learning Center, an experiential program that offers project-based learning, mainly outdoors, at the New England Base Camp. During the COVID-19 pandemic, frustration with the effects of online education on their children drove many parents to seek alternatives like Home Base, where enrollment tripled, then reached capacity. Meanwhile, public schools in the region sought to improve outdoor education facilities and programming to encourage teachers and students to spend more time outdoors, where the virus was less likely to spread.

BRIDGING THE EDUCATION GAP

AKOS STILLER | MULTIPLE LOCATIONS, HUNGARY | JANUARY 2021

Below: Marika learns to measure the human pulse as part of an online physical education course run by the Igazgyöngy Foundation. *Right:* Dominika Beri rides the 5:10 a.m. bus from Mezosas into the neighboring city of Debrecen to take her graduation exam. Beri attended the strongest high school in the county, which required three hours of daily commuting. Amid homeschooling during COVID-19, she used that time to study, but admitted that many highlights of her teenage years—friendships, prom, and graduation—had been taken away.

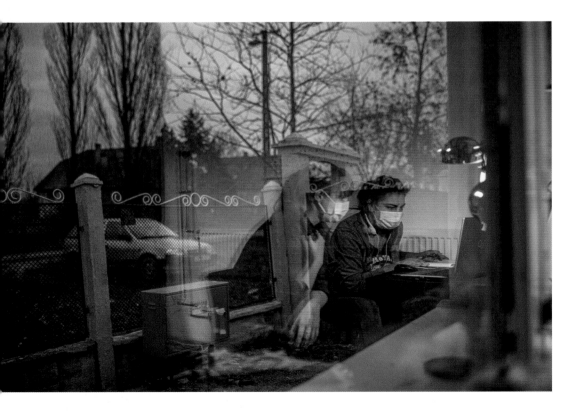

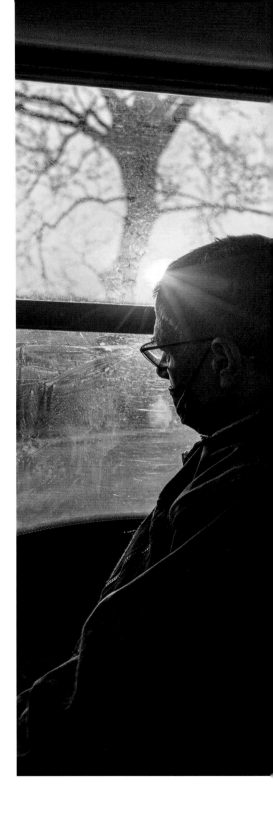

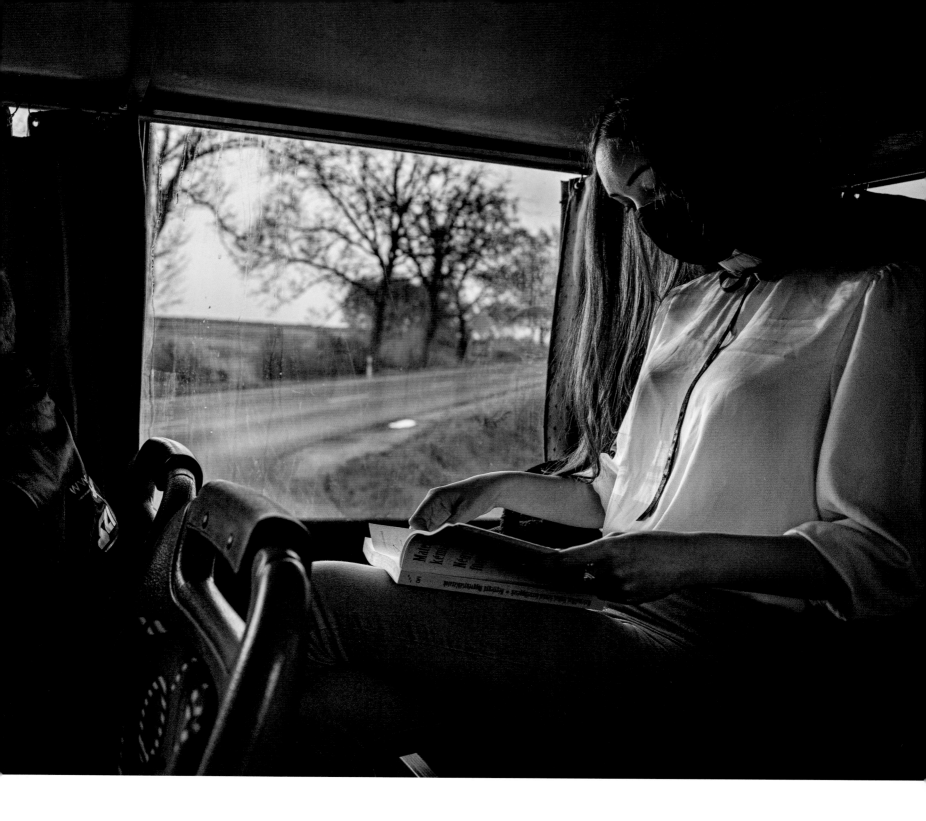

VIRUS OF FEAR

ANNA LIMINOWICZ
POZEZDRZE, WARMIAN-MASURIAN
VOIVODESHIP, POLAND | MARCH 2021

Joanna Soćko, headmistress of a
primary school in Pozezdrze,
peers out the window of an empty
classroom. Most of the students
in the school's upper grades
handed in blank papers for their
practice final exam—a reflection
of the futility they felt while
attending class entirely online
amid the COVID-19 pandemic.
None accepted the headmistress's
invitation to come to school to
see the correct answers. While
the school had hoped to have an
on-staff psychologist work with
the students through this difficult
period, there were no applicants
for the job.

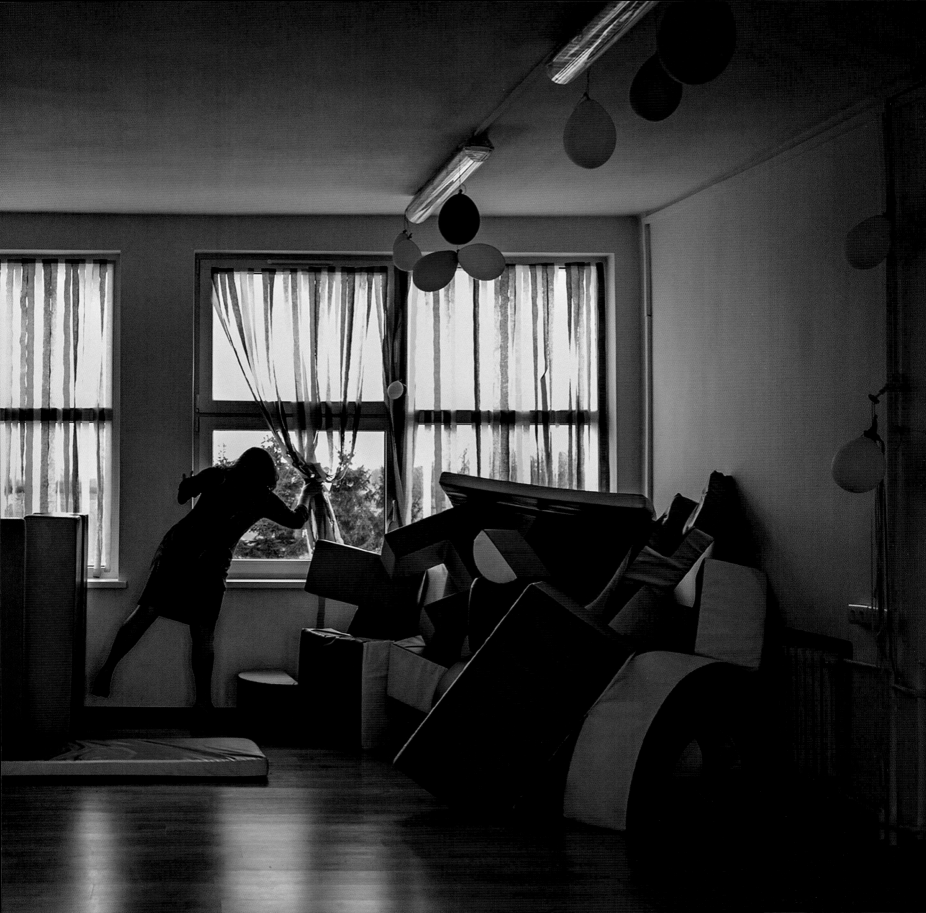

EXPLOIT

PROTECT

FINDING HARMONY. In the year 2020, the world went silent. Planes stopped buzzing overhead, cars stopped rumbling down the road, and quiet settled across the globe in a way that it hasn't since the industrial revolution began. The unprecedented pause in normal activity offered an unprecedented opportunity to reconsider the impact we're having on the natural world. Is there a better way for us to live that won't harm the planet? The projects in the pages that follow consider how the pandemic has encouraged us to appreciate nature and live in greater harmony with our environment.

EXPLOIT

Woramet Mali-Ngam bathes his elephant. As COVID-19 suddenly halted international travel, many of Thailand's mahouts (elephant caretakers, who are often marginalized ethnic minorities) were exploited by the tourist industry even as it formed their income stream. They migrated away from the country's tourist destinations and began the struggle to care for their families and their elephants. Amid the pandemic, Woramet's elephant was transformed from a valuable asset to an additional burden.

JITTRAPON KAICOME
SURIN PROVINCE, THAILAND | NOVEMBER 2020

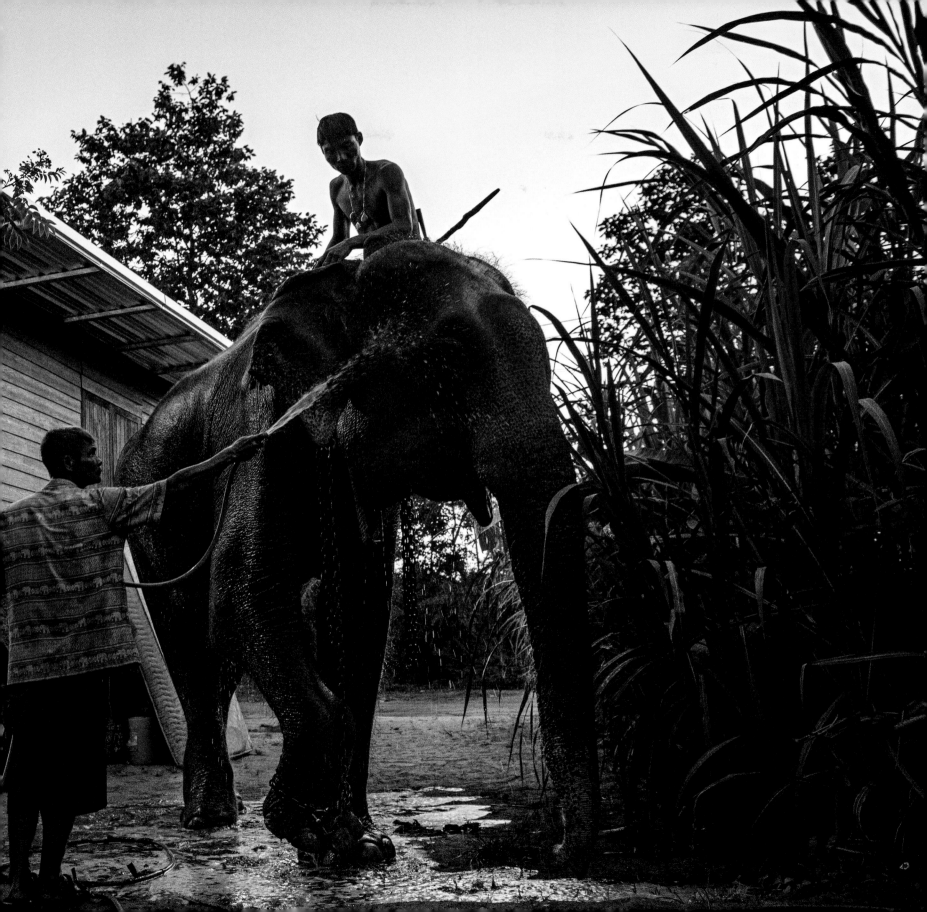

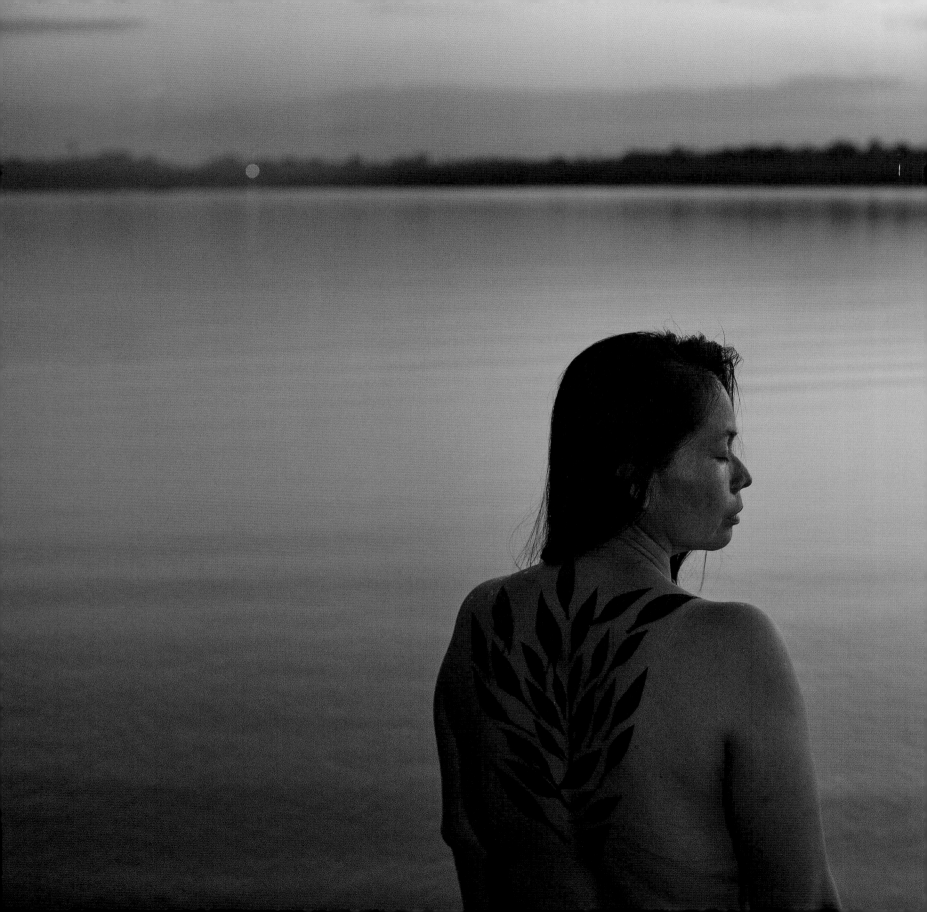

PROTECT

Celinda Cahuaza, 41, a healer in the Shipibo-Conibo Indigenous community, stands on the shores of Lake Yarinacocha in Peru. *Yuna rao* leaves, used to treat the COVID-19 symptoms that threatened her life, are applied to her body. Faced with poverty and a lack of access to basic services, some members of the Shipibo-

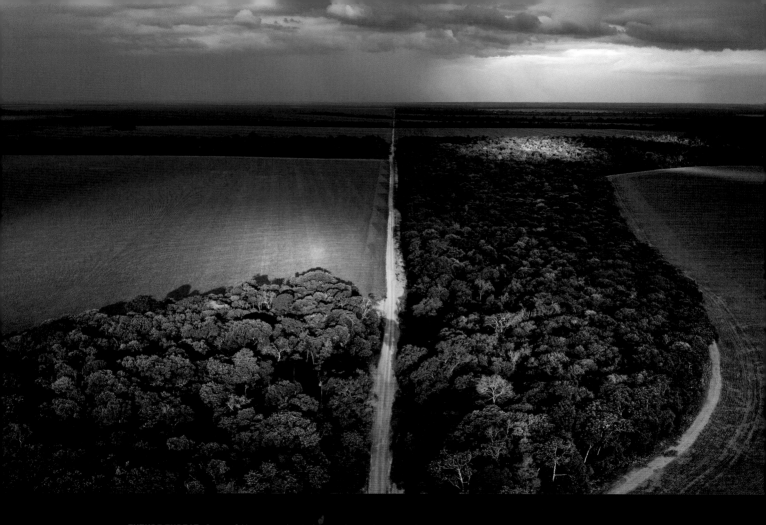

FUTURE THREAT: One of the country's largest producers of soybeans and cattle, the Brazilian state of Mato Grosso is also leading the deforestation of the Amazon rainforest. Intensification of industrial farming in Brazil is fueling its alarming loss of biodiversity, which may be a contributing factor for the emergence of new zoonotic diseases and endemic outbreaks.

ESSAY

PRESERVING THE NATURAL BALANCE

BY NOEL KOK

Noel Kok is a filmmaker based in Durban, South Africa. His Emergency Fund grant supported "Beyond the Headlines," a short film produced as a rallying cry to support a town whose economy and existence were severely impacted by the pandemic.

Folklore has it that as whales swim up the east coast of Africa and pass the rivers that flow into the ocean, they beach themselves as a gift to a community that has best preserved those rivers. As Africans, we have never hunted these animals, though we do eat them when they wash ashore.

In March 2020 five French tourists were on holiday in Kruger National Park; one of the men, experiencing suspicious symptoms, took a COVID-19 test. But instead of waiting for the results, the group continued their holiday. Alarmingly, the man's test returned positive.

The group had made their way to St. Lucia, located in the iSimangaliso Wetland Park; the town's existence and economy rely primarily on wildlife tourism. All five travelers were now positive, and the authorities were hard-pressed to engage in meaningful contact tracing. Just as South Africa entered one of the strictest lockdowns in the world, the small town became exposed to the virus.

Three months later, the annual humpback whale migration from the Antarctic up the east coast of Africa was about to reach St. Lucia. With quarantine still in effect, the town remained shut; some newspaper headlines even proclaimed that its citizens had died of COVID-19.

These same resilient people had rejected the lure of mining and its rapid, yet short-lived, economic benefits. They chose instead to preserve their natural heritage, basing their future on the promise that the whales would return each year. For them to crumple under the weight of this pandemic was hard to imagine.

But the whales did return, reinforcing the legend that the gift of life and the promise of tomorrow belong to those who take care of our planet.

The tourists who visited our country and brought disease with them may have upended the natural balance, including the community's own health and the ecosystems they visited. But we as a nation were able to face this challenge and survive by remembering that when we do not overtax its resources, Earth will always provide.

LEADING WITH
SELF-SUFFICIENCY

REHAB ELDALIL
ST. CATHERINE, SOUTH SINAI, EGYPT
OCTOBER 2020

Seliman uses a leaf of the khodary plant as a mock face mask in his garden. He and his family manage an ecolodge in Egypt's Gharba Valley; amid the COVID-19 pandemic, fewer and fewer guests came to stay, leading the family to redirect their focus to the garden. The Bedouin community, which depends on tourism for 80 percent of its income, experienced a poor economy and high rates of joblessness as the pandemic shut down international travel. Like Seliman, many turned to citizen-led solutions—including traditional desert farming practices and subsistence gardens—to survive.

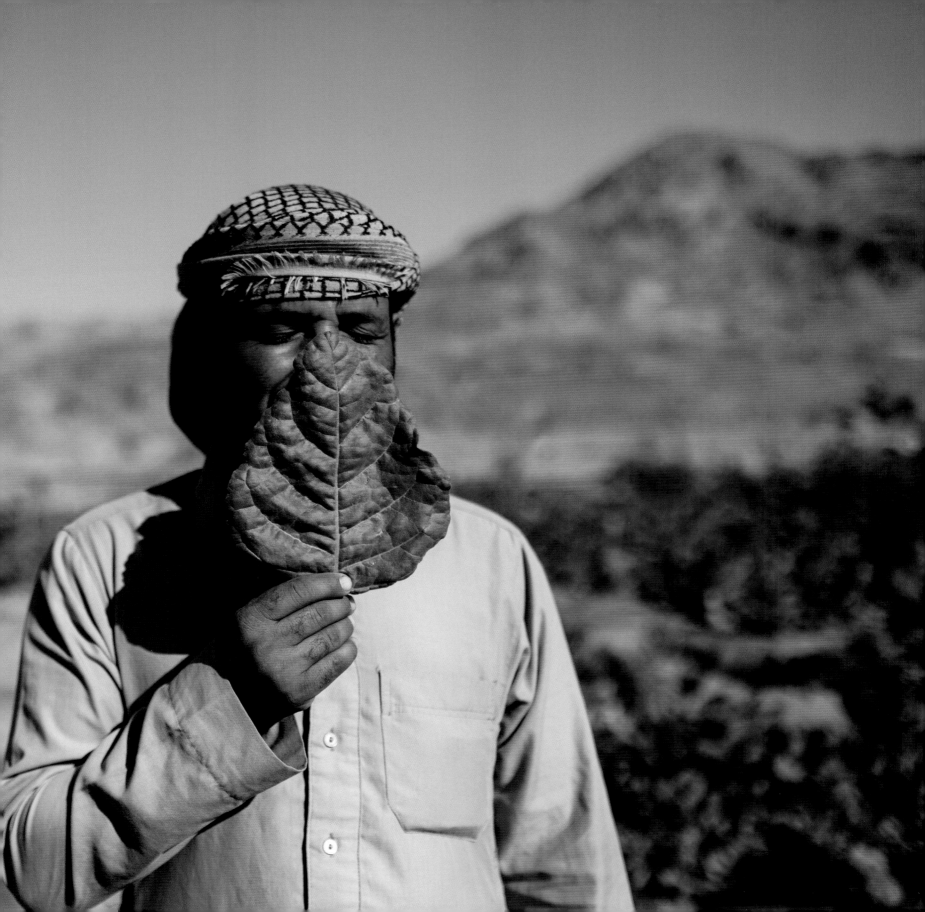

A RETURN TO TRADITION

RAFAEL VILELA | SÃO PAULO, BRAZIL | MARCH-JUNE 2020

Below: Manuela Vidal, an Indigenous Mbyá Guaraní child, takes in a deforested area in Guaraní territory that was burned during a fire of unknown origin. *Right:* A member of Brazil's Mbyá Guaraní Indigenous community joins a demonstration in downtown São Paulo to protest new construction planned on their ancestral lands.

During the COVID-19 pandemic, the Mbyá Guaraní strove to maintain their language, traditions, and culture—traditionally kept by elders, who were most threatened by the virus—while living on the encroaching edges of one of the Americas' largest metropolises.

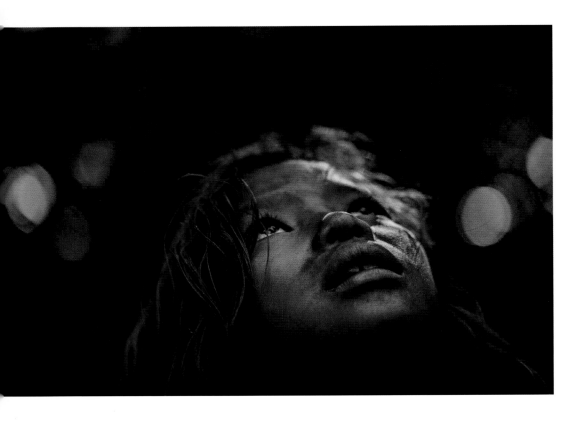

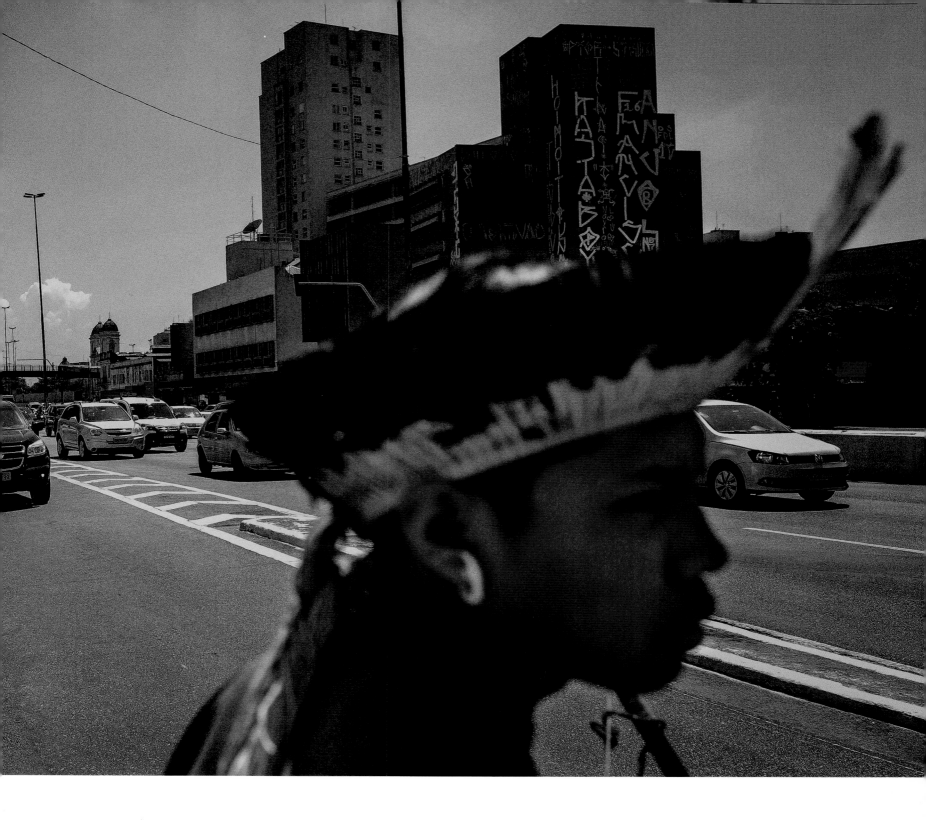

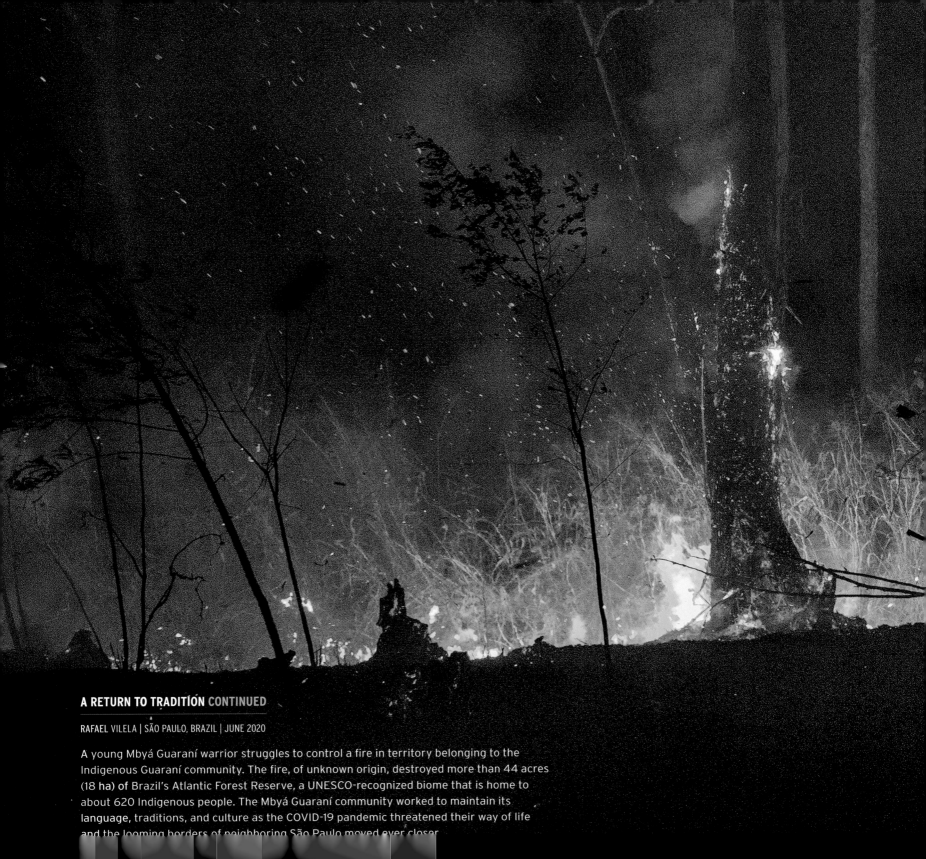

A RETURN TO TRADITION CONTINUED

RAFAEL VILELA | SÃO PAULO, BRAZIL | JUNE 2020

A young Mbyá Guaraní warrior struggles to control a fire in territory belonging to the Indigenous Guaraní community. The fire, of unknown origin, destroyed more than 44 acres (18 ha) of Brazil's Atlantic Forest Reserve, a UNESCO-recognized biome that is home to about 620 Indigenous people. The Mbyá Guaraní community worked to maintain its language, traditions, and culture as the COVID-19 pandemic threatened their way of life and the looming borders of neighboring São Paulo moved ever closer.

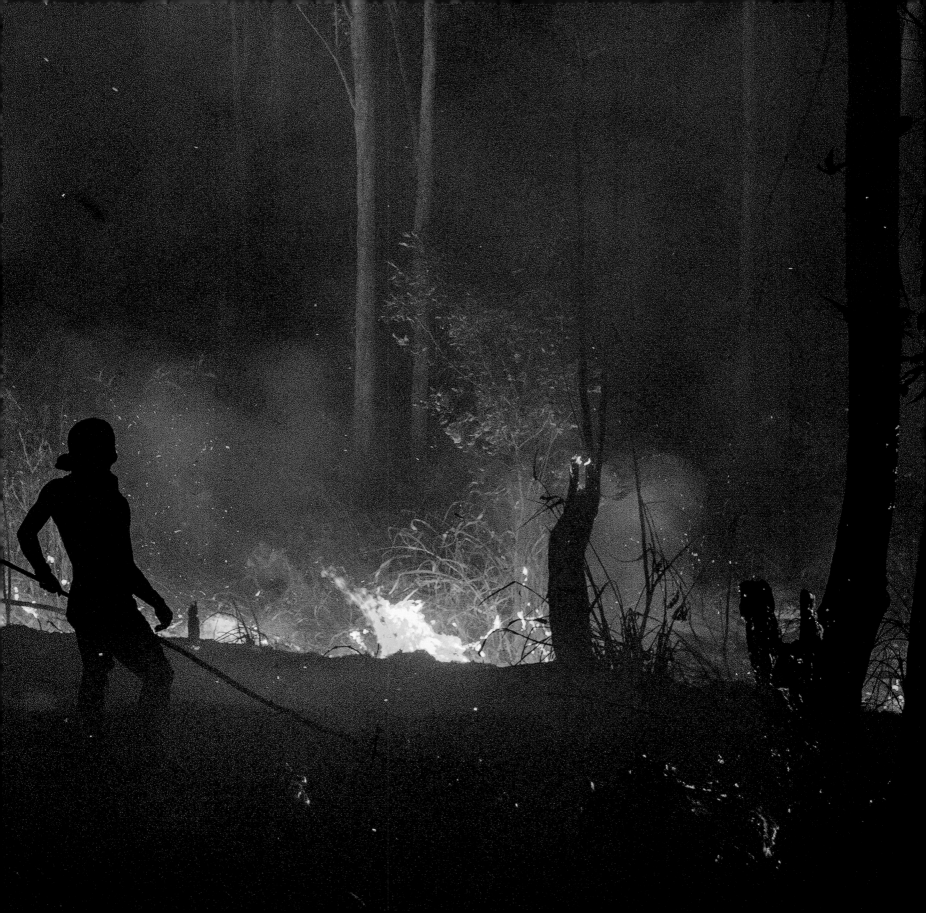

RURAL INDUSTRIES DISRUPTED

AITOR LARA | MULTIPLE LOCATIONS, SPAIN | MAY 2020–APRIL 2021

Below: The biologist Plácido Rodríguez feeds baby Eurasian nuthatches (*Sitta europaea*) at the Cañada de los Pájaros, a conservation center for endangered species and the restoration of Spain's Guadalquivir Marshes. The center, which finances itself through public visits, lost considerable revenue during the COVID-19 pandemic. *Right:* Sergio Cruz simulates the movements of a bull in a training session with bullfighter Lea Vicens (not pictured).

In Spain, rural industries, including agriculture and livestock, were severely impacted by the pandemic. To maintain her business, Vicens was forced to open her farm to tourism, inviting visitors to experience bullfighting training.

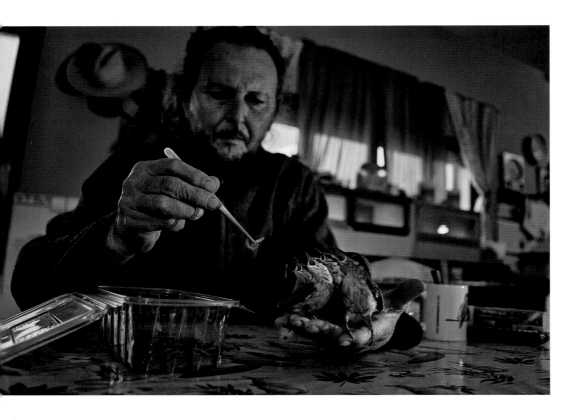

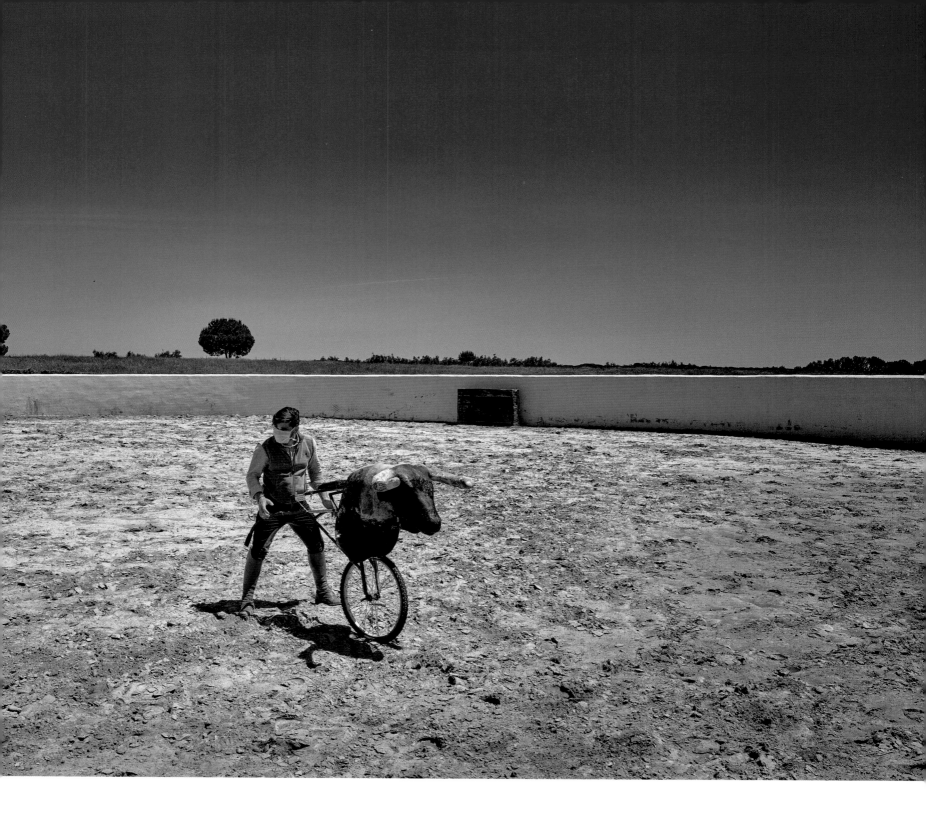

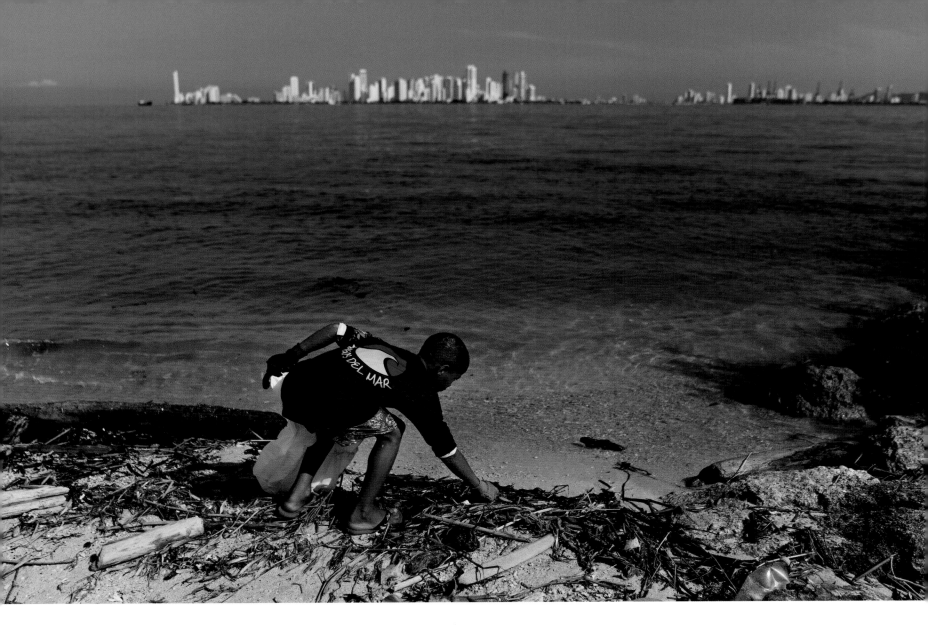

MEDICAL WASTE PILES UP

CHARLIE CORDERO | MULTIPLE LOCATIONS, COLOMBIA | OCTOBER 2020

Left: Esleider Córdoba Moncaris, 12, collects reusable materials to sell to social enterprise Olas Paz, as well as disposable masks and gloves, during a beach-cleaning day in Punta Arena, Colombia. *Right:* Carlos, part of the association of recyclers known as Puerta de Oro, shows the disposable masks that he has collected on his recycling route. One of his biggest fears is catching COVID-19 from the face masks that he finds going through garbage for recyclable material.

Disposable masks and gloves help limit the spread of COVID-19 but often end up polluting the environment.

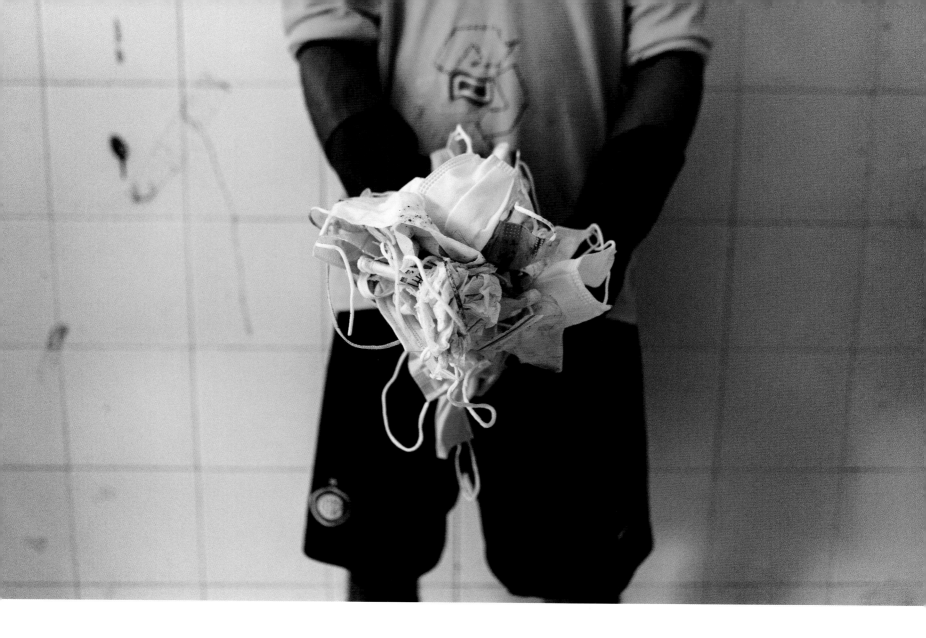

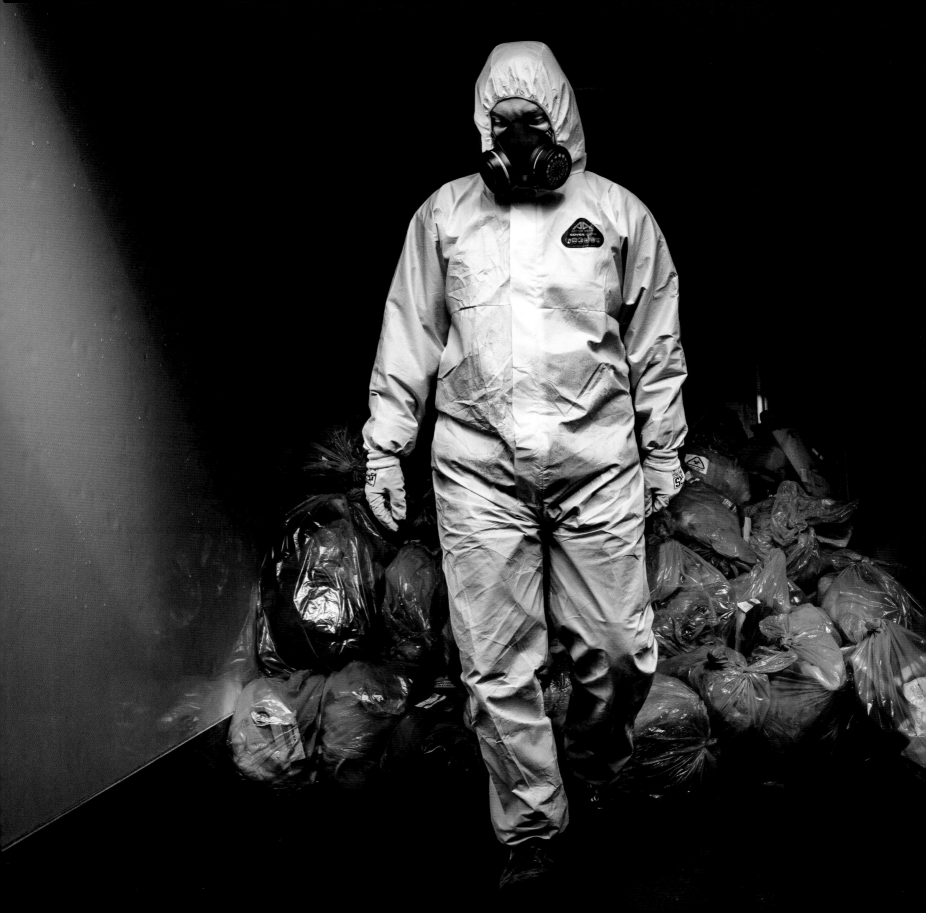

HANDLING COVID TRASH

JAKUB RYBICKI | MULTIPLE LOCATIONS, POLAND | FEBRUARY-MARCH 2021

Left: Contaminated medical trash is taken from a hospital in Gdańsk, Poland, to be incinerated—part of the 500 tons (450 metric tons) that is disposed of each month in Gdańsk alone. The amount of this waste grew by at least 50 percent in 2020, due to COVID-19. *Above:* The outline of a disposable medical mask in freshly fallen snow is all that remains of this once vital piece of protective equipment.

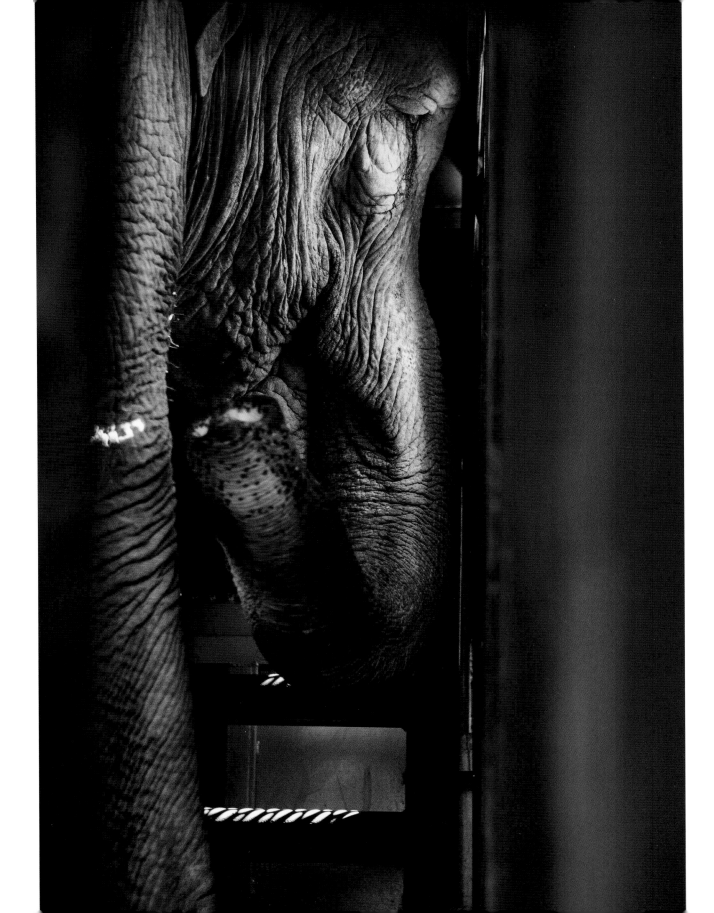

A PATH TO FREEDOM

SOFÍA LÓPEZ MAÑÁN
MULTIPLE LOCATIONS, ARGENTINA
MAY 2020

Left: Mara looks curiously out of her transfer box at a roadside gas station, which was closed amid the COVID-19 pandemic. *Top right:* Argentine national police officers guard Mara's transfer box at the Iguazú international border crossing. *Bottom right:* Finally free, Mara walks through Elephant Sanctuary Brazil.

As the world locked down in quarantine, Mara, a 55-year-old Asian elephant, began her long-awaited journey to semi-freedom. She was transferred from the former zoo of Buenos Aires to a sanctuary in the Brazilian state of Mato Grosso that is much more similar to her natural habitat. Stay-at-home orders, international border closings, and the danger of working in close proximity to others made Mara's journey both urgent and risky.

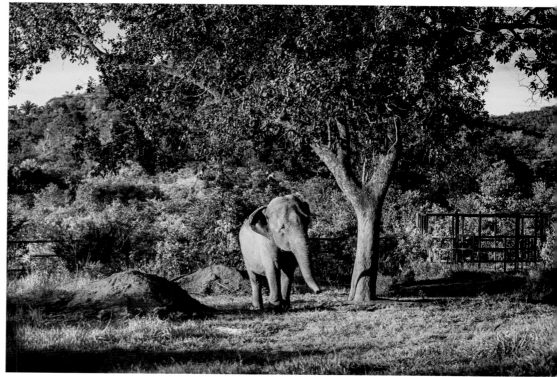

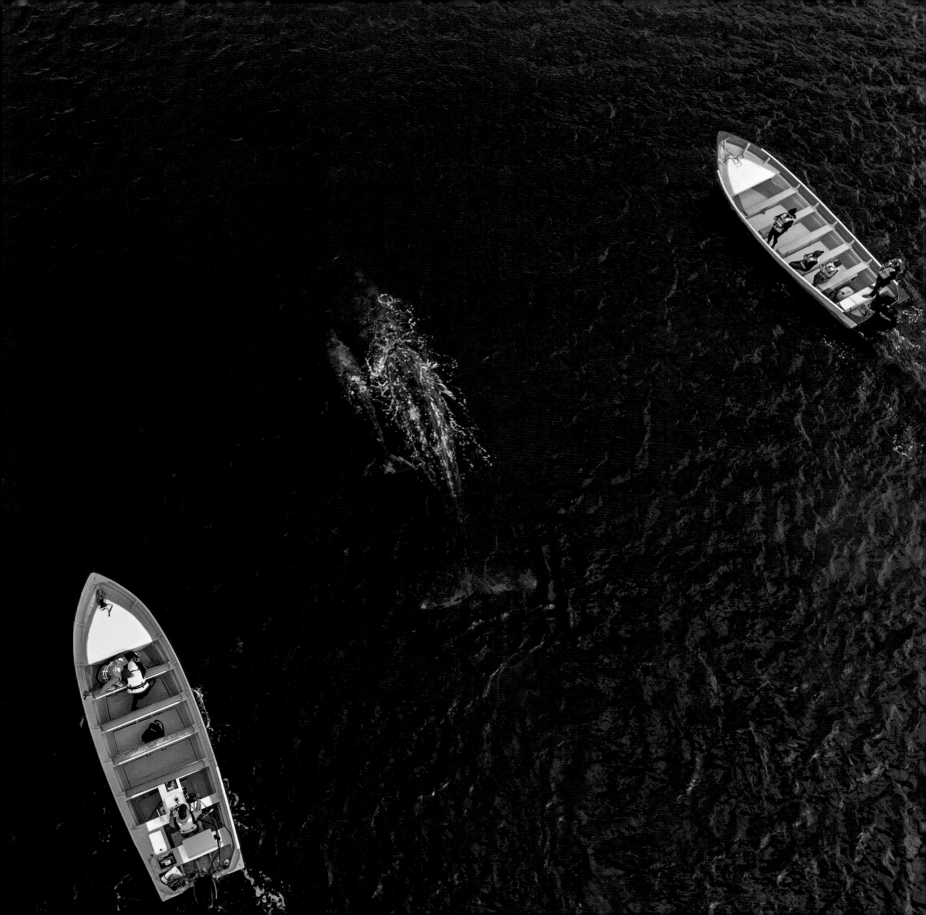

THREATS TO ECOTOURISM

MEGHAN DHALIWAL | BAJA CALIFORNIA SUR, MEXICO | JANUARY–FEBRUARY 2021

Left: A female gray whale and her days-old calf swim through Bahía Magdalena while two boats carrying captains and precious few tourists cruise alongside the pair. *Below:* Whale-watching guide Fernando Rojas Rodriguez stands in an empty plaza with hopes of spotting arriving tourists.

Prior to the COVID-19 pandemic, the arrival of the gray whales turned the sleepy port town of Adolfo López Mateos, on Mexico's Baja Peninsula, into a thriving ecotourism destination.

THE NECESSITY OF TRADITIONAL TREATMENTS

FLORENCE GOUPIL | MULTIPLE LOCATIONS, PERU | APRIL–JULY 2020

Below: Boains leaves (*Petiveria alliacea*) are applied to Juan Alcides Clemente, a member of Peru's Shipibo-Conibo Indigenous community, to treat his active case of COVID-19. *Right:* Rusber Rucoba, a fellow member of the Shipibo-Conibo community, lies among leaves of the matico herb (*Piper aduncum*), used to treat respiratory problems.

Throughout the COVID-19 pandemic, Shipibo-Conibo communities had extremely limited access to health care and government services, leading them to rely on traditional remedies and medicinal plants.

Behind the story: Photographer Florence Goupil reported that according to Shipibo-Conibo tradition, each plant of the Amazon has a deity or spirit that acts as a doctor, protecting humanity. Matico, called Roca-roca Noi Rao *in the Shipibo-Conibo language, was used to treat the symptoms of COVID-19.*

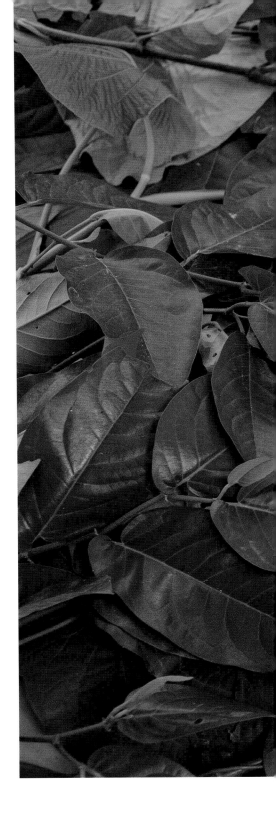

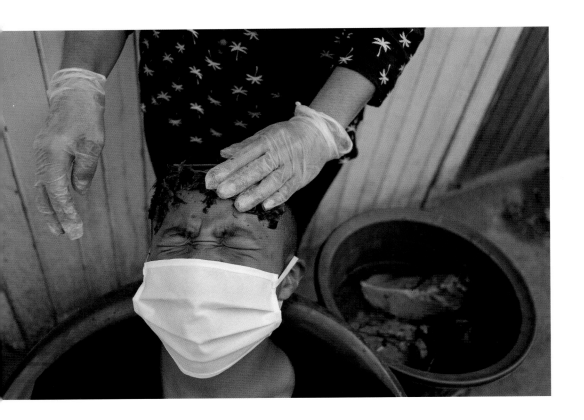

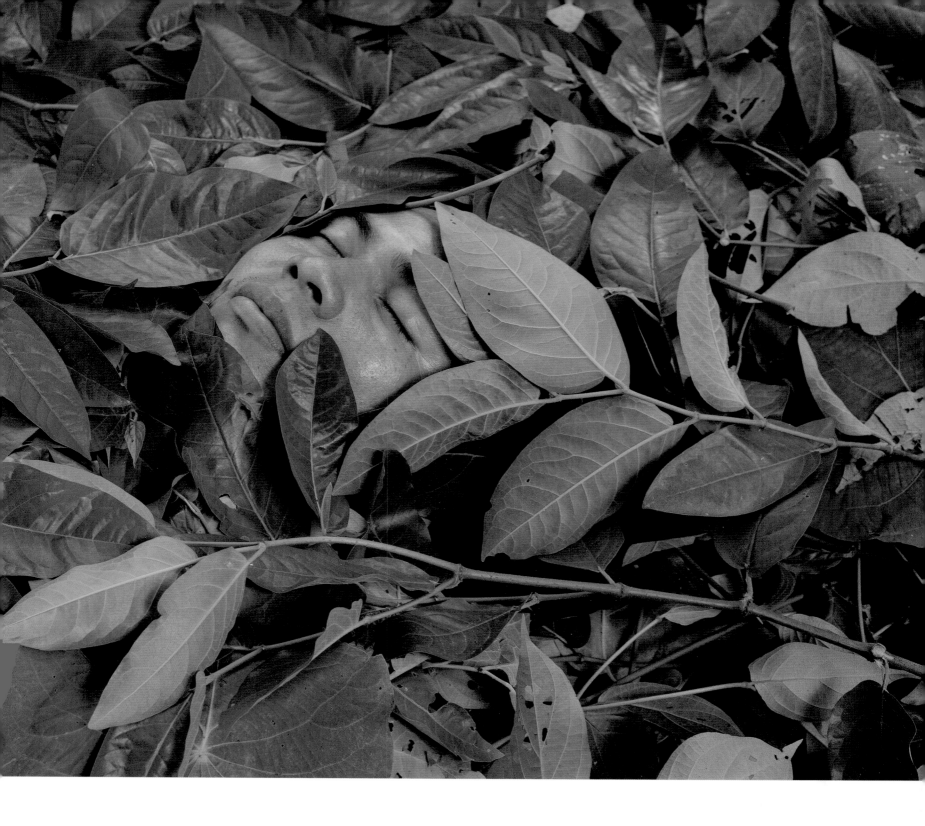

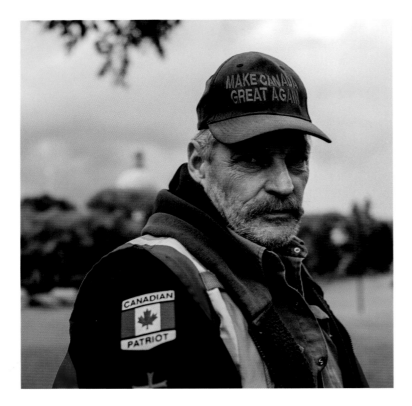

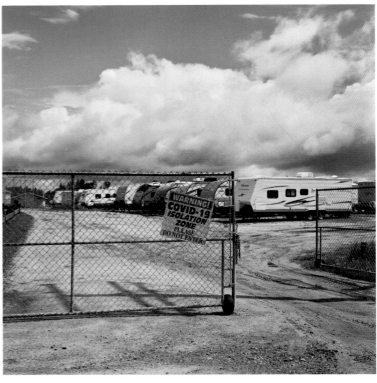

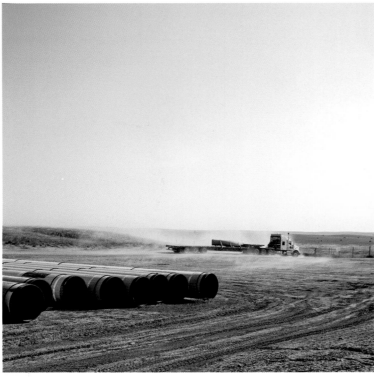

EXTRACTIVE INDUSTRY
CONTINUES AMID COVID-19

AMBER BRACKEN, LAURENCE BUTET-ROCH, AND SARA HYLTON
MULTIPLE LOCATIONS, CANADA | JULY–SEPTEMBER 2020

Above left: Kevin Peters, a member of the pro-energy Yellow Vest movement, attends an unmasked Canada Day celebration. *Above right:* A COVID-19 isolation unit in La Loche, an Indigenous Dene community, houses those suspected of infection, which can be traced back to a Kearl Lake oil-sands work camp. *Bottom left:* A truck loaded with pipe leaves a Keystone XL pipe yard. *Right:* Edward Dennis, 71, observes a parallel between COVID-19 being carried by industrial workers and diseases brought by colonizers to Indigenous people in the past.

Amid the COVID-19 pandemic, the Canadian government designated the expansion of energy infrastructure as essential, allowing the extractive industry to continue to operate—at the possible expense of public health and safety.

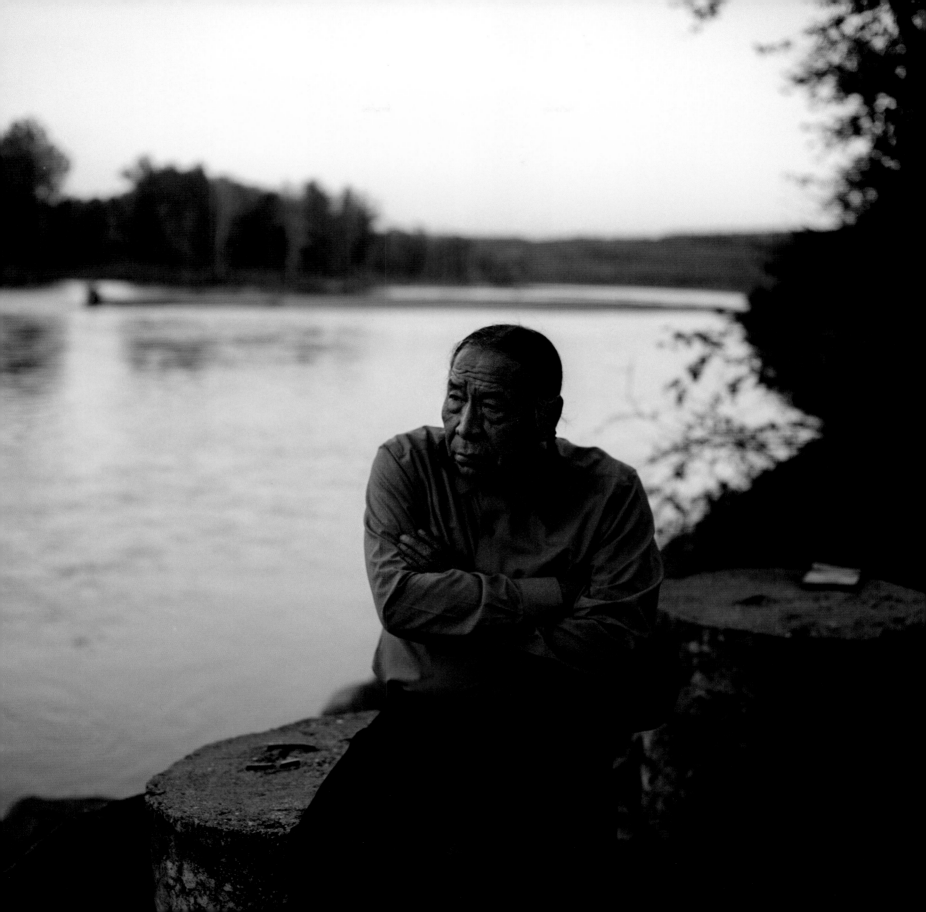

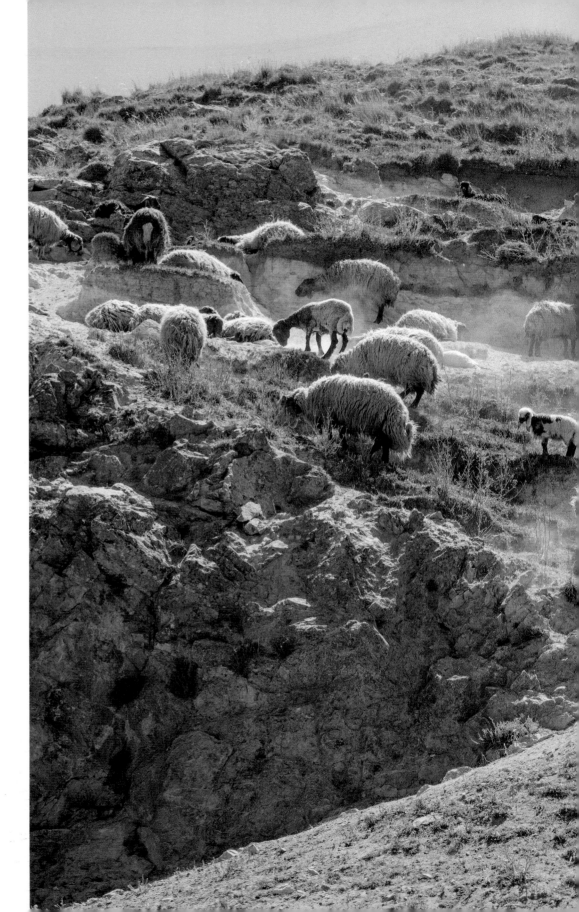

MIGRATION AMID
A LOCKDOWN

EMIN ÖZMEN | VAN, TURKEY | JUNE 2021

Siddik, 26, wrangles sheep for milking while on his community's annual movement of livestock, which involves crossing 300 miles (500 km) of mountainous terrain from Nusaybin to Van. As COVID-19 induced a worldwide standstill amid border closings, travel restrictions, and stay-at-home orders, Turkey's nomadic Kurdish community remained intrinsically tied to this movement to ensure their livestock's—and their own—survival. The group's income relies entirely on the milk, cheese, and meat produced from their animals; their unique cheese is known across Turkey as "nomad cheese."

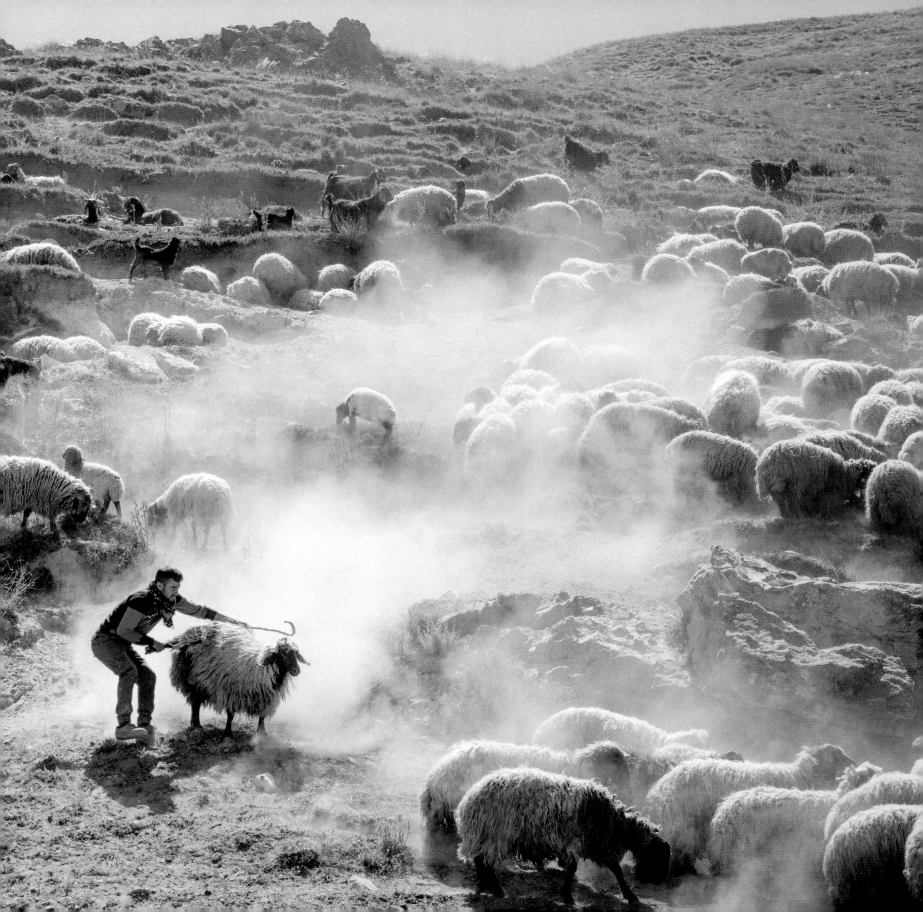

MIGRATION AMID A LOCKDOWN CONTINUED

EMIN ÖZMEN | VAN, TURKEY | JUNE 2021

Up with the first light of the sun, members of Turkey's nomadic Kurdish community take a few precious moments to start their day with breakfast. Traditionally, men milk their livestock while women transform the milk into the cheese appreciated by local buyers and renowned throughout the country. This community's livelihood remained dependent on movement throughout the COVID-19 pandemic, even as the rest of the world stayed at home.

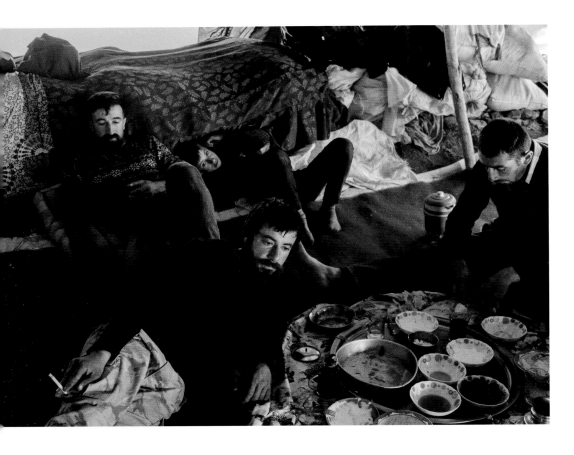

A RETURN TO NATURE

JORGE PANCHOAGA
TIERRADENTRO, COLOMBIA | MARCH 2021

Matilde Díaz, the spiritual authority of the Tumbichucue community of the Nasa Indigenous people, carries a backpack full of medicinal plants. In response to the COVID-19 pandemic, the Nasa people combined their botanical, medicinal, and spiritual knowledge to find the appropriate treatments for the virus. The Nasa view COVID-19 as a spiritual and corporeal imbalance that reflects the disconnection of people from nature. Their treatments focus on restoring balance by healing the body through the spirit.

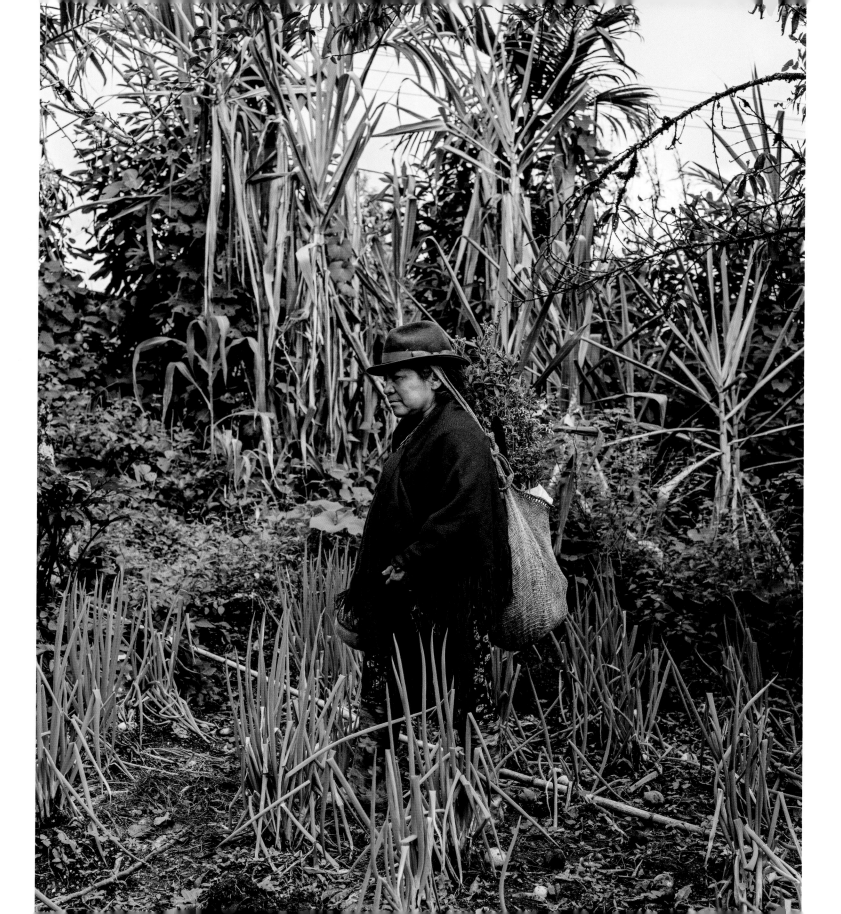

REFLECTION AND REDISCOVERY OF TRADITIONS

MARTIN SAN DIEGO
LAKE SEBU, PHILIPPINES | AUGUST 2021

Rhea Mindal, 18, laughs while posing in her T'boli dress on her family's farm during the 2021 harvest. Rhea was performing dances and songs for tourists for a few years prior to the COVID-19 pandemic. When her audience dissipated during the pandemic, her family suffered financially but embraced the opportunity to live off the land as their forebears did. For the Indigenous people of the Philippines, the COVID-19 pandemic presented financial challenges but also an opportunity to rediscover their fading roots and traditional practices amid the tourist void.

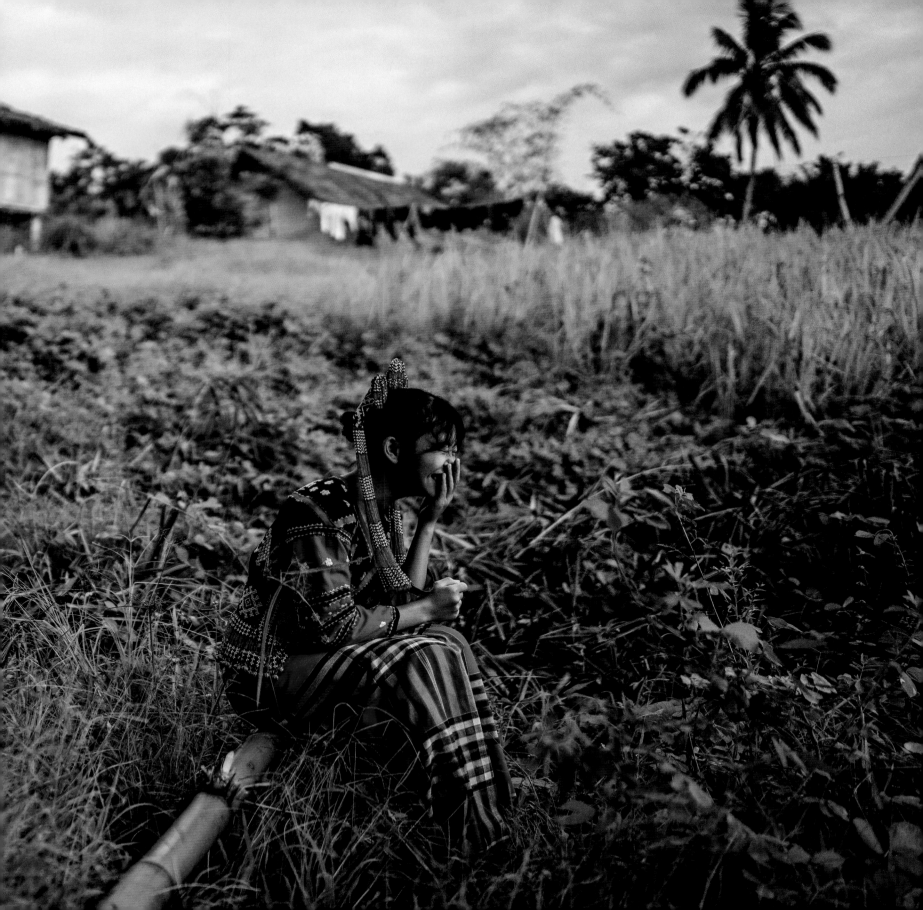

URBAN URBAN URBAN URBAN URBAN URBAN RURAL RURAL RURAL URBAN RURAL RURAL RURAL RURAL RURAL

WHERE THE HEART IS. Urban, rural, or somewhere in between, home is what matters most. But whether you bed down in a concrete jungle or in a real, tree-filled one, the coronavirus has upended aspects of all our lives. The specific disruptions we're facing are partially tied to the places we live, and the pandemic has had markedly different effects on life in urban and rural environments. The projects featured here shine a light on the challenges faced by residents in all communities.

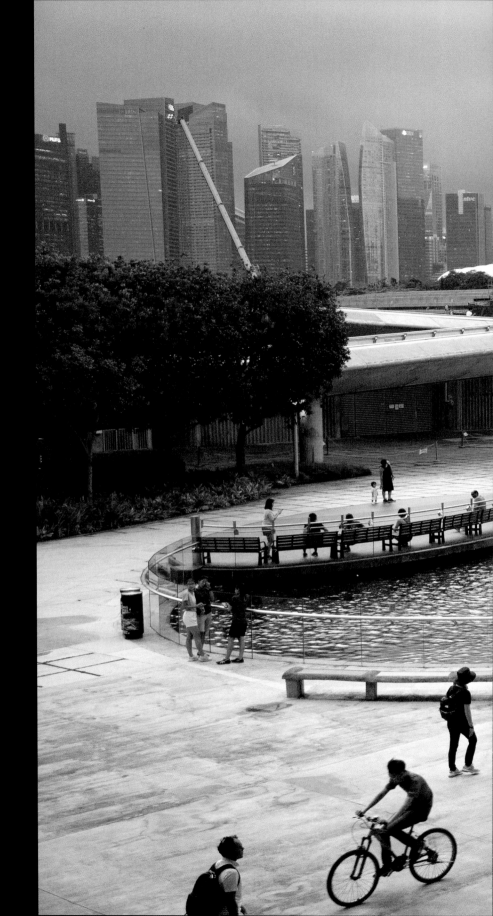

URBAN

People walk and bike through Singapore's Marina Barrage unmasked, just prior to the outset of COVID-19. In April 2020 Singapore began to see a spike in the number of confirmed cases.

ORE HUIYING | DOWNTOWN CORE, SINGAPORE
MARCH 2020

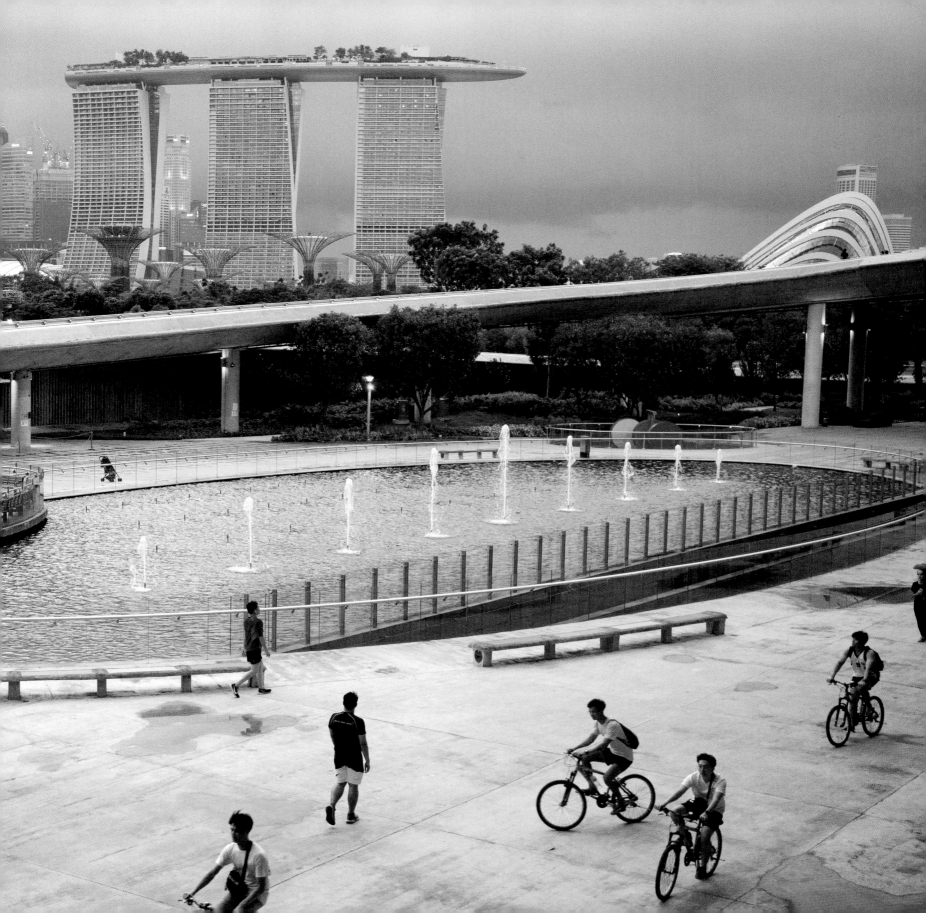

RURAL

Musician Beatriz Mendes (left), 26, records Celeste Pereira, 79, a farmer, poet, songwriter, and keeper of musical traditions in Portugal's rural northern interior. The region is home to ancient and unique cultural traditions that have been maintained through practice and oral traditions. Restrictions on social gatherings during the COVID-19 pandemic protected some of their last living practitioners but caused the cancellation of local festivals and events that kept the traditions alive.

VIOLETA SANTOS MOURA
TRÁS-OS-MONTES E ALTO DOURO, PORTUGAL
JANUARY 2021

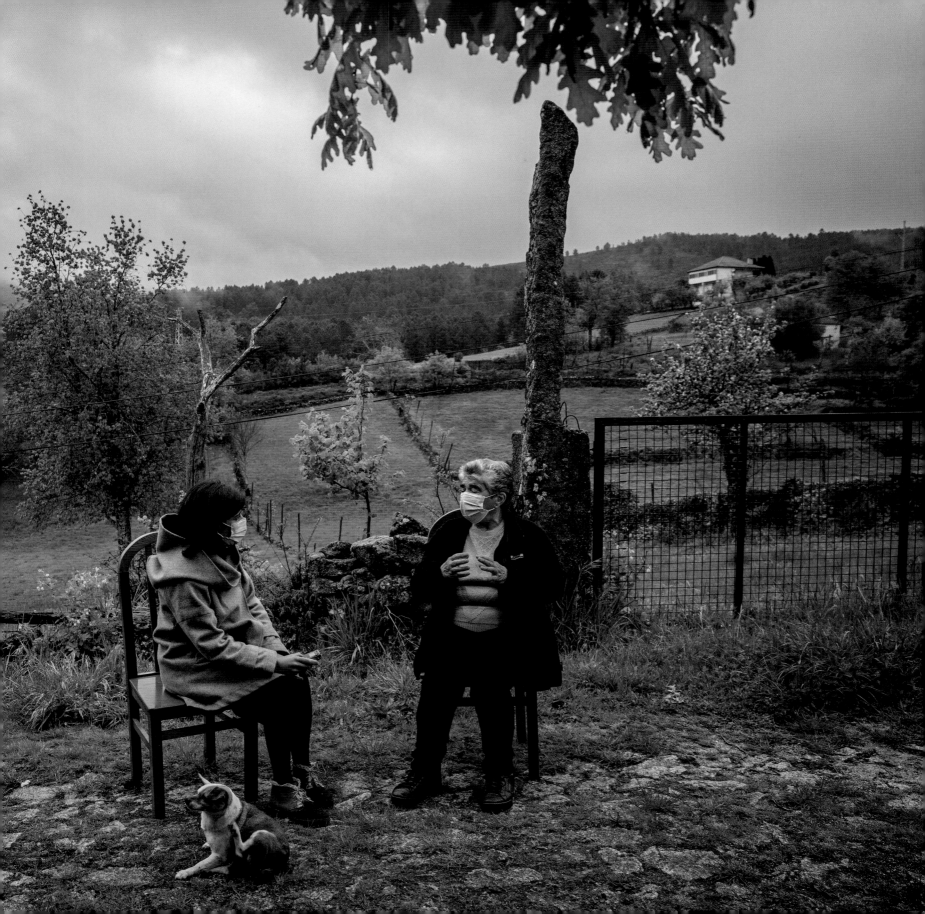

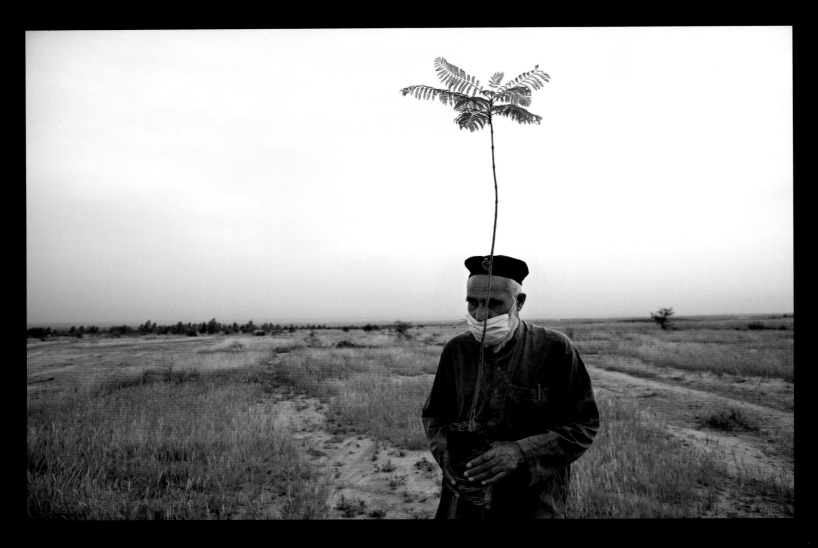

TREES OF HOPE: Adalat Khan holds a sapling in a field near Azakhel Mattani, Pakistan. Those recently unemployed in the wake of the COVID-19 pandemic have been hired by the government to plant trees to help address climate change.

SAIYNA BASHIR | AZAKHEL MATTANI, PAKISTAN | MAY 2020

ESSAY

QUIET HEROS

BY SAIYNA BASHIR

Saiyna Bashir is a photojournalist based in Islamabad, Pakistan. Her Emergency Fund-supported project covered the impact of COVID-19 on Pakistani workers.

The focus of my National Geographic Society-sponsored project was to bring to light the experiences of those who often go unheard. As I worked, I made sure not to put my subjects at risk of contracting the virus. I was also getting used to the new normal of the pandemic, including wearing a face mask during summer in Pakistan.

As of April 3, 2020, Pakistan was estimated to have lost 2.5 trillion rupees (U.S. $33 billion) as a result of the pandemic. Pakistanis who have suffered the harshest economic impact of the outbreak are primarily the country's daily wage earners and urban slum dwellers.

That same month, I met Arif Masih's family of seven; they were living in Islamabad in a slum filled mostly with Christian families. Arif was a daily wage laborer and the family's sole breadwinner; he had been out of work since the lockdown. I spent many evenings with them at a nearby park, observing their love and unity as they prepared meager meals.

One day I watched Arif's wife take back a piece of dried sweet toast, or rusk, from her youngest son, Yushwa; he had already eaten the one piece that he was allotted from that day's ration. I will never forget the tears in his eyes and the way that he went back to the jar and grabbed it, after she had put it back, because he was still hungry.

I also met Nusrat Bibi, a tailor by profession. During the outbreak, she began stitching face masks for Hashoo Foundation, a nonprofit organization that teaches vocational and entrepreneurial skills to women in impoverished areas.

To cover government-led efforts to support those out of work, I traveled to the outskirts of Peshawar, where laborers entered a plant nursery to start working on fresh saplings. The government had hired them as "jungle workers" in an initiative to plant 10 billion trees to deal with climate change threats in Pakistan.

The ability to survive during this pandemic without losing an income is a privilege. We must never forget those who are struggling yet remain resilient.

REFORESTING A NATION

SAIYNA BASHIR
AZAKHEL MATTANI, PAKISTAN | MAY 2020

So-called jungle workers tend to plants on the outskirts of Peshawar. Pakistan's government hired newly unemployed citizens during the COVID-19 pandemic to join this group, which is planting trees to alleviate the threats from climate change; the goal is to plant 10 billion.

In Pakistan, 45 percent of the country's 220 million people live in urban slums; the challenges that these communities previously faced were compounded amid restrictions on in-person work and the ever present threat of contracting the virus. Many families were forced to find innovative ways to adjust to life during the pandemic as they struggled to maintain their livelihoods.

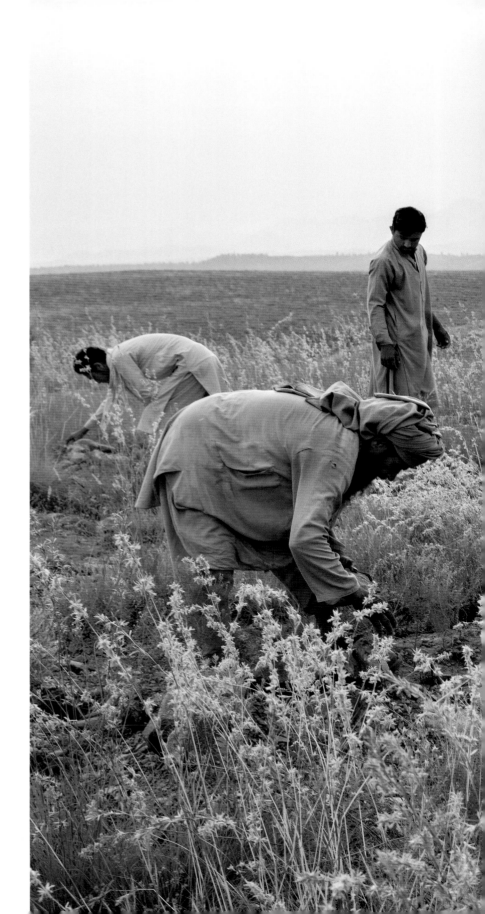

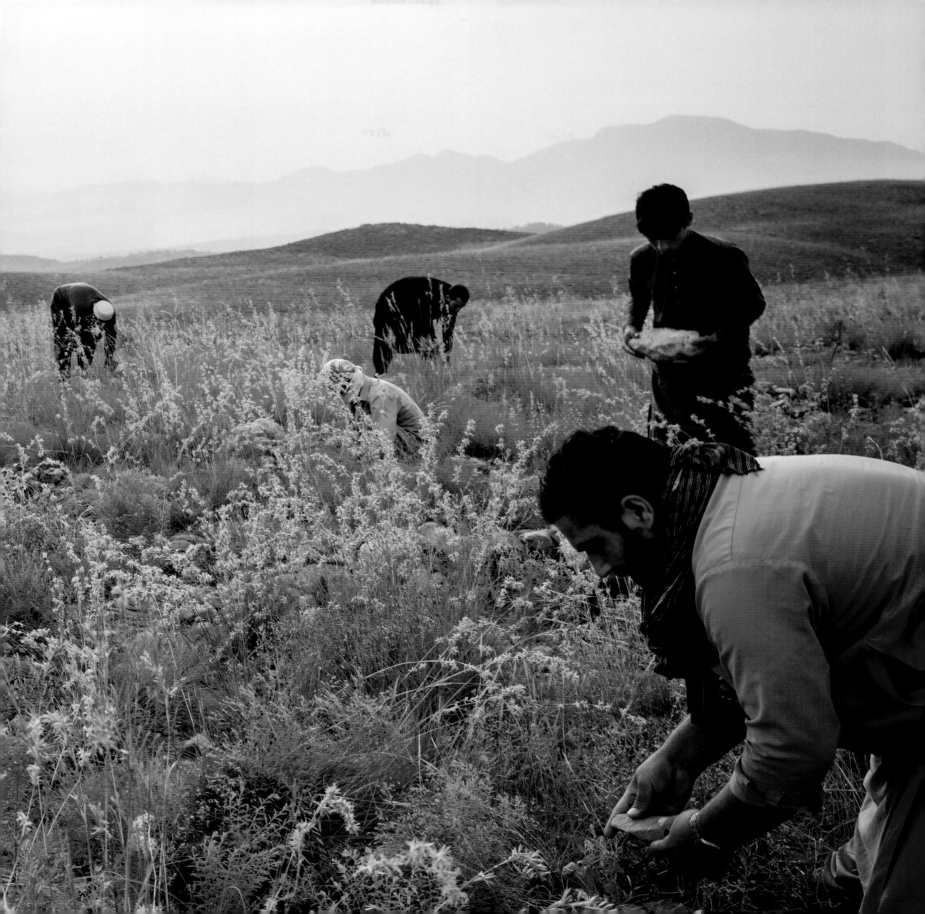

URBAN FARMING AIDS FOOD INSECURITY

MIORA RAJAONARY | JOHANNESBURG, SOUTH AFRICA | JUNE–JULY 2020

Below: Refiloe Molefe, one of Johannesburg's pioneers of urban farming, stands among crops at the Bertrams Inner City Farm cooperative. Although the COVID-19 pandemic impacted the cooperative financially, Molefe organized a weekly soup kitchen for Johannesburg's most vulnerable citizens. *Right:* Tim Abaa and fellow Ubuntu Project team members distribute parcels of fresh vegetables to residents of the informal settlement Esilahliwe. Throughout the pandemic, the initiative provided food sourced from local permaculture farms to vulnerable communities.

In South Africa, the pandemic led to a severe increase in food insecurity, highlighting urban farming as a potential sustainable solution.

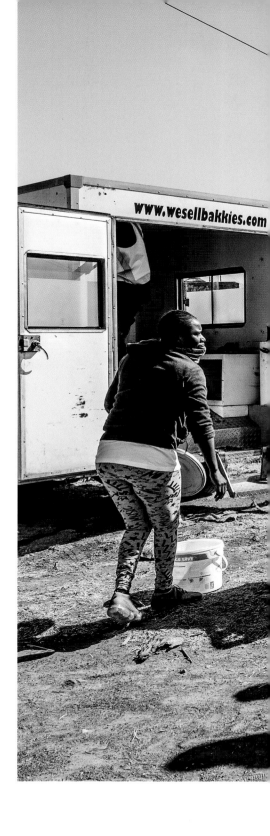

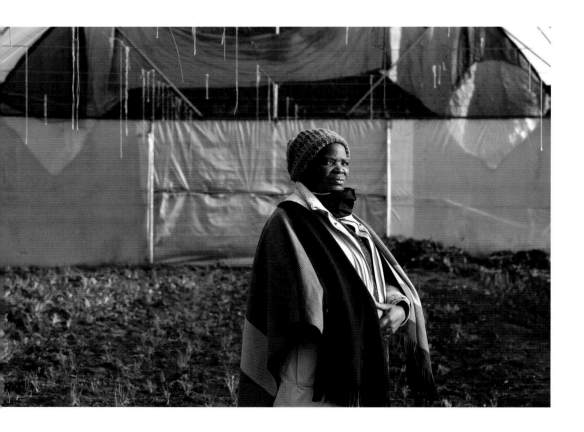

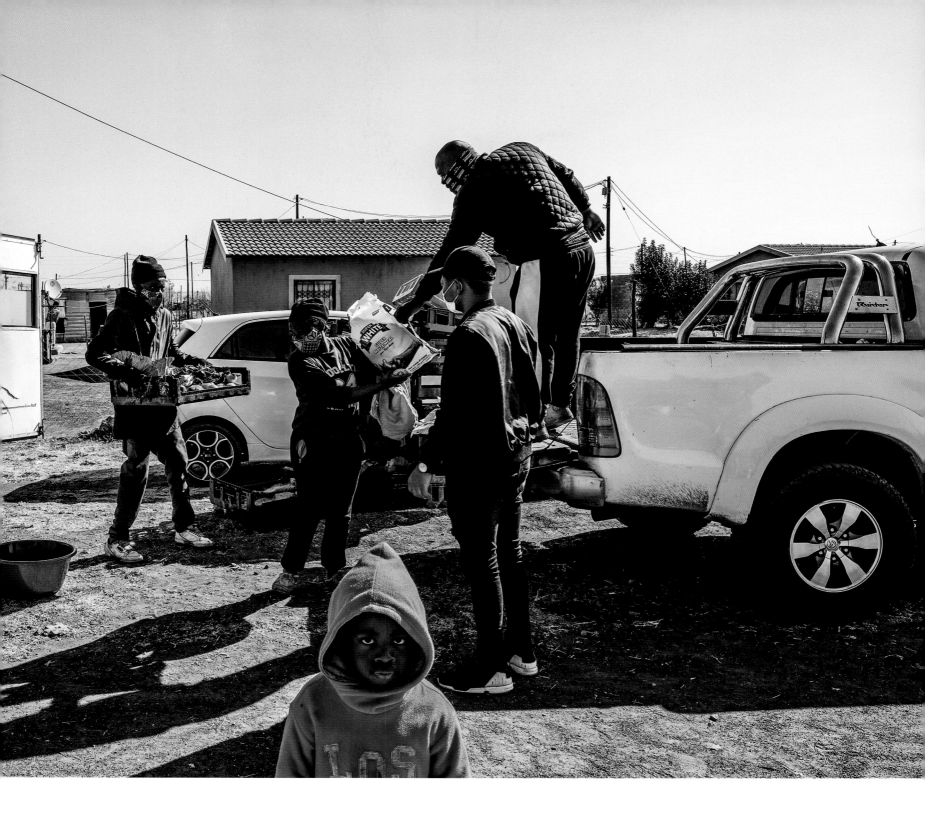

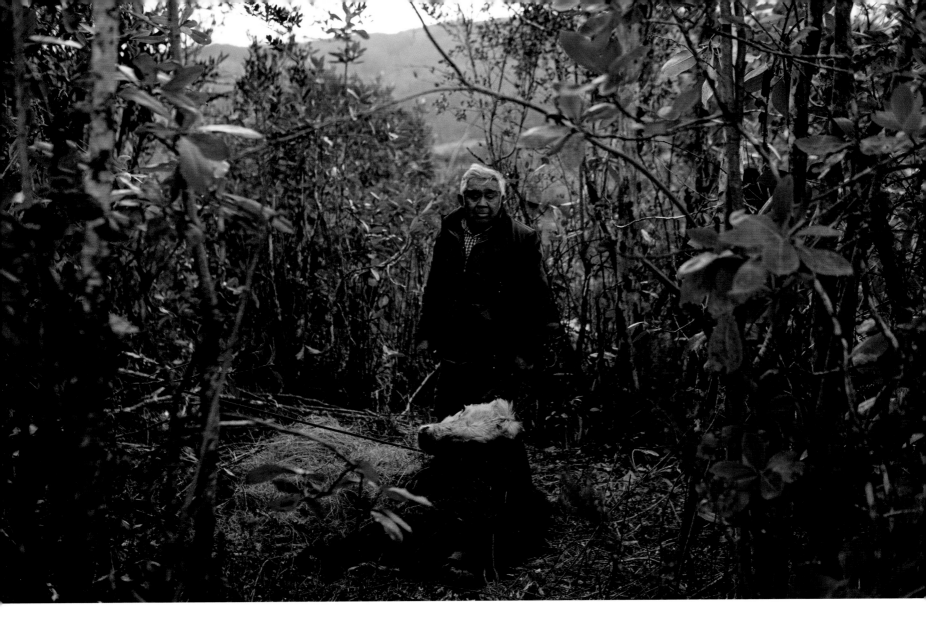

HEIGHTENED CHALLENGES FOR INDIGENOUS COMMUNITIES

NICOLÁS AMARO | ARAUCANÍA REGION, CHILE | SEPTEMBER–OCTOBER 2020

Above: Don Benedicto Wuankilen surrenders after a full day of struggling to free his cow from the mud. The flooding on his land is suspected to be exacerbated by the construction of a road that obstructed the flow of nearby rivers. *Right:* Francisca Calfin ceremonially welcomes the spring, part of her ancestral heritage as a member of the Mapuche Lafkenche Indigenous community.

During the COVID-19 pandemic, Indigenous people often faced heightened challenges, including a critical lack of government services and repressive enforcement of curfews.

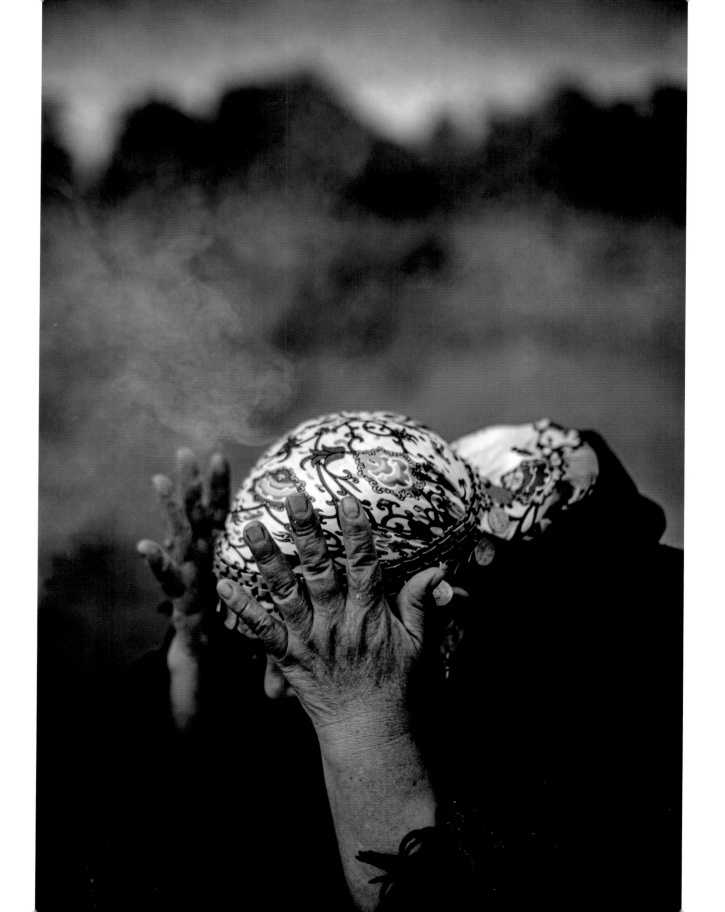

RECIPROCITY FOR SUSTENANCE

DINA COLECTIVO | CUENCA, ECUADOR | AUGUST-SEPTEMBER 2020

Below: Ruth Auquilla (right) barters a selection of vegetables from her garden for illustrated children's books by Gemma Rosas. *Right:* Joaquin and Esperanza, Ruth Auquilla's children, enjoy the illustrated stories by Gemma Rosas.

As the COVID-19 pandemic spurred economic crises for many families, Ruth, Gemma, and other members of their community found both the return to a barter system and Indigenous traditions of reciprocity to be effective ways of sustaining themselves.

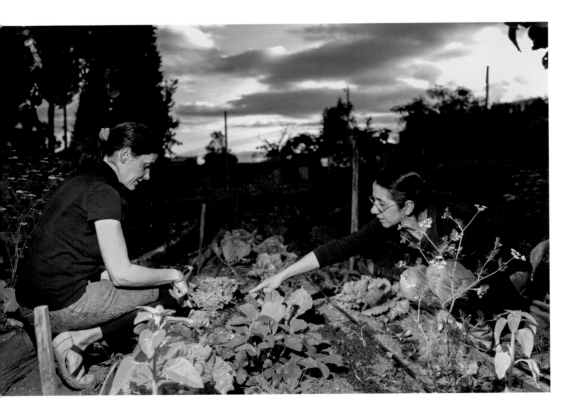

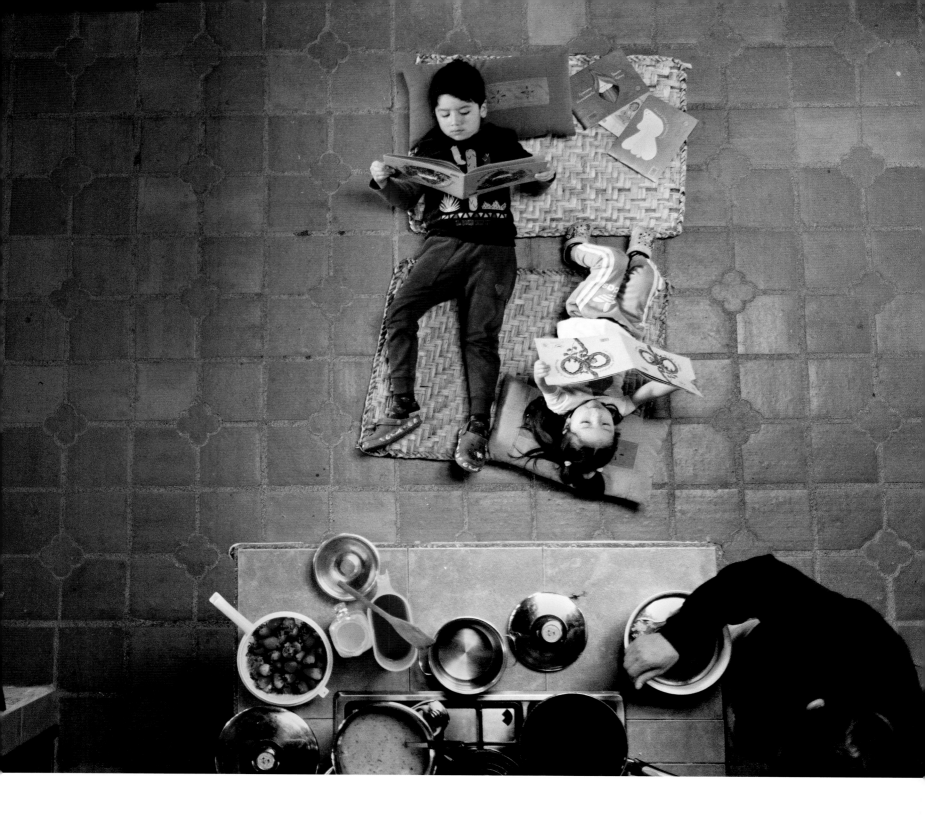

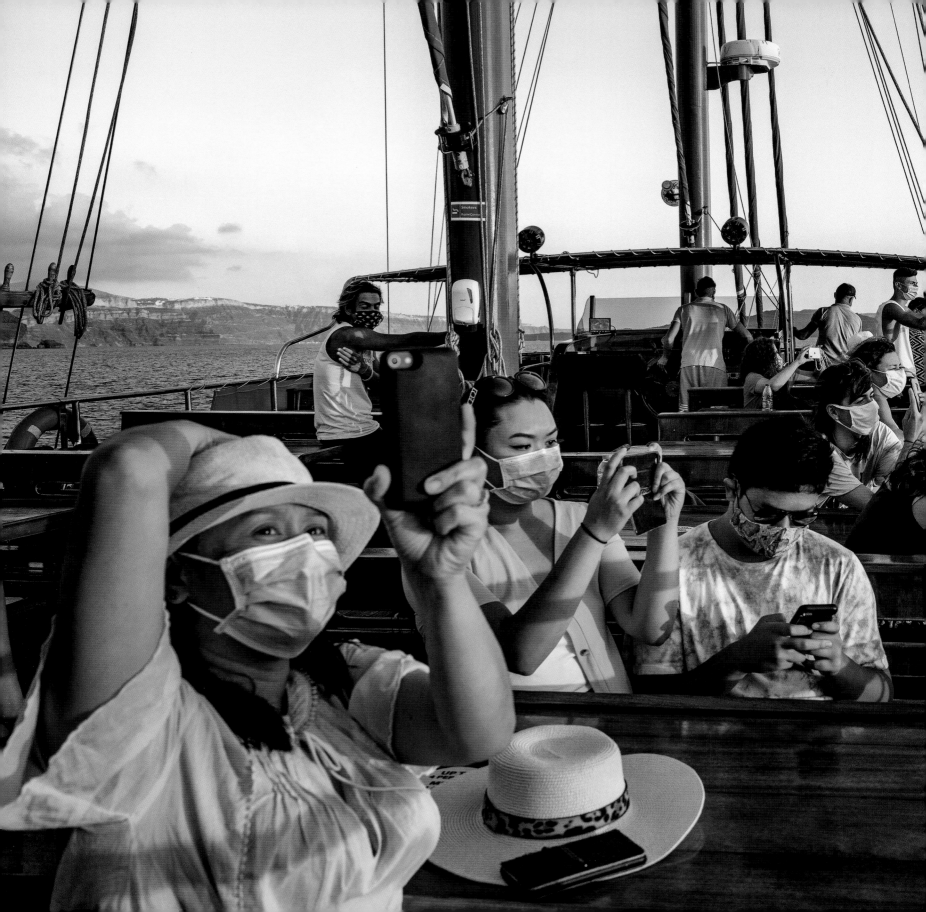

PRESERVING TOURISM AMID COVID-19

LOULOU D'AKI | SANTORINI, GREECE
AUGUST 2020

A sunset tour, sparsely filled with patrons, leaves Santorini's old port of Fira. Face masks were obligatory, passengers submitted to temperature checks, and each table was marked to indicate the maximum number of occupants. The 2020 tourist season in Santorini saw a 96 percent decline in overall ticket sales.

Greece entered the COVID-19 pandemic fresh from economic strife, including a recession, bailouts, and austerity measures. Given the country's heavy reliance on tourism, its economy was projected to contract even further, forcing Greek authorities to find the right balance between public health and a functioning economy.

PRESERVING TOURISM AMID COVID-19 CONTINUED

LOULOU D'AKI | ATHENS, GREECE | AUGUST 2020

Above: A museum guard at the National Archaeological Museum in Athens wears an obligatory face shield while watching over an exhibit. *Right:* A couple visits the Acropolis in Athens, Greece, an area typically surrounded by crowds of tourists.

Amid the COVID-19 pandemic, tourism in Greece dropped precipitously beginning in March 2020, with potentially disastrous effects on the Greek economy.

COVID-INDUCED
TOURISM STRAINS

ALI SAADI/7IBER | PETRA, JORDAN
JUNE 2020

In summer 2020 the Treasury, one of the most popular attractions in the ancient city of Petra, stands emptied of tourists. Tourism provided employment for many of the rural communities surrounding the site, including jobs as hotel workers, tour guides, drivers, and shopkeepers. When the sector abruptly came to a standstill during the COVID-19 pandemic, these communities were left with little but uncertainty and their own ingenuity.

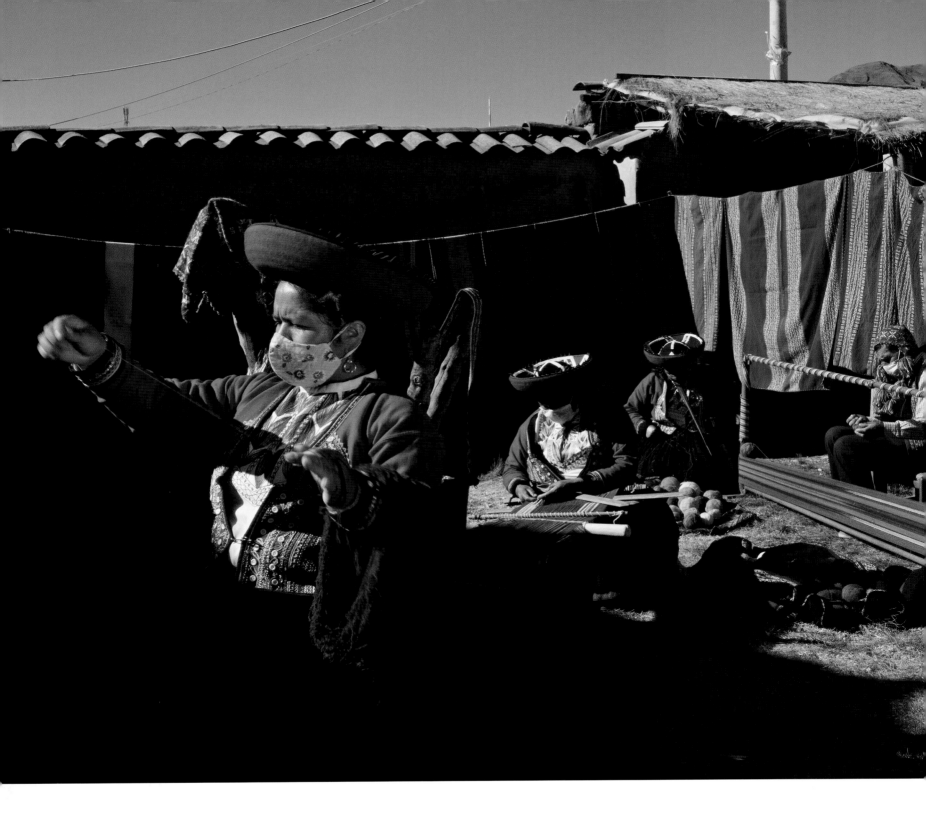

A RURAL FUTURE

VICTOR ZEA AND SHARON CASTELLANOS | CUSCO, PERU | AUGUST 2020

Left: Myriam Cuba, 43, works in the local textile center alongside other women of Peru's Ayllopongo community, where they share their weaving traditions with tourists. *Below:* Tomas Huamanttica Quispe, 48, a park ranger at the Moray Archaeological Center, watches over an area devoid of visitors.

Prior to the COVID-19 pandemic, Peru experienced high rates of migration from rural areas to large cities, where people sought new opportunities. As employment for tourism professionals, artisans, and entrepreneurs all but disappeared during the pandemic, Peruvians began reversing course, fleeing cities for opportunities in rural agriculture.

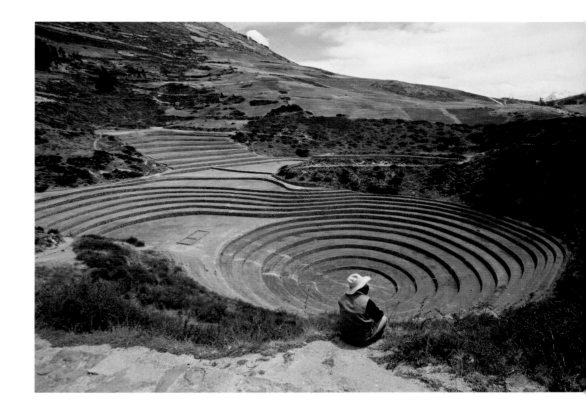

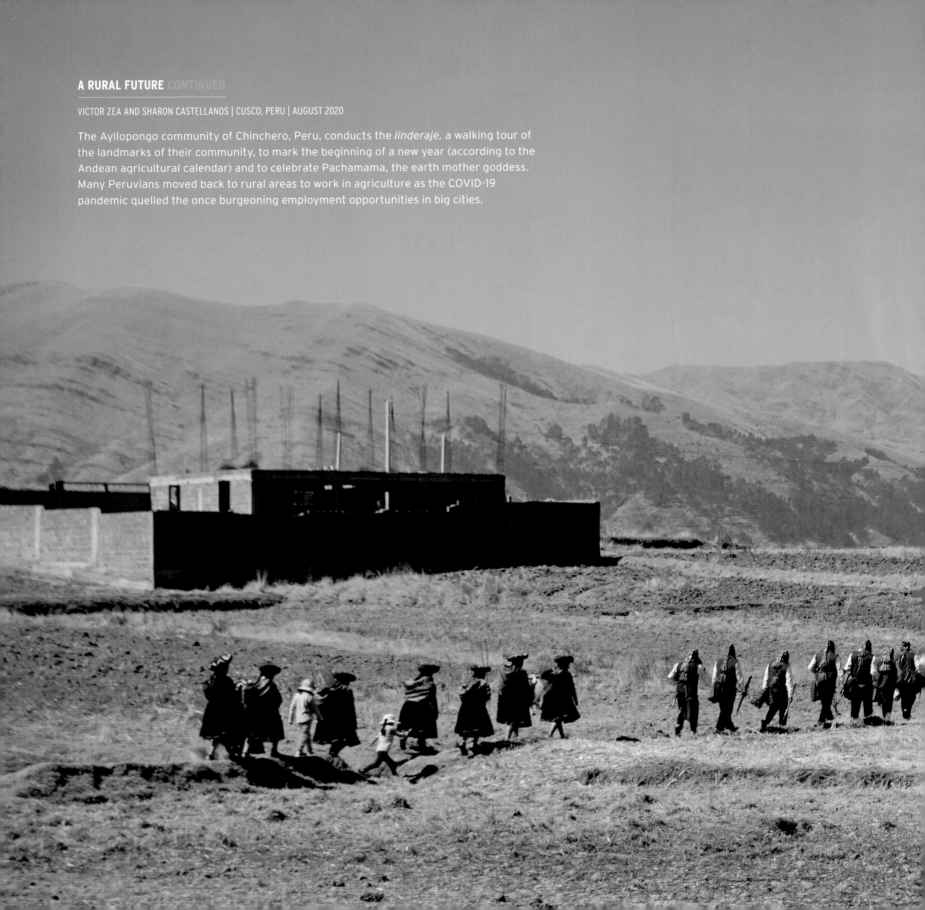

A RURAL FUTURE CONTINUED

VICTOR ZEA AND SHARON CASTELLANOS | CUSCO, PERU | AUGUST 2020

The Ayllopongo community of Chinchero, Peru, conducts the *linderaje*, a walking tour of the landmarks of their community, to mark the beginning of a new year (according to the Andean agricultural calendar) and to celebrate Pachamama, the earth mother goddess. Many Peruvians moved back to rural areas to work in agriculture as the COVID-19 pandemic quelled the once burgeoning employment opportunities in big cities.

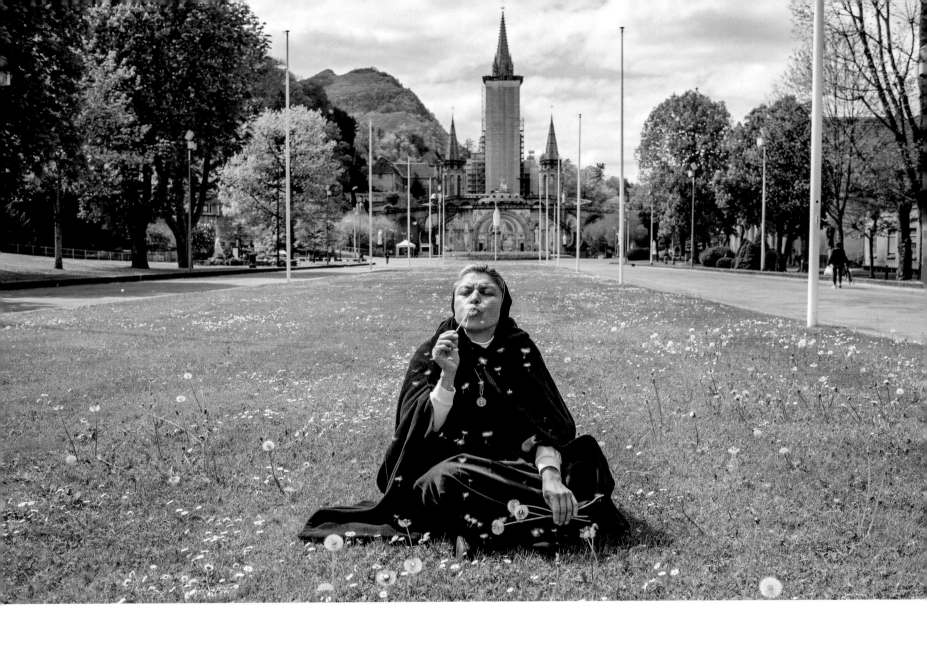

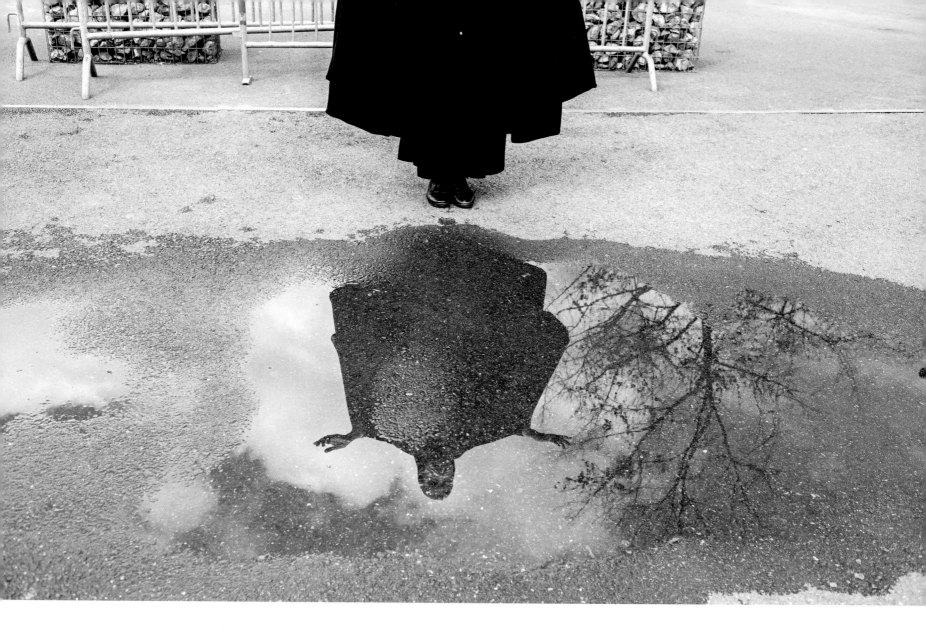

REINVENTING A PILGRIMAGE

SÉVERINE SAJOUS | LOURDES, FRANCE | APRIL 2021

Left: Sister Cecilia blows on a dandelion at the shrine of Lourdes. *Right:* A nun wearing a disposable surgical mask is reflected in a puddle.

Faced with a 95 percent drop in visitors during the COVID-19 pandemic, the Sanctuary of Our Lady of Lourdes, a prominent Catholic pilgrimage site, found a way to remain connected with its faithful: by implementing an e-pilgrimage broadcast in 10 languages that reached 80 million people.

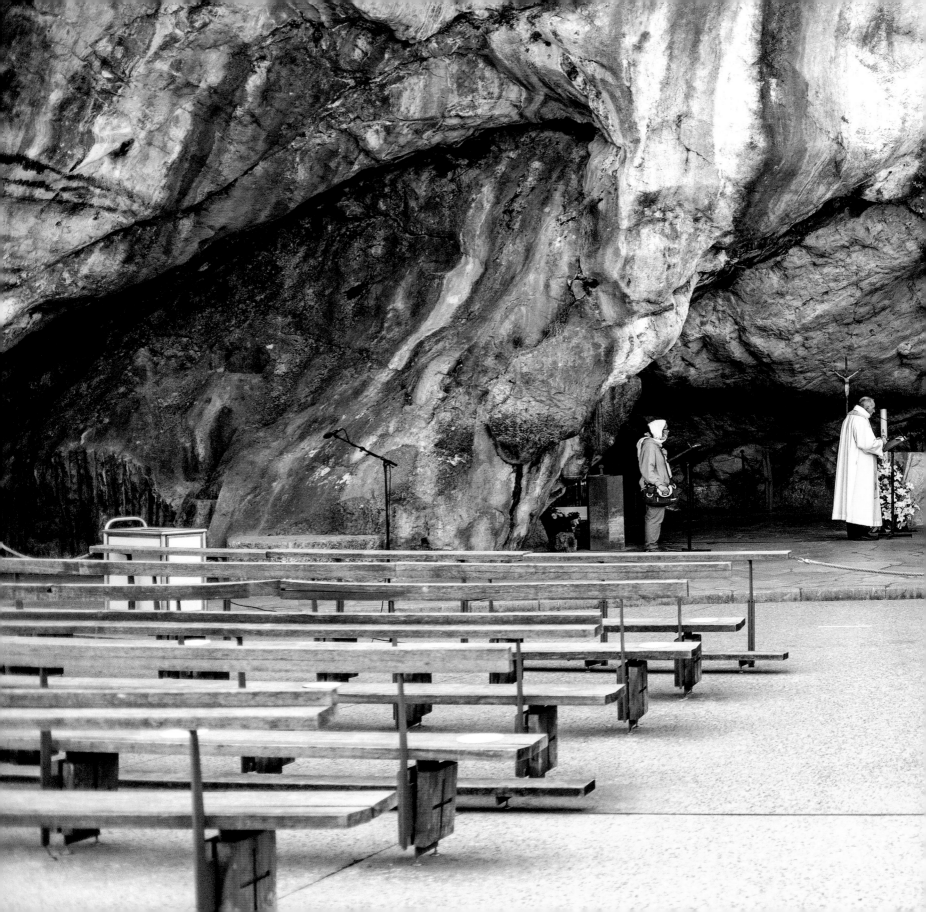

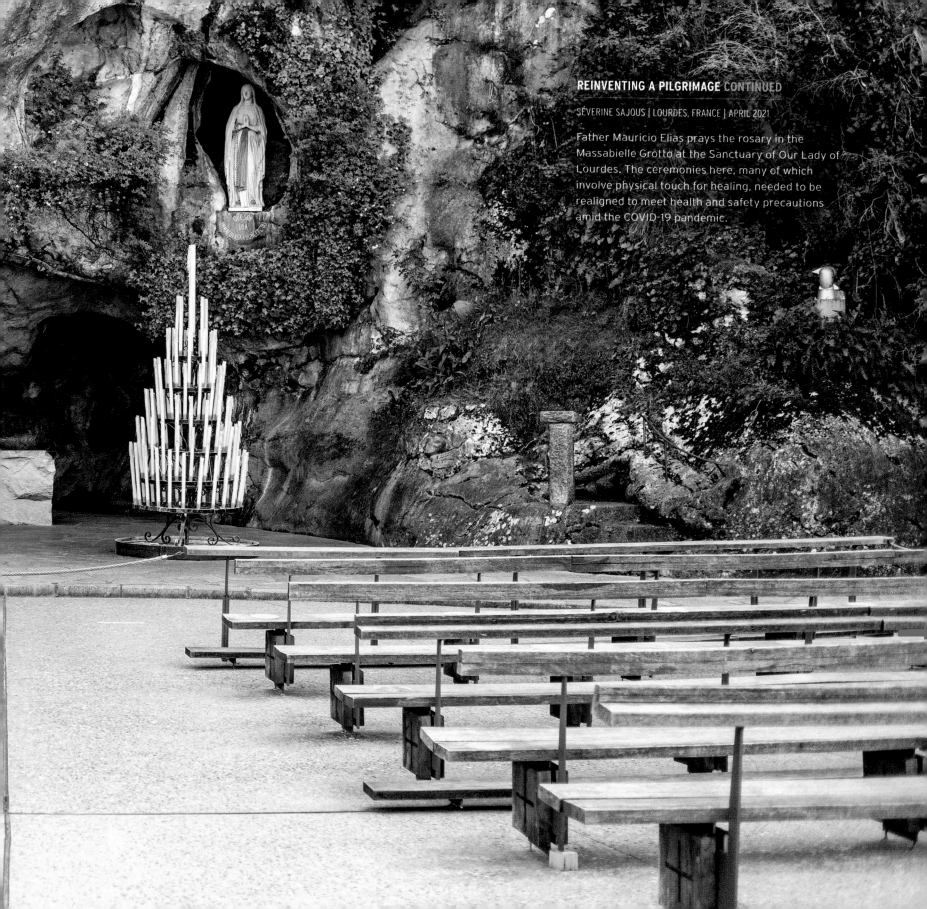

SÉVERINE SAJOUS | LOURDES, FRANCE | APRIL 2021

Father Mauricio Elias prays the rosary in the Massabielle Grotto at the Sanctuary of Our Lady of Lourdes. The ceremonies here, many of which involve physical touch for healing, needed to be realigned to meet health and safety precautions amid the COVID-19 pandemic.

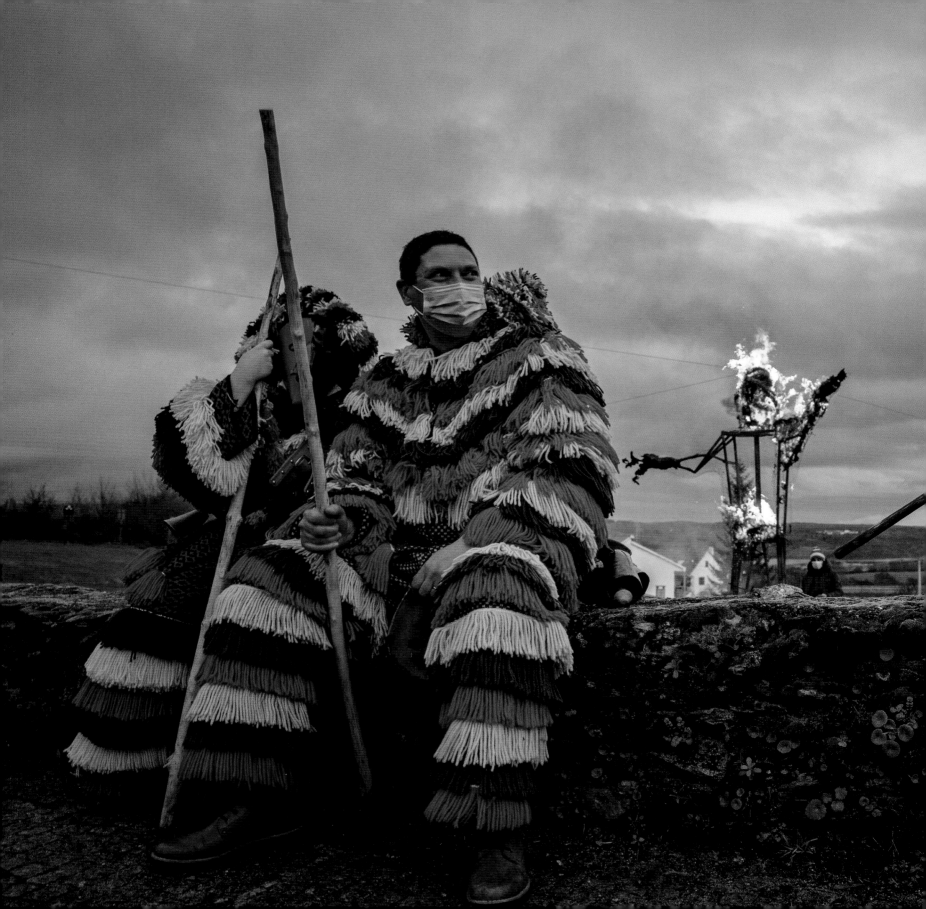

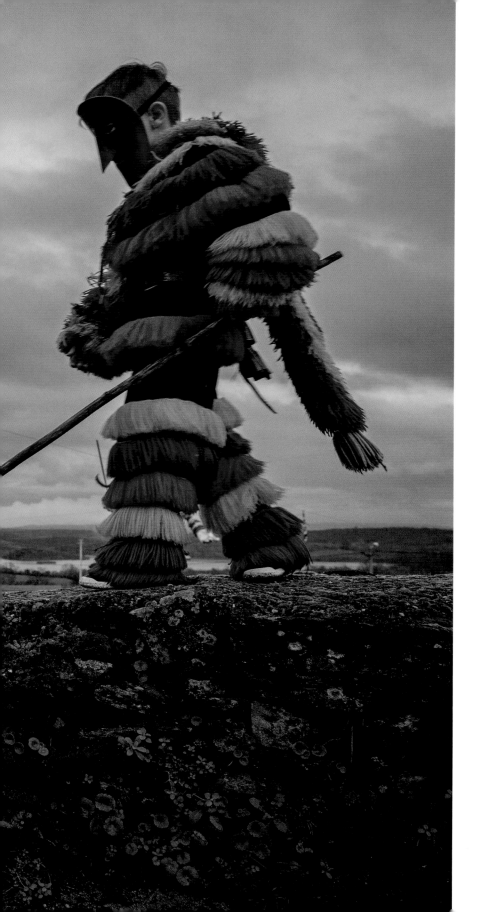

ANCIENT TRADITIONS COMPROMISED

VIOLETA SANTOS MOURA
TRÁS-OS-MONTES E ALTO DOURO, PORTUGAL
FEBRUARY 2021

Marking the Christian observance of Shrove Tuesday, António Coutinho and his children dress as Caretos, wearing traditional masks and dress as part of the ancient Entrudo tradition. Together, they burn an effigy symbolizing COVID-19 and the evils of the past year in the empty streets of the village of Podence. The annual carnival, which normally draws large crowds, was prohibited to prevent the spread of the virus.

Social inequalities including isolation, poverty, low birth rates, and emigration compounded the threat of COVID-19 for the remote, sparsely populated, and centuries-old communities of Portugal's northern interior.

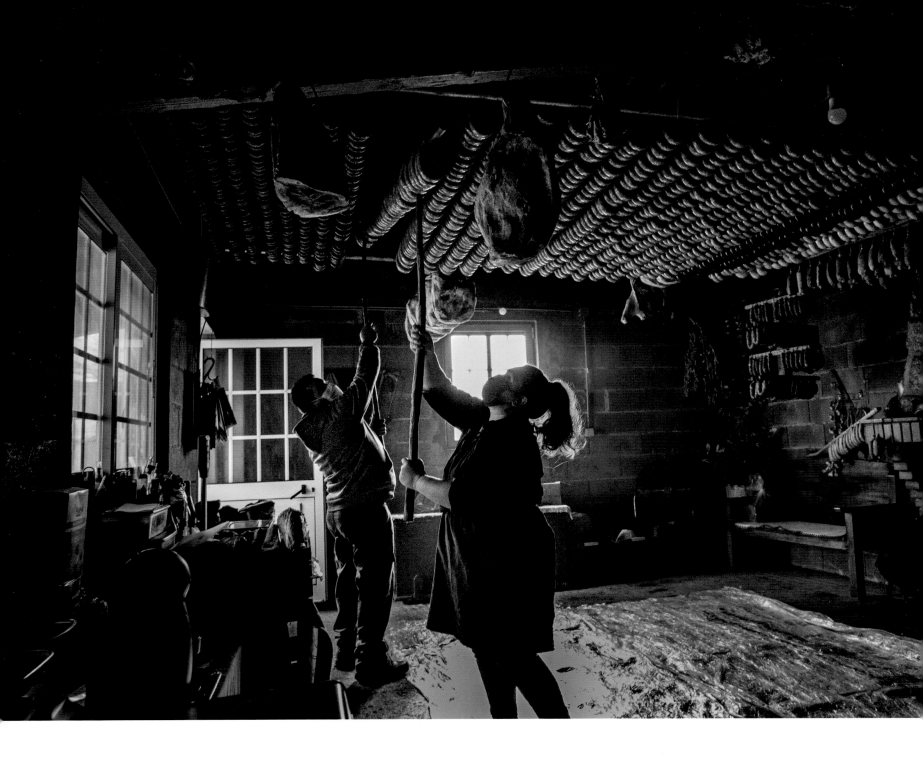

ANCIENT TRADITIONS
COMPROMISED CONTINUED

VIOLETA SANTOS MOURA
TRÁS-OS-MONTES E ALTO DOURO, PORTUGAL
APRIL 2021

Left: Farmer Lurdes Costa hangs a row of sausages in her smoke room. *Top right:* Visiting doctor Ana Loureiro participates in a COVID-19 vaccination circuit in the northern interior region of Sabrosa. *Bottom right:* Husband and wife Manuel Fortuna and Rosalina Ramos, both 83, reach out to each other through a separation screen during a visit to Rosalina's nursing home.

COVID-19 threatened the welfare, culture, and people of Portugal's northern interior, where farmers experienced unprecedented hardship amid the closing of markets. Aging populations are some of these communities' last residents.

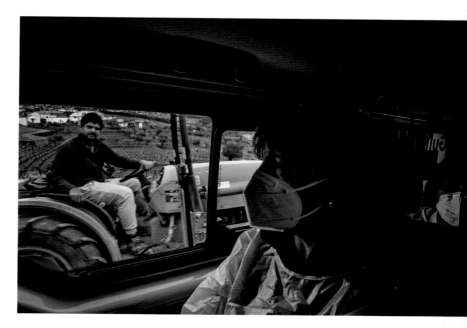

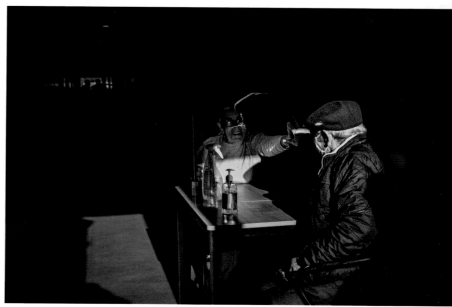

PERILOUS MIGRATIONS

ZIYAH GAFIC/VII
BIHAĆ, BOSNIA AND HERZEGOVINA
JUNE 2020

Two Pakistani migrants make their way over Plješevica mountain to reach Croatia from Bosnia and Herzegovina. Their perilous trail to the European Union took them over former front lines littered with land mines, unexploded ordnances, and treacherous rivers that regularly claim lives. COVID-19 compounded the already dangerous trek for migrants, who were at a high risk from the virus, given limited access to basic health care and sanitary facilities and subjected to overcrowded living conditions. Bosnia and Herzegovina's northwestern region, including the city of Bihać, received the highest number of migrants during this escalating humanitarian crisis, as the country became a stopover point for tens of thousands on their journey to a new life.

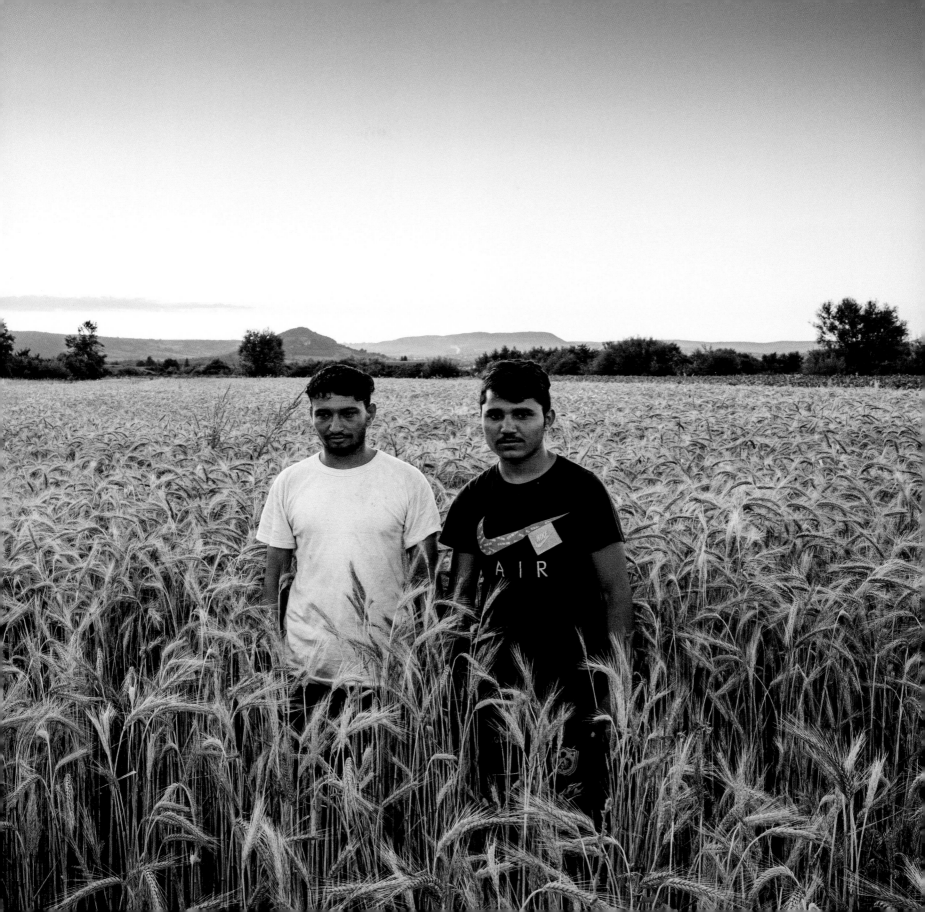

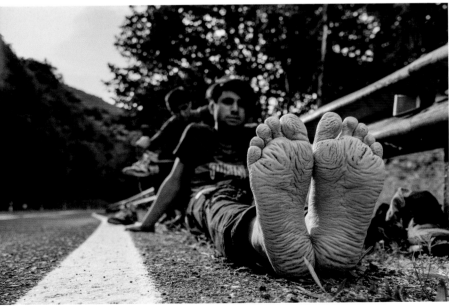

PERILOUS MIGRATIONS
CONTINUED

ZIYAH GAFIC/VII
VELIKA KLADUŠA, BOSNIA AND HERZEGOVINA
OCTOBER 2019-JULY 2020

Top left: Migrants rest on their journey to the border with Croatia. *Bottom left:* Two young Afghan migrants pause on their way back to Bosnia and Herzegovina after being stopped by Croatian police. *Right:* Migrants shield themselves from the rain in Vučjak, an informal settlement for migrants in Bosnia and Herzegovina.

As the COVID-19 pandemic unfolded, migrants were forced to navigate not only a perilous trek but also the complications of the pandemic, including border closings, prejudice toward their community, and the risk of contracting the virus.

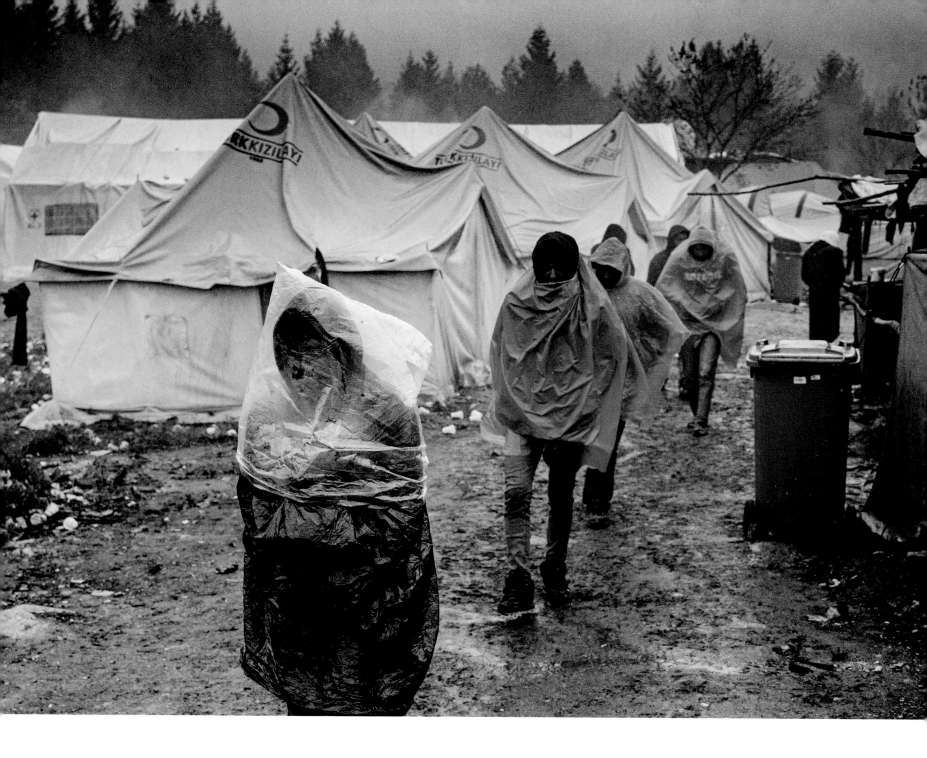

TOWARD AN ECO-CONSCIOUS FUTURE

MARICEU ERTHAL/AYÜN FOTÓGRAFAS
VERACRUZ, MEXICO | JULY 2020

In a self-portrait, photographer Mariceu Erthal stands in the ocean during her first trip out of mandatory quarantine. Although this beach in Veracruz is one of the most polluted in Mexico, its waters showed signs of healing due to human absence during the COVID-19 pandemic.

Behind the story: Erthal's travel journal related her contemplation of nature and human healing during the pandemic. She wrote: "At the end of my trip I was left with the memory of what I am in front of the sea: strength, peace, energy. And I took that home with me."

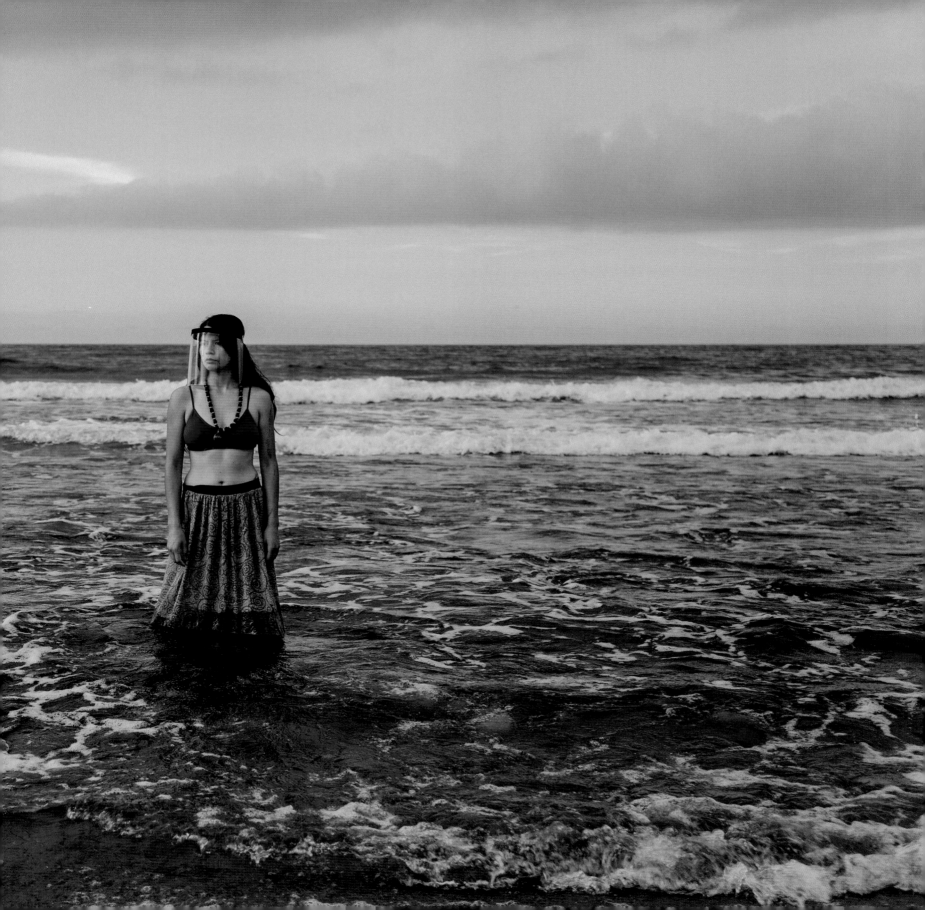

THREAT

RESILIENCE

FACING THE UNIMAGINABLE. There are, no doubt, several words and phrases you're sick of hearing in relation to the pandemic: "New normal." "Now, more than ever." "Like never before." "Unprecedented." But it's hard to quantify the magnitude of the challenges we've had to overcome in the face of COVID-19. All of us have been tested in ways we never imagined, and our experiences have given rise to unexpected results. Wave after wave, event after event, our vulnerabilities have surfaced at every turn. We have emerged from each test battered and wearied—but with newfound resilience.

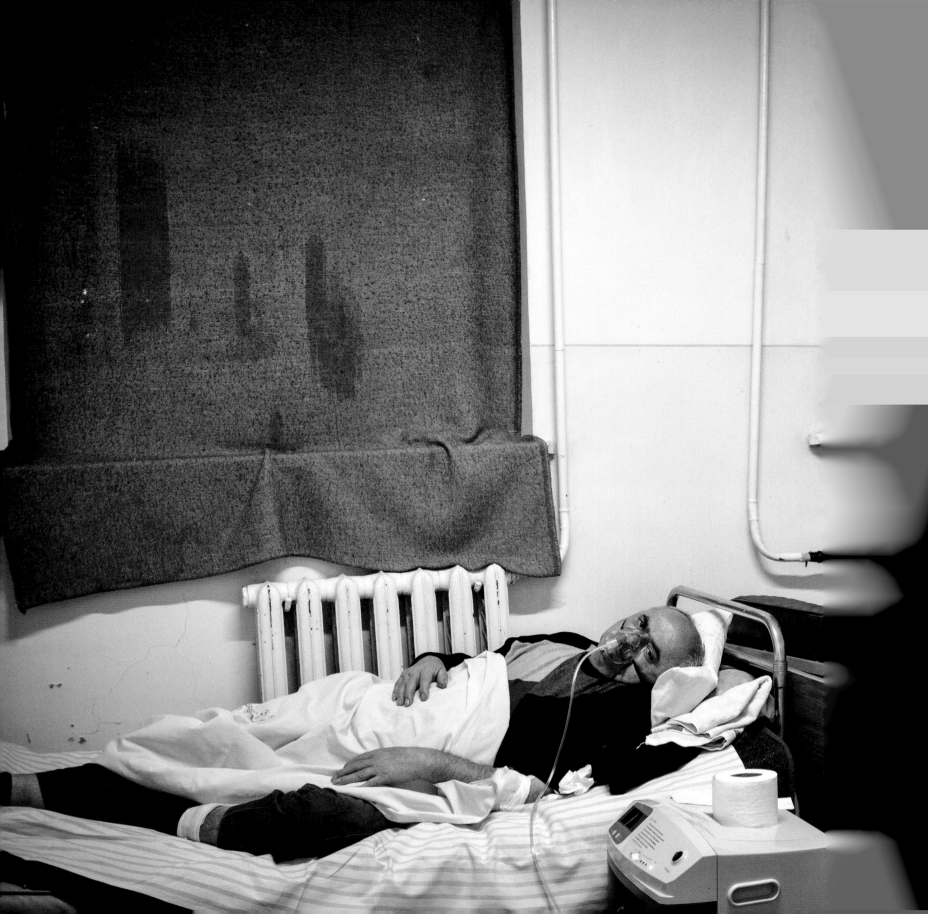

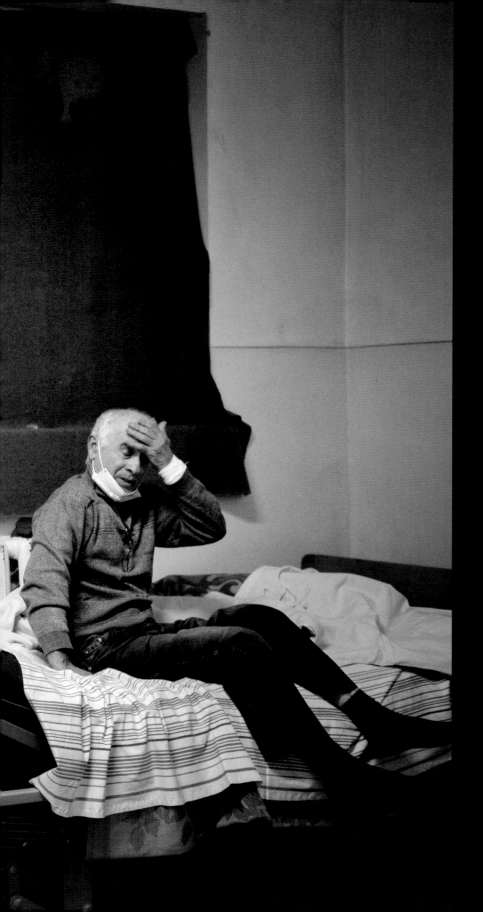

THREAT

Patients possibly infected with COVID-19 occupy a designated COVID-19 ward at the Infectious Disease Hospital in Stepanakert; the city was the target of intense bombing during the 2020 Nagorno-Karabakh war. Vitaly Khachatryan (left) succumbed to COVID-19 on November 2, 2020. Along with destruction and violence, the conflict caused COVID-19 cases in the disputed region to spiral out of control.

ANASTASIA TAYLOR-LIND
NAGORNO-KARABAKH, AZERBAIJAN
OCTOBER 2020

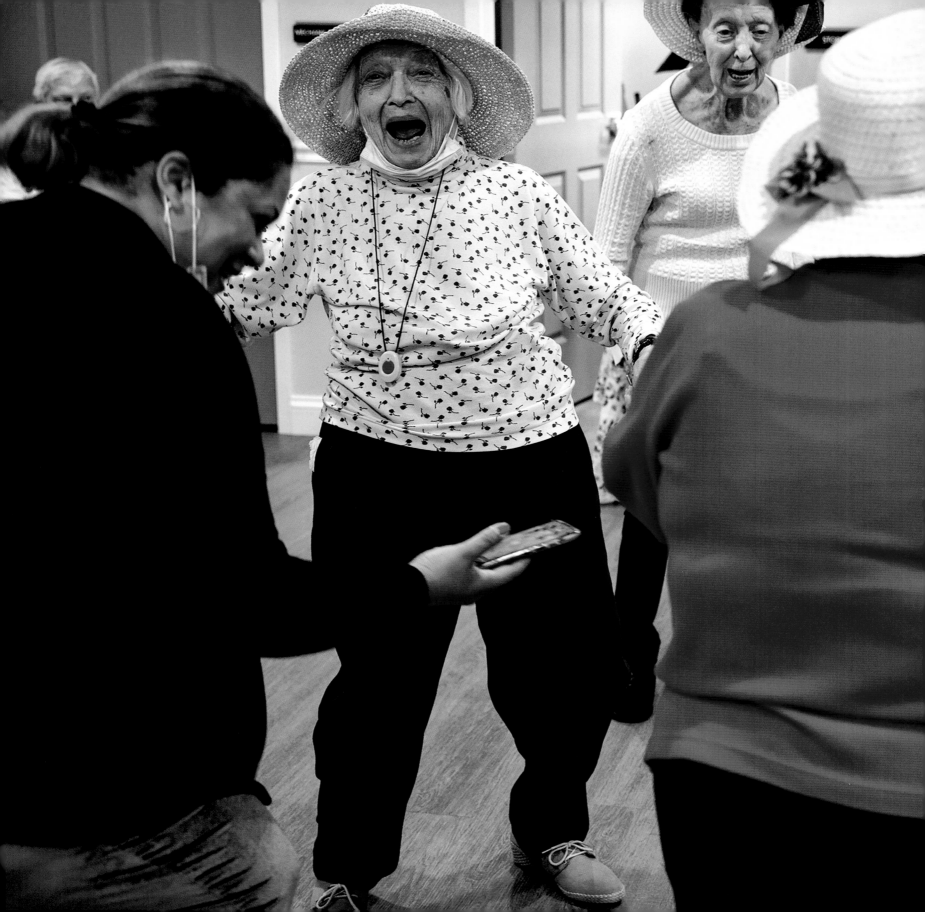

RESILIENCE

Assisted-living residents
Philomena B. (second from left),
Rosemarie M. (center), and
MaryAnn G. (second from right)
dance with activities directors
Germania Belen (left) and Motia
Johnson (right) at a Mother's Day
luncheon. The event, held at
Brandywine Living in East
Norriton, Pennsylvania, marked
the first time that a musical
entertainer was permitted to
perform since the onset of the
COVID-19 pandemic.

RACHEL WISNIEWSKI
PENNSYLVANIA, UNITED STATES | MAY 2021

TAKE IT EASY: Shielding his eyes from the afternoon sun, Mohammad, eight, who is Jordanian American, rests on a hammock in Los Angeles, California. Mohammed's mother has been instrumental in helping Afghan, Iraqi, and Syrian families acclimate to the United States. After the trauma of relocation and finding asylum, many of Los Angeles's recently resettled families responded to the stress, isolation, and health threats of the COVID-19 pandemic with help from a strong grassroots network of support.

ESSAY

'YOU CANNOT HIDE THE SUN BY ONE FINGER'

BY SHOSKANA AKABAS

Shoshana Akabas is a writer based in New York City, New York, United States. Her Emergency Fund project covered Afghan refugees resettling in New York City.

Each day in the first spring of the pandemic, a young woman from the Central African Republic sat on the stoop of a shuttered New York Public Library building to access Wi-Fi for her virtual college courses. "It's impossible," she wrote to me. "All my classmates are on track, and I'm not." She had to share a single laptop with her four younger siblings; she tutored them by day, catching up on her own studies at night, and somehow pulling out mostly A's by the end of the semester.

Through my reporting with refugees in New York City, I saw families from Egypt and Pakistan kept apart by travel restrictions; a mother from Guatemala escaped one hell only to watch her husband die of COVID-19 a month after arriving in New York.

Newly resettled refugees stepped from one tumultuous world to another. They arrived with much hope at an inhospitable time, unable to meet community members and find support in the traditional ways. Now, tasks like job hunting, navigating benefits, and adjusting to new schools all became unthinkably difficult.

In spring 2020 I spoke on the phone with a father from Afghanistan who had put his life at risk to translate for U.S. troops in Kandahar but was forced to flee to America when he was threatened by the Taliban. Despite years of professional experience, he could find work only as a janitor to support his wife and four young children. His job paid too little and ate up nearly four hours in commuting time each day. Then, one month into the pandemic, he was wrongfully terminated for taking COVID-19 sick leave.

As he spoke, his voice was a tide of rising anger and sinking defeat. He told me that not being able to feed his family was the worst experience of his life.

"We have a saying in our language: 'You cannot hide the sun by one finger,'" he told me. "It means that if you face one or two people who are bad, it doesn't mean all people are bad. There are a lot of kind people in America. We have a lot to be thankful for."

As a writer, I'm faced with the question of how to honor that kind of resilience. How does the heart find space for these to coexist?

"We hope it will be over soon," the Afghan father said at the end of the interview, "You will come to our home. We will cook for you, and then we will be happy."

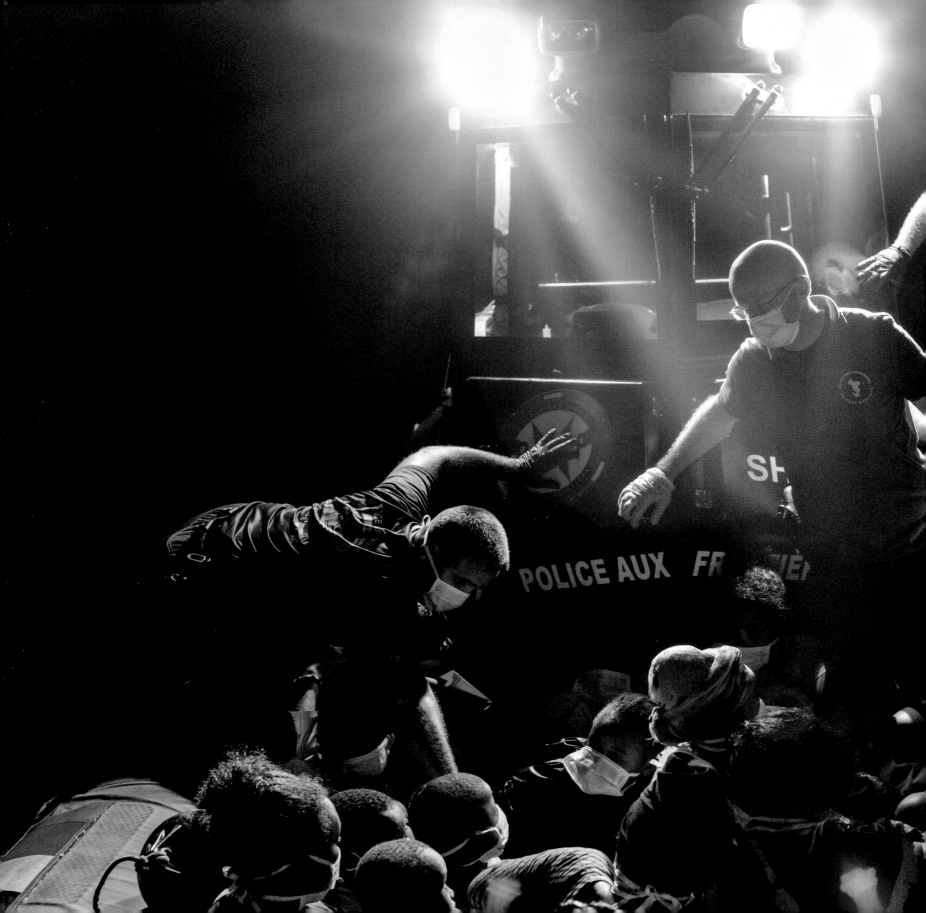

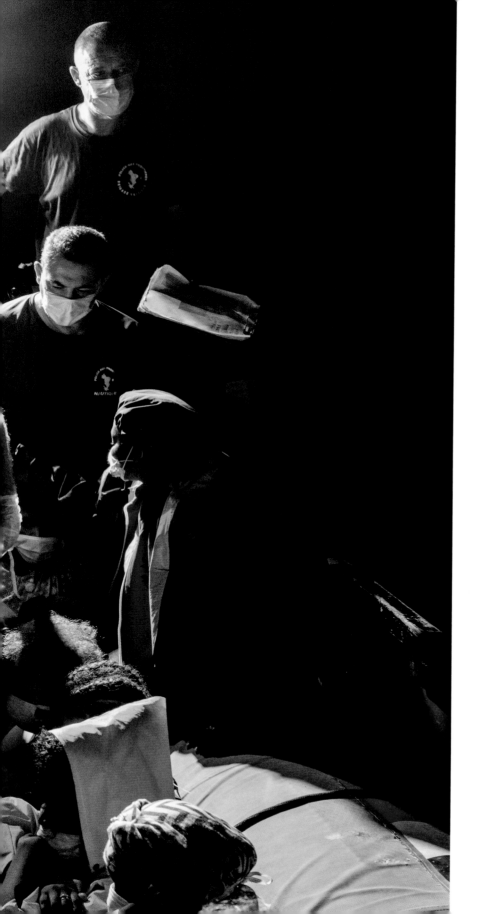

MIGRATORY PRESSURE OVERSEAS

WILLIAM DANIELS | OFF MAYOTTE ISLAND, MOZAMBIQUE CHANNEL | MARCH 2021

At 3:00 a.m., French border police intercept a boat carrying 46 undocumented immigrants from Madagascar off the southern shore of the Department of Mayotte, a tiny French overseas territory in the Mozambique Channel. Those aboard were arrested and taken to the region's administrative detention center. Immigrants typically sail for 18 hours in unstable *kwassa kwassa* boats, paying the equivalent of $850 (U.S.) per person to reach this territory—itself reeling from the COVID-19 pandemic.

Behind the story: This photo was taken on March 25, 2021. The photographer, William Daniels, reported that since the beginning of that March, police intercepted approximately 40 kwassa kwassa boats filled with undocumented immigrants.

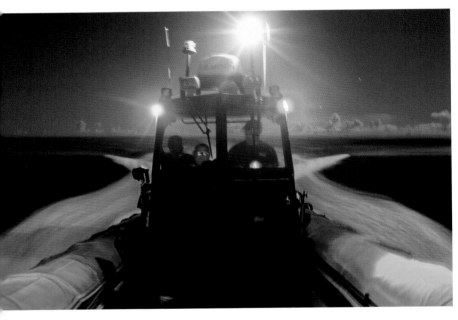

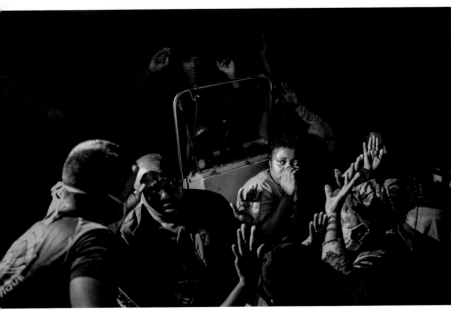

MIGRATORY PRESSURE
OVERSEAS CONTINUED

WILLIAM DANIELS | OFF MAYOTTE ISLAND, MOZAMBIQUE CHANNEL | MARCH 2021

Top left: A French national police boat patrols the coast of Mayotte. *Bottom left:* A boat carrying 46 undocumented immigrants from Madagascar, including 15 children, is intercepted by French police. *Right:* Undocumented migrants await unknown next steps as they are intercepted by police during their attempt to reach Mayotte.

The COVID-19 pandemic severely exacerbated Mayotte's socio-economic and other crises. Its population numbers also swelled, mainly because of rising undocumented immigration and a record-high birth rate.

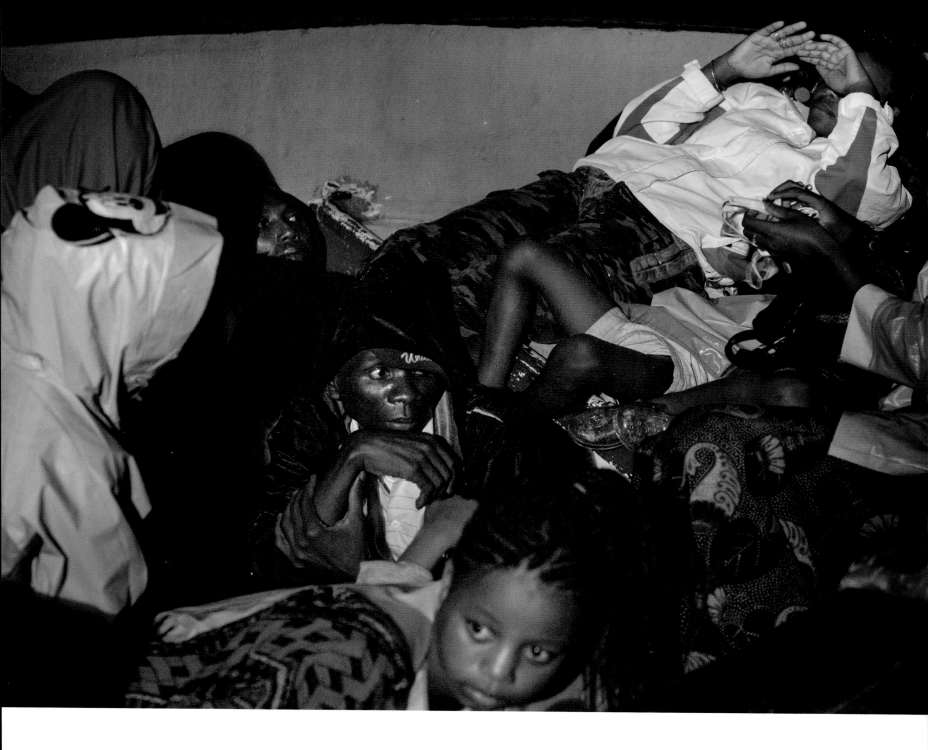

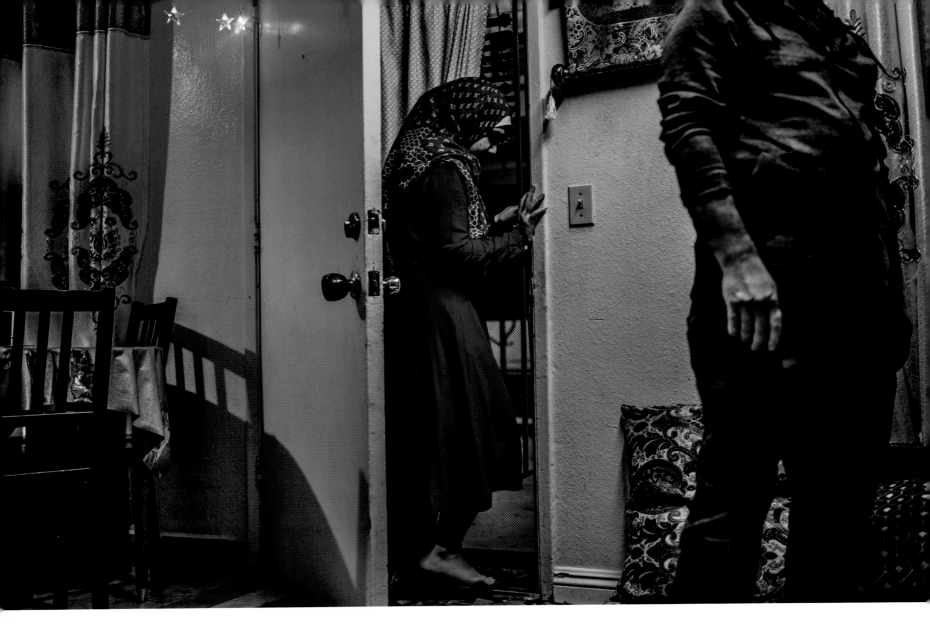

REFUGEE OUTREACH AND ASSIMILATION

ANNA BOYIAZIS | CALIFORNIA, UNITED STATES | APRIL-JUNE 2021

Left: Syrian new arrival Khadijah, 13, closes her family's front door after welcoming guests for *iftar* (a Ramadan evening feast) in their San Diego home. *Right:* Afghan new arrival Breshna, eight, participates in an English-language-learning program for resettling refugees from the safety of her Los Angeles home.

For some of the United States' most recent arrivals, the isolation of the COVID-19 pandemic exacerbated the challenges of assimilation. Many found crucial support in fellow resettled families and grassroots organizations.

Behind the story: Breshna's father conducted controlled collection and detonation of improvised explosive devices for the U.S. military in Afghanistan. Soon after this photo was taken, three of her siblings and her parents were airlifted out of Afghanistan during the August 2021 Taliban takeover; they had returned to Kabul to attend a wedding.

250

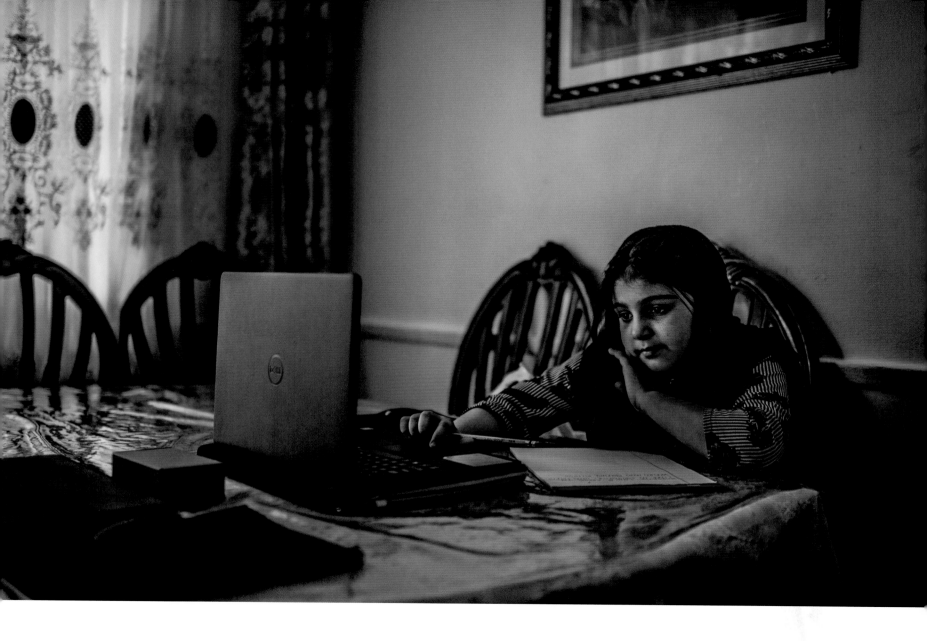

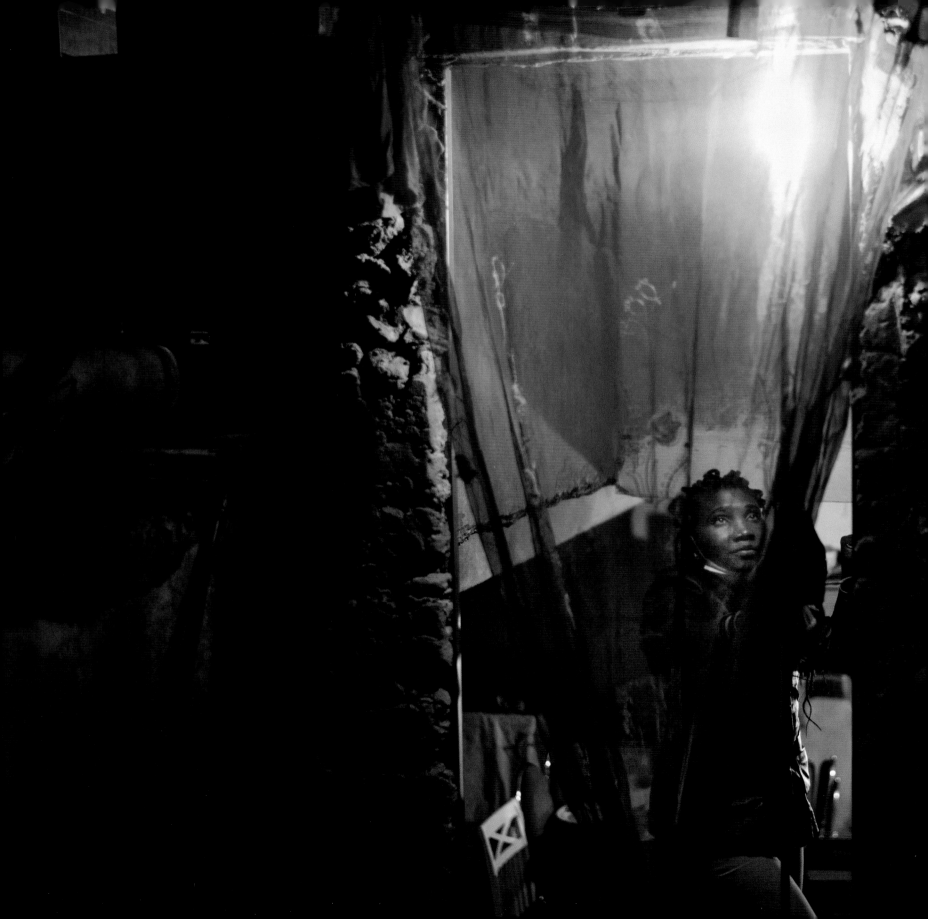

DEEPENING DIVIDES

JOSÉ SARMENTO MATOS
SEIXAL, PORTUGAL | NOVEMBER 2020

Telma Reis, 36, opens the curtain of the basement where she lives with her three children in Seixal's Jamaica neighborhood, located on the outskirts of Lisbon. In 2020 Reis lost her job as a waitress as a result of the pandemic, which deepened divides of poverty and isolation in this historically marginalized community of African descendants and migrants. It took Reis months to find a new job; she finally ending up working in construction. Water leaks inside the family's basement apartment, along with high humidity levels, made confinement during the pandemic especially challenging.

A LOCAL COVID-19 RESPONSE

GUILHERME CHRIST | SÃO PAULO, BRAZIL | APRIL 2020

Below: Paraisópolis, an urban informal settlement (or favela) that's home to 150,000 people, lies surrounded by tall buildings in higher-income neighborhoods. *Right:* Dr. Ricardo Vieira da Silva waits as a rescue team prepares a potential COVID-19 patient for transportation. With severely limited access to hospitals and public services, Paraisópolis's residents created a response team to transport people suspected of infection to nearby hospitals.

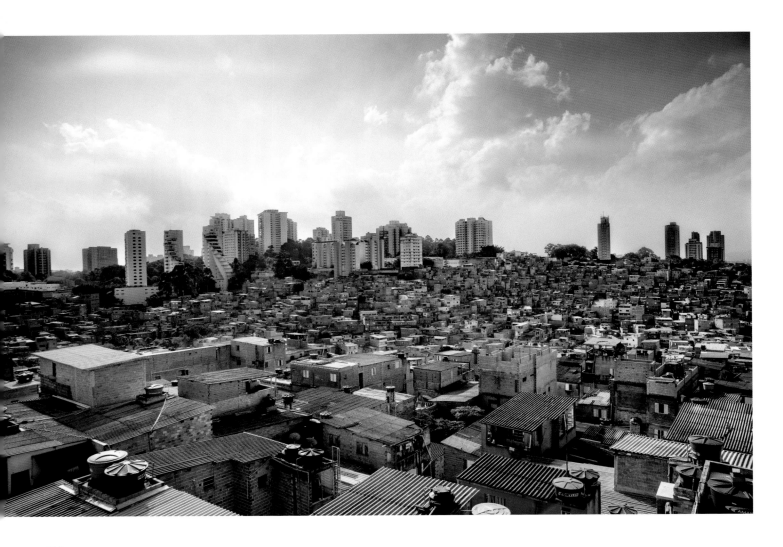

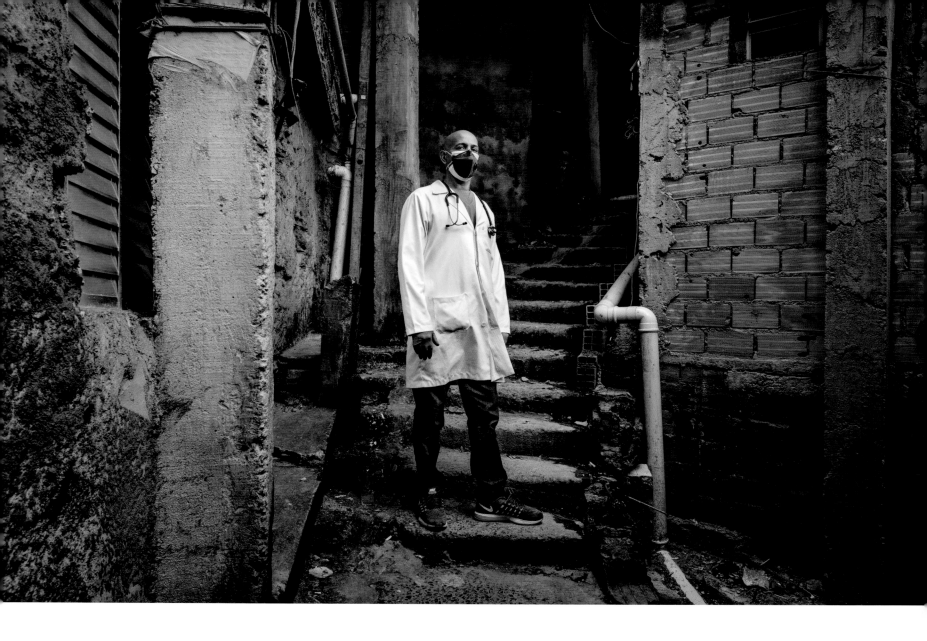

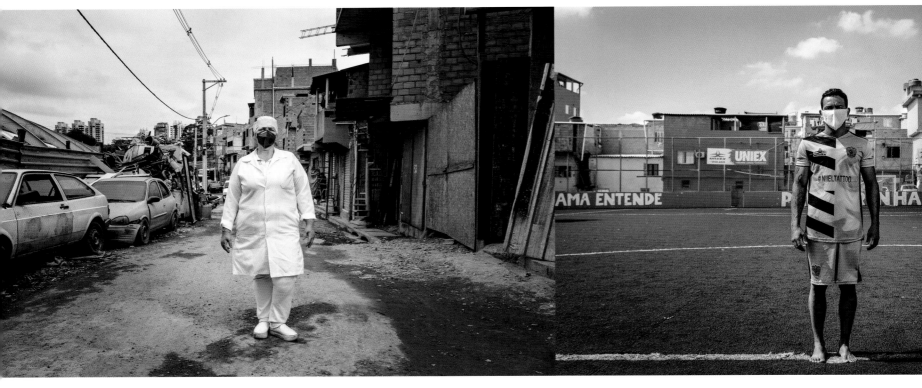

A LOCAL COVID-19 RESPONSE CONTINUED

GUILHERME CHRIST | SÃO PAULO, BRAZIL | APRIL 2020

From left: Paraisópolis residents nurse Adriana Bianchi, Adriano Silva Santos, Antonio Ednaldo da Silva, and Adailson Silva de Oliveira. Brazil's largest informal settlement was particularly vulnerable to COVID-19. The favela has the highest population density in the country; many homes are co-inhabited by different families. Residents lacked adequate access to health care, public services, and proper sanitation to counter the virus, and could not properly social distance or work from home.

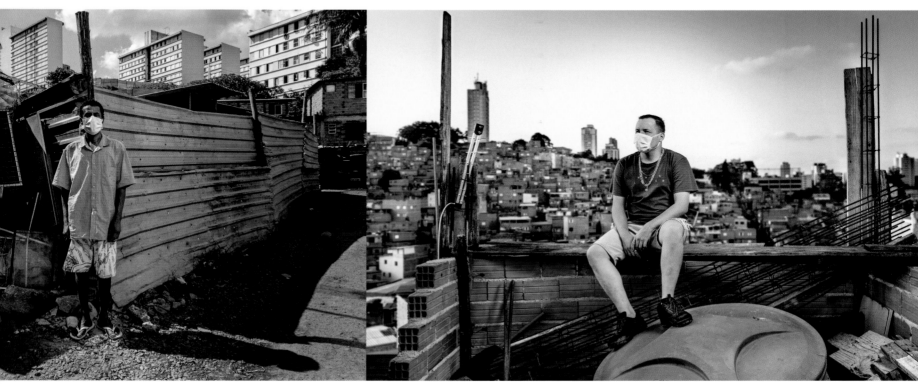

257

COMMUNITY ACTION COUNTERS COVID-19

MARK LEONG | CALIFORNIA, UNITED STATES
MAY 2020

The Street Medicine Team of LifeLong Medical Care in Berkeley tests unhoused residents for COVID-19 as well as does other medical checks. The team runs a regular circuit of mobile testing and treatment stations near encampments for the unhoused.

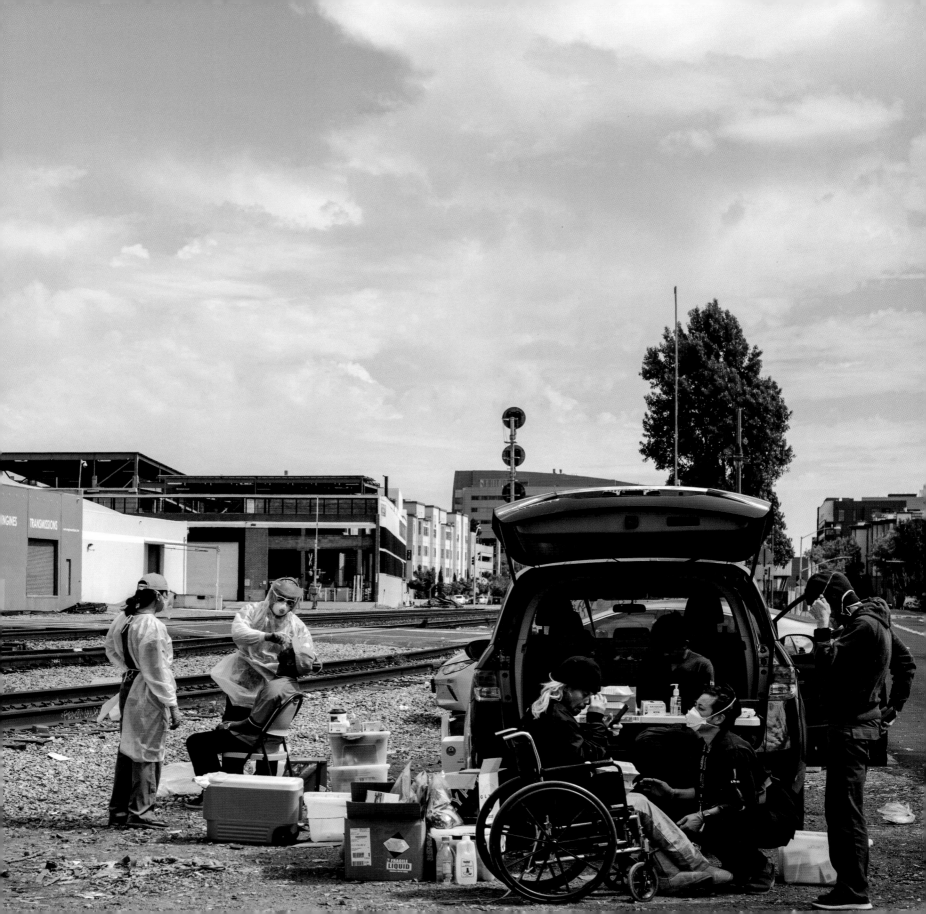

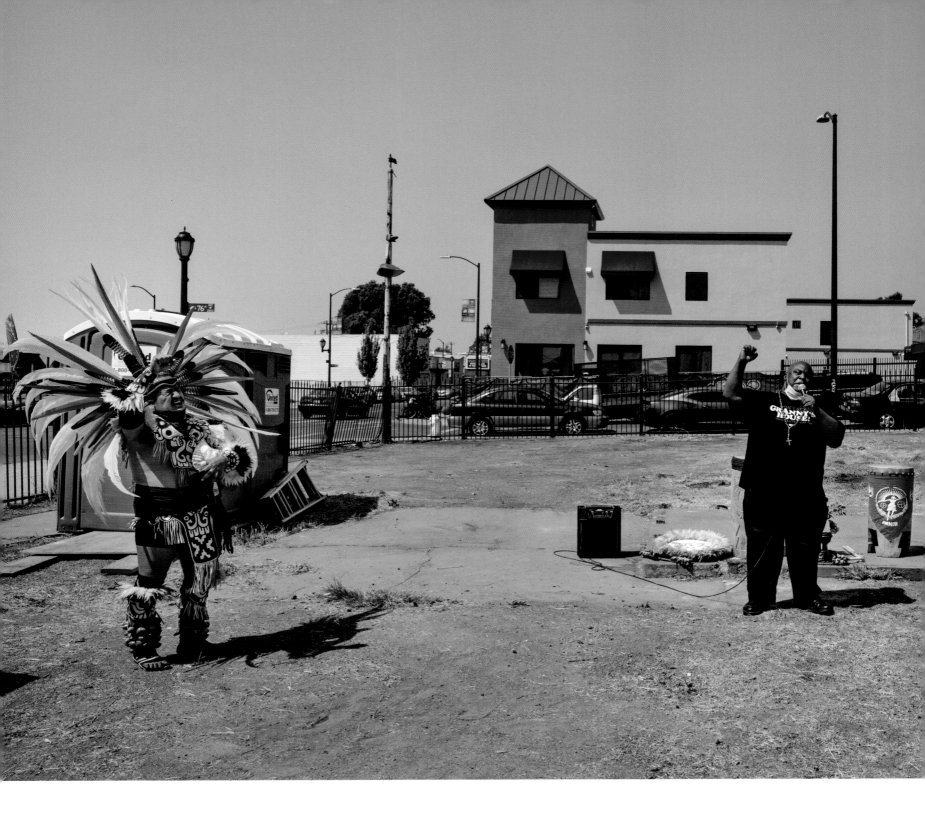

COMMUNITY ACTION COUNTERS COVID-19 CONTINUED

MARK LEONG | CALIFORNIA, UNITED STATES | SEPTEMBER 2020

Left: Muteado, dressed in traditional Aztec regalia, and the Reverend Harry Williams, aka "the O.G. Rev," consecrate a lot in Oakland. The site was acquired by Homefulness, a project run by *Poor* magazine, to host new apartment buildings that will house people in need. *Below:* Demitria, a former bartender who lost her job in the wake of the COVID-19 pandemic, distributes supplies and secondhand clothing she collected for her unhoused neighbors.

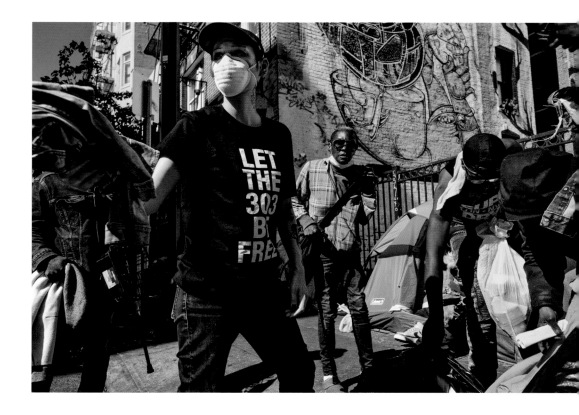

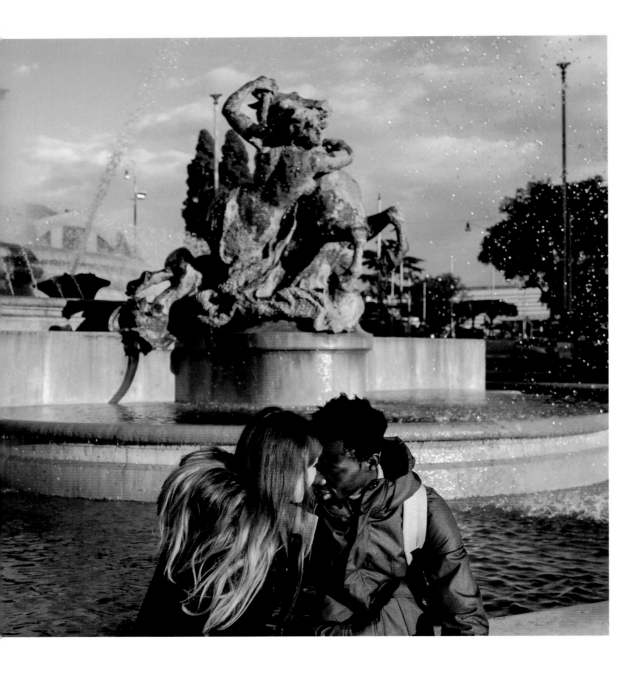

UNDOCUMENTED MIGRANTS FACE COVID-19

MATTEO BASTIANELLI | ROME, ITALY
APRIL-NOVEMBER 2020

Left: Giorgia Giannetti, 19, and Lamine Sane, 21, embrace in front of the Fountain of the Naiads. Giannetti and Sane met in 2016, while Giannetti was volunteering to teach the Italian language to refugees. Sane was issued a residence permit for subsidiary protection expiring in 2024.
Right: A man originally from Morocco inhabits a makeshift shelter near Termini station. He is a member of a community of 8,000 immigrants who lack housing in Rome.

Throughout the COVID pandemic, Rome's significant migrant community faced not only the threat of the virus but also the rising anti-immigrant sentiment that it helped fuel.

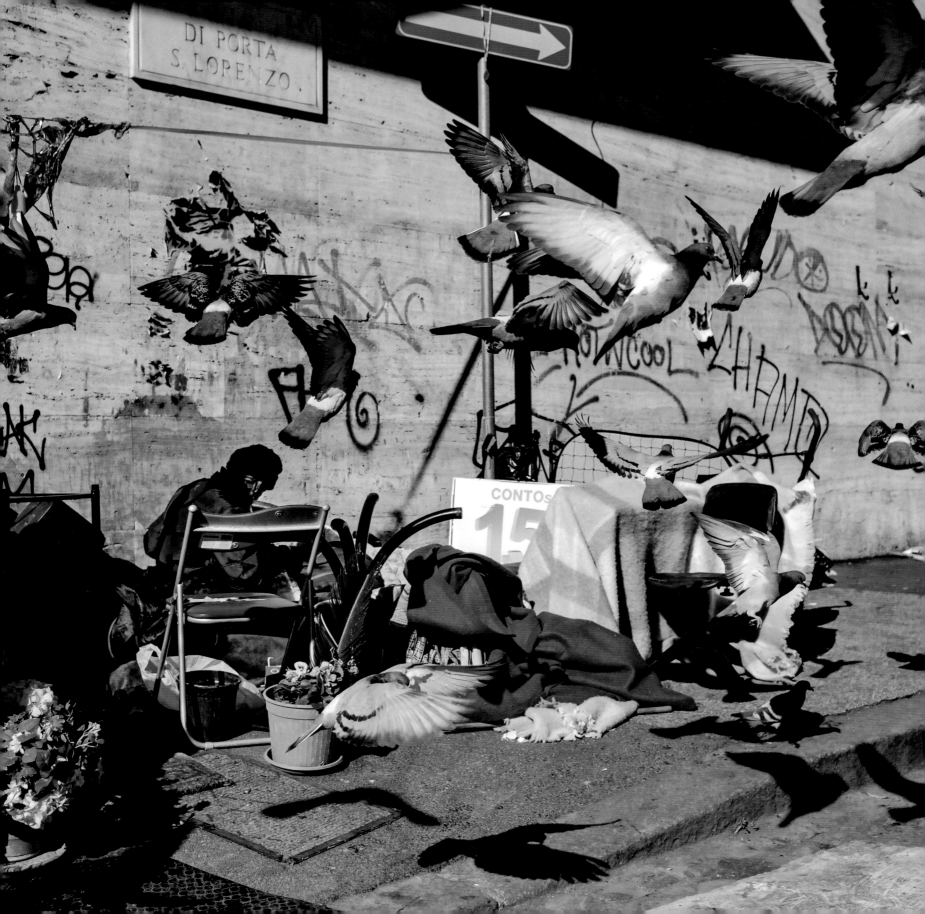

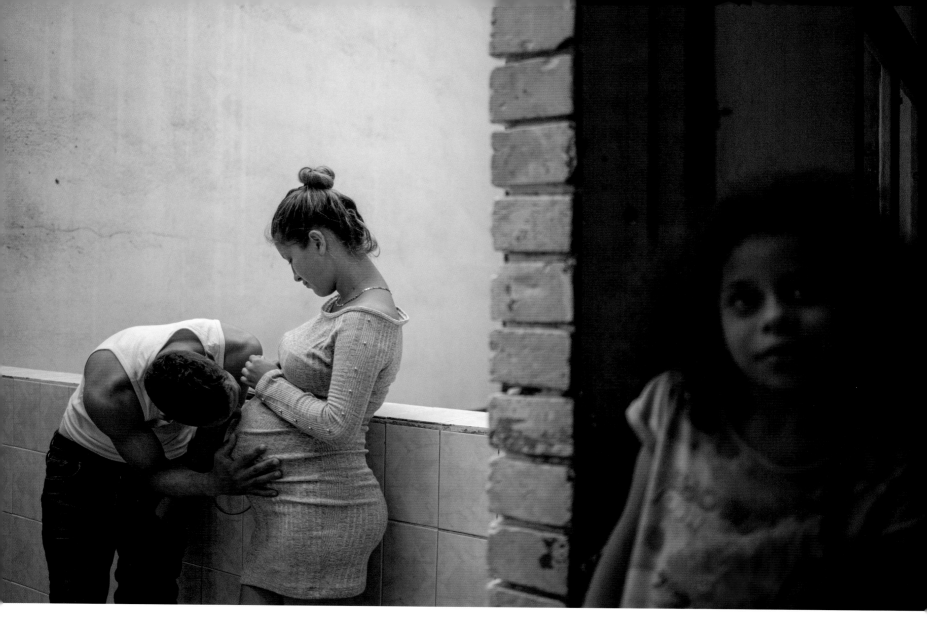

A RETURN TO WHAT THEY RAN FROM

FABIOLA FERRERO/RUDA COLLECTIVE | BOGOTÁ, COLOMBIA | APRIL 2020

Left: Living in a building with only one shared kitchen during the COVID-19 pandemic, Venezuelan migrant Angel Correa stores his food where he can. *Above:* Pregnant Venezuelan migrant Carolina Gómez receives a kiss from her husband inside their *pago diario* (daily pay) apartment building.

As job opportunities in Colombia dissipated because of the COVID-19 pandemic, Venezuelan migrants returned to not knowing how—or if—they would find food each day, reliving the same trauma that drove them to leave their homes in the first place.

COMPOUNDING CHALLENGES AND VULNERABILITY

DAN AGOSTINI | SÃO PAULO, BRAZIL
OCTOBER 2020

Celina Ferraz (left), 20, and Barbara Garcia, 22, work near the Praça do Jaçanã, a spot known for sex work, close to the support house where they lived together in 2020. Garcia takes on the job only during times of financial emergencies; Ferraz does so full-time. Due to discrimination associated with their identities as transgender women, it's extremely difficult to find formal jobs—a situation greatly exacerbated by COVID-19. For transgender people, who often lack access to services, the pandemic increased social isolation, economic crisis, violence, and difficulty accessing public health care.

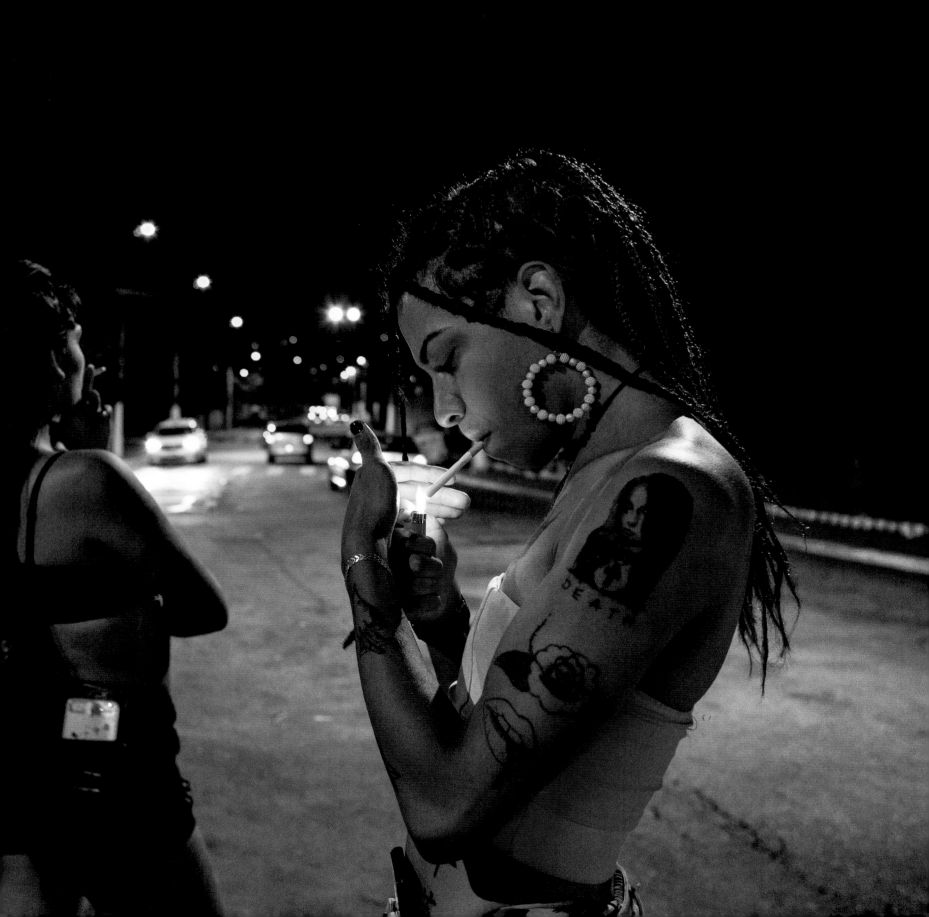

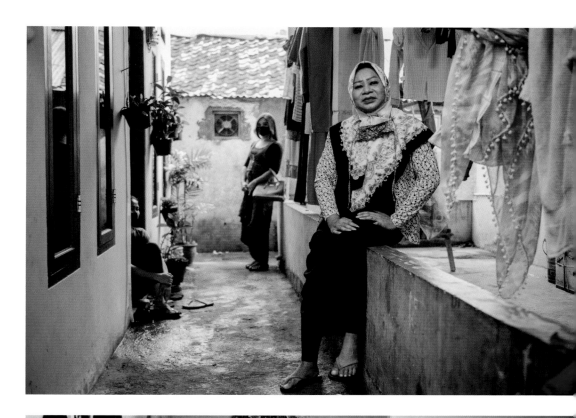

WOMEN'S LIVES
ARE CHANGED

YOPPY PIETER
MULTIPLE LOCATIONS, INDONESIA | MAY 2020

Olivia (left), Ira (above right), and Encum (below right) reflect on their experience as trans women in Indonesia. Many had found jobs in cosmetology or as sex workers, putting them at great risk of contracting COVID-19 and depriving them of income when restrictions on in-person work were enforced. The pandemic exacerbated poverty, job loss, and the threat of infection in this community, alongside the damaging effects of stigma and discrimination.

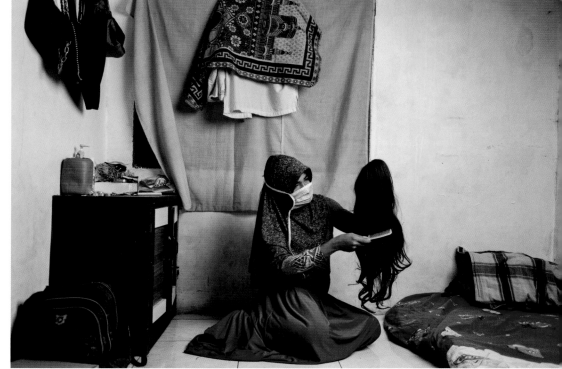

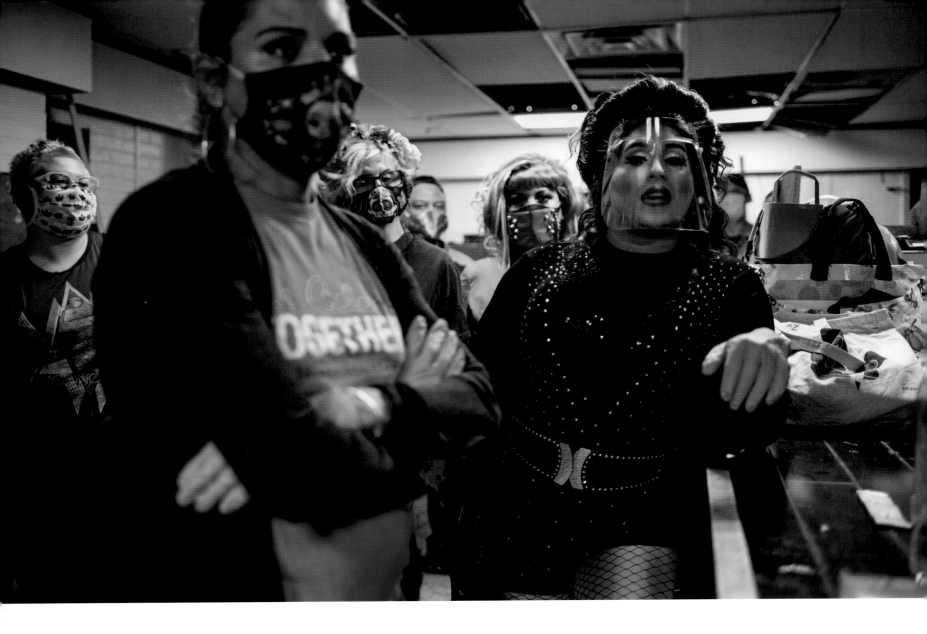

CREATING COMMUNITY SUPPORT

JOANA TORO | NEW YORK, UNITED STATES | OCTOBER 2020

Transgender woman Joselyn Mendoza (left), Betty ¿UBttm? (right), and other volunteers prepare to distribute food as part of Love Wins. The LGBTQ-led service addresses food insecurity created by the COVID-19 pandemic within the Jackson Heights community in Queens, New York City.

LOCKDOWN FOR DOMESTIC VIOLENCE VICTIMS

IRINA UNRUH | WARENDORF, GERMANY | SEPTEMBER 2020

While he was supposed to be putting on his shoes for school, the photographer's four-year-old son, Yuri, becomes enthralled with stirring up dust in the sunlight.

Behind the story: Mandatory quarantine during the COVID-19 pandemic meant confining some women and children at home with their abusers; reports indicated that domestic violence increased during this time. As Irina Unruh was reporting on this alarming increase in Germany, she took this photograph, remembering that similar moments of distraction could lead to sudden violence against children during her childhood in the Soviet Union.

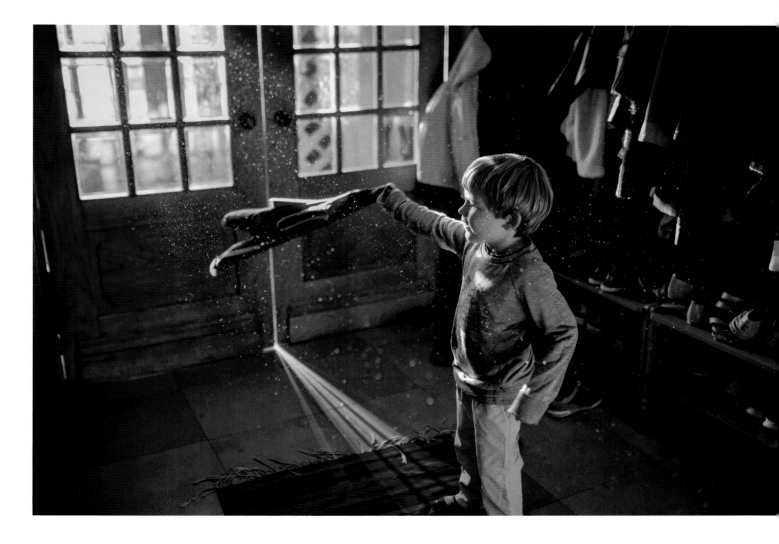

EXACERBATING STRUGGLES FOR THE DISABLED

WARA VARGAS LARA | LA PAZ, BOLIVIA
SEPTEMBER 2020

A woman is blocked and pushed by police during a demonstration by the blind population of La Paz. The group had assembled to petition the government for support amid the economic crisis fueled by the COVID-19 pandemic. Many members of La Paz's blind community worked in the informal economy, or as street performers, living day to day by singing for passing audiences. As crowds and street traffic vanished with the outbreak of COVID-19, many individuals without sight found themselves struggling to earn even a basic income.

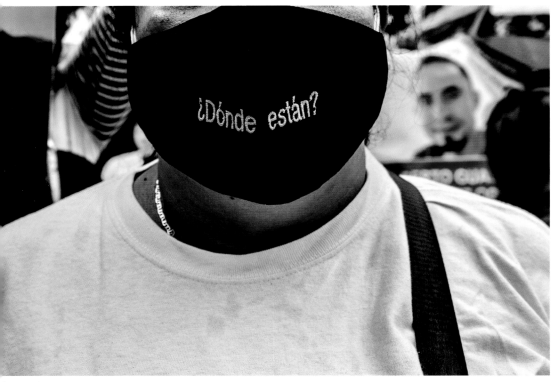

THE SEARCH FOR THE MISSING AMID COVID-19

ZAHARA GÓMEZ LUCINI
IRAPUATO, GUANAJUATO STATE, MEXICO
MAY 2021

Top: Families with missing loved ones carry portraits to demand that the government recognize victims of forced disappearances. *Bottom:* A woman wears a face mask reading *"¿Dónde están?–* Where are they?" to reference the 90,000 missing persons in Mexico.

Reacting to Mexico's numerous forced disappearances, many victims' families formed collectives to organize searches and call attention to this atrocious injustice. Although the COVID-19 pandemic caused many of these families to lose their incomes, while others were struck with the virus, their efforts on behalf of their loved ones continued unabated.

QUEER ACTIVISM AMID COVID-19

SARAH WAISWA | NAIROBI, KENYA | MARCH 2021

Marylize Buibwa, 30, a queer Kenyan feminist and gender rights activist, sits by the window of her apartment; a pride flag doubles as a curtain. In 2018 Buibwa came out to her family and was kicked out of their home and disowned. Navigating the COVID-19 pandemic without the support of her family has been extremely difficult for her.

CARE ADAPTING TO COVID-19

SINAWI MEDINE | LE BARP, FRANCE | FEBRUARY 2021

Left: Elodie, an autistic resident of l'Airial du Nid de l'Agasse assisted-living facility, lives in what the facility's deputy director called "a parallel world full of life … [that] we are constantly exploring." *Below:* Caregivers engage Florence in a stimulating and calming multisensory experience involving light, music, and sensory objects.

Throughout the COVID-19 pandemic, the staff of l'Airial du Nid de l'Agasse continued their essential mission of caring for residents' health and emotional well-being by adapting their practices to new health and safety measures.

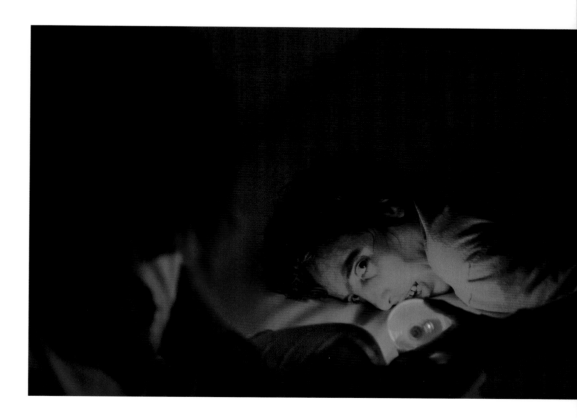

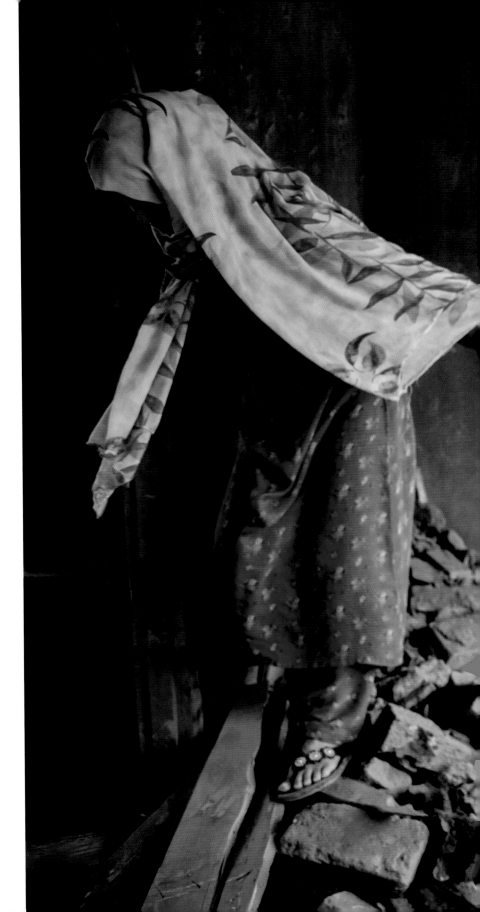

FACING QUARANTINE AND CONFLICT

SHOWKAT NANDA | SOPORE, KASHMIR
JULY 2020

Ayman (right), 10, and her sister Ulfat stand inside what used to be their kitchen. In July 2020 their home was destroyed in a gunfight between suspected Kashmiri militants supported by Pakistan and Indian soldiers in north Kashmir's town of Sopore.

Children in Kashmir have witnessed trauma on a daily basis. The COVID-19 pandemic slammed into a region roiling from years of bloody conflicts, which did not let up as the virus permeated bodies and minds. Studies have revealed that 75 percent of the children and adolescents in this long-contested region have experienced some kind of conflict-related trauma. Mental health advocates fear that in the wake of the COVID-19 pandemic, children here could experience an unprecedented rise in depression, anxiety, and post-traumatic stress disorder.

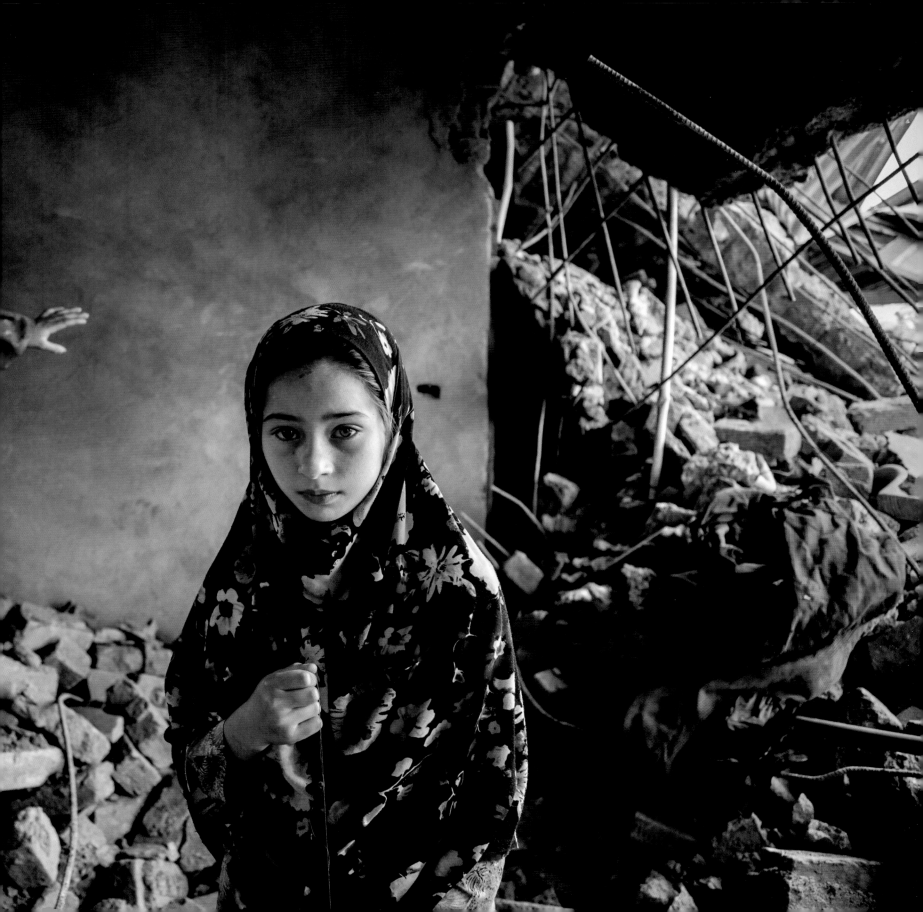

SOCIAL RESTRICTIONS FOR SPECIALIZED EDUCATION

LAURE D'UTRUY | MULTIPLE LOCATIONS, FRANCE | SEPTEMBER 2020–MARCH 2021

Left: Children with Down syndrome rehearse to take the stage, arranged by the association Rien Qu'un Chromosome en +, which brings them together to dance. *Right:* Abellino, eight, who has Down syndrome, practices with his swim teacher.

The pandemic increased educational inequities for children with disabilities in France by effectively eliminating the in-person visual communication, physical stimulation, and social interaction required for their development. Eventually, the government made exceptions for these children.

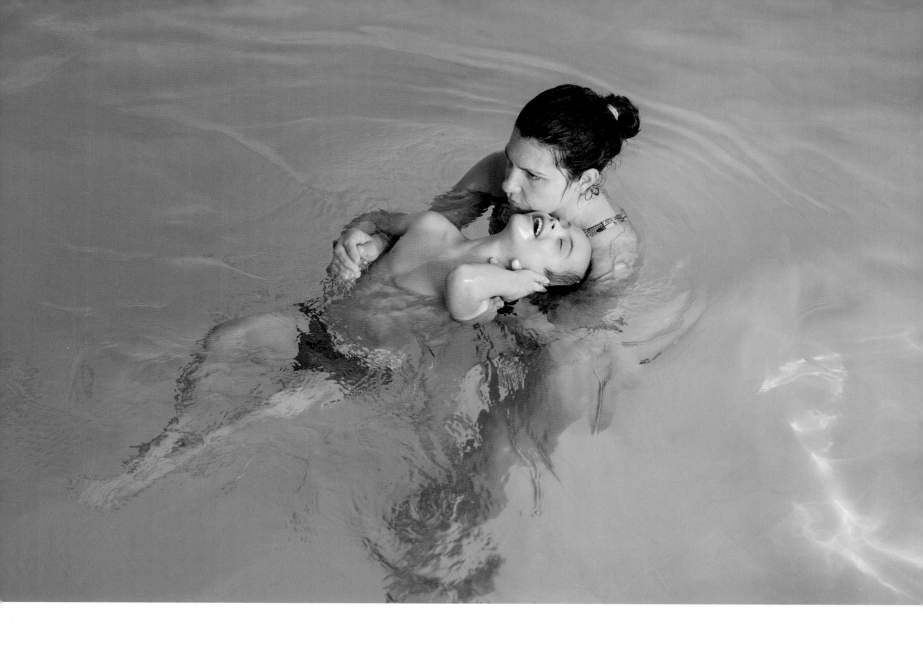

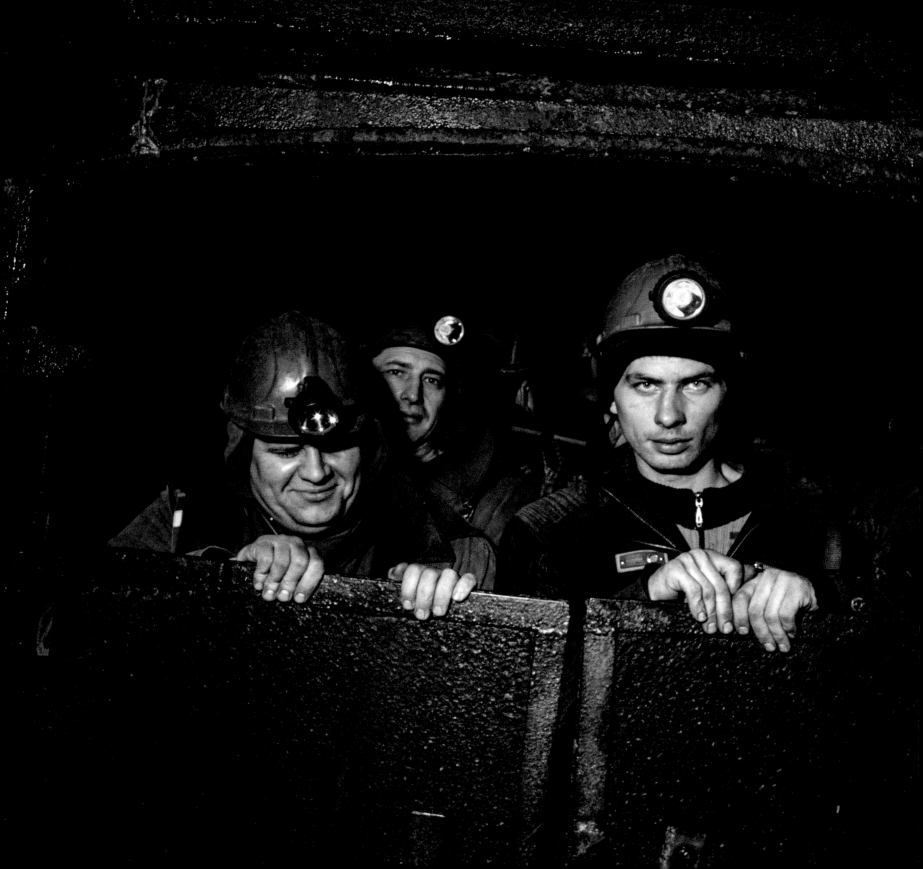

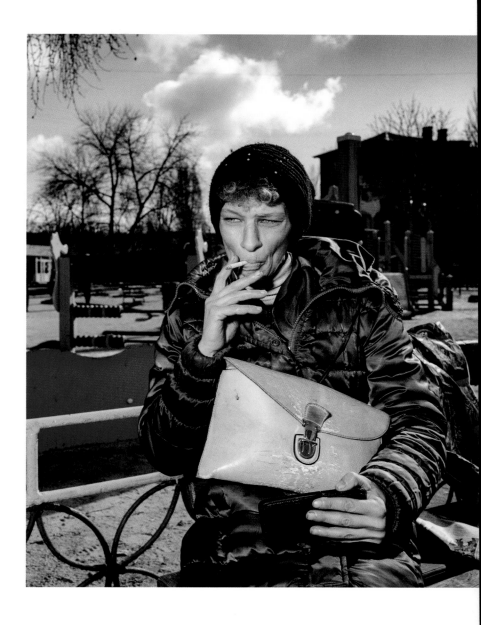

WHEN CRISES CONVERGE

MARK NEVILLE | MULTIPLE LOCATIONS, UKRAINE | FEBRUARY 2021

Left: Coal miners enter Hirs'ke Mine, located only three miles (5 km) from the front line of deadly clashes between the Ukrainian government and Russian-backed separatist forces. *Above:* A woman smokes a cigarette in the mining town of Myrnohrad.

When the COVID-19 pandemic hit, mining communities in eastern Ukraine were already embroiled in hardships. The global health emergency, living on the doorstep of a war, and wage arrears that left miners unpaid for months pushed many families into mental and physical health crises.

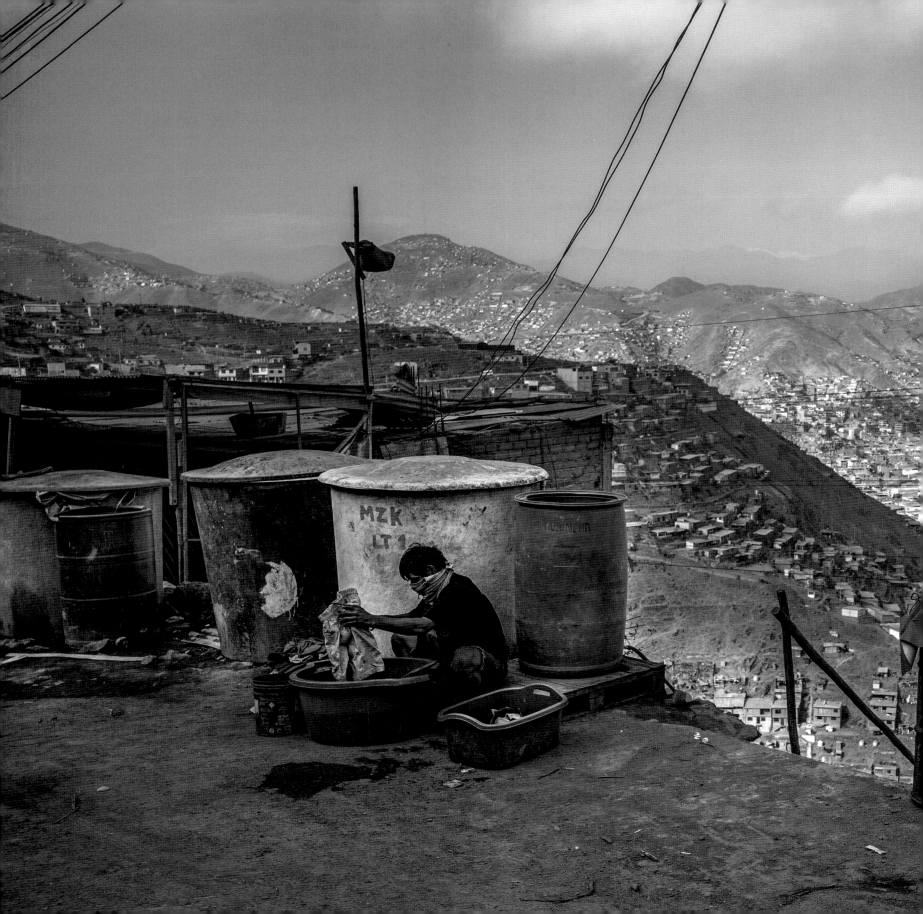

WATER SCARCITY AMID COVID-19

MUSUK NOLTE | VILLA MARÍA DEL TRIUNFO, LIMA, PERU | MAY 2020

A villager in Villa María del Triunfo washes clothes next to a water tank infrequently filled by tanker trucks. The scarcity of freshwater here forced residents of Villa María del Triunfo to pay up to 20 times more than the cost of water in wealthier areas of the city. This disparity, along with the inconsistency of deliveries, only worsened during the COVID-19 pandemic, given labor restrictions and the increased demand for water to realize more hygienic practices.

Behind the story: Using this story to raise awareness, photographer Musuk Nolte guided donations of food and sanitation supplies to Indigenous communities in Lima and pressured a local company to resume water deliveries to these communities.

WATER SCARCITY AMID COVID-19 CONTINUED

MUSUK NOLTE | VILLA MARÍA DEL TRIUNFO, LIMA, PERU | MARCH–APRIL 2020

Left: A resident of Villa María del Triunfo fills a tank with precious reserves of water. *Right:* Antonia Cabana, 46, stands above Villa María del Triunfo. Cabana and her family receive water once every 15 days and have learned to ration it.

Clean freshwater is both scarce and expensive among the low-income communities of Lima's arid outskirts–an issue that worsened as new hygiene protocols aimed at stopping the spread of COVID-19 placed an increased demand on this resource.

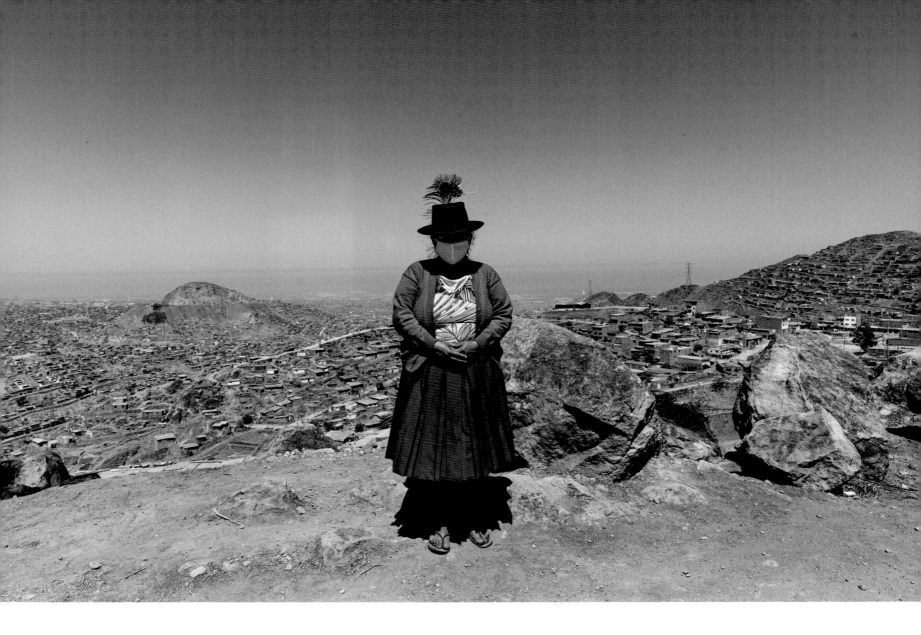

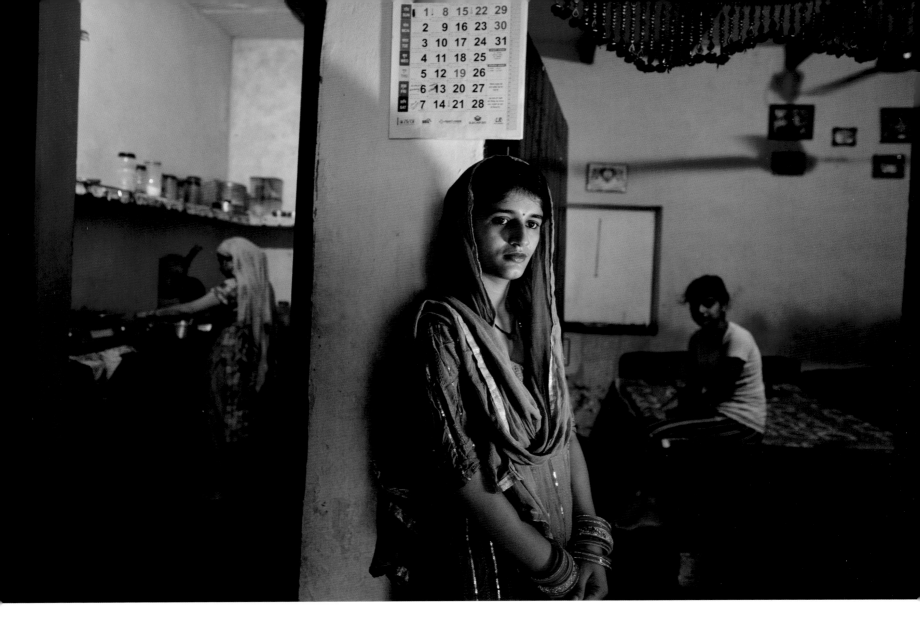

UNINTENDED CONSEQUENCES: CHILD MARRIAGES RISE

RUHANI KAUR | HARYANA, INDIA | AUGUST 2021

In 2018 Ashu (pictured above)—along with her sisters and a cousin—were married on the same day in accordance with Gujjar custom. In only ninth grade at the time, Ashu stayed at her parents' home after the ceremony. As the COVID-19 pandemic engulfed families in financial desperation and many girls could not afford to connect to school online, such marriages increased. Ashu was sent to live with her in-laws before her 12th-grade results were announced.

Behind the story: This portrait is part of a series by photographer Ruhani Kaur that explores the intertwined destinies of daughters struggling for education and mothers striving for financial independence during the COVID-19 pandemic.

MASS TESTING PRIMARY SCHOOLS AMID COVID-19

BRIAN OTIENO | NAIROBI, KENYA | MAY 2020

At a primary school in Kibera, Kenya, a health-care worker swabs a sample from a child during a mass test for COVID-19. Residents of this neighborhood, known as Africa's largest informal settlement, were at high risk for contracting COVID-19 as the community struggled with crowded living conditions, an inability to work from home, and unhygienic environments while lacking such basic necessities as soap.

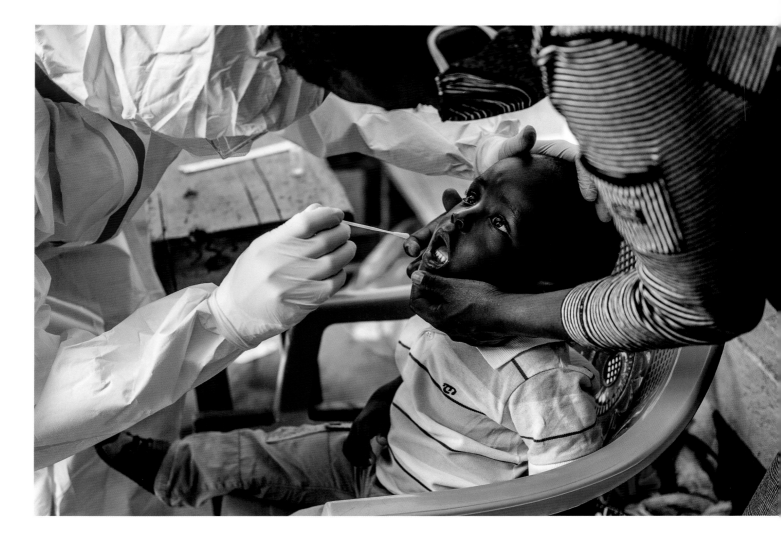

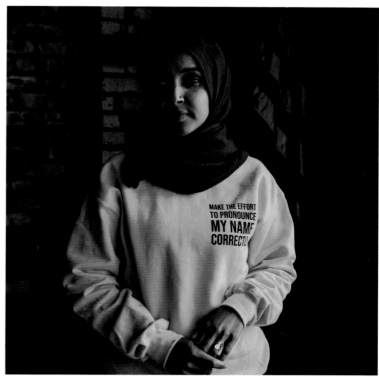

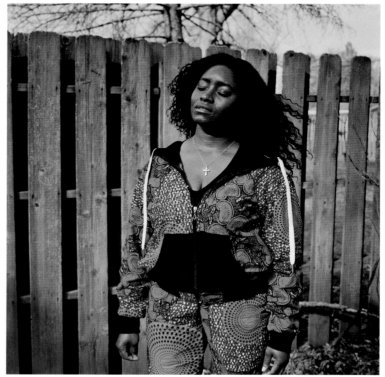

LOSS AND REMEMBRANCE
AMID DISPARATE IMPACTS

ANDREA ELLEN REED | MINNESOTA AND ILLINOIS, UNITED STATES
MARCH–APRIL 2021

Left: Theresa Neal reflects on the life of her "sister cousin," Sabra Mitchell, who succumbed to COVID-19 just before her son awoke from his COVID-19-induced coma. *Above left:* Simons Mortuary funeral co-directors Cynthia Gilkesson and James Gilkesson discuss homegoing services for their community. *Above right:* Representative Ilhan Omar speaks about how her father, Nur Omar Mohamed—whom she called her shield—passed away from COVID-19. *Bottom right*: Sokonie Reed recalls her feelings about losing her mother, Enid Zoe Freeman, to COVID-19.

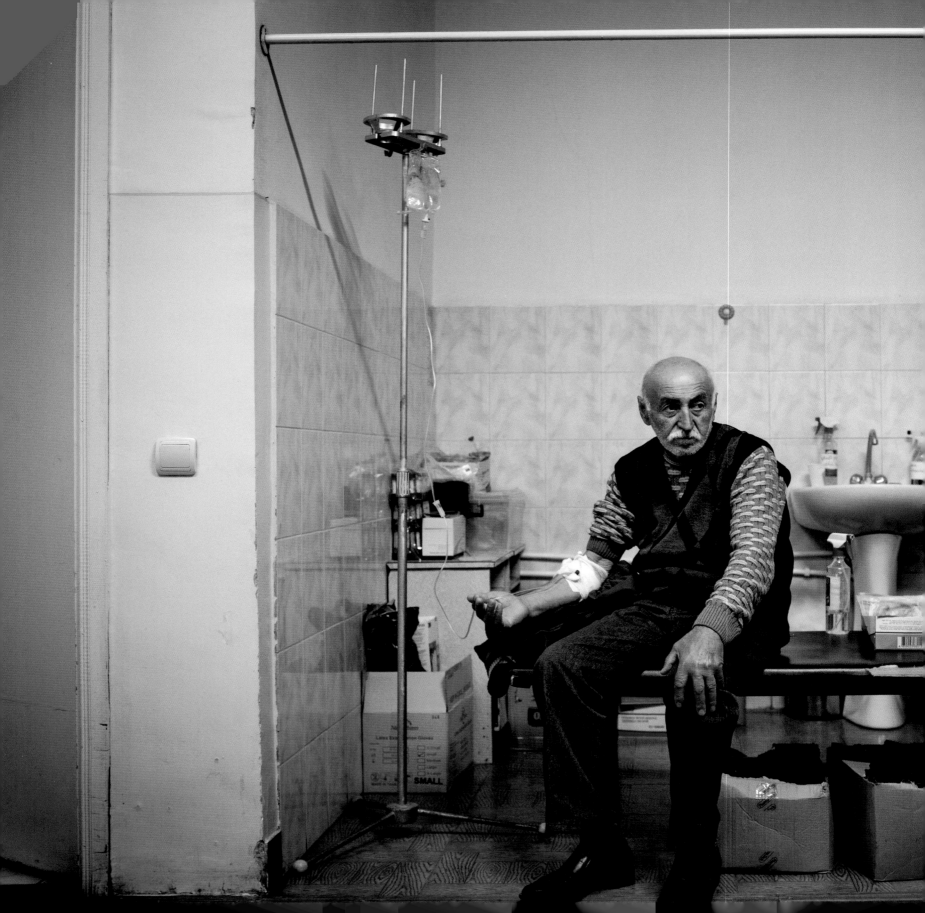

WAR AND
THE PANDEMIC

ANASTASIA TAYLOR-LIND
NAGORNO-KARABAKH, AZERBAIJAN
NOVEMBER 2020

A patient possibly infected with COVID-19 is treated at the Infectious Disease Hospital in Stepanakert in the disputed region of Nagorno-Karabakh. Azerbaijan and Armenia warred intensely for six weeks for control of the territory until a Russian-mediated peace deal on November 10, 2020, resulted in Azerbaijan retaining Nagorno-Karabakh and regaining control of surrounding districts.

The overlap of the war and the COVID-19 pandemic proved especially deadly for residents of Nagorno-Karabakh. Overwhelmed medical staff contracted and spread COVID-19, citizens sheltered together in groups, and the flow of refugees and volunteers quickly opened channels for the virus to invade communities affected by conflict. Rates of COVID-19, which had been comparatively low, began spiking amid violence, armed conflict, and bombings.

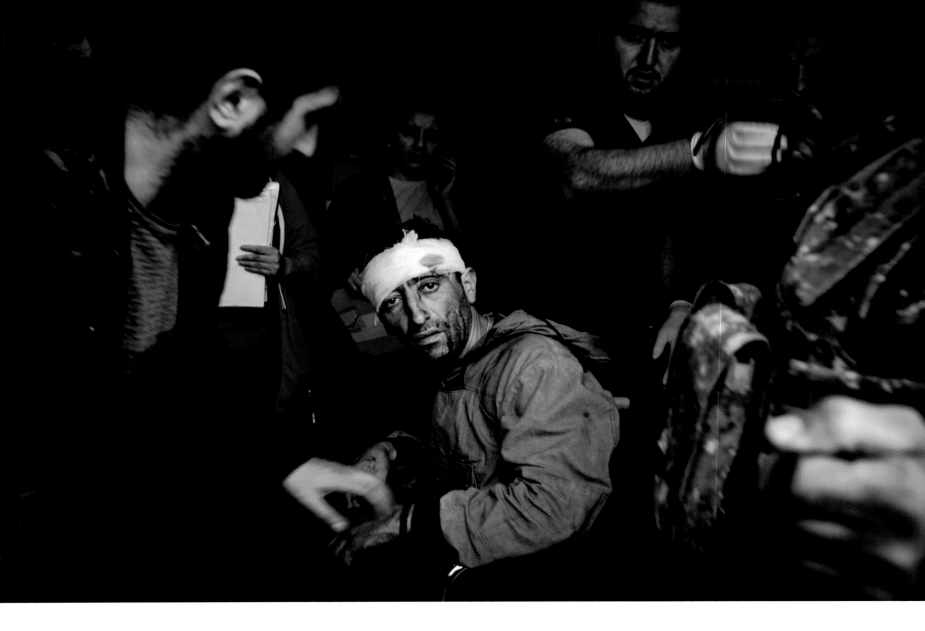

WAR AND THE PANDEMIC CONTINUED

ANASTASIA TAYLOR-LIND | NAGORNO-KARABAKH, AZERBAIJAN | NOVEMBER 2020

Left: An Armenian combatant wounded in the battle for Shusha is admitted to the Republican Medical Center in Stepanakert. *Right:* At a refugee processing center in Yerevan, Armenia, few occupants lie among emergency beds for displaced persons from Nagorno-Karabakh.

Amid horrific conflict in the disputed region, around 100,000 people fled Nagorno-Karabakh, leaving many elderly residents behind. COVID-19 rates spiked in conjunction with armed violence, bombings, and the movement of refugees—with deadly consequences for the area's most exposed people.

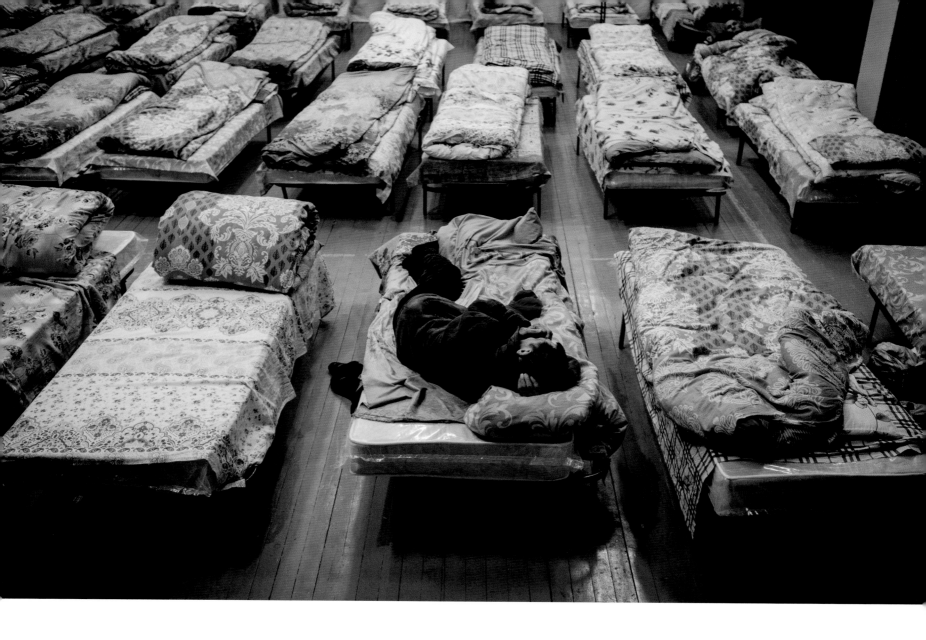

UNDER THE STIGMA
OF THE VIRUS

KAZUMA OBARA | KANSAI REGION, JAPAN
MAY 2020

Left: Medical staff clean a hotel
room that was used as a COVID-19
care facility for asymptomatic
and mildly symptomatic patients.
Right: A hotel room being used as
a COVID-19 care facility awaits its
next occupant.

In Japan, fear of COVID-19
infection led to the shunning of
health-care workers and those
recovering from the virus; many
medical workers quit their jobs
because of the discrimination.
Some recovering patients were
even forced to relocate after
returning home from the hospital.

*Behind the story: In Japan the
fear of association with COVID-19
was so strong that photographer
Kazuma Obara was not permitted
to photograph these patients or
their families, who preferred
anonymity. Instead, he
documented the rooms of this
makeshift care facility before the
patients arrived.*

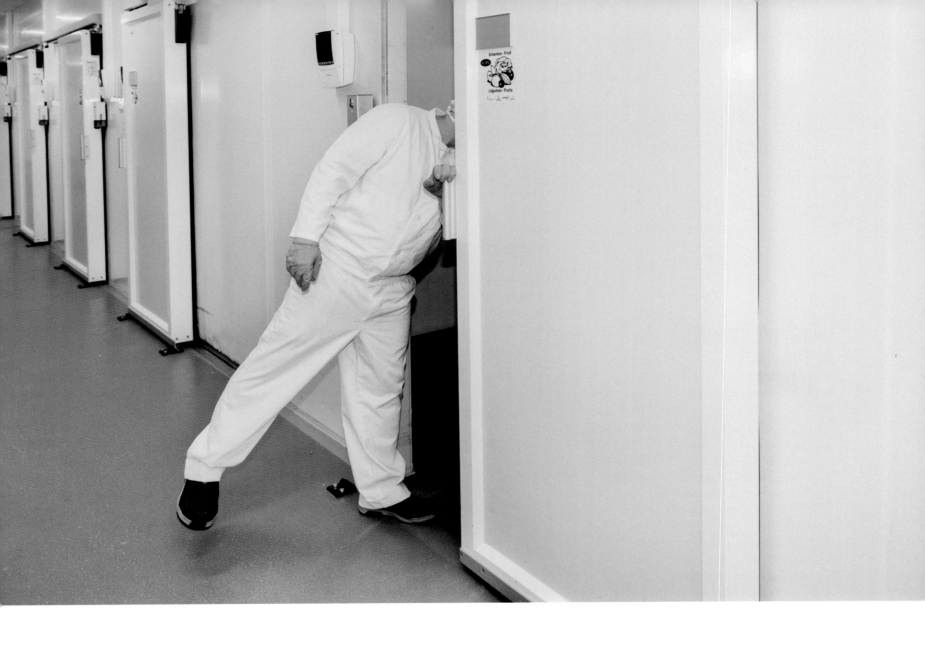

DOUBLE LOCKDOWN UNDER LOCK AND KEY

SANNE DE WILDE/NOOR | BEVEREN, BELGIUM | MAY 2020

Left: One of the inmates of the Beveren prison checks a kitchen refrigerator before locking up at the end of his shift. *Right:* The prisoner in charge of coordinating with prison staff to manage the work achieved by his department shows off a soccer ball in his cell.

Work is highly valued inside the prison. But as COVID-19 case numbers seesawed among the population, all labor was suspended aside from a few limited job opportunities in the kitchen.

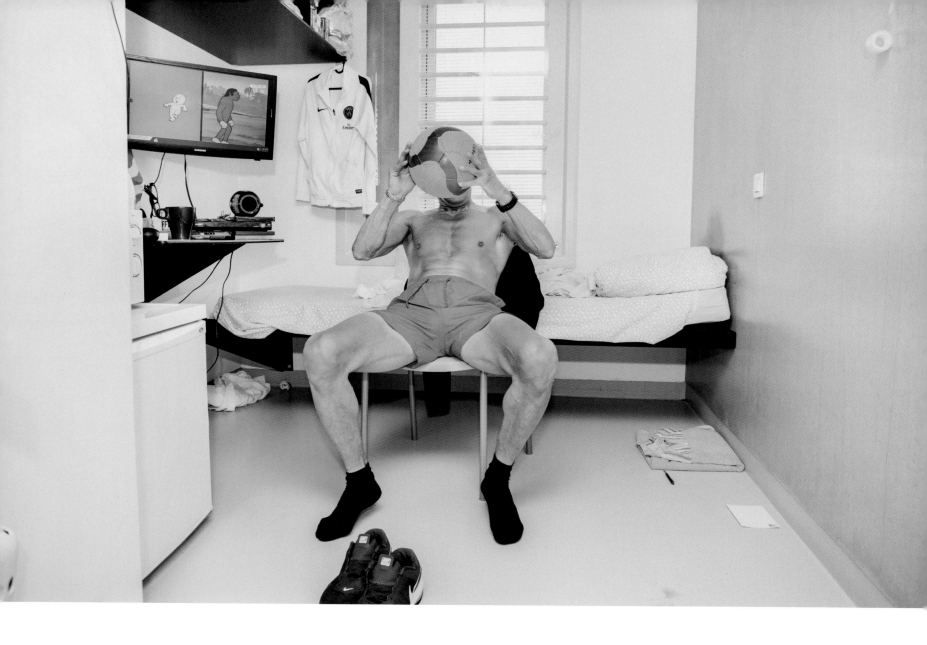

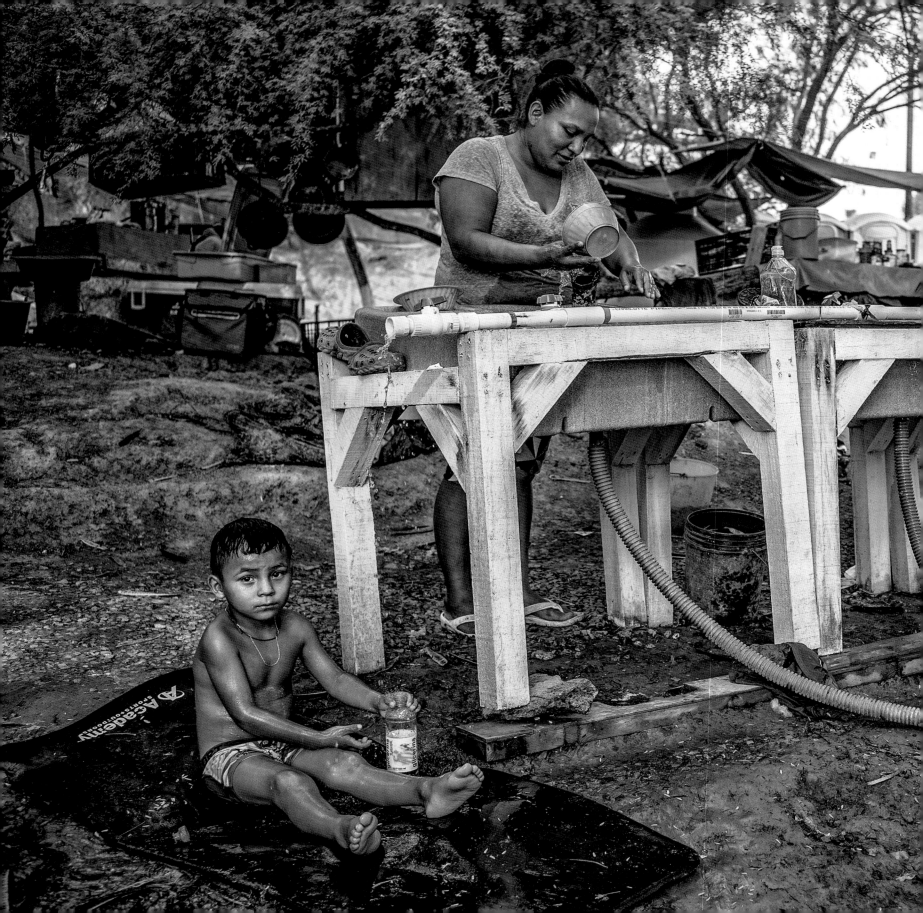

AWAITING ASYLUM AMID COVID-19

ALEJANDRO CEGARRA
MATAMOROS, MEXICO | SEPTEMBER 2020

Margarita Atanacio washes her clothes using a homemade washing pan, while her son bathes in water from the outgoing pipe. Roughly 1,500 asylum seekers from Mexico and Central and South America awaited asylum hearings—some for months at a time—in this improvised refugee camp in Matamoros, Mexico. The cramped and unhygienic conditions—including shared bathrooms, showers, and dining areas—put its residents at extremely high risk for transmission of COVID-19.

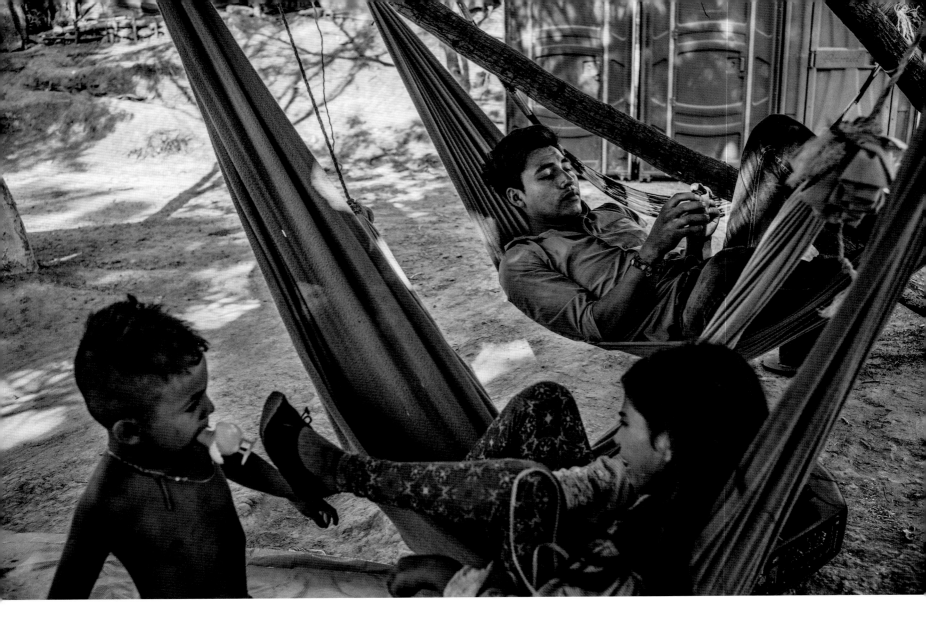

AWAITING ASYLUM AMID COVID-19 CONTINUED

ALEJANDRO CEGARRA | MATAMOROS, MEXICO | SEPTEMBER 2020

Left: Saul, a Mexican citizen seeking refuge in the United States, rests at a camp for asylum seekers in Matamoros. *Right:* Salvadorian children play inside a tent at the camp that was used as a dining room prior to the COVID-19 pandemic.

When the pandemic reached this provisional village, several nongovernmental organizations were forced to leave during the migrants' most pressing moment of need.

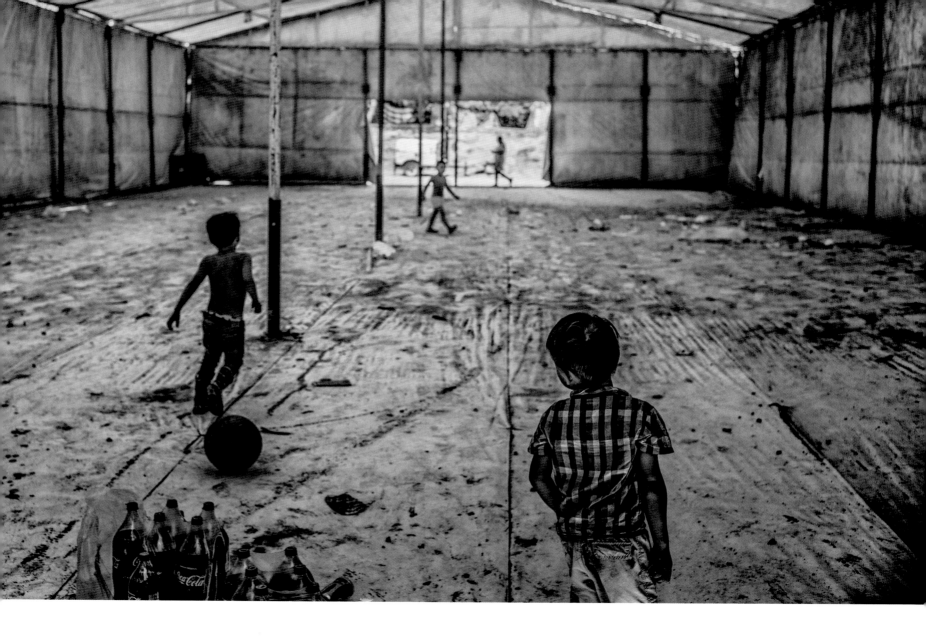

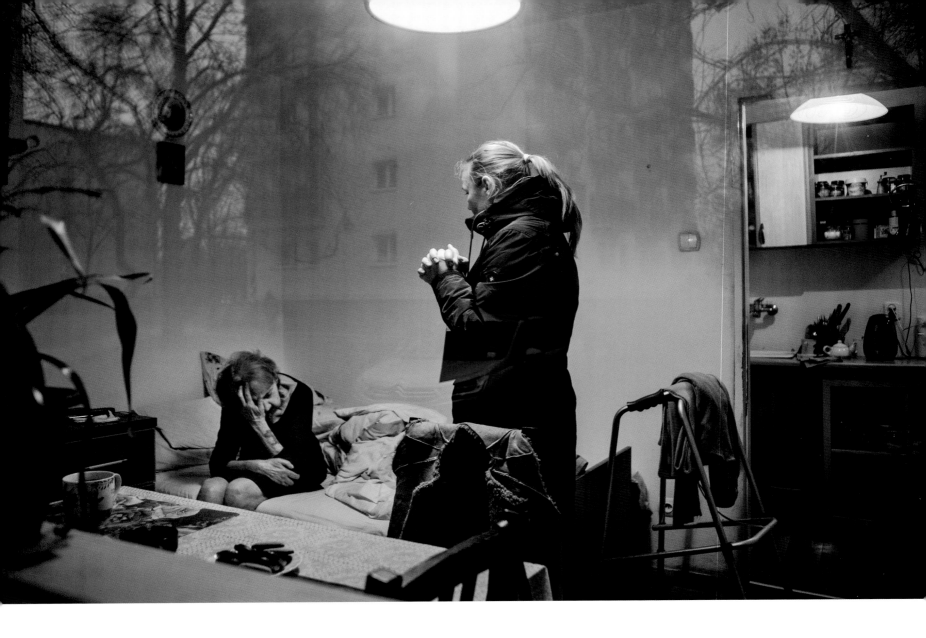

SUPPORTING THE ELDERLY

KASIA STREK | WARSAW, POLAND | DECEMBER 2020

Magda Gilarska, coordinator of the Senior Foundation of the Crown, checks in on Barbara Dabrowska, 79. Throughout the COVID-19 pandemic, Gilarska visited Dabrowska and a group of other senior citizens like her, delivering meals on weekends and coordinating and administering elder services. Gilarska became especially close to Dabrowska, who lived alone and had recently become visually impaired. During the pandemic she visited Dabrowska daily, brought her food, organized her medical appointments, and kept her company during this unprecedented time of social isolation.

SENIOR COMMUNITIES FACE COVID-19

RACHEL WISNIEWSKI | PENNSYLVANIA, UNITED STATES | MAY 2021

Phyllis R. uses a face mask to shield her eyes from the sun as she takes a nap outside Brandywine Living at Senior Suites in East Norriton, Pennsylvania. Phyllis lives at Brandywine, an assisted-living community, with Bill, her husband of 66 years. In 2020 six residents of Brandywine died from COVID-19, although all residents were affected by the new safety protocols, suspension of visitors, and looming threat of sickness.

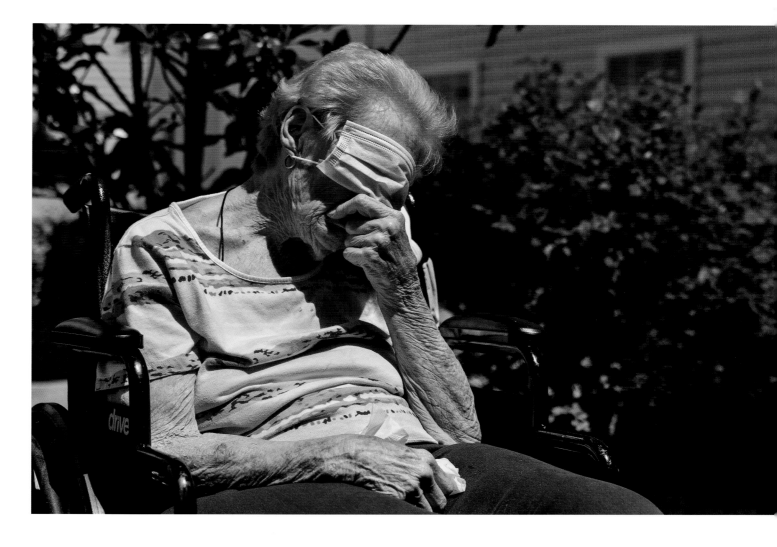

CAMPUS
CONFINEMENT

PAU VILLANUEVA
QUEZON CITY, PHILIPPINES | JUNE 2020

Two Indigenous Lumad teenagers
take a private moment at the
Bakwit School, which educates
close to 100 internally displaced
youths from Mindanao, an island
of the Philippines. The school is
located in Manila, which in 2020
had one of the highest rates of
COVID-19 cases in the Philippines.
Although teachers advised
Lumad students to avoid
isolating themselves from the
other students—especially during
a time when many were
reporting emotional distress—
some said they preferred the
social isolation.

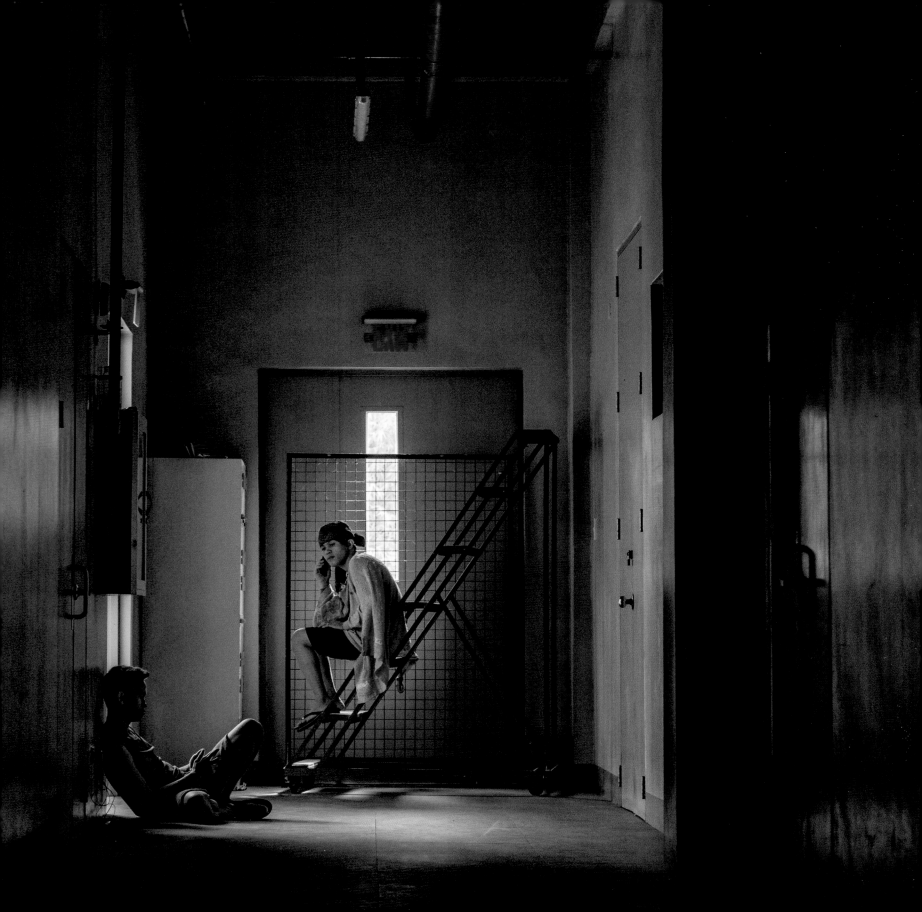

RECOVERY ON HOLD: COVID-19 THREATENS DISPLACED COMMUNITIES

JAMES RODRIGUEZ | LA TRINIDAD, ESCUINTLA, GUATEMALA | JUNE 2018-AUGUST 2020

Below: The Fuego Volcano erupts in August 2020 as seen from 15 de Octubre La Trinidad, one of the communities deemed uninhabitable after an earlier eruption on June 3, 2018, that killed hundreds and displaced thousands who had lived in surrounding villages. *Right:* Juan Ortiz, 63, stands on six feet (2 m) of volcanic debris that covers the former main thoroughfare of San Miguel Los Lotes following the 2018 eruption.

As COVID-19 reached Guatemala, hundreds still lived in cramped, hastily built transitional shelters without electricity or proper sanitation, placing them at extremely high risk for contracting the virus. The pandemic added a new urgency to their struggle for adequate housing and services.

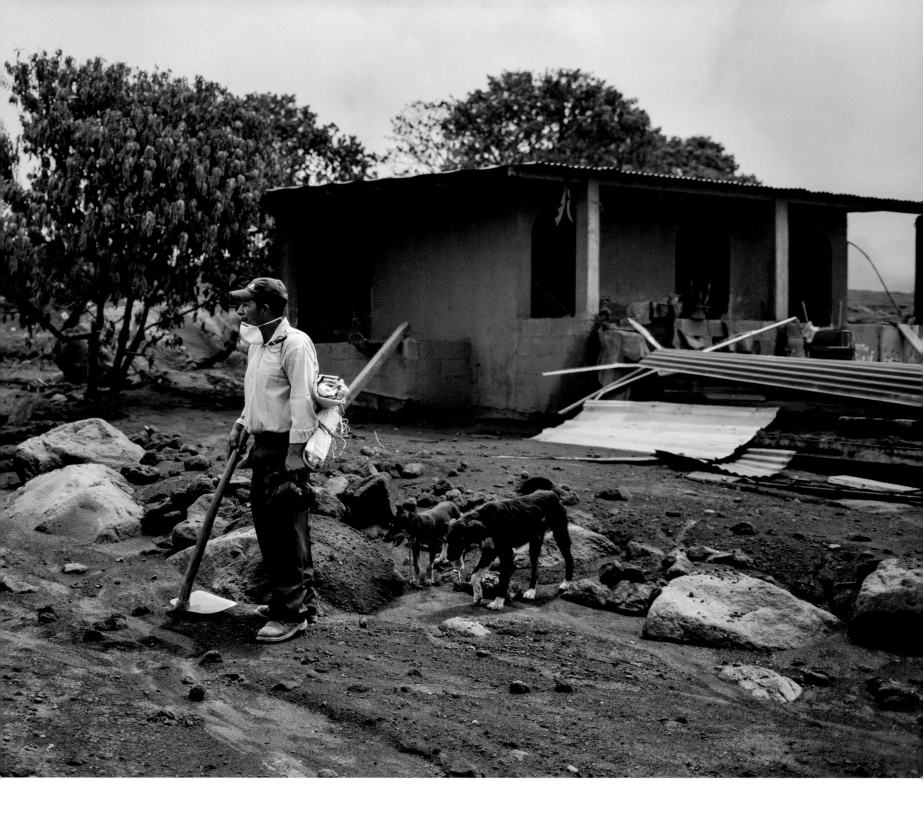

COVID-19 IMPACTS THE JOURNEY TO ASYLUM

DANIELLE VILLASANA | TAPACHULA, MEXICO
DECEMBER 2020

Alexa Smith pauses to wash her hair amid her journey to claim asylum in the United States. Smith, a Honduran transgender woman, was sexually assaulted as a minor during her first attempt to migrate; her current attempt was delayed after she broke her leg running from a sex work client who attempted to assault her. Even before COVID-19, many trans women faced dangers— including violence from gangs and assault by clients, police, and even family members—that sometimes forced them to seek refuge in a new place. But as the pandemic erupted around the world, asylum processes everywhere froze, compounding the already serious perils of migration, including border closings, travel restrictions, and the threat of the virus.

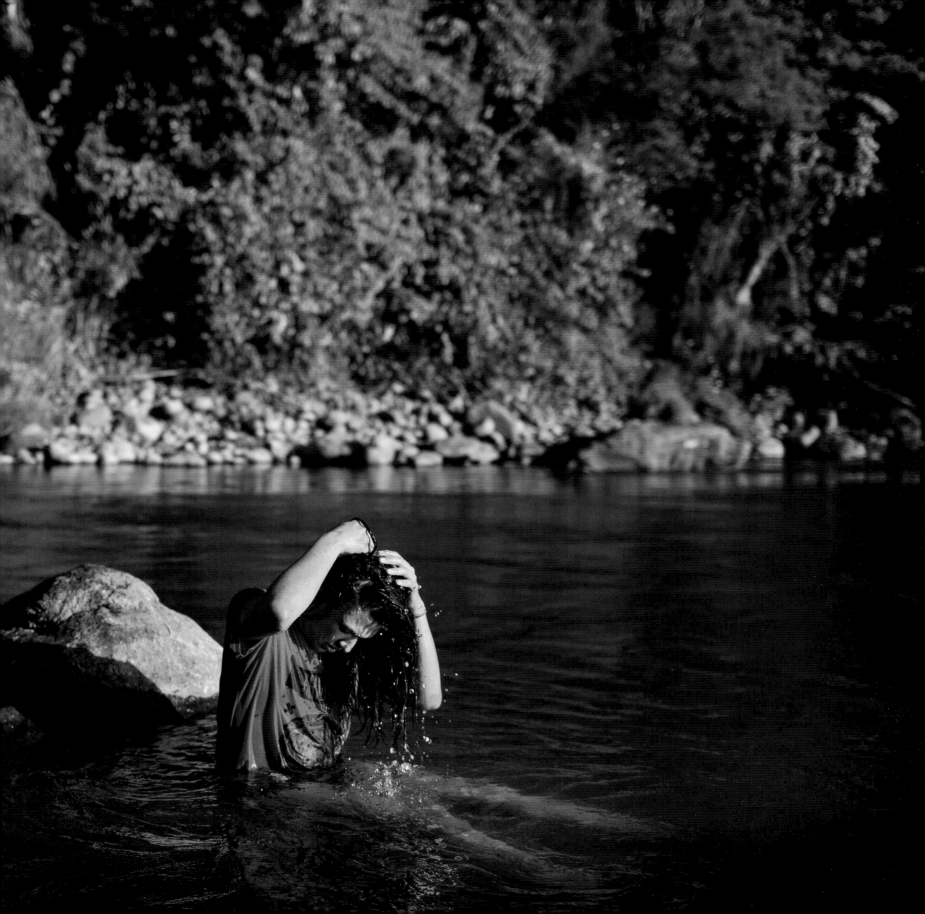

GRIEF

GRIEF GRIEF GRIEF GRIEF GRIEF GRIEF GRIEF GRIEF HOPE HOPE HOPE HOPE HOPE HOPE HOPE HOPE

HOPE

A LIGHT IN THE DARK. These days it seems that there is darkness all around us. The pandemic has claimed the lives of millions of people across the planet, and the full effects of the collective crisis remain unfathomable. But this shared experience has also forced us to find flickers of hope amid our rage and sorrow. New life has brought joy into the world in a troubling time. And vaccines are giving the world hope that we can fight this virus. The projects in the pages that follow examine our shared grief and our hope during the pandemic.

GRIEF

Wrapped in yellow infectious waste bags and plastic, the body of a suspected COVID-19 victim in an Indonesian hospital lies on their deathbed awaiting a body bag. To suppress the spread of the virus, the Indonesian Ministry of Health mandated that every suspected and confirmed COVID-19 death be handled with these precautions.

JOSHUA IRWANDI | INDONESIA | APRIL 2020

Behind the story: Upon publication on National Geographic's Instagram account, this image went viral, sparking much debate around the handling of the virus in Indonesia. Since its initial posting, this image has received thousands of online references, millions of impressions on social media, and multiple awards for impactful journalism.

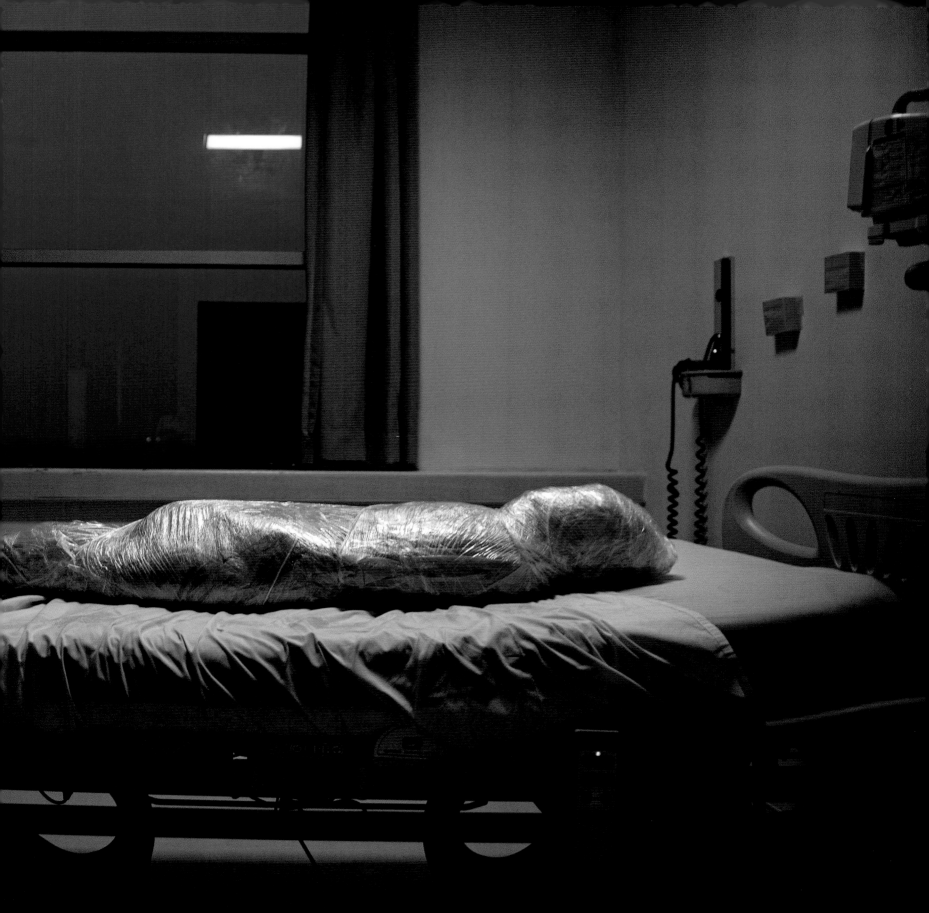

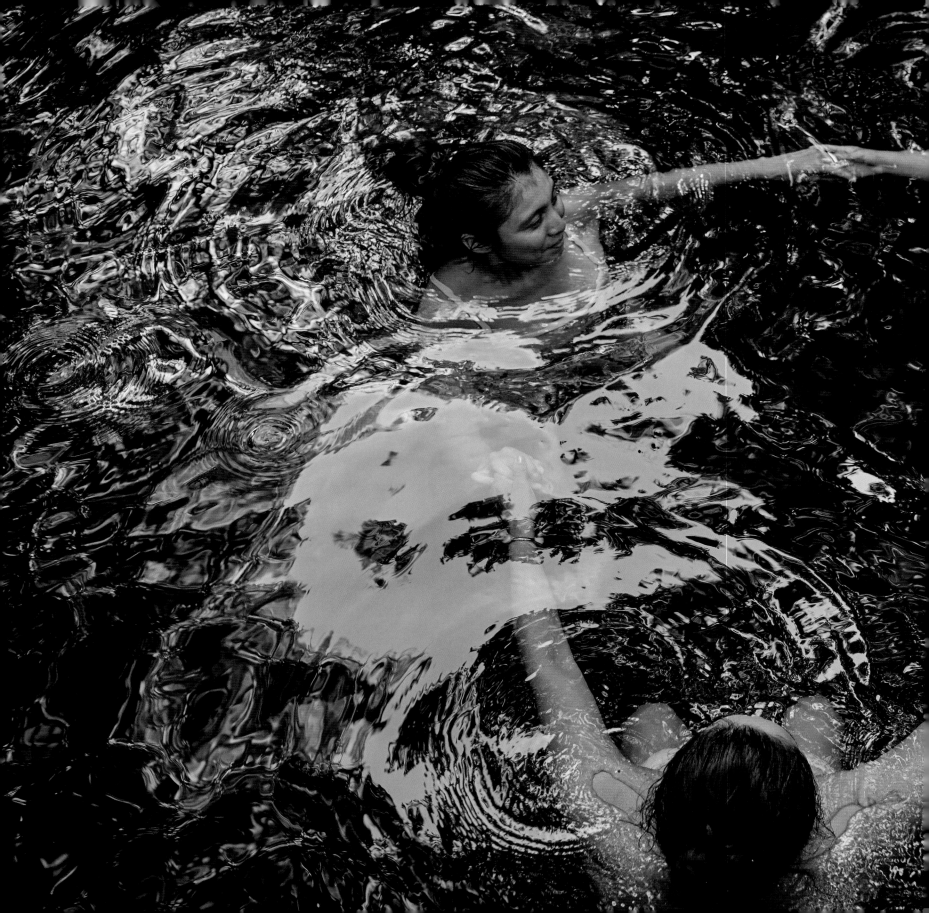

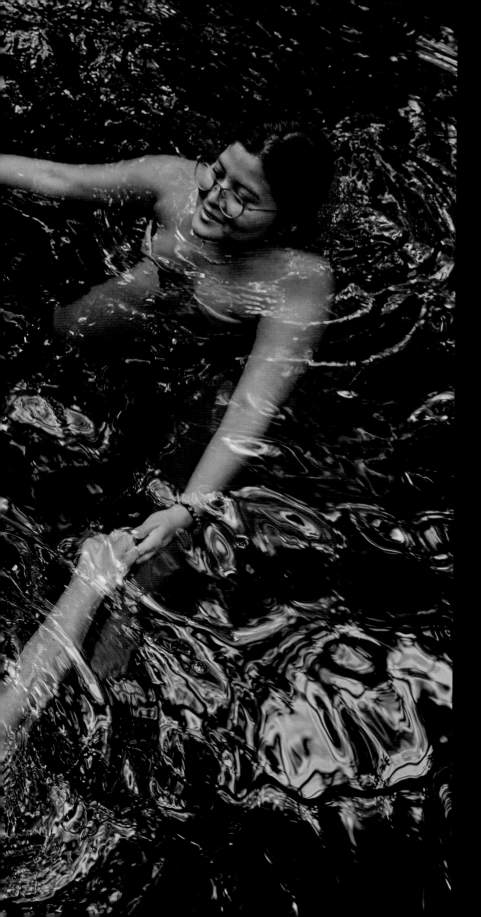

HOPE

Maya women Grecia (left), Maritza (center), and Dulce (right) take a break in a cenote during a rural campaign to urge women in need to seek assistance at Casa de la Mujer Indígena. This safe place, located in the city of Felipe Carrillo Puerto, Mexico, offers care to women who have been victims of violence or who need legal assistance, psychological care, or health care. The COVID-19 pandemic hindered Casa de la Mujer Indígena's ability to inform communities of the services available, since it relies heavily on word of mouth and social interactions.

MAHÉ ELIPE (IN COLLABORATION WITH LIZBETH HERNÁNDEZ)
FELIPE CARRILLO PUERTO, MEXICO
JUNE 2021

317

STORM ON THE HORIZON: Wild weather is visible outside a window in Jakarta during COVID-19-induced social restrictions known locally as PSBB (short for *pembatasan sosial berskala besar*, translated as "large-scale social restrictions"). These constraints proved detrimental to Jakarta's economy, with

ESSAY

THE HUMAN COST OF COVID-19

BY JOSHUA IRWANDI

Joshua Irwandi is a documentary photographer based in Jakarta, Indonesia. His Emergency Fund-supported project covered struggle and resilience in Indonesian hospitals during the COVID-19 pandemic. One of his images, "The Human Cost of COVID-19" (pages 314-315), went viral after publication by National Geographic *magazine.*

Ambulances lined up, sirens off, emitting crimson and blue lights. As they arrived, gravediggers carried the plain white coffin off an ambulance and onto the plot. Families followed behind, their members holding their phones for video calls.

Soon enough, an excavator rolled through the mud. Nearing the plot, it swiveled, carrying the soil and dropping it on top of the grave. The families lamented. As one family ended a ritual, another waited. As one grave was filled, gravediggers made way for another.

Such is the sound of Rorotan cemetery in Jakarta, Indonesia, the epicenter of the COVID-19 pandemic in Asia, midway through 2021. To experience Rorotan is to be shattered.

In July 2020 *National Geographic* published my image of a suspected COVID-19 victim wrapped in layers of plastic in a hospital awaiting a body bag. As a photojournalist embedded with the medical workers, I wanted first and foremost to highlight the human cost of the coronavirus and to appreciate the medical workers who were continuously risking their lives to save ours. I wanted people to know what the reality was after months of statistics and shifting advice.

In an unforeseen turn of events, the image went viral and received polarizing reactions on social media. Celebrities and government officials doubted the veracity of the image. I was accused of setting up the photo to spread fear. I was called a "slave of WHO" and an "agent of the Jews." I received racial abuse and violent threats. I read the fear behind these reactions—the power in showing people what might happen to them.

Knowing that time is finite, we turn to gratitude for every minute we are allowed to be alive. We take new courses of action, with science leading the way. We seek for answers, to see light, to find a way out.

While it will take all our might to fight the pandemic, ultimately it is our ability to hope that will truly win us this battle. It is the very essence of our survival.

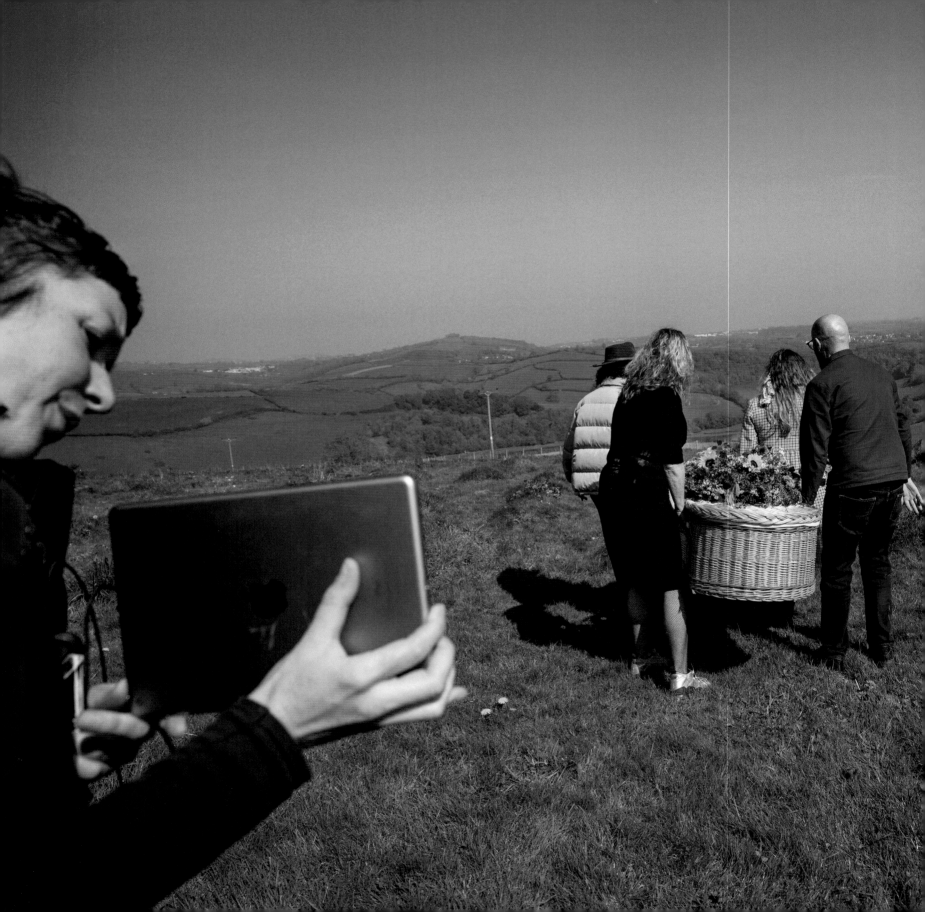

SAYING GOODBYE
AMID COVID-19

LYNSEY ADDARIO | TOTNES, ENGLAND
APRIL 2020

Claire Callender (second from
left), 57, director and co-founder
of the Green Funeral Company,
is helped by her partner, Ru
Callender (right), 49, as they
prepare to lower her mother's
body into the ground. Due to
COVID-19 restrictions, Claire
was forced to personally lead a
funeral service for her mother,
Rosemary Phillips, who died of
natural causes at 84. Claire
used Zoom (a popular video
communications platform) to
include her siblings and father
in the service.

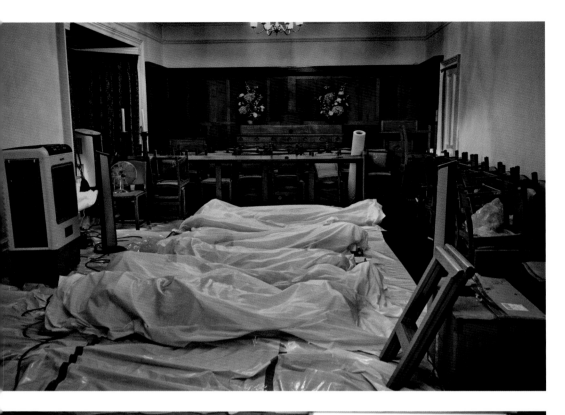

SAYING GOODBYE AMID
COVID-19 CONTINUED

LYNSEY ADDARIO | SURREY, ENGLAND
MAY 2020–MAY 2021

Above left: An overflow of bodies is laid out on the chapel floor of a funeral home forced to incorporate makeshift storage methods to accommodate the deceased. The enterprise handled double the amount of funerals than it had prior to the COVID-19 pandemic. *Below left:* Zak Rolfe, a pallbearer at Stoneman Funeral Services, takes protective precautions as he prepares to remove a pacemaker from the body of a COVID-19 victim.

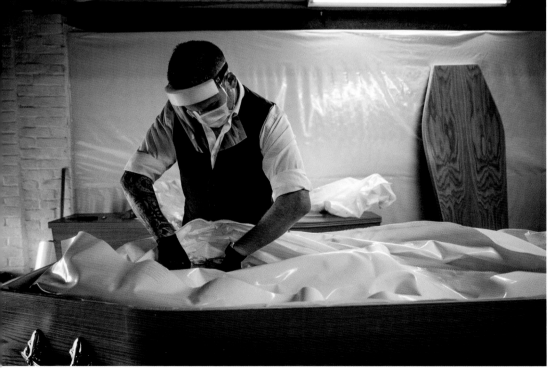

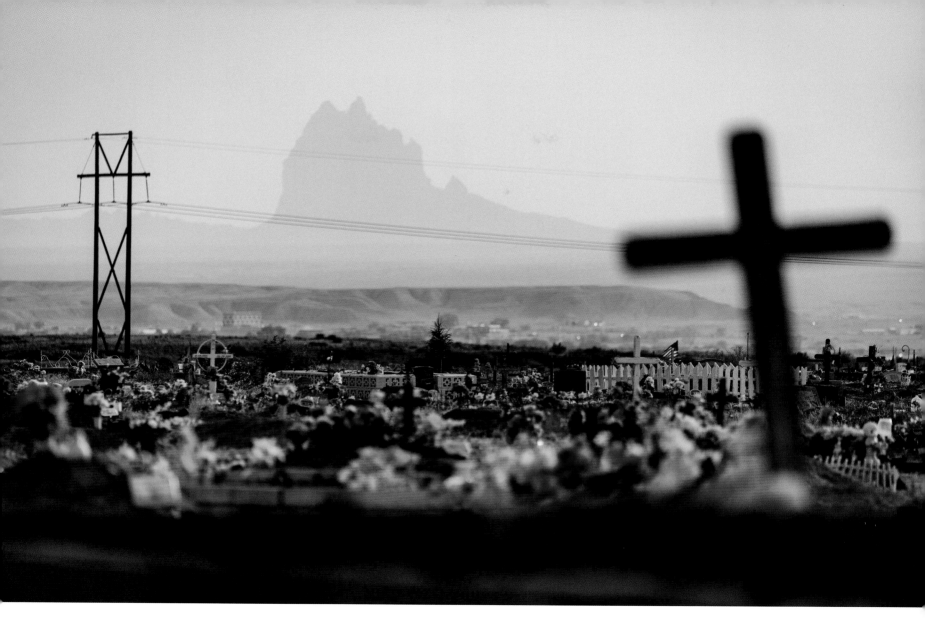

DISPARATE DEVASTATION

TARA KERZHNER | NAVAJO NATION, UNITED STATES | AUGUST 2020

A sudden abundance of activity at a cemetery in Shiprock, New Mexico, demonstrates how severely the earliest wave of COVID-19 impacted the Navajo Nation. Soon, painful stories of families losing multiple relatives in just a matter of days emerged. The pandemic's devastation left few untouched and threatened an entire culture and language that is preserved by elderly community members. Overcrowded housing, a lack of running water and electricity, in-person jobs, and long-standing poverty and health disparities left the Navajo community highly susceptible to COVID-19.

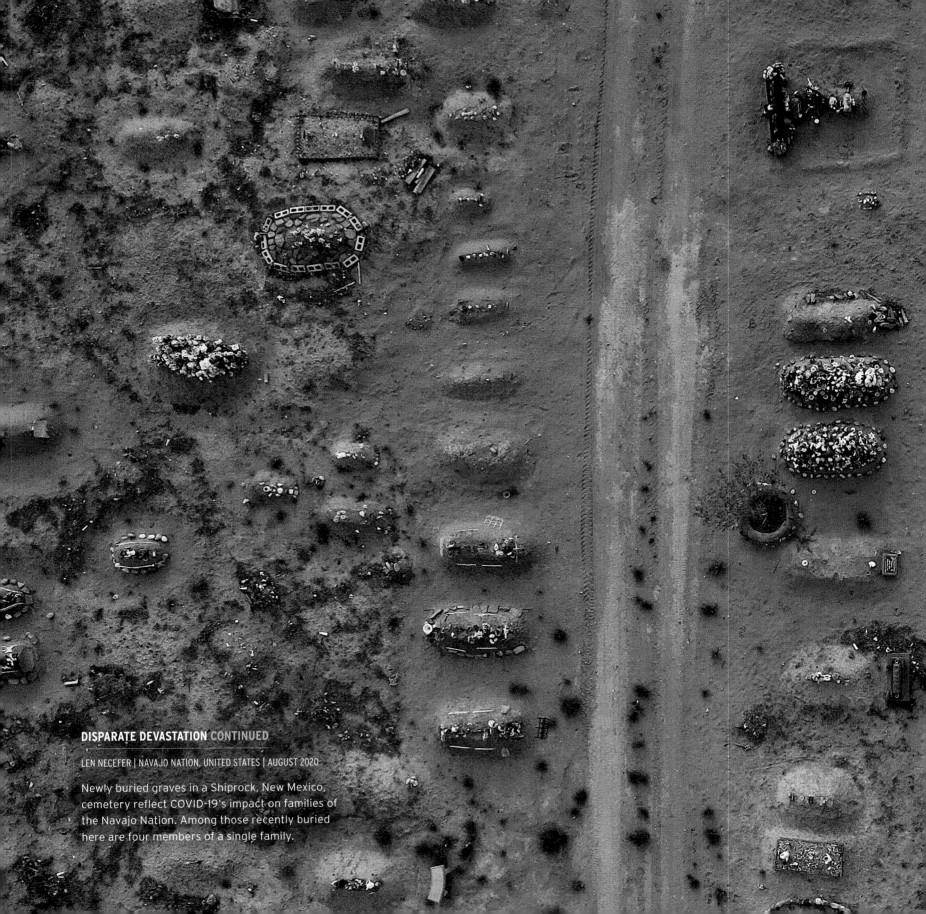

DISPARATE DEVASTATION CONTINUED

LEN NECEFER | NAVAJO NATION, UNITED STATES | AUGUST 2020

Newly buried graves in a Shiprock, New Mexico,
cemetery reflect COVID-19's impact on families of
the Navajo Nation. Among those recently buried
here are four members of a single family.

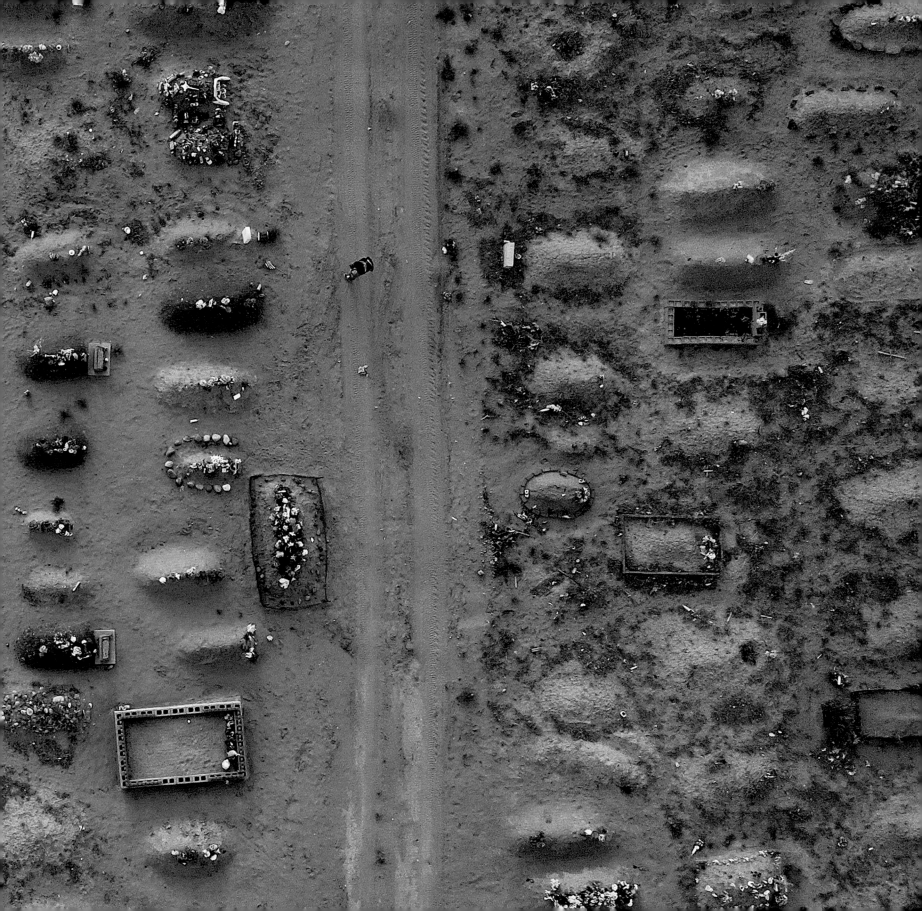

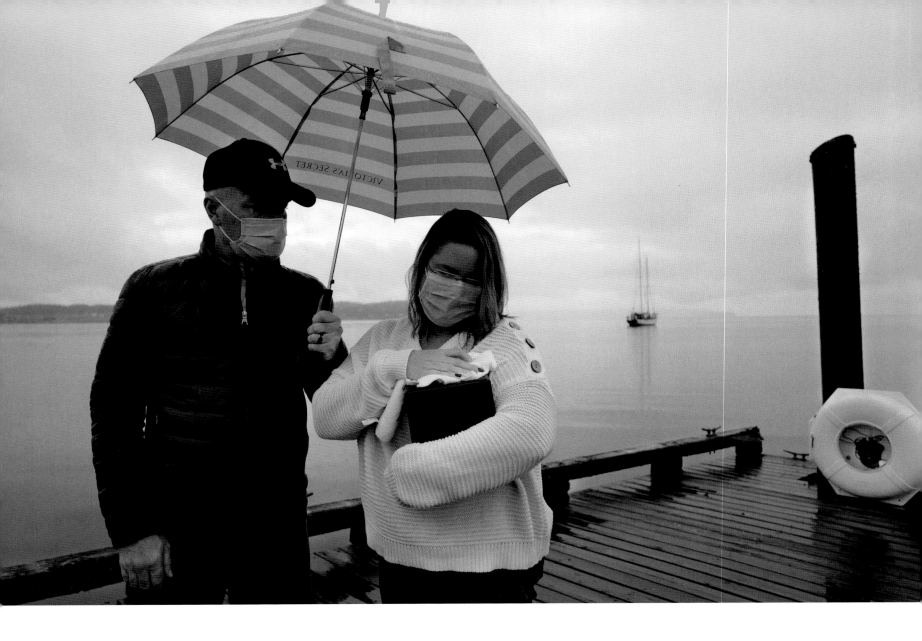

NO CHANCE TO SAY GOODBYE

LYNN JOHNSON | WASHINGTON, UNITED STATES | APRIL 2020

Accompanied by her husband, Dawnelle Conslik stands on the Coupeville boardwalk by Puget Sound, holding the box that contains her mother-in-law's ashes in what was once her favorite earthly place. Conslik worked as a nurse in a medical center close to her mother-in-law's nursing home. When she heard that her mother-in-law had passed away from COVID-19, she ran through the parking lot to say goodbye, only to see her body being hastily loaded into a van to avoid possible transmission.

LIVES LOST TO COVID-19

LORENA RÍOS TREVIÑO AND ARMANDO VEGA | TLAPA DE COMONFORT, MEXICO | SEPTEMBER 2020

Five months after the death of her son, Claudio Ortega Maldonado, Juana Maldonado receives his ashes from Juan Carlos Ruiz, a Lutheran pastor and co-founder of the New Sanctuary Coalition. The delay in receiving his remains stemmed from complications of the pandemic, which had slowed bureaucratic processes and travel. In April 2020 Claudio died of COVID-19 in a New York City hospital, along with thousands of other undocumented migrants and essential workers. He had left Mexico when he was 16 and died at 29 without seeing his family again.

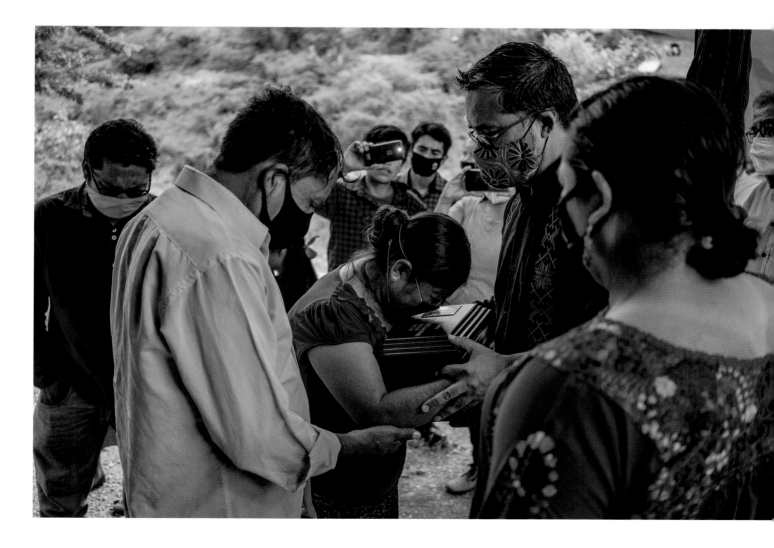

YET ANOTHER GRAVE

CÉDRIC GERBEHAYE | LA LOUVIÈRE, BELGIUM
MARCH 2020

Maxime and Alphonso, grave-diggers employed by the city of La Louvière, create a plot in the old cemetery of Haine-Saint-Pierre. Successive surges of COVID-19 put a strain on these workers.

Behind the story: Some of the images in this series by Cédric Gerbehaye will be included in the La Louvière archives as official historical record keeping.

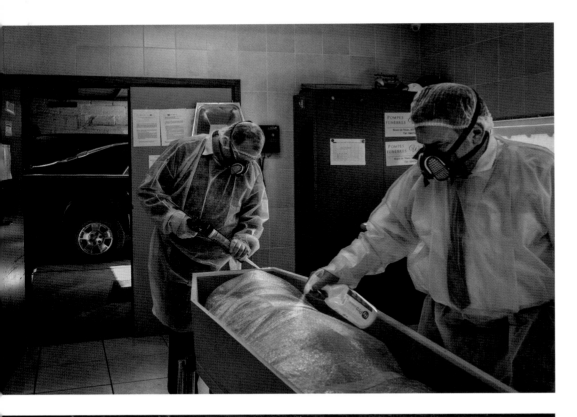

CÉDRIC GERBEHAYE | LA LOUVIÈRE, BELGIUM
MARCH 2020

Top: Greg and Jean-Pierre, employees of Donato funeral services, seal the coffin of a 48-year-old man who died of COVID-19. Both men were exhausted, having worked several days on end. *Bottom:* A protective suit, a face shield, and a stethoscope potentially contaminated by the virus lie on the ground where they were left by a doctor who treated a suspected COVID-19 patient in the emergency room of Tivoli University Hospital Center.

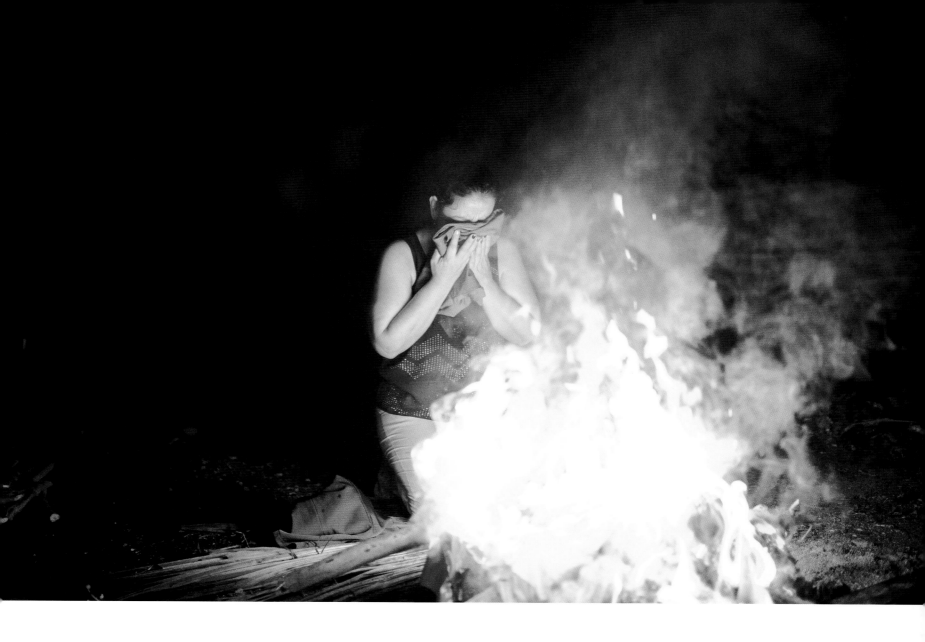

A FAMILY'S FAREWELL

ANDRÉS CARDONA | PUERTO RICO, COLOMBIA | OCTOBER 2020

Enid holds the clothes of her mother, Mary, who died of COVID-19. Mary had requested that her belongings be cremated when she died. Amid restrictions on gatherings and burials during the COVID-19 pandemic, the family was unable to perform the traditional Catholic rituals according to their faith. So they gathered around a campfire to fulfill Mary's request, providing them a moment to say farewell.

Behind the story: Photographer Andrés Cardona documented how grief in Colombian Amazon communities manifests after the death of a family member amid the isolation and uncertainty of a global pandemic.

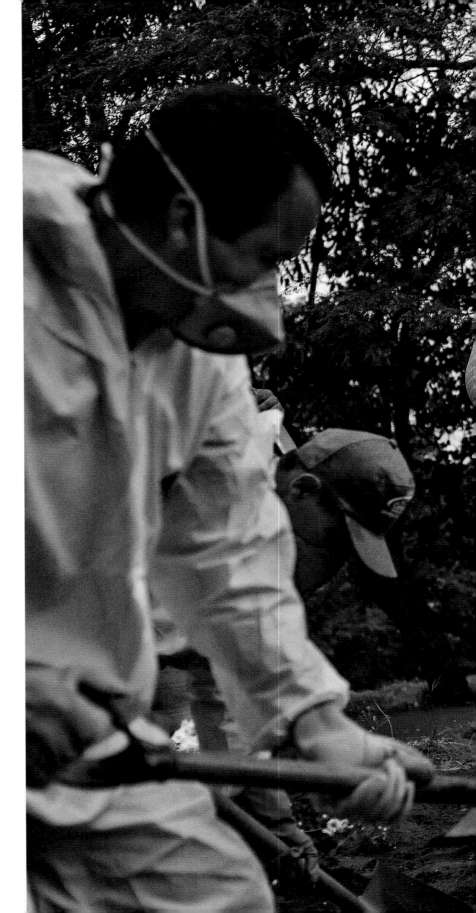

FUNERALS TRANSFORMED

RAFAEL VILELA | SÃO PAULO, BRAZIL
APRIL 2020

In São Paulo, gravediggers from Vila Formosa, the largest cemetery in Latin America, bury a possible victim of COVID-19 with his family in attendance. By November 2021 Brazil had registered more than 600,000 deaths due to the pandemic, according to the Ministry of Health. Attendees of burials were restricted, and social distancing guidelines were in effect, as government safety protocols were toughened to prevent further spread of the virus.

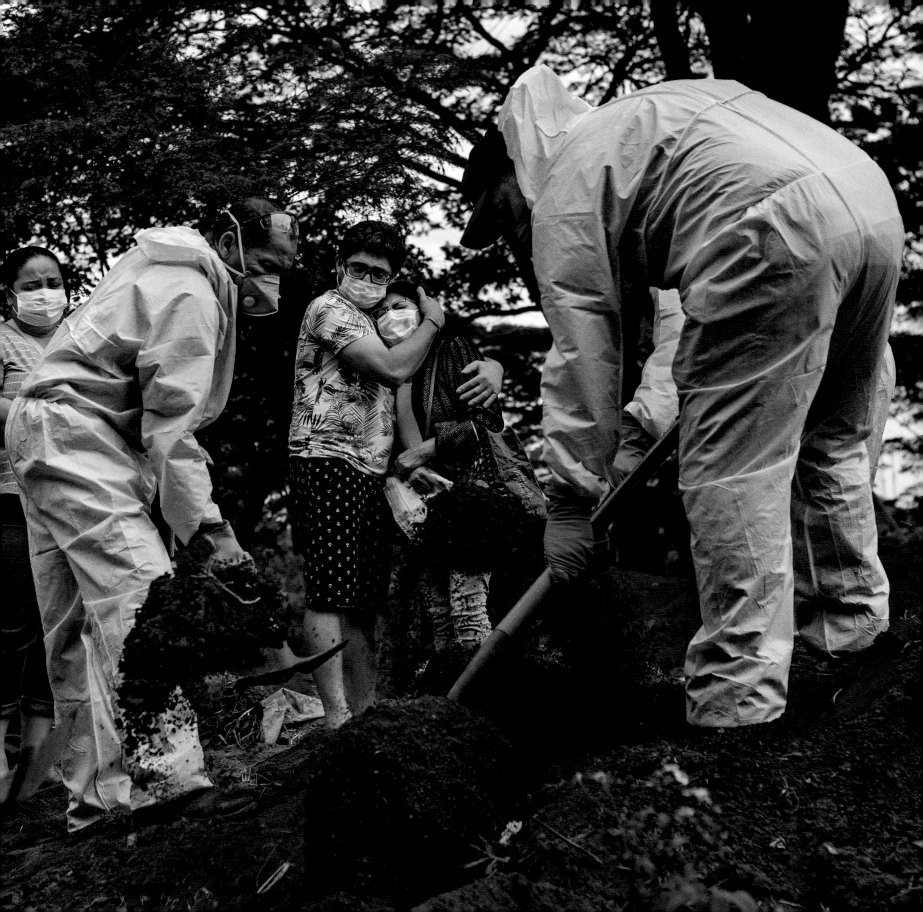

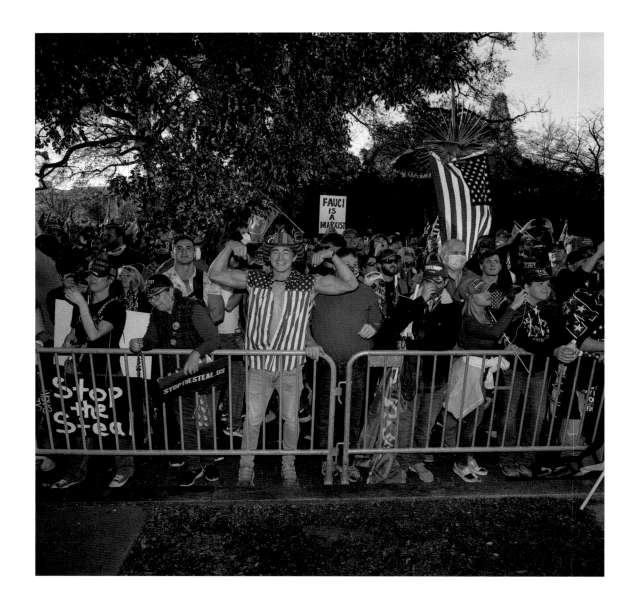

COVID-19'S POLITICAL IMPACT

LOUIE PALU | WASHINGTON, D.C., UNITED STATES | NOVEMBER 2020

Above: Thousands of mostly maskless demonstrators rally in front of the U.S. Supreme Court to support President Donald Trump's unproven claims of voter fraud in the 2020 election. *Right:* Protesters demonstrating against President Trump on election night in Washington, D.C.'s Black Lives Matter Plaza use umbrellas to shield their identities.

The COVID-19 pandemic affected broad aspects of U.S. government policy and American identity, including race, science, law, and history, and became a central issue in the 2020 presidential election.

PANDEMIC-SPARKED PROTESTS

STEPHEN FERRY | BOGOTÁ, COLOMBIA | MAY 2021

Left: Protesters disperse after officers of the Mobile Anti-Riot Squad direct a water cannon at their barricades. *Below:* Protesters gather in Bogotá.

In April and May 2021, as the COVID-19 pandemic worsened economic hardship and deepened furrows of social inequities, thousands of Colombians took to the streets daily to demonstrate against the government.

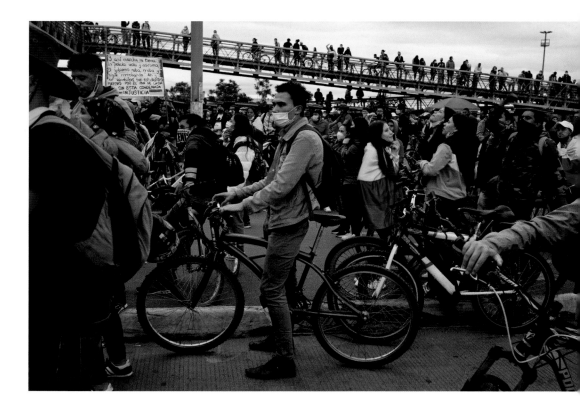

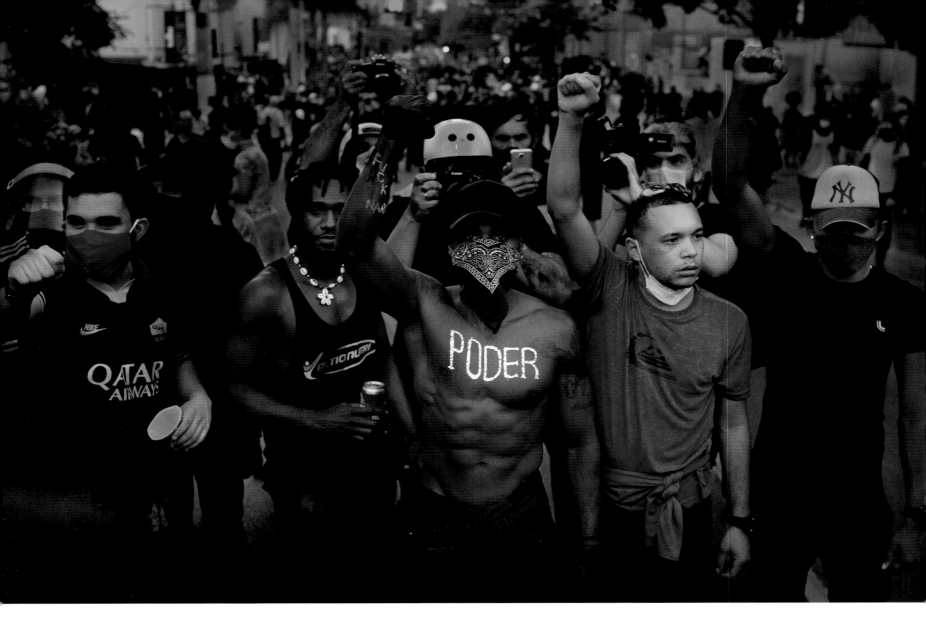

UNREST RESONATES GLOBALLY

RAFAEL VILELA | SÃO PAULO, BRAZIL | JUNE 2020

Left: Protesters gather in São Paulo, Brazil. *Right:* A man holds a sign that reads "*Racism é um vírus*—Racism is a virus." Inspired by the protests in the United States that followed the murder of George Floyd by a police officer, demonstrations erupted in Brazil in solidarity with the Black Lives Matter movement and to voice support for the country's democracy. The COVID-19 pandemic here pushed previously stable population segments toward food insecurity and jeopardized their access to such basic services as water, housing, and health care.

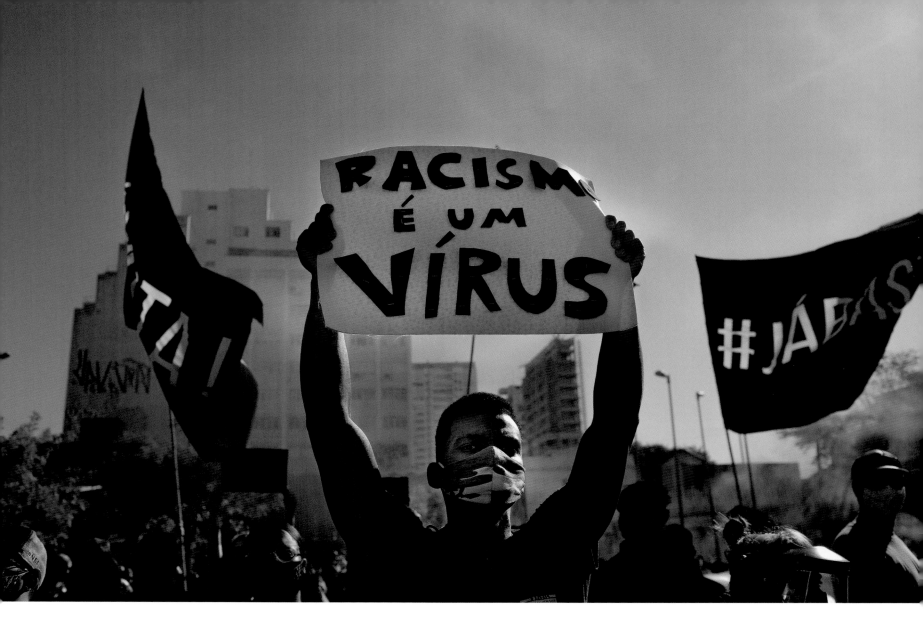

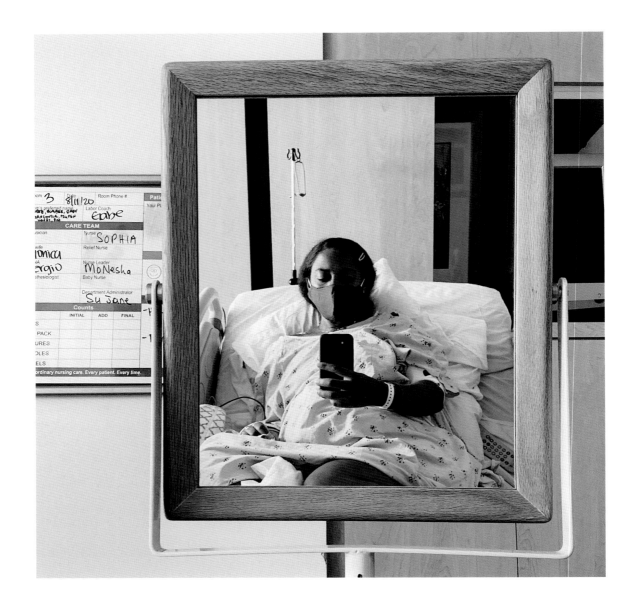

PREGNANCY DURING A PANDEMIC

BETHANY MOLLENKOF | CALIFORNIA, UNITED STATES | AUGUST 2020

Above: Photographer Bethany Mollenkof's self-portrait documents her experience as a first-time pregnant Black woman during the COVID-19 pandemic. *Right:* Mwende Card, Bethany's sister, meets her newborn niece for the first time via FaceTime.

Behind the story: Bethany Mollenkof discovered she was pregnant three months before the COVID-19 pandemic forced her to shelter in place in Los Angeles. As a photographer, Mollenkof had documented the experiences of pregnant Black women in the U.S. South, but she used the extraordinary circumstances of the pandemic to turn the camera on her own experience.

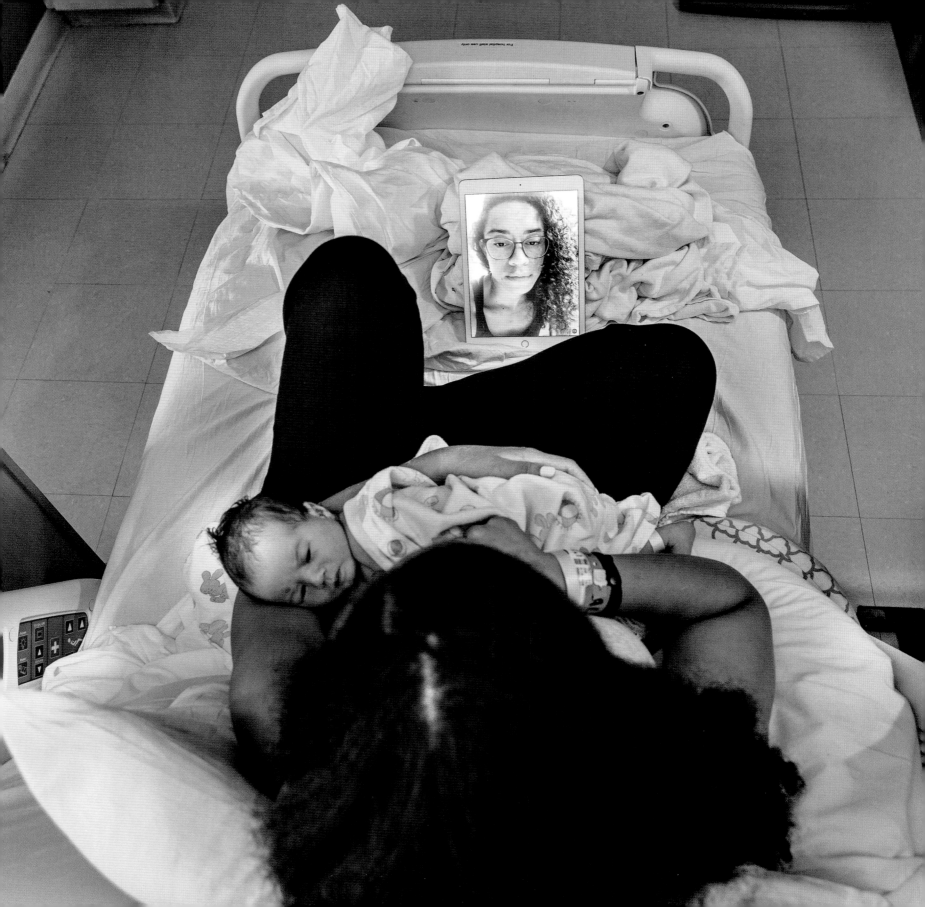

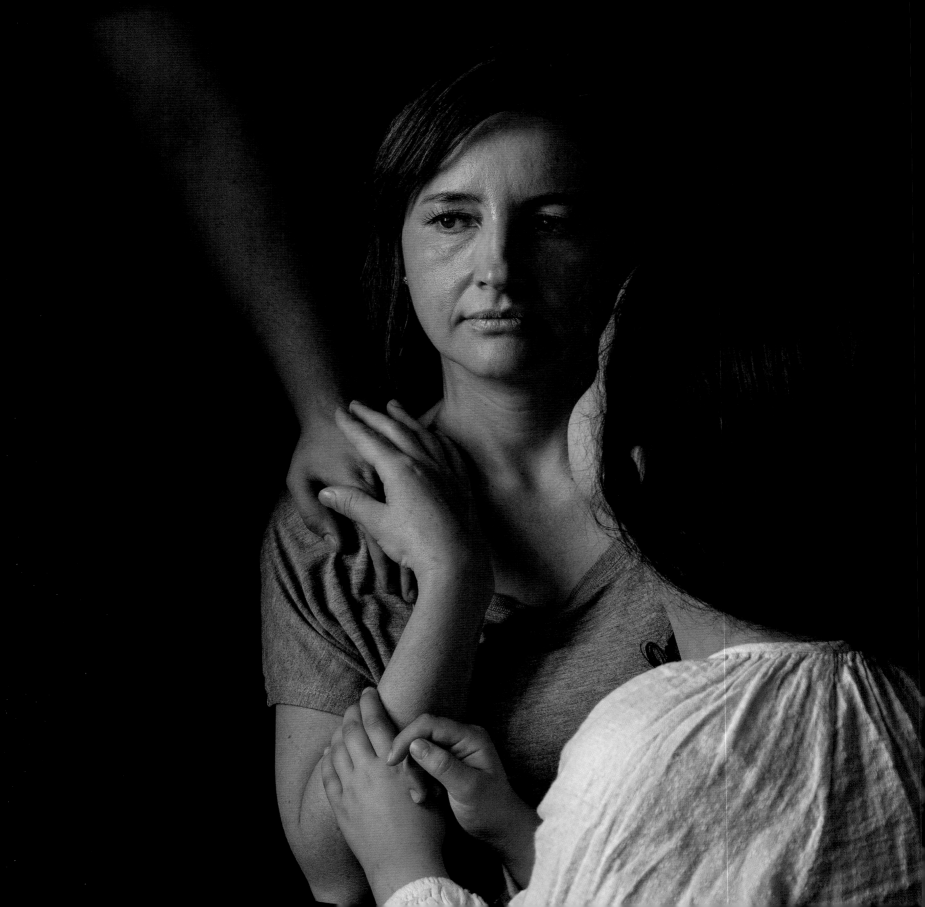

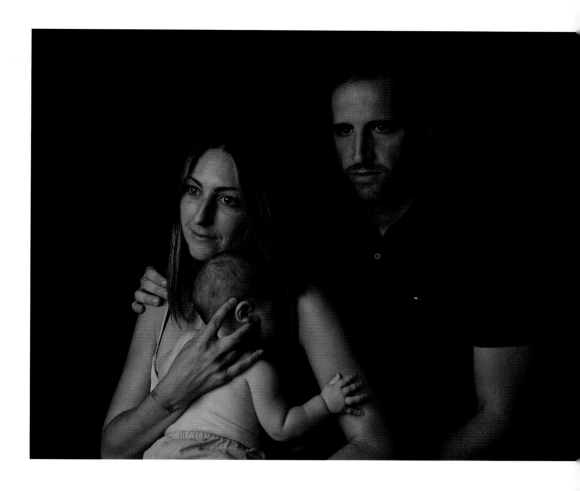

SURVIVORS' STORIES EMERGE

CAROLE ALFARAH | MADRID, SPAIN | MAY-JULY 2020

Left: Blanca Mabel Rodas Alfonso, 42, holds her daughter, Lara, and her son, Matias. Blanca survived COVID-19 after battling the virus outside a hospital when the first wave overwhelmed health-care systems. *Above:* Ana Delgado López, 34, and her husband, César Antonio Chichón, hold their baby girl, Valeria, who was born in March 2020. Delgado López was pregnant when diagnosed with COVID-19; she underwent an emergency cesarean and was unable to touch her daughter until she tested negative, almost two months later.

NEIGHBORHOOD REFUGE

ADRIENNE SURPRENANT/COLLECTIF ITEM
MONTRÉAL, CANADA | OCTOBER 2020

Members of the Tran-Adsett
family make bubbles in an
alleyway located in Montréal's
Outremont neighborhood. As
the city entered repeated
quarantines, corresponding with
iterative waves of COVID-19, its
4,300 alleyways, which have long
been a part of its social DNA,
became the last places where
the social fabric of each
neighborhood could remain
intact. The eight children of the
Tran-Adsett family were able to
safely play together in the
alleyway throughout the
pandemic, allowing them to
spend time outside, break up
school and family routines, and
improve their French and English
via social interaction.

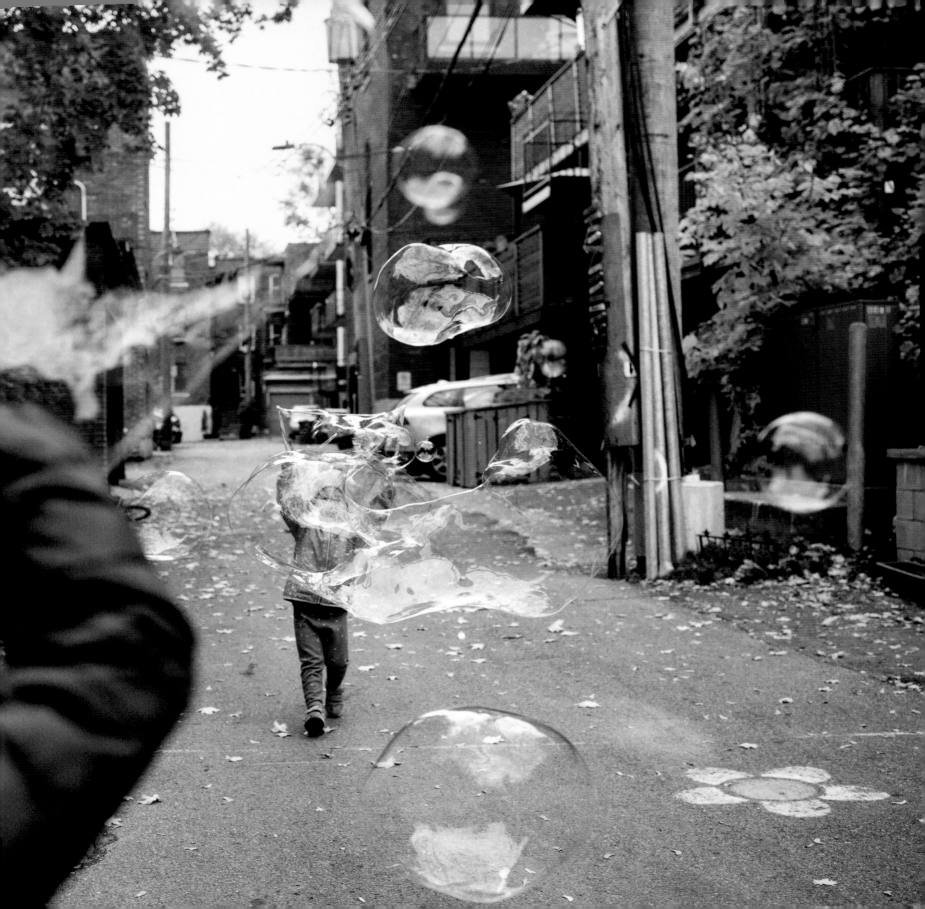

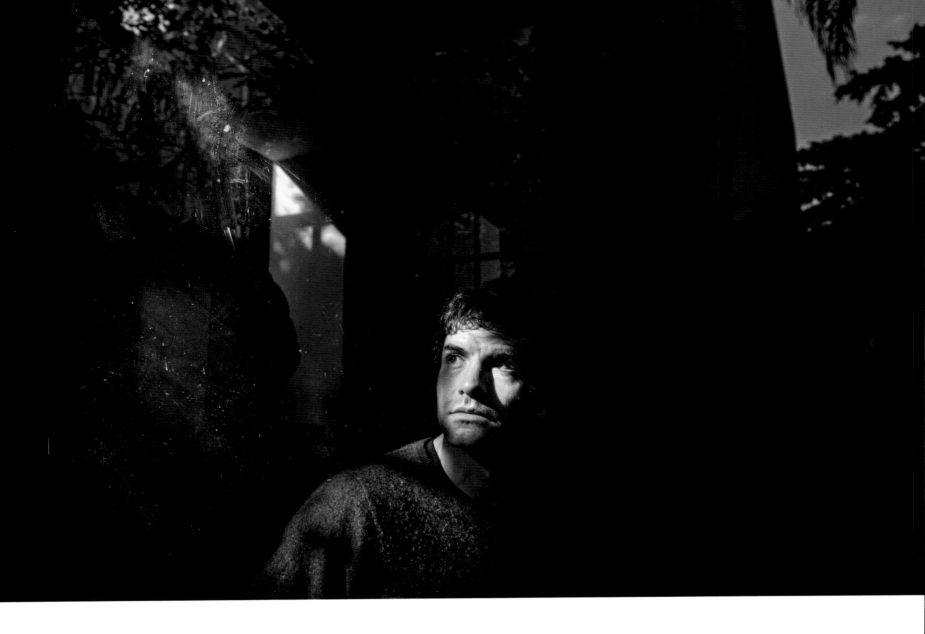

YEARNING FOR NATURE

SARAH PABST/AYÜN FOTÓGRAFAS | BUENOS AIRES, ARGENTINA | MAY–JUNE 2020

Left: The photographer's husband, Blas, looks through a window to view his father's garden, one of the few places that his daughter could play outside during the COVID-19 pandemic.
Right: In a self-portrait, photographer Sarah Pabst carries her daughter Elena in a woven wrap. She initiated this practice to calm her daughter during stressful days in quarantine with virtually no contact with the outside world.

Behind the story: A few days prior to the time of this self-portrait, Sarah Pabst lost an early pregnancy and was struggling with feelings of grief and guilt. She longed to break free from quarantine to reconnect with nature in order to work through these feelings.

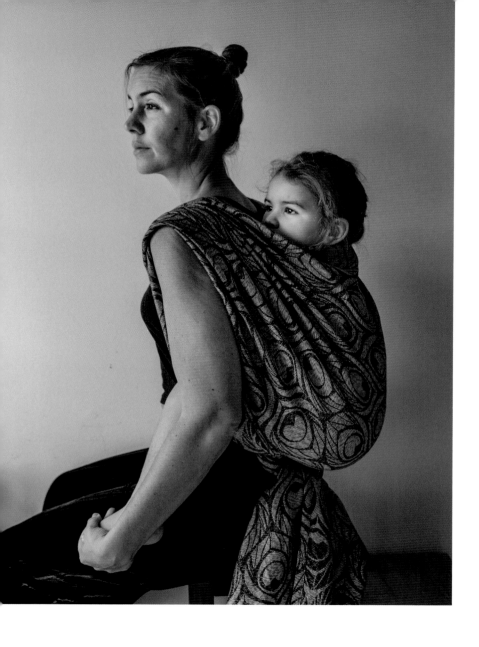

FOLLOWING PAGES

VACCINATION CAMPAIGNS

SANTIAGO ARAU | MEXICO CITY, MEXICO
JANUARY 2021

Under the presiding gaze of a whale skeleton, individuals and families line up for the COVID-19 vaccine. Mexico City organized numerous sites as part of their public vaccination campaign, including a location at the celebrated Biblioteca Vasconcelos.

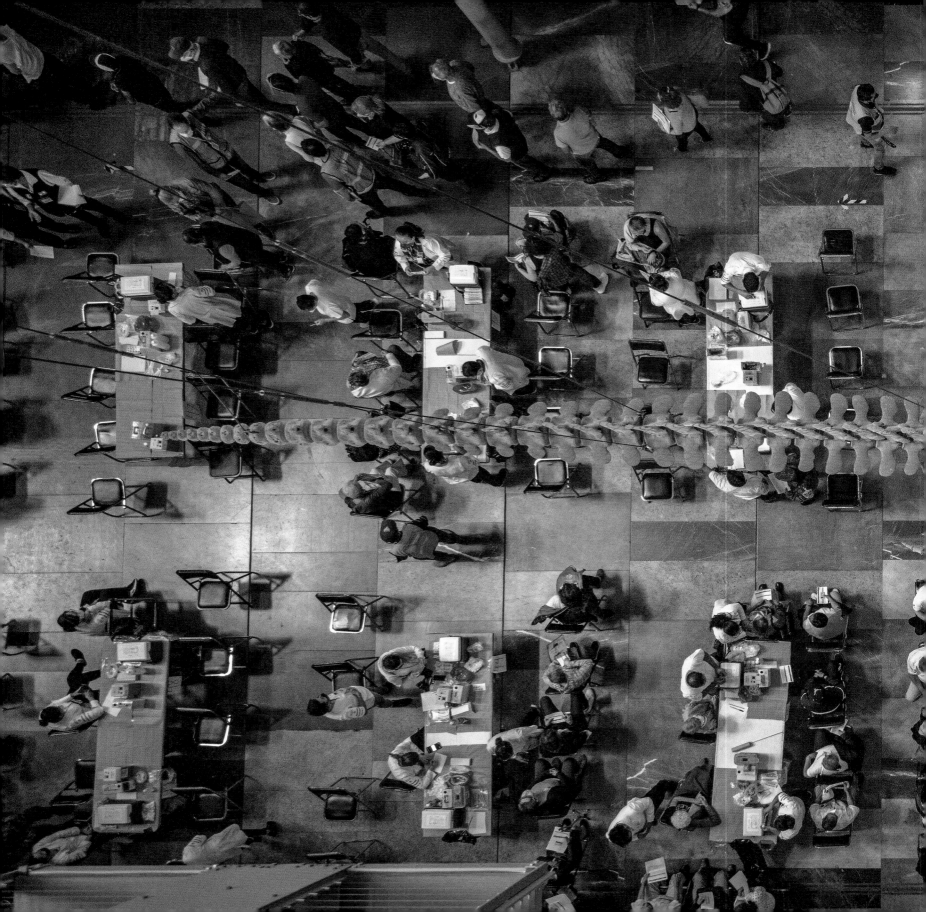

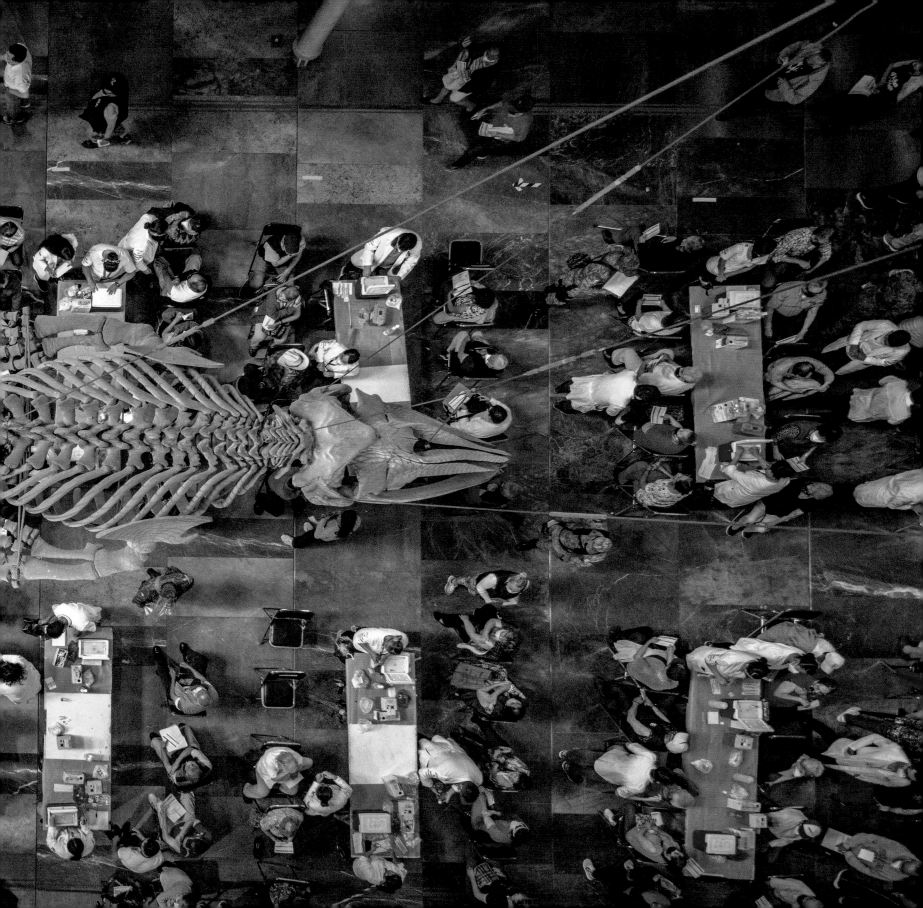

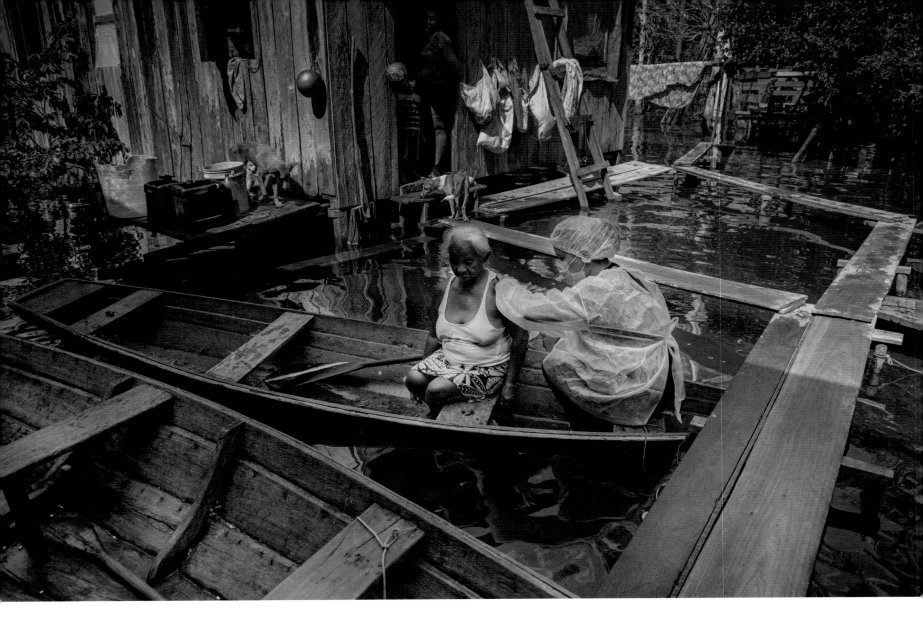

VACCINATING REMOTE COMMUNITIES

CHRISTIAN BRAGA | AMAZONAS, BRAZIL | MAY 2021

Dona Maroca receives the COVID-19 vaccine in the Novo Brasil community, located within the municipality of Anamã, approximately 100 miles (160 km) of dense Amazonian rainforest west of the bustling city of Manaus. The 2021 seasonal floods were perhaps the largest in the history of the Amazon, increasing rivers by about 98 feet (30 m). Fortunately, the flooding did not impede the transit of health workers, who distributed the vaccine in hard-to-access rural communities by boat.

INOCULATIONS BECOME POLICY

SOLIMAN HIJJY | GAZA STRIP | NOVEMBER 2020

Palestinian medical workers evaluate the health status of a Palestinian couple at Erez Crosspoint as they enter the Gaza Strip from Israel. In August 2020 the first confirmed cases of COVID-19 were recorded in the crowded, blockaded Gaza. The outbreak spread rapidly, inundating an already overwhelmed health-care system despite severe precautionary measures imposed by the territory's Hamas governance. Among the challenges the region faced in containing COVID-19 were widespread misinformation about the vaccine and a corresponding hesitancy to receive it.

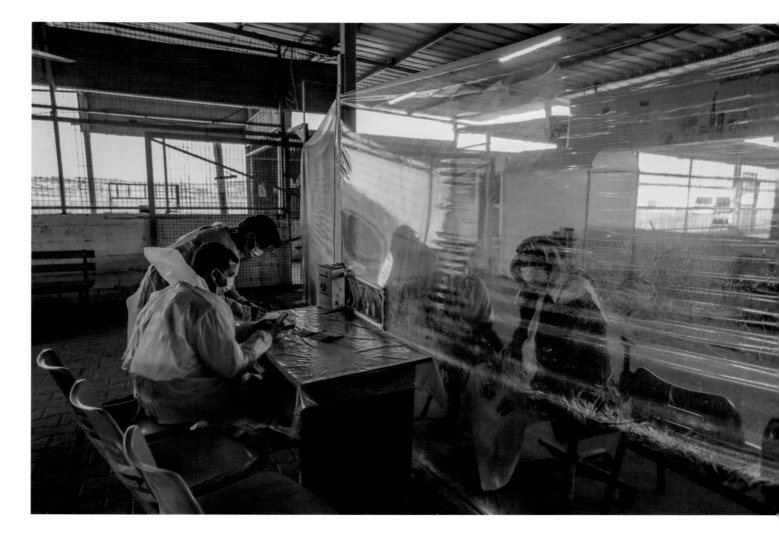

FIRST STEPS TOWARD REBUILDING

DAN BALILTY | MULTIPLE LOCATIONS, ISRAEL | MARCH 2021

Below: Israelis receive the COVID-19 vaccine in Hod Hasharon. *Right:* Unmasked Israelis gather at the Tender bar in Tel Aviv. Israel's efficient and early vaccination rollout allowed it to be one of the first nations to reopen public spaces and businesses and ease restrictions. Daily life changed as the country moved from high morbidity and a struggling economy toward the reopening of cafés, restaurants, theaters, prayer houses, and schools. Amid this reopening, the country faced criticism for a reported inequitable rollout of the vaccine in the Palestinian territories.

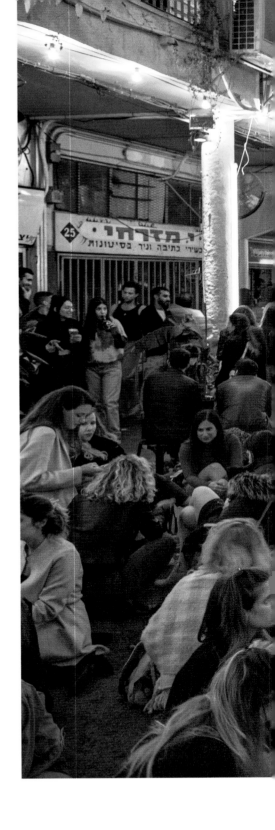

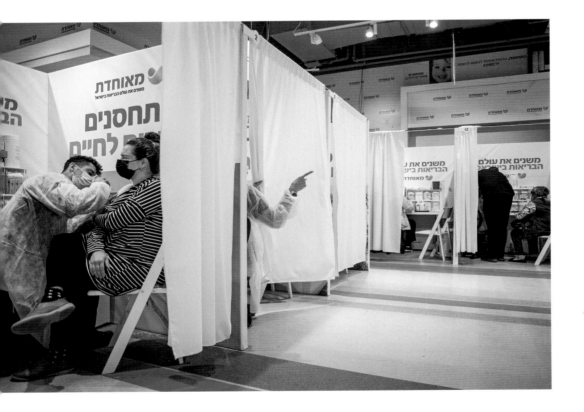

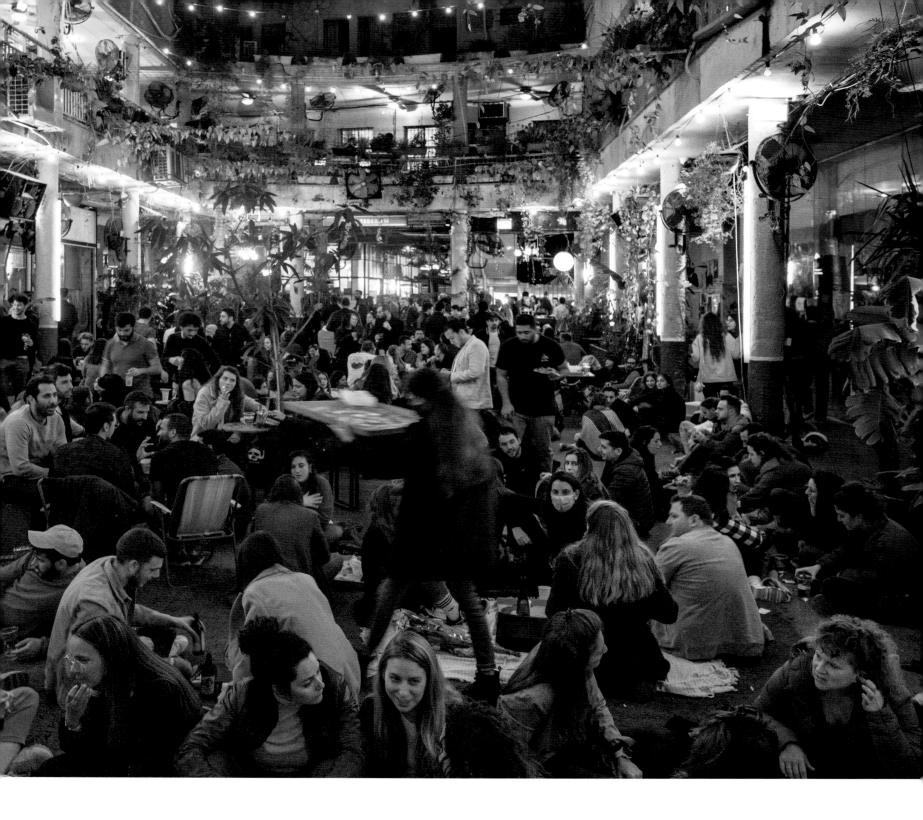

FIRST STEPS TOWARD
REBUILDING CONTINUED

DAN BALILTY | TEL AVIV, ISRAEL | APRIL 2021

A crowd watches a live show at the
Habima Theatre in Tel Aviv. To enter
the venue, attendees were required
to show proof of vaccination.
Following a highly efficient public
vaccination campaign, Israel became
one of the first countries to ease
restrictions on gatherings and
reopen public spaces and businesses.

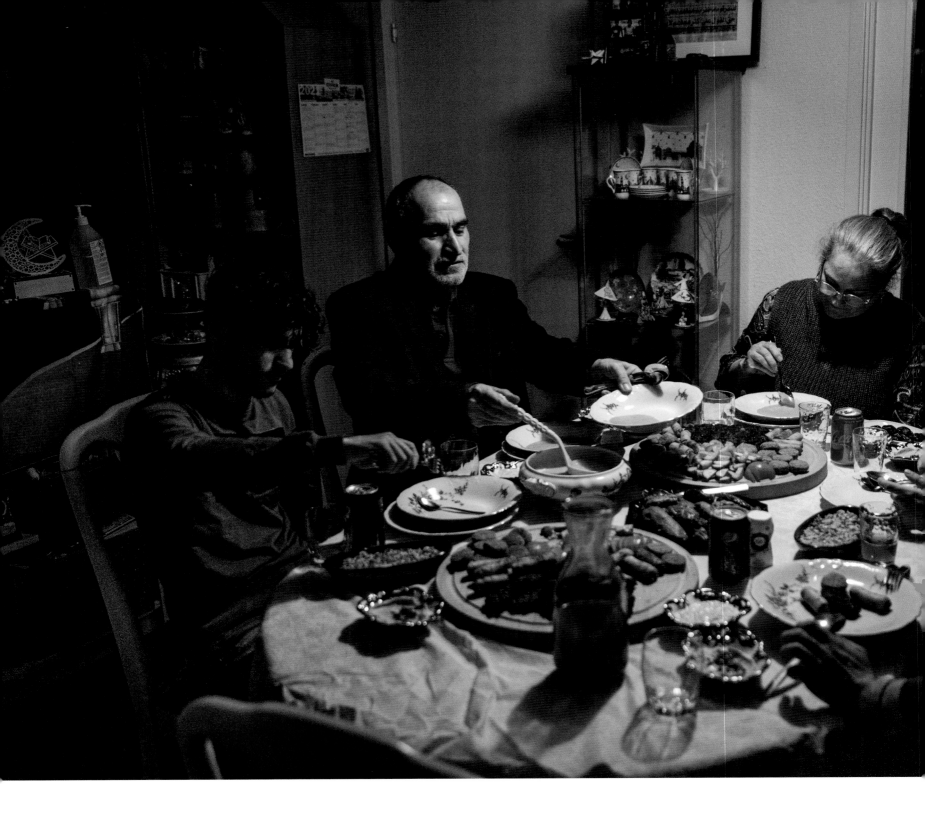

DISPARITIES IN INFECTION RATES

ÓLAFUR STEINAR RYE GESTSSON AND FREDERIK TILLITZ | MULTIPLE LOCATIONS, DENMARK | APRIL 2021

Left: Sarwa Sharif, Salem Rahman, and their three children, Elan, Allan, and Aryan, break their fast during Ramadan. *Below:* Dr. Urfan Zahoor Ahmed administers the COVID-19 vaccine to 78-year-old Erik Eriksen.

Throughout the COVID-19 pandemic, Denmark experienced an alarming disparity in infection rates between wealthier and lower-income communities, which include immigrants and their recent descendants. Immigrant communities make up 9 percent of Denmark's population but constituted 18 percent of its COVID-19 cases.

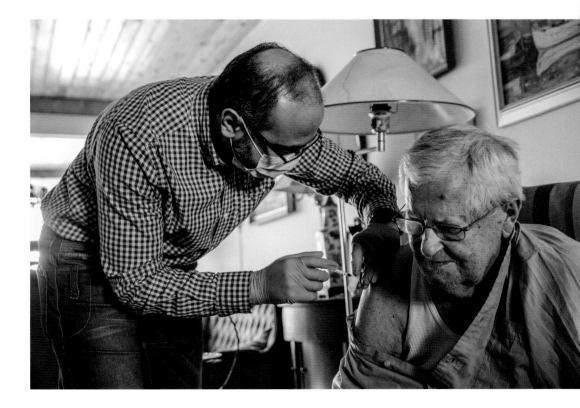

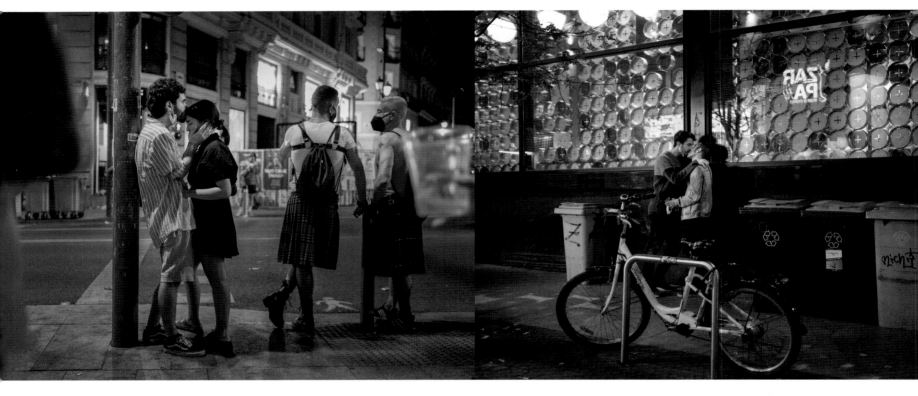

THE RETURN OF
PUBLIC AFFECTION

DANIEL OCHOA DE OLZA
MULTIPLE LOCATIONS, SPAIN
JUNE–OCTOBER 2021

Couples kiss in public spaces after nearly a
year and a half of experiencing social
distancing, mandatory face masks, and
other isolating measures enacted to
counter the spread of COVID-19.

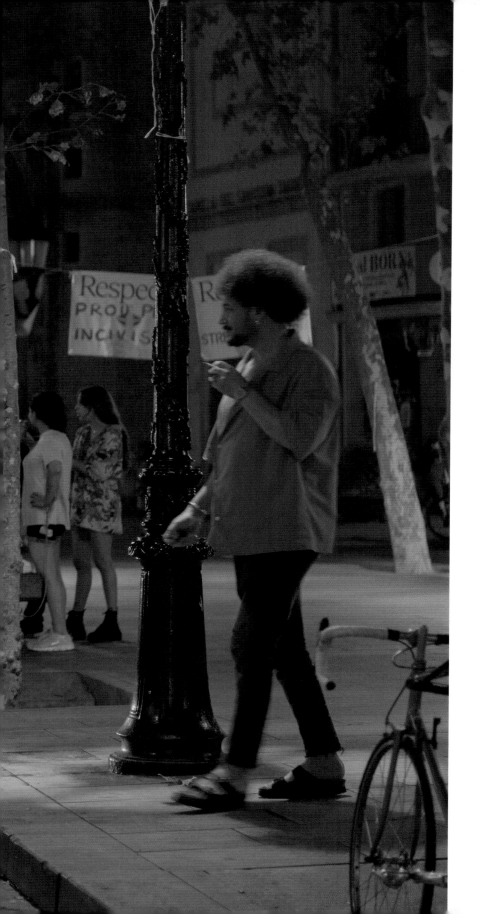

THE RETURN OF PUBLIC
AFFECTION CONTINUED

DANIEL OCHOA DE OLZA | BARCELONA, SPAIN
SEPTEMBER 2021

A couple kisses at the Passeig del Born.

Behind the story: After more than a year of social isolation, fear of the COVID-19 virus, and uncertainty about the future, photographer Daniel Ochoa de Olza chose to portray couples kissing in public places as a symbol of restoring love and life to once emptied, desolate streets. His work demonstrates that love is a monumental force capable of igniting the vital spark that lifts the spirits of many, even in times of adversity.

A PAINFUL GOODBYE: Colleagues of deceased paramedic Peter James Hart drive in an ambulance through East Surrey, England. Hundreds of friends, family, and supporters of the National Health Service (NHS) lined the route as Hart's coffin was transported to a private family funeral. Hart died on his 52nd birthday after testing positive for COVID-19; he had worked for years at the South East Coast Ambulance Service before joining the Surrey and Sussex NHS Trust in 2017.

LYNSEY ADDARIO | EAST SURREY, ENGLAND | JUNE 2020

WHAT WE'VE LEARNED

BY LYNSEY ADDARIO

As a conflict photographer of some 20 years, I'm often asked how I can stay optimistic about the world around me. From Afghanistan to Iraq to Darfur to Yemen, I've witnessed people caught in the crossfire of battle; my coverage of wars between nations, populations, and tribes now extends to the war of man versus the environment, and the devastating effects of climate change.

In 2020 and 2021 our world turned upside down with the COVID-19 pandemic, which struck suddenly and indiscriminately, regardless of geography or socioeconomic status. It left few peoples' lives unaffected, and it created a global understanding of pain and uncertainty, somehow uniting us in our respective loneliness. For one of the first times in my life, I photographed a crisis where I lived, in England and the United States: the victims in intensive care units, relatives burying their loved ones, funeral homes overwhelmed. I even photographed a funeral parlor employee on his lunch break at Rowland Brothers in South London, bidding a quiet goodbye to his own mother in her casket in one of the viewing chapels. As the pandemic extended from weeks to months to years, the collective toll immense, it became harder and harder to glimpse any hope amid the never ending despair.

So what have I learned? Through my lens, and through their most vulnerable moments, my subjects have shown me the resilience of the human spirit. I have learned the strength of mothers and fathers, of children, of brothers and sisters, and their capacity to overcome, to forgive, to move forward—with grief but with hope. Most recently, I've learned that in an interconnected world, the gift of freedom from poverty, sickness, and hunger is one that is bestowed upon very few of us, and one that can easily be taken away.

We must care about the fate of those who are across the globe as we care for our neighbors and family members. Because today we're not as far apart as we may have once imagined.

Lynsey Addario is a photographer based in the United Kingdom. Her Emergency Fund-supported work covered the rituals of death and burials during the coronavirus pandemic in southwest England.

ABOUT THE GRANTS

Through the COVID-19 Emergency Fund for Journalists, the National Geographic Society awarded 324 projects in more than 70 countries to report on the complexity of the COVID-19 pandemic across an array of formats, including photography, writing, documentary films, audio journalism, cartography, and data visualization.

While the complete body of work produced by these journalists could not be included in the pages of this book, all of it was integral to telling the global story of the COVID-19 pandemic.

Below is the full list of the projects awarded by the National Geographic Society's COVID-19 Emergency Fund for Journalists.

KEY TO GRANTS 📷 Photography ▷ Film, documentary, and multimedia 🎧 Audio, podcasts, and radio 🗒 Writing

MUSTAFAH ABDULAZIZ
Berlin in the Time of COVID-19
Berlin, Germany

📷 As the capital of Germany and as Europe's largest economy, Berlin is a both an economic hub and a cultural melting pot. Amid societal tensions, including recent large-scale immigration, a complex history, and an uncertain future, Berlin faced the outbreak of COVID-19 by grappling with its cultural identity and navigating the balance between public safety and economic recovery. In his compelling images, Mustafah Abdulaziz explores how the diverse cultures of Berlin, including its immigrant, refugee, and historically German communities, addressed the challenges of COVID-19—and how the cultural and economic responses to the outbreak are intrinsically linked.

BRIAN ADAMS, ROUSSEL DANIELS, TAHILA MINTZ, AND SARAH STACKE
Diverse Native American Communities Prepare for Vaccine Rollouts
Minneapolis, Minnesota, United States

📷 Native Americans have suffered tremendous losses from COVID-19, including the demise of many elders who helped preserve their language, history, and culture. Vaccination is a critical step in protecting Native

people. In their body of work, Brian Adams, Russel Daniels, Tahila Mintz, and Sarah Stacke document the inoculation rollout in four communities: in Alaska, the Southwest, the Midwest, and the Northeast. Their imagery reveals the complexity of working across different communities by highlighting distinct approaches to vaccine distribution, as well as varying community responses. The images are paired with landscapes from each region that show the beauty and diversity of the areas covered.

LYNSEY ADDARIO
How COVID-19 Changed the Way We Say Goodbye
West Country, England

📷 As of May 2020, roughly 300,000 people around the world had died from COVID-19. That circumstance changed the way that people are laid to rest, how medical and funeral professionals handle the dead, and how quarantining and social distancing measures have impacted funerals. In her arresting images, Lynsey Addario documents how COVID-19 upended long-standing rituals of burials and mourning through the prism of four family-run funeral homes in a farming community in southwest England. They reveal how undertakers

are finding unconventional ways to bury the dead with respect and dignity, and how families have found new ways to say goodbye to loved ones.

DIL AFROSE JAHAN
Maintaining Maternal Health Amid a Pandemic
Dhaka, Bangladesh

▷ In his compelling body of work, Dil Afrose Jahan explores maternal health and safety measures during the COVID-19 pandemic in Bangladesh, with an emphasis on community and stakeholder responses on behalf of peoples' health. He also documents socioeconomic and mental health consequences for mothers and children during the pandemic.

DAN AGOSTINI
How COVID-19 Threatens the Vulnerable
São Paulo, Brazil

📷 In powerful images, Dan Agostini tells the stories of 15 transgender women living in a support house in São Paulo, Brazil. They document the new challenges this group is facing in the wake of the pandemic, including social isolation, economic crisis, violence, and difficulty accessing public health measures.

LUJÁN AGUSTI
Heart of the Island
Tierra del Fuego, Argentina

▷ In her revealing body of work, Luján Agusti investigates the threat of the COVID-19 pandemic to one of the most remote and socially isolated places in the world: the center of the island of Tierra del Fuego, Argentina. In this place of great historical, natural, and cultural significance—including initiation rituals of the Indigenous Selk'nam community—Agusti explores the potential impacts of the pandemic on the people and culture, which as yet have not yet been directly affected.

SHOSHANA AKABAS
On the Front Lines: The Afghan Special Immigrant Visa in 2020
New York City, New York, United States

🗒 🎧 In New York City, many Afghans who received Special Immigrant Visas (SIVs) after serving as translators for U.S. troops in Afghanistan went on to serve as security guards and sanitization workers and in other essential positions still operating throughout the COVID-19 outbreak. Shoshana Akabas examines how this community coped on the front lines of a new war: the outbreak of a virus. She also explores

how misinformation affected these newly arrived refugees, some of whom were welcomed by a country already grappling with the pandemic.

ALLAN AKOMBO
Keeping Kenya's Schoolchildren Current
Homa Bay, Kisumu, and Siaya, Kenya

 As schools in western Kenya closed amid the COVID-19 outbreak, Allan Akombo documented the plight of rural schoolchildren unable to afford or access technology for online learning. Facing poor infrastructure, high levels of HIV/AIDS, and some of the highest poverty levels in the country, many children were forced to take menial jobs to help their families survive. Akombo highlights the urgent need for new resources and strategies to ensure that these children can access education in the midst of a pandemic.

YORIYAS YASSINE ALAOUI
Facing COVID-19
Asilah, Morocco

 Yoriyas Yassine Alaoui documents how the coastal city of Asilah, Morocco—known for local and international tourism—adapted to COVID-19, including the closing of restaurants and small businesses, the spread of information through social connections, and the strong fabric of community support that held the town together. Alaoui explores the steps this unique, close-knit community took to prepare for the pandemic, keep itself safe, and provide comfort amid uncertainty for the future.

CAROLE ALFARAH
The Survivors
Madrid, Spain

 A survivor of the war in Syria, Carole Alfarah chose to tell the stories of those who survived COVID-19. In this poignant body of work, she made portraits of 19 coronavirus

survivors who, after grappling with a traumatic disease, discovered light in their lives.

SARA ALIAGA AND LISE HERMANN
COVID-19 Threatens Yuqui Culture
Cochabamba, Bolivia

 The Indigenous Yuqui people of the Bolivian Amazon number just 360. In this vivid body of work, Sara Aliaga and Lise Hermann document how COVID-19 threatened the lives of this group, as well as the tenuous state of their territory and culture in an increasingly accelerated world. Aliaga and Hermann relate the Yuqui's efforts—led by Carmen Isategua, guardian of the territory—to weather the hazards of the COVID-19 pandemic while defending their territory against threats from the outside world.

NICOLÁS AMARO
COVID-19 and Indigenous Well-Being
Toltén, Chile

 In this compelling body of work, Nicolás Amaro investigates the Chilean government's mistreatment of the Indigenous Mapuche people during the COVID-19 pandemic, including violence, indifference, and repressive enforcement of curfews. By highlighting the story of Marcelo, who survived being shot by Chilean special forces during a fishermen's riot, Amaro underscores how the pandemic has reinforced the authorities' history of disinterest and cruelty toward Mapuche people.

SYEDA AMNA HASSAN
COVID-19 and Pakistan's Wildlife
Lahore, Pakistan

In this body of work, Syeda Amna Hassan explores the effects of the COVID-19 pandemic on Pakistan's wildlife, which live at the intersection of conservation

and local economies. Happily, travel disruption during the pandemic stemmed the tide of hunters, poachers, and tourists, causing a welcome increase in the numbers and populations of certain species. But the drop in visitors, which led tourism-dependent communities to turn to poaching, is more concerning.

MAURICIO ANGELO
COVID-19 Disrupts Unique Cultural Funerary Practices of Brazil's Indigenous Cultures
Roraima, Brazil

The Indigenous peoples of Brazil represent more than 256 different groups, speak more than 150 different languages, and practice specific funerary rituals that adhere to the ancestral cultures of each people. Mauricio Angelo documents how COVID-19, which affected about 25,000 Indigenous people as of August 2020, disrupted these distinct funerary customs—a poignant example of how the new reality of the pandemic challenged the people of Brazil.

SANTIAGO ARAU
Resilience Through Change: Mexico City in a Time of COVID-19
Mexico City, Mexico

 In his arresting body of work, Santiago Arau documents how Mexico City's nearly 22 million residents were affected by the COVID-19 pandemic, from Mexican president Andrés Manuel López Obrador to impoverished communities and prisons. This comprehensive look spanned a full year of the outbreak, demonstrating the city residents' resilience while providing a panorama of the unique physical, social, economic, and cultural impacts of the disease.

ANA MARÍA ARÉVALO GOSEN
***Sinfonía Desordenada*: A Pandemic-Era Album From the Venezuelan Orchestra**
Caracas, Venezuela

 The Venezuelan Orchestra has traditionally provided opportunities for young people that steered them away from drug abuse and crime. But the COVID-19 pandemic made it nearly impossible for the orchestra's 75 young musicians to play together: Members experienced power outages, isolation, and quarantine, and had to take on side jobs to make ends meet. Ana María Arévalo Gosen tells the story of *Sinfonía Desordenada (Jumbled Symphony)*, a unique album recorded individually by each member of the Venezuelan Orchestra during quarantine. The album—recorded under the direction of Elisa Vegas, the only professional female conductor in Venezuela—is a testament to the power of music as a form of resilience, healing, and community-building.

JUAN ARIAS
Coping With COVID: Returning to Indigenous Traditions
Cali, Colombia

The Siloé settlement in the city of Cali, Colombia, is one of the country's most underserved neighborhoods. Through a deep-rooted Indigenous tradition of *minga,* or collective community work, the residents have managed to meet their needs in the absence of government services; they've paved their own streets and built their own parks. In the midst of the COVID-19 pandemic, they've maintained this tradition by collecting food and cooking for neighbors who have lost their incomes and are suffering food insecurity. Juan Arias documents Siloé's minga tradition, both as a source of pride and as an example for the rest of the world.

SIRACHAI ARUNRUGSTICHAI

COVID-19 Along Bangkok's Fault Lines
Bangkok, Thailand

 In this unique body of work, Sirachai Arunrugstichai examines how the COVID-19 outbreak affected Bangkok's more than eight million citizens—and how preparation and responses varied among different socioeconomic groups in light of the city's vast income inequality. Arunrugstichai's work focuses on low-income communities highly susceptible to the outbreak, medical professionals on the front lines of treatment and containment, and the efforts of communities to support each other amid the pandemic.

AYÜN FOTÓGRAFAS: TAMARA MERINO, JOHIS ALARCÓN, ANA MARÍA ARÉVALO GOSEN, MARICEU ERTHAL, KARLA GACHET, ANDREA HERNANDEZ, SARAH PABST, AND DANIELLE VILLASANA

Can COVID-19 Guide Our Environmental Future?
Santiago, Chile

 In this intimate body of work Ayün Fotógrafas, a collective of women photographers linked by Latin America, documents the relationship between human beings and nature in the context of the COVID-19 pandemic. They explore such themes as environmental degradation, activism under lockdown, sustainable living, and the relationship to nature within our own families—as well as how the lessons learned from COVID-19 can inform our choices for a more environmentally friendly future.

TOMAS AYUSO

Breaking Point: Will COVID-19 Push the Honduran Capital Over the Edge?
Tegucigalpa, Honduras

 In Tegucigalpa, the capital of Honduras, citizens remained resilient through the country's crises in the face of internal displacement, violence, food scarcity, and a collapsed health-care system that sunk the country to the bottom of global equality and justice rankings. Tomas Ayuso documents COVID-19's effect on this city, already in the grip of social turmoil and national anxiety. Photographed from the point of view of Tegucigalpa's citizens, this body of work reveals how the pandemic strained their resilience and ability to cope in a time of crisis.

ANUSH BABAJANYAN

Armenia's New Education in a Time of Crisis
Yerevan, Armenia

Since March 16, 2020, Armenia has been in a countrywide state of emergency in an attempt to fight the spread of COVID-19. Anush Babajanyan covered the impacts of these measures on education as communities adapted to at-home learning. While teachers and professors learned to teach remotely, many families could not afford the devices needed to access an online education; Babajanyan documents the unconventional teaching methods and support efforts enacted to aid Armenia's education system.

XYZA BACANI

Food Insecurity in the COVID Era
Nueva Vizcaya, Philippines

Restrictions on movements to reduce COVID-19 transmissions created a breakdown in the agricultural supply chain in the Philippines, pushing small farms toward bankruptcy. Xyza Bacani investigates how COVID-19 caused a disastrous farm-to-table chain of food insecurity and how this circumstance has affected small-scale farmers, the Philippine agriculture sector, and the environment.

WESAAM AL-BADRY

Keeping a Nation Fed: Essential Workers in the Salad Bowl of America
Salinas Valley, California, United States

California's Salinas Valley is known as "the salad bowl of America," producing two-thirds of the nation's lettuce and much of its strawberries and broccoli. With the majority of the state on lockdown, farmworkers in the valley were considered essential and carried on working. Wesaam Al-Badry documents the emotional choices that these farmworkers made as they faced long hours—at times without overtime pay, health insurance, or sick leave.

DIANA BAGNOLI

Cuba Aids Italy: A Story of Global Solidarity
Turin, Italy

In April 2020 members of the Henry Reeve International Medical Brigade, a humanitarian medical group based in Cuba, arrived in Turin, Italy, to assist with the outbreak of COVID-19. Diana Bagnoli documents the medical work and daily life of the brigade members—trained doctors, nurses, and technicians—as they supported the overwhelmed medical system in a makeshift hospital converted from a cultural event space. The support of the brigade provides a lasting example of global solidarity among nations and showcases a stark portrayal of Italy's plight at the height of the pandemic.

DAN BALILTY

Israel's National Vaccine Rollout and the New Normal
Tel Aviv, Israel

Dan Balilty documented the COVID-19 vaccination rollout in Israel, focusing on how daily life changed as the country moved from high morbidity and a struggling economy toward full vaccination and the reopening of cafés, restaurants, theaters, prayer houses, and schools. Balilty's reporting covers ongoing vaccination efforts, as well as societal shifts in remote places and among minority communities, to explore different aspects of Israel's unique and extensive vaccine operation.

JEFF BARAKA

Healing Hip-Hop: Artists Keep Their Communities Moving Forward in a Time of Crisis
Chicago, Illinois, United States

 The year 2020 was already momentous as tensions grew with the presidential election. Then COVID-19 hit, and life as we knew it changed forever. The pandemic compounded long-standing social inequities that adversely impacted health in chronically disadvantaged communities of color. And worldwide protests were triggered by police killings of Black citizens as their communities and allies sought balance and recovery during this surreal, anxiety-inducing convergence. THE #DOWNNOW Project (as in "It's goin' down now!" and "Are you down now?") presented stories of healing and activism from socially conscious Chicago hip-hop artists as well as the city's broader music, arts, and cultural community.

SANTIAGO BARREIRO

Loneliness in the Time of Pandemic
Montevideo, Uruguay

Uruguay has both the oldest population in Latin America and one of its leading rates of depression and suicide. Therefore, its citizens are highly susceptible to the physical and mental health dangers of COVID-19. Through the stories of several Uruguayans, Santiago Barreiro investigates the consequences of isolation and loneliness in the context of a global pandemic crisis.

SAIYNA BASHIR

Pakistan's Settlements Battle COVID-19

Rawalpindi, Pakistan

 In Pakistan, 45 percent of the country's 220 million people live in urban settlements. In this powerful body of work, Saiyna Bashir documents the lives of families in these communities, which battled the COVID-19 outbreak as well as violence and extremism. Bashir's work contrasts the stories of families struggling to maintain their livelihoods under the newly imposed restrictions with those who found innovative and cost-effective ways to adjust to life during the pandemic.

MATTEO BASTIANELLI

Rome's Refugees Face a New Front Line

Rome, Italy

In this vivid body of work, Matteo Bastianelli documents the devastating effect of the COVID-19 outbreak and resulting quarantine on a Rome community of 8,000 immigrants who lack housing. After fleeing areas of conflict, these displaced individuals faced the global pandemic amid rising anti-immigrant sentiment. Bastianelli's images explore the avenues of information and assistance available to this population, and examine how Rome's institutions and society responded to their needs.

CÉCILE SMETANA BAUDIER

How COVID-19 Affects Coming of Age

Copenhagen, Denmark

In this vivid body of work, Cécile Smetana Baudier examines how the COVID-19 pandemic impacted the teenage coming-of-age experience through the story of Anna and Thea, 16-year-old identical twins in their first year of boarding school. Growing up inseparable, the twins were not able to visit each other in their respective dorm rooms. Baudier explores how

the pandemic has affected their relationship, their attempt to make new friends, and their view of the world.

ASHLEY BELANGER

Quarantining Brings Uncertainty for Domestic Abuse Victims

Orlando, Florida, United States

 Amid the outbreak of COVID-19, protections for victims of domestic violence were negatively impacted by shelter closings and shelter-at-home restrictions. Despite these challenges, Harbor House, a domestic violence shelter, continued to offer services—but the organization faced a precarious situation due to a lack of funding. Ashley Belanger tells the critical story of these local heroes and documents a shifting environment of safety for women around the world.

BERNICE BELTRAN

Surviving COVID-19: Manila's Women

Manila, Philippines

In Manila, Philippines, the outbreak of COVID-19 burdened women in low-income communities with many responsibilities and risks, including serving as providers for children and elders and experiencing domestic abuse. Bernice Beltran examines how the pandemic affected these women and the steps community organizations and government workers in Manila took to protect them from both the virus and domestic abuse.

RAJNEESH BHANDARI

COVID-19 Closes the Roof of the World: How the Pandemic Is Affecting Nepal's Sherpas

Kathmandu, Nepal

In this body of work, Rajneesh Bhandari documents how the lives and businesses of Sherpas in Nepal are affected by the COVID-19 pandemic. In the wake of lockdown, many mountaineering expeditions, including those to Mount Everest, have

been canceled. According to estimates, 80 percent of the population in Nepal's mountainous region depends on mountaineering and mountain tourism for their livelihoods; the disruption of travel to this area will likely impact this regional economy for years to come.

SARAH BLESENER

Senior Citizens Counter COVID-19

New York City, New York, United States

 Sarah Blesener documents the experience of elderly individuals living in Brooklyn, New York, to examine the intergenerational disparities surrounding the COVID-19 pandemic. Focusing on a couple in their 80s who are community activists, this project not only records the challenges of the pandemic but also explores how grassroots organizations and strategies were used to heal and bolster the senior community during this time.

JAMES BOO

In the Wake of Virus Prejudice, Communities Counter Anti-Asian American Hate Incidents

Oakland, California, United States

James Boo and the podcast *Self-Evident*, which offers a space for Asian American representation, reflections, and stories, produced two reported audio features to illustrate recent spikes in anti-Asian hate incidents, as well as community-based responses led by Asian Americans.

ADIL BOUKIND

Québec's Asylum Seekers Risk COVID-19 to Help Others

Québec, Canada

 In 2020 the Canadian government promised permanent resident status to asylum seekers willing to put themselves at risk of contracting COVID-19 to perform critical health-care duties. But

even after doing so, some qualifying refugees may have been deported from Canada, and many more live under threat of deportation. In this body of work, Adil Boukind gives voice to those who were promised resident status at the price of their own safety and documents how COVID-19 has affected Québec's immigrant population overall.

ANNA BOYIAZIS

Helping Hands: Syrian Refugees Face COVID-19

Los Angeles, California, United States

Southern California, including Los Angeles and San Diego Counties, hosts more resettled Syrians than the rest of the United States combined. Many of these families responded to the stress, isolation, and health threats of the COVID-19 pandemic by preparing and delivering Syrian meals to health-care workers. Anna Boyiazis documents this inspiring story to underscore how Syrian refugees and asylum seekers in Southern California contributed to America as COVID-19 raged.

DOMINIC BRACCO II

SK8 COVID

Mexico City, Mexico

The short film by Dominic Bracco II, made in collaboration with the Mexico City company Ludica Skate, follows a skateboarder and artist known by the pseudonym BlackWitch as she and a group of friends seek to discover the city's best skateboarding spots. With a custom score by Christina Gaillard, the film subtly encourages safe COVID-19 practices in Mexico City's skateboarding community.

AMBER BRACKEN, LAURENCE BUTET-ROCH, AND SARA HYLTON

Canada's Fossil Fuel Industry in a Time of COVID
Toronto, Edmonton, and Regina, Canada

 As the majority of Canadians sheltered in place and observed social distancing guidelines to protect themselves and others from COVID-19, the country's extractive industry continued to further its interests—sometimes at the expense of the environment, Indigenous rights, and public health. The Canadian government designated the expansion of energy infrastructure—even that in close proximity to vulnerable communities—as essential, revealing a systemic inertia of support for the energy and construction industries. Through reportage photography, citizen imagery, and activation of archival images, photographers Amber Bracken, Laurence Butet-Roch, and Sara Hylton document the network of legislation, subsidies, and policies that prioritized industrial and extractive corporations over citizens even in a time of global crisis.

CHRISTIAN BRAGA

COVID-19 and the Indigenous Communities of Novo Airão
Novo Airão, Brazil

For the Indigenous communities within Brazil's Novo Airão, the Rio Negro is a central element in their lives. The river has traditionally defined the economic, social, and cultural aspects of their societies; more recently, it has drawn ecotourism to the region. Christian Braga documents the socioeconomic and environmental impacts of the COVID-19 pandemic on these vibrant communities, which now rely heavily on ecotourism and whose way of life is directly linked to their surrounding natural elements.

BARO BRIZUELA AND JUANA BARRETO YAMPEY

***Ollas Populares:* Guaranteeing Food Security in a Time of COVID**
Asunción, Paraguay

 In Paraguay, where nearly a quarter of the population lives in poverty, the COVID-19 pandemic pushed the economic situation to a breaking point, as many people lost their jobs and as opportunities for informal work dissipated. In response, women in low-income neighborhoods began opening improvised kitchens, called *ollas populares,* to address hunger in their communities, and then successfully lobbied the Paraguayan government to provide these makeshift kitchens with food. Baro Brizuela and Juana Barreto Yampey tell the story of the women who supported many through the toughest moments of the pandemic—and brought hope to their communities through a plate of good food.

ANDREA BRUCE

On Opposite Ends of the Employment Crisis
Pamlico County, North Carolina, United States

 In rural North Carolina in 2020, members of the same low-income community faced opposite ends of the employment-crisis spectrum. Some joined the millions of Americans filing for unemployment; others were undocumented workers out of a job without this option. Still others, mainly in the farming and fishing industries, felt the heavy burden and risks of continuing to do essential work through the COVID-19 outbreak. Andrea Bruce examines the socioeconomic effects of these disparate ends of the employment crisis on her hometown community.

ANDRÉS CARDONA

Death and COVID: An Intimate Account
Puerto Rico, Caquetá, Colombia

 After the death of his grandmother from COVID-19 in August 2020, Andrés Cardona chose to document how pandemic losses affect the surviving family members. The circumstances of the disease exacerbate their grief; Cardona's family was unable to give his grandmother a proper funeral and were required to quarantine in the wake of contact with her prior to her death. Cardona hopes that his own family's loss will illuminate the threat of the disease for those who may doubt the deadly nature of the virus.

GABO CARUSO

COVID-19 and Single-Mother Households
Barcelona, Spain

 In this unique body of work, Gabo Caruso examines the vulnerability of Spain's estimated 1.8 million single-mother households during the COVID-19 pandemic. Through portraits taken in their homes, Caruso highlights the difficulties and uncertainties that these families faced throughout the outbreak, along with the absence of concrete measures to provide them with aid.

SHARON CASTELLANOS

COVID-19 and Peru's Traditional Folk Music
Cusco, Peru

 Amid the COVID-19 pandemic, events and concerts were canceled, leaving Peru's traditional folk musicians to seek new ways to connect with audiences—including virtual concerts. Sharon Castellanos collaborates with folk musicians to document how the pandemic inspired them to reinvent how they reach listeners by using new technologies.

ALEJANDRO CEGARRA

Asylum Seekers: COVID-19 and the Race Against Time
Matamoros, Mexico

For months during the COVID-19 pandemic, asylum seekers from Mexico, as well as Central and South America, waited for hearings in an improvised refugee camp in Matamoros, Mexico, near the U.S. border. Home to roughly 1,500 people, the camp, with its cramped and unhygienic conditions—including shared bathrooms, showers, and dining areas—put its residents at an extremely high risk for transmission of COVID-19. Alejandro Cegarra documents daily life in this camp, including the struggles of medical nongovernmental organizations to detect and contain the virus, in the hopes of moving the government to action before the encampment became a humanitarian crisis.

TURJOY CHOWDHURY

From Educators to Undertakers
Dhaka, Bangladesh

 In these images, Turjoy Chowdhury documents Al-Markazul, a 15-volunteer team in Dhaka, Bangladesh, conducting funerals and burials for COVID-19 victims. As the pandemic transformed these Muslim scholars and teachers into undertakers, they had to separate themselves from their families, live near the graveyard, and risk their lives to provide dignified burials for people of various religions.

GUILHERME CHRIST

Paraisópolis's Heroes
São Paulo, Brazil

In Paraisópolis, a low-income community in São Paulo, Guilherme Christ documents the effects of the COVID-19 outbreak on more than 150,000 residents who live in unsanitary conditions and were

therefore unable to properly social distance or work from home. His images highlight a public health initiative, led by resident and activist Gilson Rodrigues, that was aimed at equipping residents with proper sanitary products and medical care, with the ultimate goal of combating Paraisópolis's social and violence problems.

GUILHERME CHRIST

Redefining Community: COVID-19 and Brazil's Afro-Indigenous Religious Community

São Paulo, Brazil

 Many of Brazil's Afro-Indigenous religions originated in formerly enslaved communities that provided one another with mutual support, enabling them to worship their deities apart from Portuguese settlers. Today these religions have more than eight million followers and are still deeply rooted in community life. In this unique body of work, Guilherme Christ documents how these religions have reinvented their practices using new technologies in order to provide spiritual support to their members in the age of COVID-19.

BARRY CHRISTIANSON

Using the Lessons of HIV to Combat COVID-19

Cape Town, South Africa

 Against the backdrop of violent oppression and economic inequality, groundbreaking activism in South Africa led to one of the world's most progressive and effective HIV treatment programs. Drawing on this example, Barry Christianson explores notable similarities and differences in the fight for treatment for HIV and COVID-19, outlining the issues and strategies of activists fighting for affordable COVID-19 vaccines and distribution plans that will guarantee equitable access across the population.

ALESSANDRO CINQUE

Peru's Indigenous Communities Face COVID-19

Espinar, Peru

In Espinar, Peru, water is used in such large quantities by mining operations that local communities are left with only two hours of access to water per day, prohibiting them from practicing safe hygiene to guard against COVID-19. At the same time, mining operations have brought in workers from cities across the country, potentially exposing local communities to COVID-19. In this body of work, Alessandro Cinque explores how living alongside mining operations has compounded the health, economic, environmental, and social struggles of the COVID-19 pandemic for Peru's vulnerable Indigenous communities.

CITIZEN BULLETIN

Bringing Public Health Information to a News Desert

Matabeleland, Zimbabwe

Local news outlet the *Citizen Bulletin* conducted reporting in the information desert of Zimbabwe's Matabeleland region with the goal of helping its approximately three million residents navigate the lingering effects of the COVID-19 pandemic and make informed health decisions. Its coverage helped Matabeleland's people stay healthy and safe.

MARIA CONTRERAS COLL

Santa Anna: Feeding the Newly Needy in Barcelona

Barcelona, Spain

In this searing body of work, Maria Contreras Coll tells the story of Santa Anna, a field hospital operating from a former 12th-century monastery in the heart of Barcelona. Since the outbreak of COVID-19, it has provided meals for more than 200 people in need every day. Contreras Coll underscores the impact of the disease on the larger Barcelona community—especially those who never needed financial support before but found themselves abruptly unemployed in the wake of the pandemic.

CHARLIE CORDERO

The Life Cycle of Disposal PPE

Barranquilla, Colombia

 In this unique body of work, Charlie Cordero documents how the use of personal protective equipment (PPE) like masks and gloves has limited the spread of COVID-19—but to the detriment of the environment. In Colombia approximately 30,000 garbage collectors have continued working despite the risk of contracting the virus. Cordero follows the life cycle of disposable plastic protective equipment, including the perspective of garbage collectors and the protocols they use, how uncollected plastic waste is contaminating water sources, and the strategies local governments are using to mitigate this pollution.

SOPHIE COUSINS

Australia's Indigenous Communities Respond to COVID-19

Yarrabah, Australia

Indigenous Australians are at a higher-than-average risk to the dangers of COVID-19; more than 50 percent live with a chronic disease, and tens of thousands live in overcrowded housing without access to running water. In this vivid body of work, Sophie Cousins investigates how remote and urban Indigenous communities in New South Wales, Australia, responded to the pandemic—and what is at stake if the virus spreads through these vulnerable communities. Through the lens of COVID-19, Cousins examines inequalities among Australia's Indigenous and non-Indigenous communities.

LOULOU D'AKI

Can Greece Save the Summer?

Athens, Greece

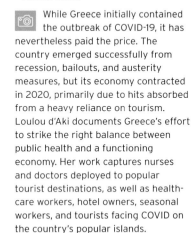 While Greece initially contained the outbreak of COVID-19, it has nevertheless paid the price. The country emerged successfully from recession, bailouts, and austerity measures, but its economy contracted in 2020, primarily due to hits absorbed from a heavy reliance on tourism. Loulou d'Aki documents Greece's effort to strike the right balance between public health and a functioning economy. Her work captures nurses and doctors deployed to popular tourist destinations, as well as health-care workers, hotel owners, seasonal workers, and tourists facing COVID on the country's popular islands.

STEFANIA D'IGNOTI

COVID-19 and Italy's Immigrants

Sicily, Italy

In 2020 the Italian Ministry of Interior estimated that 40,000 Nigerian women are in Italy. Eighty percent of them are sex workers—victims of the thriving trafficking network operating between Nigeria and Sicily. In 2015 Osas Egbon, a Nigerian woman and former victim of human trafficking, founded a women's shelter offering housing as well as legal, educational, and employment guidance to her fellow victims. But the COVID-19 pandemic brought new economic hardships and a deep suspicion of immigrants. In her body of work, Stefania D'Ignoti examines these unexpected challenges for Egbon and for underresourced Black communities across Italy.

LAURE D'UTRUY

How COVID-19 Has Compounded Inequalities in Specialized Education

Nantes, France

 A 2019 United Nations report states that more than 12,000 disabled children are excluded by the French education system. The COVID-19 pandemic has increased these disparities, limiting visual communication, physical stimulation, and social interaction, and hindering the children's development. In her body of work, Laure d'Utruy explores how three mentally disabled children and their adoptive mother have been challenged by the pandemic, including their difficulties integrating into French society and equitably accessing education. D'Utruy's reporting provides an intimate look at the obstacles this family faces, and their response to them.

JACOBIA DAHM, LUISA BECK, AND JULIA GUNTHER

Addressing Loneliness During COVID-19

Hamburg, Germany

With limited mobility and little access to technology, the elderly can be among the most vulnerable to the devastating mental and physical consequences of loneliness during the COVID-19 pandemic. Jacobia Dahm, Luisa Beck, and Julia Gunther document innovative new public projects in Germany and the Netherlands aimed at helping elderly people feel less isolated. These projects are starting points for addressing loneliness on a global scale.

WILLIAM DANIELS

Island on the Edge: COVID-19 Exacerbates Social Inequalities

Mayotte, French Overseas Territory

William Daniels's images explore the impact of COVID-19 on Mayotte, a French overseas territory comprising two islands in the Indian Ocean between continental Africa and Madagascar. Mayotte lacks standard infrastructure such as running water and has a single hospital with 80 doctors per 100,000 inhabitants; more than 80 percent of its inhabitants live below the poverty line. These challenges increase the potential for a catastrophic outbreak of COVID-19 on the islands; such a scenario would exacerbate its many existing social, economic, and public health issues.

WILLIAM DANIELS

Island on the Edge: COVID-19 Threatens Social and Environmental Security

Mayotte, French Overseas Territory

In Mayotte, a tiny overseas department of France in the Mozambique Channel, four out of five people live under the poverty line. A legacy of poverty and underdevelopment, now exacerbated by the COVID-19 pandemic, has fomented an extremely high crime rate, especially among young people unable to find jobs. William Daniels examines how COVID-19 is tearing the island's social fabric, as well as jeopardizing its lagoon, which is being decimated by poaching, overfishing, and nearby deforestation.

ARKO DATTO

COVID-19 and India's Festival Season

Kolkata, India

In 2020, as India recorded an increasing number of COVID-19 infections, Arko Datto documented how the Hindu religious festival season, which runs from September to early December, unfolded in the eastern part of the country. The 2020 festival season—which followed stringent pandemic lockdowns, faced a faltering economy, and fielded anti-Muslim legislation and attacks—embodies the pandemic's fallout, as well as disturbing new trends of nationalistic chauvinism.

AROU DAVID

COVID-19 Hits Abyei

Abyei, Sudan

 In Abyei, a disputed area claimed by both South Sudan and Sudan, the COVID-19 pandemic and ensuing public safety measures have affected the population in adverse ways. The rise in unemployment, the number of youths who lack housing, crime, and domestic violence deserve humanitarian and government attention. Arou David examines the root causes of these problems to determine effective interventions and increase awareness of these urgent issues.

LISA MARIE DAVID

Pushed to the Edge of Poverty, Blind and Visually Impaired Workers Face COVID-19

Quezon City, Philippines

 Historically, a large portion of Filipinos who are blind or otherwise visually impaired are employed in spas as massage therapists or work in more informal jobs like busking. The lockdown in the wake of the COVID-19 pandemic created mass unemployment that pushed many of them to the brink of poverty, with no guaranteed safety net, no regular government aid, and no quality health care. Lisa Marie David explores how this group is facing up to the struggles, fears, and uncertainties of the pandemic, both as individuals and as a community.

ANA CAROLINE DE LIMA

Brazil's Public Health Care During COVID: Inside the Struggles Within

São Paulo, Brazil

Even as the Brazilian government assured its citizens that its public health-care system would function properly during the pandemic, patients endured long waits and exposure to COVID-19, and many were turned away from medical facilities. Ana Caroline de Lima documents the struggles and risks endured by patients seeking treatment during the COVID era through firsthand accounts of navigating the system on behalf of her ailing father.

SANNE DE WILDE

Belgian Prisoners Evade COVID Deaths

Beveren, Belgium

While incarcerated populations around the world have been hit especially hard by the pandemic, the prison in Beveren, Belgium, has experienced no deaths due to COVID-19. In her body of work, Sanne De Wilde explores what may be achieved in other prison systems by administering appropriate treatment and care.

DEBSUDDHA

Albinism, Discrimination, and COVID-19

Kolkata, India

Through his photography, Debsuddha documents how the COVID-19 pandemic has compounded the isolation and psychological struggles of his unmarried aunts, who faced discrimination as people with albinism even prior to the pandemic. His work not only explores the impacts that social isolation measures have had on his relatives' mental health but also celebrates their resilience and the uniquely strong bond of their sisterhood.

MARCELA DEL MURO, VICTORIA RAZO, AND ALEJANDRA RAJAL

COVID-19 and Livelihood Inequality for Mexican Women

San Luis Potosí, Mexico

 Amid the COVID-19 pandemic, the unemployment rate for women in Mexico grew by 110 percent—more than double that of the unemployment rate for men. Journalists Marcela del Muro, Victoria Razo, and Alejandra Rajal

investigate the disparate impact that COVID-19 has had on the professional lives of women in Mexico, underscoring how the pandemic exacerbated existing issues of inequality, discrimination, and threats to their livelihoods.

JOANNA DEMARCO

COVID-19 and Inhumane Treatment of Migrants

Valletta, Malta

 Migrants arriving in Malta have suffered a surge of inhumane treatment in the wake of the COVID-19 pandemic. They have been stranded at sea, locked in inadequate detention centers, and, in a breach of European Union human rights laws, returned to unsafe conditions in their home countries. In collaboration with the local nongovernmental human rights organization Aditus Foundation and local journalists, Joanna Demarco investigates how the pandemic fostered mistreatment and hostility, illuminating life in detention centers through the testimonies of those who have been detained in them.

BEN C. DEPP

And Still We Rise: Low-Income Renters in New Orleans

New Orleans, Louisiana, United States

 In April 2020 Louisiana had among the highest number of COVID-19 cases per capita in the United States, and double the mortality rates of anywhere else in the country. Ben C. Depp's powerful body of work examines the pandemic's impact on urban, low-income renters in New Orleans. It documents illegal evictions, housing issues, and challenges with elderly care, but it also features positive stories of neighborhood solidarity. Depp's reporting reveals how residents can access resources available to them, highlighting the consequences of unmet needs.

MUNMUN DHALARIA

Facing COVID in the Dalai Lama's Hometown

Dharamshala, India

 In this illuminating project, Munmun Dhalaria explores the impact of COVID-19 on her hometown of Dharamshala, India. Her work reveals some difficult truths—the struggles of small farmers, undocumented migrants, and Tibetans in exile—but also tells stories of hope and resilience, including that of the community leaders who have provided safe harbor during the pandemic to those who need it. Dharamshala's response to COVID-19, which enabled decentralized decision-making among community leaders, may have saved many lives; examining its success highlights the systemic weaknesses in the response of other communities and nations.

MEGHAN DHALIWAL

With the Return of the Whale: COVID-19 Threatens Vital Ecotourism in the Baja Peninsula

Adolfo López Mateos, Mexico

From January to March each year, the sleepy port town of Adolfo López Mateos, on Mexico's Baja Peninsula, transforms into a thriving ecotourism destination as the gray whales arrive to give birth. Meghan Dhaliwal investigates how the COVID-19 pandemic has impacted ecotourism here, including economic repercussions, safety precautions for locals and tourists, and the effect on the safety of the whale population. The story of Adolfo López Mateos highlights the fragility of communities and ecosystems around the world that are reliant on outsiders.

DINA COLECTIVO: FABIOLA CEDILLO, FERNANDA GARCÍA, AND ALESSANDRO BO

Returning to *Ayni:* Indigenous Traditions and COVID-19

Cuenca, Ecuador

 In Ecuador, the COVID-19 crisis reignited a return to the ancient practice of barter. Among some Indigenous communities, when a person receives a good or product, they cannot just reciprocate with gratitude; instead, appreciation must be demonstrated with *ayni*, the Andean tradition of reciprocity. In their body of work, Fabiola Cedillo, Fernanda García, and Alessandro Bo explore the story of three women—Tatiana, Gemma, and Fanny—who, after experiencing serious economic crises in the wake of COVID-19, found barter to be an effective way to sustain themselves.

RIDWAN KARIM DINI-OSMAN

Countering Deadly COVID-19 Vaccine Misinformation

Volta Region, Ghana

In Ghana, misinformation and conspiracy theories are leading to widespread fear and mistrust of COVID-19 vaccines. Vaccine hesitancy is disrupting the government's goal of inoculating most of its 30 million people, as well as prolonging the economic and societal consequences of the disease. In his project, journalist Ridwan Karim Dini-Osman explores vaccine science, as well as the complex historical and cultural factors that fuel hesitancy here, to help dispel vaccine misconceptions.

RORY DOYLE

The Only Constant Is Chuck's: COVID-19 in the Lower Delta

Rolling Fork, Mississippi, United States

 Iconic eatery Chuck's Dairy Bar has been a mainstay for generations in the lower Mississippi Delta, feeding farming families and serving as a meeting place where

locals stay connected. In this body of work, Rory Doyle uses Chuck's—an enduring fixture in this rural area, where the economy and population are dwindling—as a way to explore how COVID-19 has compounded the challenges in the lower delta, including the monumental rainfall and flooding that has prevented many farmers from planting.

ALICE DRIVER

Essential Workers Endure High COVID-19 Risks to Maintain Food Supply

Oark, Arkansas, United States

Alice Driver examines how essential workers in Arkansas—mostly consisting of undocumented immigrants or those from low-income rural communities—risked heightened exposure to COVID-19 as they continued to produce meat and meat products. In April 2020 newspapers around the world reported that many U.S. meat-processing plants did not follow basic COVID-19 safety guidelines, nor did they provide paid sick leave for all workers. This greatly elevated the public health risk to those keeping food available during the pandemic—many of them immigrants.

TIMOTHY EDZEANI DOH

Zaratu in Old Fadama: A Head Porter Navigates COVID-19

Accra, Ghana

 In his short documentary film, Timothy Edzeani Doh examines the plight of Ghanaian *kayoyos*—marketplace porters who carry goods on their heads—in the face of COVID-19. We meet Zaratu, a 25-year-old kayoyo who migrated to Accra from northern Ghana to work in the Agbogbloshie market. She lives in a single room with nine other women and four of their children in one of Accra's largest informal settlements; we watch as they

try to protect themselves against COVID-19 and navigate the ensuing quarantine measures.

PATRICK EGWU

Food Crisis Fears Amid COVID-19
Makurdi, Nigeria

 Even before the outbreak of COVID-19, the number of undernourished people in Nigeria was estimated at more than 25 million. The pandemic brought multiple economic shocks to the country, exacerbating food insecurity. Nigeria's smallholder farmers—those working less than 25 acres (10 ha) of land—are most at risk from this issue. Patrick Egwu documents how this group is taking steps to maintain food security, including partnering with the Nigerian government. His reporting can help these vulnerable communities access critical information to aid in their fight against hunger.

AMEH EJEKWONYILO

Abandoned and Forgotten: Education Compromises Amid COVID-19
Abuja, Nigeria

After shutting down in the face of COVID-19, most schools in Abuja, Nigeria, reopened after installing necessary safety measures. But Wuna Primary School, serving children in a low-income community that lacks potable water, wasn't able to accommodate precautionary measures like handwashing kits and hand sanitizers, and it remained shut down. Then another disaster struck: Several of the school's classrooms and the community's only primary health-care center were destroyed in a windstorm. Ameh Ejekwonyilo tells the story of Wuna Primary School—and of students who face an uncertain educational future—in the hope of spurring the Nigerian government to reopen it with proper safety measures in place.

REHAB ELDALIL

Keepers of the Land
South Sinai, Egypt

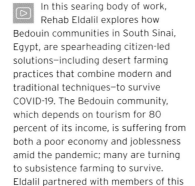 In this searing body of work, Rehab Eldalil explores how Bedouin communities in South Sinai, Egypt, are spearheading citizen-led solutions—including desert farming practices that combine modern and traditional techniques—to survive COVID-19. The Bedouin community, which depends on tourism for 80 percent of its income, is suffering from both a poor economy and joblessness amid the pandemic; many are turning to subsistence farming to survive. Eldalil partnered with members of this community to tell their story through a collaborative process that incorporates poetry, embroidery, and written and spoken commentary.

CHLOË ELLINGSON

Midwives' Vital Role Amid the Pandemic
Toronto, Canada

Despite providing vital health-care services throughout the COVID-19 pandemic, midwives across Canada have not been supported on an institutional level; initially, they were not recognized as frontline or essential workers, and therefore did not receive increased pay or access to personal protective equipment. Chloë Ellingson highlights the important role that midwives played during the pandemic, including providing home visits as the rate of births outside hospitals rose.

SARA ESCOBAR

The Pandemic Babies
Mexico City, Mexico

Sara Escobar's images tell the story of babies who were conceived and born during the COVID-19 pandemic. Her reporting illuminates how the length of the pandemic and its resulting lockdowns have exceeded many people's expectations, and how

this new circumstance has provided the opportunity for many mothers to reexamine the advantages of a home birth.

BENJAMIN EVINE

Preparing Gabon's Rural Communities for COVID-19
Ogooué-Ivindo Province, Gabon

Ivindo FM, a local radio station in Gabon, gathered feedback from rural and Indigenous citizens to provide culturally, linguistically, and geographically correct information about COVID-19's impact on their communities. The station hopes to increase the overall understanding of the virus so that these groups can better protect themselves in the face of an overwhelming public health crisis.

CITLALI FABIÁN, EVA LÉPIZ, AND GRETA RICO

Indigenous Female Artisans Struggle Amid COVID-19
Oaxaca City, Mexico

The COVID-19 pandemic has been catastrophic for Mexico's tourism economy—especially for Indigenous female artisans who not only saw their incomes disappear almost overnight but also face steep gender barriers when pursuing the opportunities that remain. Through portraits, Citlali Fabián, Eva Lépiz, and Greta Rico document the challenges faced by three Indigenous women who produce wood crafts, pottery, and textiles during the pandemic and examine their roles as breadwinners in a traditionally patriarchal society.

ANTONIO FACCILONGO

Stillbirths Amid COVID-19
Rome, Italy

During the COVID-19 pandemic, the rate of stillbirths rose substantially around the world. Evidence shows that this is not directly

due to the COVID-19 virus but rather to various factors associated with the pandemic, including pregnant women skipping prenatal checks because of the risk of infection at medical facilities, the prolonged psychological stress of the pandemic, and transportation complications that prevent women from reaching hospitals. Antonio Faccilongo documents how this issue manifested in Italy, where, according to the Sapienza University of Rome, prenatal deaths tripled compared with those in pre-pandemic years.

MUHAMMAD FADLI

Indonesia's Second-Wave Response to COVID-19
West Java, Indonesia

 Although Indonesia experienced a slowing of its COVID-19 outbreak in the first few months of 2021, a second wave hit the country in July, overwhelming both the health-care system and cemetery workers. Amid the crisis, groups of volunteers came forward to fill the gaps, administering vaccines, recovering the bodies of those who had died during isolation, and building coffins for the dead. Muhammad Fadli tells the story of these volunteers—and how they have become a vital force in Indonesia's COVID-19 response.

MOHAMMAD FAHIM AHAMED RIYAD

Dhaka's Changing Landscape
Dhaka, Bangladesh

Dhaka, a densely populated city in Bangladesh, has been experiencing a large-scale departure of migrant workers to other regions of the country. Among those remaining, socioeconomic disparities have created stark differences in the ways that citizens have been able to quarantine and prepare for new COVID-19 outbreaks. Amid Bangladeshi citizens, medical professionals, and government

officials using limited resources to fight the spread of COVID-19, Mohammad Fahim Ahamed Riyad gives voice to individuals in Dhaka and illuminates how the inequalities they face impact public health preparations.

ISMAIL FERDOUS

The Immigrant Experience in America's Essential Meatpacking Plants
South Dakota, United States

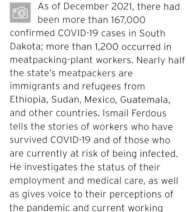 As of December 2021, there had been more than 167,000 confirmed COVID-19 cases in South Dakota; more than 1,200 occurred in meatpacking-plant workers. Nearly half the state's meatpackers are immigrants and refugees from Ethiopia, Sudan, Mexico, Guatemala, and other countries. Ismail Ferdous tells the stories of workers who have survived COVID-19 and of those who are currently at risk of being infected. He investigates the status of their employment and medical care, as well as gives voice to their perceptions of the pandemic and current working conditions.

MARIA FERNANDA RIBEIRO

COVID-19 Threatens Indigenous Elders, the Guardians of Traditional Knowledge
Santo Antonio do Içá, Brazil

COVID-19 has permeated Indigenous communities in the Brazilian Amazon—a region that, as of November 2021, had recorded 41,504 confirmed cases and 1,020 deaths. The disease particularly threatens community elders, who are the guardians of Indigenous traditions and wisdom. The closest hospitals are often days away, and health-care systems are overwhelmed, so many Indigenous peoples have turned to traditional methods to treat and prevent suspected COVID-19 cases. Maria Fernanda Ribeiro explores how intact forests may offer health benefits to Indigenous peoples at this crucial moment.

TUANE FERNANDES

Event Economy Suffers Amid COVID-19 Cancellations
São Paulo, Brazil

As events around the world were canceled in the wake of the COVID-19 pandemic, Brazil suspended football matches and postponed the country's celebrated Carnivale in 2021. Tuane Fernandes investigates the effect of these cancellations on the communities and families that have built their livelihoods around these gatherings. His body of work explores how these events have provided structure and even social services to those in need, as well as mitigated these communities' reputation for violence and disorganization.

MOLLY FERRILL

COVID-19 and Indigenous Communities
Cancún, Mexico

 Recent studies have shown that Indigenous people in Mexico have a 50 percent higher fatality rate from COVID-19 when compared with the rest of the population. The highest death toll among all Indigenous people was registered in the Cancún area—likely due to international tourism that has continued throughout the pandemic. Molly Ferrill reports on the high death rate among this population to urge tourists to protect it—and to highlight the underlying inequities that have enabled this alarming disparity.

STEPHEN FERRY

COVID-19 Spurs a Bicycle Boom
Bogotá, Colombia

Between April and December 2020, bicycle use among Bogotá's citizens increased by 80 percent in a civic attempt to avoid crowded public transportation and reduce costs amid the COVID-19 pandemic. Today the city has an estimated 830,000 daily riders. To facilitate and spur this trend, Bogotá's government has added nearly 125 miles (200 km) of new bikeways to the existing network of 340 miles (550 km), with plans to build another 175 miles (280 km). It has also reorganized its existing traffic strategy to prioritize bike lanes. In this body of work, Stephen Ferry explores how Bogotá is leveraging the popular response to the COVID-induced transportation crisis to create a sustainable model that can lower carbon emissions into the future.

ANNA FILIPOVA

Untouched by COVID-19
Longyearbyen, Norway

 Longyearbyen, Svalbard—considered the world capital of polar bears, with a population of 3,000—is one of the northernmost towns on the planet. Relatively protected from the pandemic, it recorded its first COVID-19 case only in November 2021. Anna Filipova documents life in this remote town, including the strict measures it enacted to remain COVID-free, its vaccination campaign, and its increasing isolation as the pandemic shuttered travel and tourism.

FLUXUS FOTO: VANESSA TERÁN, JOHANNA ALARCÓN, ANA MARÍA BUITRÓN, JOSUÉ ARAUJO, DAVID DIAZ ARCOS, KAREN TORO, AND ANDRÉS YEPEZ

Education Through WhatsApp
Quito, Ecuador

Masterminded by a team of visionary photographers and educators, this compelling body of work illuminates the increasing social inequalities around education in Ecuador during the COVID-19 emergency and explores the responses and consequences. Ecuador is one of the Latin American countries most affected by COVID-19.

JEWEL FRASER

COVID-19 Highlights Systemic Inequities in Caribbean Education Systems
St. Augustine, Trinidad and Tobago

Since the advent of the COVID-19 pandemic in March 2020, the Ministry of Education indicated that among Trinidad and Tobago's 200,000 students, as many as 46,000 may be unable to participate in online learning. Some students lack computers or internet connectivity, while others are in need of social support. In her podcast, Jewel Fraser explores how the pandemic affected student achievement in Trinidad and Tobago and Barbados—and how it underscores the need for a more inclusive system of education.

ANDREA FRAZZETTA

Into the Woods: Outdoor Schools in Italy
Milan, Italy

In his body of work, Andrea Frazzetta explores the potential for outdoor schools—where children are in direct contact with nature, animals, and plants—as a new way to rebuild Italian school systems after they shut down in the face of the COVID-19 pandemic. These schools, which emphasize a relationship with the outdoors from an early age, may be a first step toward combating nature-deficit disorder, which can result in a wide range of behavioral issues. These institutions may also foster empathy for the environment—and a desire to protect it.

GIULIA FRIGIERI AND MARTA BELLINGRERI

Loneliness and Isolation Plague the Islands

Aeolian Islands, Italy

 The communities of Sicily's Aeolian islands, which thrive on seasonal tourism, often experience isolation and loneliness during the winter months. In their body of work, Giulia Frigieri and Marta Bellingreri explore how COVID-19 has compounded this experience for the youths and adolescents living there, documenting their emotional responses as well as educators' tireless efforts to keep them engaged.

KARLA GACHET AND IVAN KASHINSKY

L.A.'s Dreamers: Essential Workers Risk Deportation

Los Angeles, California, United States

 Since 2020 more than 200,000 recipients of the Deferred Action for Childhood Arrivals, or DACA, have risked their health to meet America's needs during the COVID-19 pandemic as essential workers. Legal challenges to DACA were heard in the Supreme Court; in June 2020 a decision came down to uphold the Obama-era program that had protected so-called Dreamers from deportation. In this critical moment, Karla Gachet and Ivan Kashinsky explored the daily lives of young immigrants working in critical positions in Los Angeles who were facing the twin threats of COVID-19 and extradition.

ZIYAH GAFIC

"The Game" in the Age of a Pandemic

Sarajevo, Bosnia and Herzegovina

 For decades, Bosnia and Herzegovina has become a stopover point for tens of thousands of undocumented migrants and refugees in "the game," a vernacular term used to describe their perilous journey to reach the European Union. With limited access to basic health care and sanitary facilities as well as overcrowded living conditions, this group is at a high risk for contracting COVID-19. Ziyah Gafic tells the stories of these migrants as they navigate the pandemic, including societal perceptions of their community.

DADO GALDIERI

How Plastic-Wrapped Hugs Helped Combat COVID

Rio de Janeiro, Brazil

In her compelling body of work, Dado Galdieri tells the story of Maura Cristina Silva, a teacher in Rio de Janeiro who believes that no meaningful, long-lasting education can be possible without love. Her method for teaching underprivileged students has always been "winning their hearts first to have their attention later"—an attitude that often yields above-average results on their academic testing. When the COVID-19 pandemic struck and in-person classes were suspended, Silva replaced homework with affection, visiting her students to deliver plastic-wrapped hugs to help them overcome depression and loneliness.

PAUL GAMBIN AND ALEJANDRA OROSCO

Worlds Apart: A Portrait of Multinational Couples Separated by COVID-19

Lima, Peru

The COVID-19 pandemic forced thousands of binational couples to separate with little notice or opportunity to plan for the future. The circumstance caused relationships to break apart, families to split, mothers to give birth alone, and wedding dates to be postponed or even canceled, placing significant strains on mental and emotional health. In their body of work, Paul Gambin and Alejandra Orosco share the personal stories of couples who were separated,

underscoring what it means to be in a relationship and part of a family in the 21st century.

MICAH GAREN

A City Where Everyone Has Access to a COVID-19 Test

San Miguel County, Colorado, United States

 In 2020 entrepreneurs and residents of San Miguel County, Colorado, offered to privately fund COVID-19 testing for all 8,000 of the county's residents. Micah Garen, a resident, covered the results of this effort, as well as the social and public health implications of privately funded testing. Garen contrasts this experience with that of a nearby Navajo community countering the outbreak of COVID-19 with few available resources.

CÉDRIC GERBEHAYE

Amid COVID-19, a Small Town in Belgium Quietly Fights for Its Life

Charleroi, Belgium

In this unique body of work, Cédric Gerbehaye documents a town in one of the hardest-hit regions in Belgium, underscoring local heroes and the daily lives of essential workers under pressure from the pandemic. His images provide both a record and a testimony of this ravaged community.

ÓLAFUR STEINAR RYE GESTSSON AND FREDERIK TILLITZ

How the COVID-19 Pandemic Has Exposed and Compounded Denmark's Inequalities

Ishøj, Copenhagen, Denmark

In this unique body of work, Ólafur Steinar Rye Gestsson and Frederik Tillitz explore how the COVID-19 pandemic exacerbated inequalities in Danish society. Their area of focus is the alarming disparity in infection rates between wealthier and lower-income communities, which include immigrants and their recent descendants. Gestsson and Tillitz examine how this disparity may further exacerbate inequality if recovery in low-income communities lags behind that in wealthier ones.

SUBHASH GHIMIRE

As Nepalis Return Home, an Uncertain Future Awaits

Kathmandu, Nepal

Nepal's citizens make up a significant diaspora community, with remittances accounting for 28 percent of the country's GDP in 2019. As jobs decreased in neighboring countries, due to the outbreak of COVID-19 and resulting economic downturn, Nepal braced for large numbers of workers returning home to face poor employment prospects and a fragile political situation. Subhash Ghimire explores the economic, social, and cultural impact of this harrowing scenario.

ZAHARA GÓMEZ LUCINI AND DANIELA REA

COVID-19 and Enforced Disappearances in Mexico

Sinaloa, Mexico

 In the face of indifference from Mexican authorities toward the country's numerous enforced disappearances, the victims' mothers, wives, and other relatives took actions into their own hands, forming collectives to organize searches and provide safe places for community and support. The onset of COVID-19 caused many of these families to lose their incomes; others were struck with the virus. In this body of work, Zahara Gómez Lucini and Daniela Rea document how the pandemic inspired these collectives to advance their searching methods and establish a stronger sense of solidarity.

FLORENCE GOUPIL

Cantagallo Island: Indigenous Community Finds Nourishment in Tradition
Lima, Peru

 Cantagallo Island is an Indigenous community founded in Lima by the Shipibo-Conibo people of the Peruvian rainforest; it suffers from extreme poverty and lacks access to running water and other basic necessities. In her unique body of work, Florence Goupil documents the ways this community is using traditional medicine in response to the pandemic outbreak.

FLORENCE GOUPIL AND TEO BELTON

Preserving the Knowledge of Indigenous Elders Amid COVID-19
Ucayali, Peru

As the elders of the Indigenous communities of the Peruvian Amazon and Andes pass away, a living memory—of their culture, their heritage, and the forest and its biodiversity—is vanishing with them. The COVID-19 pandemic has greatly impacted these communities, threatening their elders as well as the knowledge and traditions that emphasize a connection to nature. Poor access to health care and services, the influence of Western cultures, and conflict with the industry that has deforested and polluted their lands have left these Indigenous communities with few of the resources they need to flourish. Photographer Florence Goupil and filmmaker Teo Belton interview these communities' elders and leaders to preserve the knowledge of these "living libraries" in a time of pandemic.

JANE HAHN

Community Organizers Work to Close Racial Gaps in Vaccine Distribution
Los Angeles, California, United States

Although the Black and Latino communities in Los Angeles County, California, are suffering from high rates of COVID-19, many who are eligible for vaccination have yet to receive a dose. This is due partly to vaccine hesitancy, given historical abuses by the medical establishment and the resulting lack of trust. But the disparity is also attributable to a county vaccine-rollout plan that requires technological proficiency, as well as time, flexibility, and transportation resources. Jane Hahn documents how community organizations have filled gaps by disseminating information, easing the appointment process, and organizing vaccination locations in targeted areas, providing a framework for addressing the structural inequalities hindering the vaccine rollout.

JUSTIN HAMEL

Food Assistance in the Wake of COVID-19: Sidestepping the Disabled
El Paso, Texas, United States

According to the Lerner Center for Public Health Promotion, nearly a third of U.S. households experiencing food insecurity include a working-age adult with a disability. Nevertheless, many local and federal assistance programs created in response to COVID-19 assume recipients are able to drive. By documenting the daily challenge the disabled community faces in accessing consistently healthy food, as well as those helping to alleviate the shortcomings of traditional food pantries, Justin Hamel illuminates the bias inherent in the design of many emergency programs.

RITA HARPER

A Portrait of Atlanta: Why Black Americans Are Dying of COVID-19 at Higher Rates
Atlanta, Georgia, United States

In this series of images, Rita Harper investigates why Black Americans are dying from COVID-19 at disproportionate rates. A number of factors play into this outcome. First, many Black Americans are essential workers who continue to go to work. They also have a higher prevalence of health conditions—including diabetes, hypertension, asthma, and high blood pressure—as well as a lack of access to healthy food choices.

NANNA HEITMANN

COVID-19 Rages Across North Asia
Siberia, Russia

As COVID-19 spread across the Urals and Siberia, where the freezing winter arrives early, Nanna Heitmann documented Russia's battle against the pandemic. Heitmann crafts an in-depth portrait of life in the far reaches of Siberia during the outbreak—where a lack of doctors, an obsolete health-care system, and the extreme cold compounded the threat of the virus and led to a deep crisis.

ANDREA HERNANDEZ

When Social Distancing Is Impossible
Caracas, Venezuela

Despite a government-imposed shutdown, Petare, one of Latin America's largest low-income neighborhoods, is still vibrant with activity as residents continue to seek closeness and contact. Andrea Hernandez documents how these Venezuelans—who faced an economic crisis with a collapsed health-care system even prior to the outbreak of COVID-19—have coped with the global pandemic when social distancing is impossible.

LIZBETH HERNÁNDEZ AND MAHÉ ELIPE

Amid COVID-19, Mexican Women Create a Turning Point in Their Fight for Freedom
Mexico City, Mexico

Violence against women in Mexico has increased dramatically amid the COVID-19 pandemic. But through it all, this group has fought for freedom from violence and full access to sexual, reproductive, and economic rights. Lizbeth Hernández and Mahé Elipe tell the story of this historic moment through visual media, including a fanzine and photos, covering key moments in this feminist movement and the women who made them happen.

SOLIMAN HIJJY

Countering Vaccine Disinformation
Gaza Strip

As COVID-19 ramped up, the virus raged in the Gaza Strip. As of June 2021, the death toll there had topped 900, and more than 100,000 had been infected. Officials warned that the overwhelmed health-care system was barely coping, and there were only enough doses of vaccine to fully inoculate about 50,000 of Gaza's two million residents. Adding to these challenges was widespread misinformation about the vaccines and hesitancy about taking them. Soliman Hijjy's short documentary film counters false information with facts about the COVID-19 vaccines.

JODI DANIELLE HILTON

COVID-19 and the Chance to Rethink Education
Boston, Massachusetts, United States

 Jodi Danielle Hilton's imagery explores how outdoor education has become a safe option for schooling during COVID-19—and how the pandemic may afford the opportunity to explore alternative models for education.

AIDA HOLLY-NAMBI
COVID-19 and Kenya's Safari Industry
Nairobi, Kenya

Historically, safaris in Kenya have been marketed to wealthy, predominantly white foreign guests. Although they are often viewed as drivers of conservation, they have excluded Black local Kenyans. But the COVID-19-induced halt in international tourism—an industry that brought the country an estimated $1.6 billion (U.S.) per year—has forced this sector to reevaluate race, conservation, and local participation. Aida Holly-Nambi explores how COVID-19 has changed Kenya's historical narratives about tourism and conservation.

GREY HUTTON
Heroes in Hackney: Community Lifelines
London, England

Hackney is one of the most diverse and underserved boroughs in the United Kingdom, and once possessed the third highest COVID-19 mortality rate in the country. Informal support networks, including food hubs, community-support organizations, and translators of critical health and safety information, have become residents' unsung lifelines. Grey Hutton documents these networks and the individuals that stand at their center, exploring the human impact of the COVID-19 pandemic beyond the headline-grabbing statistics.

STUART HYATT
The Great Quieting
Anchorage, Alaska, United States

Amid silent, carless streets and planeless skies resulting from COVID-19 lockdowns, it turns out that Earth itself went quiet. A study published in the September 11, 2020, issue of the journal *Science*, co-authored by 76 scientists, described "the longest and most coherent global seismic noise reduction in recorded history." Stuart Hyatt explains this phenomenon through a multifaceted, interdisciplinary project that expresses these data through an exhibition, a film, a music album, and an accompanying book, as well as a series of educational programs.

ANNIE HYLTON
Despite COVID-19 Risk, Citizens Open Their Homes to Asylum Seekers
Paris, France

Amid the pandemic, migrants and asylum seekers continued to cross oceans and mountains to seek safety in France. So many asylum requests were registered in Paris that many newly arrived people, including families and unaccompanied minors, were forced to live on the streets for weeks or months as they waited for appointments. Annie Hylton tells the story of the people who opened their homes to this group despite the risk posed by the virus.

TAILYR IRVINE
How Centuries-Old Tribal Ceremonies Are Adapting to COVID-19
Flathead Indian Reservation, United States

In this body of work, Tailyr Irvine documents how the Indigenous people of the Flathead Indian Reservation—a community particularly at risk from COVID-19, due to high rates of preexisting conditions and limited access to health care—are adapting to the pandemic. Irvine examines these threats to health care and explores the pandemic's effect on tribal cultures, including how annual ceremonies were adapted in the face of public health restrictions.

JOSHUA IRWANDI
Viral: Photography in a Post-Truth Landscape
Jakarta, Indonesia

When National Geographic published an image of the corpse of a suspected COVID-19 victim wrapped in plastic, it immediately went viral. Public reaction was intense: Joshua Irwandi's photograph received more than 350,000 interactions on Instagram—along with a severe backlash. Irwandi, accused of staging the photo to spread fear, received violent abuse on social media. Through his body of work, titled "Viral," Irwandi examines the transformation of newsgathering in the age of social media—and its threat to journalism as a watchdog of democracy.

NÚRIA JAR
Women Scientists Lead the Fight Against COVID-19
Barcelona, Spain

Half a century ago, June Almeida discovered the first coronavirus; her relative obscurity is just one example of media underrepresentation of women scientists. Núria Jar produced a six-chapter narrative podcast that gives voice to six female scientists pursuing solutions to the COVID-19 pandemic, including new treatments, vaccines, diagnostic devices, and other scientific advancements. The podcast highlights how female scientists working in institutions, research centers, universities, and hospitals play a central role in the global effort to treat and counteract this deadly pathogen.

SHAKER JARRAR, ALI SAADI, AND AMMAR SHUKEIRY
Jordan's Shuttered Tourism Sector Hits Rural Communities
Petra, Jordan

Jordan's tourism industry has been growing steadily, with income from this sector up by 10 percent and the number of tourists up by 7.7 percent over the course of 2019. Projections forecast even more growth—until the outbreak of COVID-19. Rural communities, which have grown to depend almost entirely on tourism for their livelihoods, were among the most impacted. Shaker Jarrar, Ali Saadi, and Ammar Shukeiry report on the struggles these communities face—and the solutions they have created to deal with the pandemic's ramifications.

ANA JEGNARADZE
Easter in Quarantine: The Georgian Orthodox Church Adapts
Gomi, Georgia

For centuries, visiting faraway family members has been integral to the joyful celebrations of Easter in Georgia. This has remained unchanged even during times of war—that is, until the outbreak of COVID-19. In her film, Ana Jegnaradze tells the story of this year's Easter festivities as the Georgian Orthodox Church navigates the isolating effects of the pandemic and its resulting quarantine.

LYNN JOHNSON
How COVID-19 Is Threatening Rural Health Care
Whidbey Island, Washington, United States

In 2020 it was projected that a quarter of rural hospitals in the United States will be forced to close due to the extreme financial and social pressures created by the COVID-19 pandemic. In her poignant body of work, Lynn Johnson investigates the ways, both subtle and profound, that the COVID-19 outbreak is changing—and at

times threatening—medical caregiving for millions of people in U.S. rural communities. As her canvas, Johnson turns to Washington State's Whidbey Health Medical Center and Whidbey Island, the community it serves.

SYLVIA JOHNSON

Humanizing Vaccine Safety Messaging
Garfield County, Colorado, United States

 Garfield County in western Colorado is roughly 30 percent Latinx. Because this population makes up the majority of the county's essential workers, it is particularly vulnerable to COVID-19. As of February 2021, only 3.5 percent of Latinx people in the United States had been vaccinated—compared with 9.1 percent of white Americans—despite suffering disproportionately high levels of complications and deaths. Sylvia Johnson covers this issue from the perspective of the Latinx community, both to underscore the safety of the vaccine and to help its members better understand how to protect themselves during the pandemic.

TOYA SARNO JORDAN

COVID-19 Leaves Sex Workers Living on Buenavista's Streets
Mexico City, Mexico

In this series of images, Toya Sarno Jordan documents the potentially devastating consequences of COVID-19 for sex workers in Mexico City's Buenavista neighborhood. Since the pandemic began, this group has seen a sharp downturn in clients, leaving many without incomes and living on the streets or in shelters. Through the story of Nicky, an HIV-positive trans sex worker, and her partner, Juan, Jordan highlights the struggles of trans sex workers during COVID-19, including the threat of potential exposure amid escalating cases.

SANDESH KADUR

COVID-19: A Filmmaker's Story of Loss and Recovery
Bangalore, India

 After losing his father to COVID-19, wildlife filmmaker Sandesh Kadur retraces his personal journey through the pandemic to understand its larger impact on society. His investigation spans the initial outbreak, the death of his father, and the effects of the pandemic on the environment and India's wildlife. Kadur's reporting makes the connection between the jarring loss of human life and the pandemic's costs and benefits to the environment.

PAULA G. KAHUMBU

COVID-19 Undoing Years of Conservation Gains in Kenya
Nairobi, Kenya

With the collapse of Kenya's wildlife tourism economy in the wake of COVID-19, conservation gains made over the past 30 years were suddenly at risk. Thousands of tourism-sector jobs disappeared overnight, exacerbating poverty and increasing the likelihood that newly impoverished people will turn to wildlife poaching to make ends meet. Paula G. Kahumbu documents how state and private sector actors are adapting to Kenya's new reality—and how communities are innovating to ensure the protection of wildlife in their region.

JITTRAPON KAICOME

Mahouts and Their Elephants Face COVID-19
Chiang Mai, Thailand

For decades, Thailand's mahouts (elephant caretakers) have relied on the tourism industry to survive. With the sudden halt of travel in the wake of COVID-19, many mahouts—who are often marginalized ethnic minorities—have returned from the country's tourist destinations to their birthplaces and find themselves struggling to care for their families and their elephants. Jittrapon Kaicome explores these issues, illuminating how, in a time of COVID, the fates of mahouts—at once social outcasts and symbols of national pride—and their elephants are inextricably linked.

M. KALEIPUMEHANA CABRAL AND MARIE ERIEL HOBRO

The Past Repeated: Visitor-Induced Outbreaks Return
Kailua, Hawaii, United States

In this innovative body of work, M. Kaleipumehana Cabral and Marie Eriel Hobro document the parallels between the deadly diseases of Hawaii's past—introduced by visitors to the islands—and the COVID-19 pandemic. They aim to educate people locally and globally by frankly comparing Hawaii's history with its present, demonstrating how each scenario has led to extractive economies and race-related health-care disparities.

PATRICK KANE

Life Inside a COVID-Free Zone
Yellowknife, Canada

 The Northwest Territories—an enormous subarctic region of Canada with a small population scattered across several mainly Indigenous hamlets—has so far avoided large-scale transmission of COVID-19. However, the impact of transmission in smaller villages could be disastrous to an at-risk population with limited health-care infrastructure and resources. Patrick Kane provides a portrait of life inside this tenuously fragile COVID-free zone. He explores how western governance structures have left the Indigenous Dene people particularly vulnerable, especially in regard to health care, food security, housing needs, and the high costs of living. Kane also documents how Dene worldviews—including staying connected to the land, caring for elders, harvesting meat, and using traditional medicine—are providing the physical and mental support that residents so desperately need.

ADITYA KAPOOR

COVID 19: A Dual Threat
New Delhi, India

When COVID-19 struck India, 1.3 billion people were told to stay home and practice social distancing, abruptly leaving the country's many thousands of migrant and day-to-day workers without employment. Aditya Kapoor produced a documentary that examines the dual nature of the COVID-19 crisis here: the impact of the virus and the dangers of poverty, food insecurity, and forced migration for the recently unemployed.

ALEX KATSOMITROS

How E-Learning Is Broadening Urban-Rural Education Disparities
Athens, Greece

Alex Katsomitros unpacks how the rapid adoption of e-learning programs resulting from the COVID-19 pandemic is exacerbating educational inequality among rural and urban communities in Greece. Katsomitros's reporting explores the role of technology in the education system, how it's been affected by the pandemic, and how emerging technologies have meshed with an aging education system that favors rote memorization over critical thinking and creativity.

RUHANI KAUR

Intertwined Destinies: How COVID-19 Is Impacting Mothers and Daughters
Faridabad, India

 In India, four out of every 10 working women have lost their jobs amid COVID-19. Women over 40 with older daughters have been particularly vulnerable to the pandemic, often spiraling into a debt trap. The precedent is passed down to their daughters, many of whom cannot afford the equipment necessary to connect to online learning. Ruhani Kaur created a series of environmental portraits that highlight the intertwined destinies of mothers who lose their livelihoods and daughters who face threats to their education.

MARK KAUZLARICH

COVID-19 in America's Rural Communities
Marks, Mississippi, United States

 Mark Kauzlarich documents the factors that make America's rural communities particularly vulnerable to COVID-19: an aging population, declining employment, the opioid addiction crisis, hospital closures, and a lack of other medical facilities.

SYDNEY KAWADZA

Can Border Breaches Contribute to COVID-19 Spread and Mutation?
Harare, Zimbabwe

Border breaches in the southern African countries of Zimbabwe, South Africa, and Zambia threaten to increase the spread and mutation of the COVID-19 virus. Sydney Kawadza investigates the illegal flow of human traffic between the three countries to identify and explore new ways to plug potential border weaknesses.

TARA KERZHNER AND LEN NECEFER

The Unseen Hotspot
Navajo Nation, United States

In their revealing body of work, Tara Kerzhner and Len Necefer document how COVID-19 is devastating the Navajo Nation, which, as of May 2020, had the highest per capita COVID-19 infection rate in the United States. They share the stories of this community's public health emergency, as well methods that community members can use to respond to the crisis. Their reporting disseminates critical information about contracting the virus and fosters public understanding of the health-care shortfalls in U.S. Indigenous communities.

NATALIE KEYSSAR

Faith and COVID-19
Birmingham, Alabama, United States

Alabama was hit hard by COVID-19 while also suffering from climate-change-induced hurricanes, an ongoing opioid-addiction epidemic, and an economic downturn. During these trying times, diverse religious groups provided food aid, spiritual balm, and a sense of community amid increased isolation. As the pandemic drove many to embrace their spirituality, Natalie Keyssar documented religious practices and rituals across Alabama, illuminating the many ways that faith manifests itself in times of crisis.

AYSHA KHAN

Muslim Communities Respond to COVID-19 Threats
Boston, Massachusetts, United States

 In this body of work, Aysha Khan examines the impact of COVID-19 on low-income Muslim communities in the United States. She focuses on the experiences of Black and Bengali Muslims and how the pandemic has compounded existing social issues, including domestic violence, substance abuse, and addiction. Khan reports on the challenges that domestic violence shelters and substance abuse treatment centers have faced during the pandemic, as well as their resilience and creativity in continuing to serve their communities.

TASMIHA KHAN

Exploring Mistrust of the COVID-19 Vaccine Among Muslim Americans
Bridgeview, Illinois, United States

Tasmiha Khan investigates mistrust of the COVID-19 vaccine among Muslim communities in the United States, along with the factors that may prevent Muslim Americans from being vaccinated. Khan's reporting focuses on the role that faith plays in vaccine hesitancy and how it can be a barrier to inoculation, as well as how the Muslim perspective can be used to build trust in the vaccine and improve public health.

PETE KIEHART

How Pets Are Aiding the Study of COVID-19
Durham, North Carolina, United States

In 2020 the Molecular and Epidemiological Study of Suspected Infection at Duke University, a longitudinal experiment initially organized to research HIV, pivoted to examine COVID-19 in both human subjects and their pets. Pete Kiehart documents the inclusion of animals in the researchers' efforts, which will be conducted at patient's homes to better understand how the pathogen is transmitted in a household. Kiehart's reporting demonstrates how domesticated animals are part of the race to understand the pandemic.

M'HAMMED KILITO

My Isolation: Watching a State of Emergency Unfold
Rabat, Morocco

M'hammed Kilito's body of work documents his family's life in quarantine, using his own isolation as a lens through which to examine the economic, social, and food security struggles of his fellow Moroccans during the pandemic. With disease risks exacerbated among his family due to immune system deficiencies, the effects of seclusion were amplified for Kilito.

HAJIME KIMURA

Then and Now: How COVID-19 Changed Social Landscapes
Tokyo, Japan

The COVID-19 virus, undetectable by the naked human eye, left populations exhausted by the changes, fears, and restrictions fueled by an invisible threat. To visualize the alarming rate of social change caused by the virus, Hajime Kimura juxtaposes thermal imaging footage of central Tokyo's Ueno district from July 2020 and February 2020.

KAMIKIA KĨSÊDJÊ

Sustainability and COVID-19
Canarana, Brazil

When the COVID-19 pandemic struck, the Kĩsêdjê Indigenous people, who inhabit the Xingu Basin in the Brazilian Amazon, were cut off from the industrialized world. Kamikia Kĩsêdjê tells the story of how the Kĩsêdjê have protected themselves from the virus, coped with the shifting landscape of the pandemic, and maintained their internationally lauded sustainability project, Óleo de Pequi, with ingenuity and conviction.

AIDAN KLIMENKO

Fleeing COVID-19, Urban Families Find Hope in New Rural Communities
Cotopaxi Volcano, Ecuador

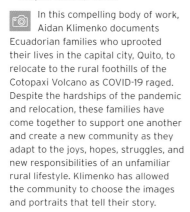 In this compelling body of work, Aidan Klimenko documents Ecuadorian families who uprooted their lives in the capital city, Quito, to relocate to the rural foothills of the Cotopaxi Volcano as COVID-19 raged. Despite the hardships of the pandemic and relocation, these families have come together to support one another and create a new community as they adapt to the joys, hopes, struggles, and new responsibilities of an unfamiliar rural lifestyle. Klimenko has allowed the community to choose the images and portraits that tell their story.

NOEL KOK

In an Idyllic National Park, One City Searches for Options
St. Lucia, South Africa

 When a tourist visiting St. Lucia tested positive for COVID-19, the small coastal town, located in South Africa's biodiverse iSimangaliso Wetland Park, became the focus of media and tabloid scrutiny. The country's response to the COVID-19 pandemic had included stopping all local and international travel, as well as closing all nonessential businesses, plunging the town into an economic crisis. Noel Kok investigates how the local communities, park, and wildlife have been impacted, underscoring urgent challenges as well as how people can support recovery plans.

KOLEKTIF 2D: PIERRE MICHEL JEAN, DAPHNINE JOSEPH, RÉGINALD LOUISSAINT, JR., MIILO MILFORT, GEORGES HARRY ROUZIER, AND ESTAÏLOVE ST.-VAL

Countering Haiti's COVID-19 Denial
Port-au-Prince, Haiti

 Wearied by decades of corruption, conflicts between citizens and government, and successive economic and social crises, much of the Haitian population harbors a strong distrust of politicians and government. As a result, many citizens have treated their government's response to COVID-19—including imposed quarantines, curfews, and the declaration of a national health emergency—with mistrust and disbelief, leading to friction as state armed forces impose sanitary and social distancing measures. Meanwhile, the lack of health and sanitary infrastructure creates dire conditions as the virus spreads. In their body of work, the members of Kolektif 2D tell the story of COVID-19 in Haiti so that local audiences can grasp the reality of the virus and that international audiences can understand the country's plight.

STACY KRANITZ

Rural Hospital Closures Accelerate During COVID-19
Fentress County, Tennessee, United States

 In her unique body of work, Stacy Kranitz documents the crisis of rural hospital closures. These accelerated during the COVID-19 pandemic due to the suspension of outpatient care and elective procedures, which pushed infirmaries teetering on the edge of bankruptcy to collapse. Rural hospitals are often the largest employer in the counties that they serve, and closures can have a grave economic impact. Shutdowns are particularly threatening to communities that have disproportionately high rates of heart disease, obesity, diabetes, and lung disease, as well as large numbers of elderly citizens. Stacy Kranitz examines how hospital closures affect rural communities, and what might be done to return emergency care to these communities.

DEREK KRAVITZ

Understanding Local Responses to COVID-19
New York City, New York, United States

 As U.S. federal, state, and local governments continue to respond to the evolving COVID-19 pandemic, it is critical for citizens to understand how their regional health departments are managing quarantine plans, social distancing orders, shortfalls in personal protective equipment, and other issues. Derek Kravitz requested internal emails from more than 150 state and local government agencies in 39 different U.S. states to develop a nationwide digital repository of correspondence related to the outbreak of COVID-19. This reporting allows readers to evaluate government decisions through synthesized key takeaways, keyword search functionality, and reports.

BÉNÉDICTE KURZEN

Africa's Leading Contributions to the Global Fight Against COVID-19
Ede, Nigeria

 Bénédicte Kurzen explores Africa's evolving contribution to global science through the story of Nigeria's African Center of Excellence for Genomics of Infectious Diseases. ACEGID led Africa's efforts to sequence COVID-19 and has made several significant advances in tracking and preventing the virus. These include developing a virus map and rapid tests, identifying lineages and mutations of the virus, and sequencing a vaccine that has passed preclinical trials.

ANDRE LAMBERTSON

A Portrait of a Neighborhood Through COVID-19
New York City, New York, United States

 In *Elegy*, Andre Lambertson provides an intimate portrait of Harlem through a time of global grief and reckoning. The film follows funeral director Isaiah Owens as he wades through the rising death toll from COVID-19 and Dedric "Beloved" Hammond, a mentor for young people. Their stories provide a window into the emotional toll of a disease that disproportionately kills Black people while also celebrating the strength, renewal, connection, and joy of the community.

ISABELLA LANAVE, EDILAINE ALVES, LAÍS MELO, AND MANO CAPPU

COVID-19 Through the Eyes of the Young
Curitiba, Brazil

 Isabella Lanave, Edilaine Alves, Laís Melo, and Mano Cappu document the perspectives of a diverse collection of Brazilian youths to understand how their generation is experiencing the social, emotional, economic, and equity consequences of the COVID-19 pandemic. Their work underscores the impact of the pandemic on the lives and future aspirations of young people.

AITOR LARA

COVID-19 Forces Community Change
Guadalquivir Marshes, Spain

COVID-19 has exacerbated already dire conditions of poverty, inequality, and unemployment for the nearly 6,000 people who reside in Spain's Guadalquivir Marshes, the largest natural wetlands in Europe. Aitor Lara explores the pandemic's socioeconomic impact on this anachronistic community of rice farmers and those who live off the grid, whose way of life, until the pandemic, had changed very little over the last century.

LIBBY LEONARD

Amid COVID-19's Tourism Shutdown, Community-Led Solutions for Job Losses

Hawaii County, Hawaii, United States

Prior to COVID-19, tourism accounted for 25 percent of all Hawaiian jobs. But starting in 2020, that rate declined by 99 percent, leaving many people in dire economic straits. In response, local organizations have created economic solutions, including sustainable agriculture programs and training, to help Hawaii's residents cope with the pandemic and improve the state's poverty rate. Libby Leonard tells the story of these community endeavors, which have their roots in traditional Hawaiian culture.

MARK LEONG

Those Without Shelter in a Time of COVID-19

San Francisco, California, United States

As the majority of California's citizens sheltered in place, how did the San Francisco Bay Area's unhoused population—many with risk-heightening health conditions—cope? In his body of work, Mark Leong documents the lives of those without homes in the East Bay community, from the risks and trials facing this group to those who support them.

JUSTIN LEVY

One Family's Struggle to Find the American Dream Amid COVID-19

New York City, New York, United States

New York City's historic Chinatown community is disproportionately suffering economically and socially as many of the restaurants and small businesses that form its backbone have seen business drop sharply through the outbreak of COVID-19. Through a short documentary film, Justin Levy explores the impact that COVID-19 has

had on Chinatown through the eyes of a first-generation Chinese American immigrant and his family's previously prosperous business, which has been forced to cease operations indefinitely due to the pandemic.

CRISTIAN LEYVA

The Dangerous Necessity of Public Markets

Mexico City, Mexico

As COVID-19 raged, Mexico City's public markets remained open amid quarantine since so many depend on daily sales for their livelihoods. Cristian Leyva documents the stories of those working in the markets—including Indigenous peoples, the elderly, single mothers, and migrants—even as they were judged as irresponsible for continuing to gather during the pandemic. Leyva's work offers an alternative perspective on these essential public activities.

DAWN LIM

An Intimate Portrait of Frontline Health-Care Workers From One of Their Own

Toronto, Canada

Dawn Lin, an emergency room doctor, photographs the lives of her fellow health-care workers as they put themselves at risk to support their communities. "As someone who treats COVID patients, I intimately know what it feels like to be in the center of the pandemic," she says. "Through my photos, you will see my world through my eyes."

MAURICIO LIMA

As COVID-19 Fuels Poverty Rates, One Priest Advocates for the Homeless

São Paulo, Brazil

Mauricio Lima documents the story of Julio Lancellotti, a Catholic priest in São Paulo who advocates for COVID-19 care and protection for thousands of homeless

people. Despite his own risk of contracting the novel coronavirus, the 72-year-old distributes food in the streets of São Paulo every day. He also helped convince the state government to vaccinate the homeless and provide them with emergency aid. His advocacy has earned him praise but also threats from right-wing groups. Father Lancellotti's work comes at a time when Brazilian poverty tripled from 9.7 to 27 million people; as of 2019, the homeless population in São Paulo was approaching 30,000.

ANNA LIMINOWICZ

Virus of Fear

Warsaw, Poland

As COVID-19 continues and mental health issues are on the rise, the pandemic has prevented people from seeking in-person treatment and counseling. Sessions have moved online, and the income gap between those who can afford treatment and those who cannot has widened. Anna Liminowicz documents how COVID-19 has affected mental health in Poland, interviewing individuals and therapists who explain how the virus has exacerbated depression and anxiety—and how it is altering mental health treatment.

SEBASTIAN LOPEZ

The Paraná's Decline: A Receding River During COVID-19

Rosario, Argentina

In Argentina the severe water decline of the Paraná River has adversely affected the communities that rely on it for food and for transportation to health and education services, increasing their risk of contracting COVID-19. Sebastian Lopez documents the alarming drop in the river level and flow and how this affects the communities that depend on it—especially in regard to the global pandemic.

CHELSEY LUGER

Exploring Native American Resiliency During COVID-19

Phoenix, Arizona, United States

 In her body of work, Chelsey Luger explores stories of resiliency and community-based solutions that have helped keep certain Native American tribal communities relatively safe during the pandemic. Her coverage disseminates successful prevention and containment strategies among tribes who have seen particularly low numbers of COVID-19 cases—possibly due to their innovative use of federal resources and tribal funds and their creative assertion of tribal sovereignty.

MARY M. MBENGE

Religion as a Voice for Social Distancing

Kenya

As large populations in Kenya continued to attend religious services amid COVID-19—sometimes in defiance of the government's social distancing directives—houses of worship in the country soon became hot spots. With the support of regional government officials and religious leaders, Mary M. Mbenge has worked to reissue social distancing policies and discourage religious gatherings across 3,000 villages in Kenya, using local radio stations and direct messaging from the religious leaders.

MARÍA MAGDALENA ARRÉLLAGA, PATRÍCIA MONTEIRO, ISABELLA LANAVE, ANDRESSA ZUMPANO, SHAI ANDRADE, INGRID BARROS, AND TAYNÁ SATERÉ

Single Mothers Face COVID-19

São Paulo, Brazil

With the closure of daycare centers and schools to prevent the spread of COVID-19, many of Brazil's mothers lost their jobs in order to become full-time caregivers for their children. Many female-

headed households became exclusively dependent on the limited emergency aid offered by the government. Documented by seven women in seven diverse regions of Brazil, this project shines a light on new circumstances for single mothers across a variety of cities, social classes, and contexts. They reveal that women often bear the most burden in the social chain, not only working outside the home but also taking on domestic responsibilities, education, and childcare.

ANIRBAN MAHAPATRA

Countering Ocean Plastic Pollution and Unemployment Amid COVID-19
Bangkok, Thailand

 Anirban Mahapatra's film tells the story of a community-based initiative in southern Thailand that employs fishing communities and migrants to harvest plastic pollution from the ocean. The initiative aims to build a circular economy that combats the growing problem of marine plastic debris while effectively countering an employment crisis caused by the COVID-19 pandemic. Mahapatra's short film illuminates how, through innovative and inclusive action, this struggle became an opportunity for positive change.

SOFÍA LÓPEZ MAÑÁN

With the Rest of the World in Lockdown, One Elephant Finds Sanctuary
Buenos Aires, Argentina

Mara, a 55-year-old Asian elephant, once lived in the former Buenos Aires zoo. After it closed in 2016, several animals were relocated to reserves where the living conditions echo their natural habitats. The hope was that Mara would have a life of semi-freedom in a sanctuary in Brazil's Mato Grosso state, but her trip was complicated by the COVID-19 pandemic. Sofía López Mañán's series

of images documents Mara's plight, which is now more urgent and dangerous than ever.

MARIAM EL MARAKESHY

Migrant Medical Workers Save Lives in Their New Home
Istanbul, Turkey

In this body of work, Mariam El Marakeshy tells the story of five immigrant doctors and medical frontline workers in Turkey to illuminate how traditionally marginalized migrants are aiding the fight against COVID-19. Having fled their home countries years ago to escape war and conflict, this group is now fighting on a different front: braving long shifts, separation from family, and the virus itself to save lives in their new home.

NASTASSIA MARIA KANTOROWICZ TORRES

El Burrito: **A Community Effort to Protect Wetlands**
Bogotá, Colombia

For more than two decades, members of the Kennedy community in Bogotá, Colombia, have fought to protect their wetlands, known as El Burrito. While mandatory confinements and restrictions due to COVID-19 have inhibited the community's ability to learn about and legally challenge development there, a construction company has obtained a license to build on the wetlands. In *El Burrito,* a documentary, Nastassia Maria Kantorowicz Torres illuminates the community's efforts to protect the wetlands.

MARTA MARTINEZ

Domestic Workers Use COVID-19 Challenges to Rebuild Their Industry
New York City, New York, United States

COVID-19 has resoundingly impacted domestic workers in the United States. By late March 2020, 90 percent had lost their jobs; of these,

76 percent had been the primary breadwinners of their households, according to the National Domestic Workers Alliance. In 2020 less than a third of Spanish-speaking domestic workers received stimulus checks from the Coronavirus Aid, Relief, and Economic Security Act, and more than 90 percent did not receive unemployment benefits. In response to these monumental challenges, domestic workers turned themselves into political organizers and used this moment to improve their working conditions. Through an in-depth profile of Daniela Contreras, a domestic worker who turned to activism, and an oral history of immigrant domestic workers across the United States, Marta Martinez documents how the pandemic could become an opportunity to rebuild a precarious industry.

FARAI SHAWN MATIASHE

Facing Agricultural Disaster, Entrepreneurial Youths Step Up
Mutare, Zimbabwe

 When lockdowns were introduced in Zimbabwe to slow the spread of COVID-19, farmers were left with copious excess fresh produce as markets everywhere shuttered. Farai Shawn Matiashe tells the story of entrepreneurial youths who connected farmers directly with customers via online delivery companies, allowing agriculture to function through the pandemic while cutting down on pathways for the transmission of COVID-19.

CECILIA MAUNDU

How Contact Tracing Apps Are Threatening Data Protection
Nairobi, Kenya

As COVID-19 broke out, Kenya actively adopted pandemic surveillance strategies and systems—many developed by private entities and

individuals—to monitor, track, and trace the spread of the disease. This surveillance, established with limited safeguards and security measures, ultimately weakened Kenya's nascent data protection environment. Cecilia Maundu explores contact tracing in Kenya, including how data collected from COVID-19 patients may be mishandled.

JUSTIN MAXON

Eureka! Maintaining New Lives Amid Social Distancing
Eureka, California, United States

 COVID-19 has reshaped our collective understanding of what crisis is; since 2020, the privileged have been confronted by an existential threat and questions of their own mortality. But for those navigating the transition from substance use and incarceration to sobriety, these are familiar lines of questioning. Justin Maxon's project, "A Field Guide to a Crisis," collaborates with those who have prevailed over grave inequity in their access to safety and care to elevate their stories. It enables a group of formerly incarcerated individuals at various stages in their addiction recovery to offer guidance to others; their experiences allow them unique insight into grieving amid crisis.

JUAN MAYORGA, TANSY HOSKINS, DIL AFROSE JAHAN, NIDIA BAUTISTA, CONTRACORRIENTE, AND OMAR BOBADILLA

Garment Makers in the Face of COVID-19
Bangladesh, Honduras, Mexico, the United Kingdom, and the United States

In this body of work, a collective of journalists in Bangladesh, Honduras, Mexico, the United Kingdom, and the United States document the impact of COVID-19 on the already precarious lives of garment workers around the world. Their investigation focuses on how the pandemic has compounded issues related to migrant

rights, gender-based violence, blacklisting, loss of wages, lack of state protection, dangerous environments, and lack of proper oversight from brands or governments. Their reporting, based on firsthand testimony from garment workers, is coupled with an examination into the financial supply chain.

ESTHER RUTH MBABAZI

The Healing Power of Family
Kampala, Uganda

 In this compelling series of images, Esther Ruth Mbabazi documents her family's daily life and explores how emotional bonds can be an effective coping mechanism for the anxiety and depression brought on by COVID-19 even as physical connections are prohibited.

JOSHUA RASHAAD MCFADDEN

Racial Divides Lead to COVID-19 Disproportionately Affecting Rochester, New York's Black Community
Rochester, New York, United States

 In his body of work, Joshua Rashaad McFadden examines how, in the context of racially and economically divided school and health-care systems, churches, and neighborhoods, the COVID-19 pandemic has disproportionately affected Rochester's Black population. McFadden tells the story of community members who have beaten the virus and who have lost loved ones to it, including Rochester's teachers, police officers, nurses, and first female mayor, Lovely Warren.

SINAWI MEDINE

What the Pandemic Has Meant for the Disabled and Their Caregivers
Bordeaux, France

 In this series of images, Sinawi Medine documents the effect of COVID-19 on those living with disabilities and their caregivers: aides

who provide not only comfort and healing but also dignity and inclusion. He investigates how caregiving changed in light of social distancing practices as well as how caretakers are faring emotionally during this turbulent period.

GAB MEJIA

The Philippines' Wildlife Rangers Come Under Threat
Iglit-Baco National Park, Philippines

 In his body of work, Gab Mejia documents the effects of the COVID-19 pandemic on environmental defenders guarding the critically endangered tamaraw, a bovine species endemic to a single island in the Philippines. These caretakers have been left to carry out their duties through economic hardship and with little institutional support. Mejia's reporting examines how environmental opportunism has taken place in this crucial time, leaving the Philippines in peril as wildlife atrocities and poaching threats surge at an unprecedented rate.

UGO MELLONE

After a COVID-Induced Rise in Wildlife Crime and Deforestation, These Organizations Are Fighting Back
Sierra Nevada de Santa Marta, Colombia

 Quarantine and travel restrictions amid the COVID-19 pandemic fueled an ecotourism collapse in Colombia, destroying the livelihoods of many rural communities. The resulting desperation, as well as a decrease in law enforcement capabilities, led to an increase in illegal logging, poaching, and deforestation as alternative sources of income. Ugo Mellone explores conservation efforts in the Sierra Nevada de Santa Marta—a mountain range with one of the world's most irreplaceable ecosystems—to combat environmental hazards in the wake of COVID-19.

ELIZABETH MILLER

Life Without Water
Navajo Nation, United States

 In her body of work, Elizabeth Miller investigates the failure of the federal trust system to provide basic water rights to families living in the Navajo Nation, a community that had by the end of May 2020 reached the highest per capita COVID-19 infection rate in the United States. This circumstance was partially due the fact that roughly a third of the community's 357,000 residents lacked running water. Miller's reporting illuminates the historical conditions and policy failures that led to this state of affairs and how these have limited the community's ability to maintain sanitation practices, greatly exacerbating its COVID-19 exposure risk.

JAMES MILLS

Bringing the Healing Power of the Outdoors to Communities of Color
Detroit, Michigan, United States

 As COVID-19 swept the world, outdoor recreation proved to be an especially restorative way to reduce stress and strengthen the human immune system. Yet people of color, who are disproportionately impacted by COVID-19, also face sociocultural barriers to spending time outdoors. In his body of work, James Mills documents the Pictured Rocks Ice Climbing Retreat, which brings a small group of people of color to a scenic lakeshore for a three-day ice climbing experience. Mills disseminated their experiences to their communities in Detroit and Grand Rapids to inspire similar connections with the natural world.

BETHANY MOLLENKOF

Experiencing COVID-19 as a Pregnant Black Woman in America
Los Angeles, California, United States

 Even before the COVID-19 pandemic, pregnant Black women were dying at three to five times the rate of white women. By highlighting her own pregnancy as a Black woman during the COVID-19 pandemic, Bethany Mollenkof investigates how the pandemic impacted this startling mortality rate. As prenatal appointments moved online, the health-care system became overburdened, and political unrest increased, Mollenkof explored health outcomes for pregnant women of color.

ALVARO MORALES

Hidden Heroes: Undocumented Bike Delivery Workers Face the Pandemic
New York City, New York, United States

 Alvaro Morales tells the story of undocumented bike delivery workers in New York City, who provided essential services, including food delivery, to the city's 8.4 million citizens amid the outbreak of COVID-19. These workers face challenges that put their own and the community's health at risk, including the inability to work from home, crowded living conditions, and no alternative residences outside New York City.

C. ZAWADI MORRIS

COVID-19 Writers Project (C19WP)
New York City, New York, United States

 The COVID-19 Writers Project (C19WP) builds a historical record of life during the COVID-19 pandemic using first-person multimedia narratives. Through hyperlocal community reporting based in New York City, the group captures the viewpoints of those most vulnerable and most impacted by the pandemic.

LAURA MORTON

The Local-centric Rebuilding of Fisherman's Wharf
San Francisco, California, United States

 In her body of work, Laura Morton explores how the global travel shutdown in response to COVID-19 has affected San Francisco, where the largest industry—tourism—supports more than 86,000 jobs. She turned her focus to Fisherman's Wharf, the heart of the city's sightseeing attractions. Here, many historic businesses, including the world-famous Castagnola's seafood restaurant, have closed their doors in the wake of the pandemic. Morton documents the struggles, resilience, and resurgence of Fisherman's Wharf's businesses, communities, and culture.

ROSEM MORTON

A Nurse Braces for the Surge
Baltimore, Maryland, United States

 In this unique body of work, Rosem Morton documents her experiences working as a nurse during the COVID-19 pandemic. Her deeply personal imagery records her emotional response from the front lines of the crisis. Morton's perspective as a health-care worker illuminates the gravity of this pandemic, encourages empathy for frontline workers, and inspires the public to follow social distancing and other public health guidelines.

ROSEM MORTON

A Portrait of Filipino Nurses Through U.S. History
Baltimore, Maryland, United States

 Pairing archival images with her own photography, Rosem Morton explores the role of Filipino nurses in the United States today. She examines how Filipino communities were shaped by American colonialism to fill the nursing shortages, reveals the hidden roles Filipino nurses played during the 1918 influenza pandemic, and illuminates the role Filipino nurses are playing in the COVID-19 pandemic. Today this group is the largest cohort of internationally educated nurses in the United States.

NICK MOTT

COVID-19 Research Halts Unrelated Science
Missoula, Montana, United States

 In his body of work, Nick Mott explores the impact of the COVID-19 outbreak and resulting stay-at-home orders on scientific research across Montana. As virus-related research increased, scientific research on other topics—including climate change, conservation, and the state's endangered species—came to a grinding halt. Mott documents the emerging dichotomy between these two seemingly disparate scientific communities as medical research by necessity pressed forward while other forms of research were stalled.

MATT MOYER AND AMY TOENSING

The Anti-Vaxxer Next Door: Exploring the Diversity of Vaccine Hesitancy in America
Syracuse, New York, United States

Through portraiture and interviews, Matt Moyer and Amy Toensing explore the diverse subsets of Americans who are refusing the COVID-19 vaccine—whether rural, white conservatives, members of the Black community, or Muslim refugees. By exposing commonalities in these communities' reasoning, Moyer and Toensing ask viewers to challenge stereotypes and reexamine their own preconceived notions of divisions within U.S. society. Their reporting also conveys the important message that vaccine outreach and education must be as nuanced and diverse as the divergent groups who have so far resisted inoculation.

LIDUDUMALINGANI MQOMBOTHI

How Public Health Measures Are Clashing With Culture, Contributing to COVID-19 Spread
Eastern Cape, South Africa

 Shortly after the initial outbreak of the COVID-19 pandemic in 2020, the Eastern Cape recorded the highest number of cases in South Africa. The province's struggling health system collapsed. Lidudumalingani Mqombothi explores how the city's deeply ingrained communal lifestyles clashed with social distancing practices, contributing to the spread of the disease.

NYAL J. MUEENUDDIN, SHIZA MALIK, AND YUMNA RIZVI

COVID-19 Compounds Already Dire Challenges for Afghan Refugees
Islamabad, Pakistan

 For decades Afghans escaping war, terrorism, and poverty have crossed into Pakistan, with many unregistered refugees denied access to public health, education, and employment channels. Nyal J. Mueenuddin, Shiza Malik, and Yumna Rizvi document how COVID-19 has compounded the struggles of this community—particularly its members who face the most challenges, including women, people with disabilities, and unemployed day laborers. This body of work also highlights the resilience and coping strategies of this group.

FREDRICK MUGIRA

Handwashing Where Water Is Precious
Nile River Basin

 Throughout the COVID-19 pandemic, the World Health Organization encouraged handwashing and disinfecting as critical virus-prevention measures. But in Africa's Nile River Basin, many communities live in areas of water scarcity and increasing drought. The InfoNile network, of which Fredrick Mugira is a co-founder, explores how water-scarce communities in the region can contain the pandemic while ensuring local economies do not collapse. It also highlights little-known innovations to help such communities survive and adapt.

FABIAN MUIR

International Families Separated by COVID-19 Travel Restrictions
Sydney, Australia

 In response to the COVID-19 pandemic, Australia shut its borders to international travel. As a result, its citizens, including a sizable migrant population, found themselves unable to see family members who live in other countries. Drawing on personal experience, Fabian Muir created a series of portraits that personalize the challenges faced by families cut off from relatives abroad.

ANKITA MUKHOPADHYAY

Fighting for Women's Rights to Health
Gurugram, India

 In the informal settlements of Gurugram, India, women already had to fight for equal access to health care. Amid the COVID-19 outbreak, as poor communities struggle to stay healthy, this burden is felt more acutely. Through her project, Ankita Mukhopadhyay hopes to help shift the balance so that all lives—including those of women—will hold equal value.

MACIEK NABRDALIK

Migrants Face COVID-19 Risks and Socioeconomic Uncertainty
Warsaw, Poland

In this compelling series of images, Maciek Nabrdalik documents the struggles of Poland's nearly two million migrant workers over the course of the COVID-19 pandemic. Featured topics include the loss of employment, rising

homelessness, decreased remittances to families in their home countries, and an inability to return home amid strict travel restrictions.

SHOWKAT NANDA

The Longest Quarantine
Kashmir

 In this searing body of work, Showkat Nanda documents the lives of Kashmiri children who are facing both emotional trauma and an extended lockdown that began when Kashmir lost its autonomous status in 2019.

LOUIS NDUMA NDERI

Nowhere to Run: Athletes Struggle Through the Closure of International Sporting Events
Nairobi, Kenya

 For many athletes in Kenya, including long-distance runners, participation in international competitions is their sole livelihood. In the wake of the COVID-19 outbreak, many of these international sporting events were canceled, forcing Kenya's athletes to find other ways to make a living. Many struggled to earn a basic income through the course of the pandemic (especially since the vast majority of training camps and gymnasiums were indefinitely closed). Louis Nduma Nderi explores the outlook of Kenyan athletes during the pandemic: how they are adapting and the solutions they have found to cope with an extended period of global shutdown.

LINDAH ELIZABETH NDUWUMWAMI

Exploring COVID-19's Long-Term Effect on the Mental Health of Children
Kampala, Uganda

 Over the course of the COVID-19 pandemic, children in Uganda have lived through confinement, quarantine, and the looming threat of infection; many have witnessed

economic struggles, domestic abuse, and the loss of loved ones. Through in-depth interviews with parents, Lindah Elizabeth Nduwumwami explores how the pandemic has affected their mental health. Nduwumwami's reporting helps parents navigate how their reactions to the disease affect their children's well-being—and spreads awareness of this issue to households, communities, organizations, and government service providers.

MARK NEVILLE AND OLESIA BRIAZGUNOVA

COVID-19 Compounds Stress and Struggles in Frontline Communities
Zolote, Ukraine

 In eastern Ukraine, thousands of people in areas of conflict went hungry and lacked access to basic services in the face of COVID-19 price hikes and movement restrictions. Meanwhile, state-owned mining interests owed workers tens of millions of dollars, though some miners were not paid for months. In their body of work, Mark Neville and Olesia Briazgunova examine how COVID-19 has impacted the mental and physical health of families in mining communities also dealing with the cumulative stress of conflict and critical economic challenges. Neville and Briazgunova's reporting raises awareness and counters the stigmas surrounding mental health issues among people in this troubled region.

ALEX NGARAMBE

Amid COVID-19, Indigenous Peoples Are at Odds With the Law
Kigali, Rwanda

 As artisan goods and tourism—primary income sources for Rwanda's Indigenous Batwa people—steeply declined with the onset of the pandemic, many community members turned to

protected forests to survive. They gathered food and fruits, poached game, and cut timber. These incursions, though necessary for the Batwa's survival, have led to clashes with rangers, and even killings. In his unique body of work, Alex Ngarambe highlights the social and economic plight of the Batwa to advocate for their protection throughout the pandemic.

HIEU NGUYEN

Shared Solitude: A Personal Story of Quarantine
Hanoi, Vietnam

 In his striking body of work, Hieu Nguyen explores Vietnam's efforts to control the outbreak of COVID-19 through the lens of a government-imposed quarantine in Hanoi.

JEAN PIERRE NIPTEK

The Struggle to Learn During COVID-19
Port Vila, Vanuatu

 Jean Pierre Niptek documents Vanuatu's official COVID-19 prevention measures, including closing its borders, closing schools, and declaring a state of emergency. He highlights the struggles of children and teachers after schools shut down, how parents adapted to homeschooling their kids, and how frontline workers including nurses, doctors, and police were unable to do so.

DAVID NJAGI

Child Labor Makes a Comeback Amid COVID-19
Nairobi, Kenya

 As schools closed in Kenya due to COVID-19 restrictions, children in rural households without internet or electricity were forced to work on family farms. David Njagi documents the increase in child labor as child welfare officials were kept from work amid pandemic concerns. Njagi's

reporting on this important issue focuses on mitigation strategies, including establishing mobile schools and expanding internet coverage.

IFEATU NNAOBI

Finding Family Amid the New Normal
Berlin, Germany

 Ifeatu Nnaobi explores how people find community and connection during a period when social distancing, quarantining, and travel shutdowns are projected to become the new normal in the wake of COVID-19. Nnaobi's short documentary film follows a migrant, an elderly person, and a typical native German citizen as they navigate isolation and loneliness in the face of the pandemic.

MUSUK NOLTE

Lack of Water Access Amid COVID-19
Lima, Peru

 Nearly a third of Peru's population does not have access to drinking water. Clean freshwater is scarce and expensive among low-income communities in Lima's arid outskirts, presenting challenges to following hygiene protocols aimed at stopping the spread of COVID-19. Musuk Nolte documents the struggles and precarious solutions that the most water-deprived communities have encountered in the face of the pandemic while highlighting limited water access as one of the world's most pressing environmental issues.

GEMBONG NUSANTARA

Small-Scale Organic Farms Prove Adaptable Amid COVID-19
Central Java, Indonesia

 Gembong Nusantara tells the story of a community of young organic farmers in Semarang, Indonesia, who are not merely surviving the COVID-19 pandemic but also expanding their operation due to increased demand in Indonesia's big

cities for healthy, affordable food. As the co-op has added more employees to handle increased orders, its business has benefited many people along the supply line, from production to distribution. Nusantara investigates why and how this kind of small-scale organic farming has thrived during the COVID-19 pandemic.

KAZUMA OBARA

Countering Discrimination of COVID-19 Patients and Health-Care Workers
Osaka, Japan

 The fear surrounding COVID-19 has led to discrimination against both health-care workers and those who have been infected. Kazuma Obara tells the stories of the nurses and patients in Horikawa Hospital who became targets of discrimination while fighting the virus—but who nevertheless managed to foster community understanding and solidarity for those who needed it most.

ANTHONY OBAYOMI

For the Blind, COVID-19 Compounded Their Isolation—but Also Their Resilience
Lagos, Nigeria

As the world adopted social distancing measures to contain the spread of COVID-19, many blind people lost their mobility, social support, and independence. Even before the pandemic, this group experienced high rates of loneliness and depression; the pandemic worsened these conditions. Anthony Obayomi's short documentary explores how the blind cope with a new era of disconnection and loneliness.

DANIEL OCHOA DE OLZA

The Indefatigable Kiss
Madrid, Spain

 After months of social distancing, mandatory face masks, and other isolating measures enacted to counter the spread of COVID-19, the act of kissing became a symbol of the triumph of love and life. To document people's slow return to previously emptied streets, Daniel Ochoa de Olza produced a photography series of couples kissing in the streets, in parks, in subway stations, or other public places, proving that love is a monumental force capable of lifting the spirits even after hard times.

WALE OLAJIDE

Love in Isolation
Philadelphia, Pennsylvania, United States

 Wale Olajide's photography portrays people in Philadelphia who uplifted their community through resilience and found shared joy in confinement. His project prioritizes the narratives of historically underrepresented people and ethnic minorities disproportionately affected by COVID-19 across the United States.

ON SPEC PODCAST

COVID-19 Compounds Struggles for Refugees
Istanbul, Turkey

 Though Turkey was quick to respond to the outbreak of COVID-19 with health care and preventive measures for its citizens, the country's 3.5 million refugees have largely been left out of these efforts. These vulnerable people often find themselves without suitable housing, health care, or even food. *On Spec Podcast* documents stories of these refugees amid the COVID-19 pandemic, shining a light on the living conditions that have exposed them to a higher risk of contracting the virus.

AMANDAS ONG

How the Pandemic Has Impacted Migrant and Refugee Children
London, England

During the COVID-19 pandemic, children of asylum-seeking families—often those with no recourse to public funds—were more likely to experience social exclusion and poverty, and more likely to be overlooked for such critical support as free school meals. Journalist Amandas Ong explores the impact of the pandemic on these children and their caregivers in the United Kingdom. By illuminating the lived experiences of people who have been rendered invisible, Ong draws attention to the damage that the pandemic has wreaked on society's most vulnerable—and communicates the need to increase the availability of care and assistance for them.

MAURICE ONIANG'O

Police Brutality During Quarantine
Nairobi, Kenya

In March 2020 the curfew imposed by the Kenyan government to counter the spread of COVID-19 provided an opportunity for use of excessive force by police, leaving some young people dead and hundreds with life-threatening injuries. In his film, Maurice Oniang'o documents the rise of police brutality and extortion amid the enforcement of COVID-19 precaution measures. Through the stories of the victims, he reveals how young people have been systematically brutalized in Nairobi's slums and informal settlements.

ORE HUIYING

COVID-19 Hits Migrant Workers
Singapore

In April 2020 Singapore began to see a spike in the number of confirmed COVID-19 cases, primarily among communities of migrant workers. Many of these workers live in overcrowded dormitories, and they often lack proper nutrition, access to health care, and personal protective equipment, making them more susceptible to the virus. In his series of images, Ore Huiying tells the stories of these affected communities, the nongovernmental organizations working to provide them with essentials, and the government of Singapore's response.

KATIE ORLINSKY

The COVID-19 Food Crisis: Monumental Waste Amid Rising Food Insecurity
New York City, New York, United States

 In the wake of the COVID-19 outbreak, farmers and food processing plants have been forced to engage in mass disposal of inventory even as millions across the United States have lost their jobs and are struggling to afford food. In New York City, which was especially impacted by the pandemic, more than two million residents were considered food insecure as of April 2020, up from one million prior to the pandemic. In her body of work, Katie Orlinsky explores food insecurity and community resiliency around New York State, documenting food waste and food workers, the growing issue of hunger, and initiatives to counter food insecurity.

BRIAN OTIENO

The Quiet Heroes Keeping People Safe
Nairobi, Kenya

Residents of Kibera, Kenya—known as Africa's biggest informal settlement—are at a higher risk for contracting COVID-19 as they struggle with unhygienic conditions, crowded living conditions, an inability to work from home, and a lack of basic necessities like soap. Brian Otieno tells the story of those committed to stopping the spread of the virus here,

including municipal leaders, artists, local government organizations, and a budding fashion designer distributing face masks to the community.

ONYANGO OTIENO

Rethinking Masculinity: Empowering Men to Stop COVID-19-Induced Gender Violence

Nairobi, Kenya

 Men are the breadwinners in many Kenyan households, but many lost their jobs amid the COVID-19 pandemic. Due perhaps to the frustration and emasculation of unemployment, the country experienced a sharp increase in the number of rapes and other sexual and gender-based violence. On his podcast, Onyango Otieno interviews men from high-risk areas to spark critical thinking about masculine identity, what influences gender-based violence, and the role men can play in stopping it.

EMIN ÖZMEN

COVID-19 and the Annual Migrations of Nomads

Nusaybin, Turkey

For his body of work, Emin Özmen traveled with Kurdish nomads in Turkey on their annual livestock movement to explore whether COVID-19 restrictions changed their way of life. The community traveled more than 300 miles (500 km), crossing mountains from Nusaybin to Van, to set up their summer camp; for survival, they relied on the milk, cheese, and meat they produce and sell from their animals. Özmen's reporting contrasts this traditional nomadic journey with the new mass standstill and lockdowns of the modern world.

ANA PALACIOS

The Healing Power of Music: Concerts Become a Treatment in COVID-19 Hospital

Madrid, Spain

El Hospital de Emergencias Enfermera Isabel Zendal, a warehouse-like structure in Madrid, opened during the pandemic specifically to treat people with COVID-19. There, hundreds of patients suffered not only physically but also emotionally, since they were not allowed visits from the outside world. On March 1, 2021, the hospital approved holding live concerts for 20 minutes each day to soothe and entertain the patients. Ana Palacios documents how music proved a powerful tool in uplifting both the patients and medical care workers—and how it elevated overall treatment within the hospital.

LOUIE PALU

Political Year Zero

Washington, D.C., United States

The COVID-19 pandemic has affected broad aspects of U.S. government policy and American identity, including those related to issues of race, science, law, and history. Louie Palu examines the effect of COVID-19 on one of the most transformational moments in the history of modern U.S. government: the 2020 presidential election and its aftermath. Palu received extended funding for this project in 2021.

AMANDA PAMPURO

Dog Days on the Border: How Canine Adoption Has Fared Through COVID-19

Puerto Peñasco, Mexico

Travel restrictions in the wake of the COVID-19 pandemic left Barb's Dog Rescue in Puerto Peñasco, Mexico, in a bind. The shelter was cut off from the Americans it relies on to adopt its animals. While families in the

United States quickly emptied local rescue sites, volunteers at Barb's slept on the premises to maintain their COVID-19 bubble while caring for a seemingly endless supply of dogs and a dwindling stash of food. Amanda Pampuro reports on two animal rescues: Barb's in Mexico and HALO Animal Rescue in Phoenix, Arizona, highlighting the pandemic's impact on both sides of the border.

JORGE PANCHOAGA

The Foreign Disease: An Indigenous Group Treats COVID-19

Envigado, Colombia

The Nasa, an Indigenous people of southwestern Colombia, refer to COVID-19 as "the foreign disease." Their leaders view the illness as a spiritual and corporeal imbalance that reflects the disconnection of people from nature. Jorge Panchoaga examines how this group countered the pandemic by restoring a sense of balance and healing the body through the spirit. The Nasa recognize humans as a component of nature, which has helped them cope with past outbreaks—including those brought by Spanish colonization, modernization, and globalization.

PREM PANICKER

Can Kerala's Eradication Success Be Replicated?

Thiruvananthapuram, India

As the COVID-19 pandemic began, the state of Kerala in southern India earned international recognition for its effective handling of the outbreak—especially impressive given its large population of migrant workers, who are extra vulnerable to the disease. Prem Panicker unpacks Kerala's initial success in stemming COVID-19 transmission to mine lessons that might be universally applied by other governments, policymakers, and citizens around the world.

YANA PASKOVA

Filling the Gap in Female Health Services Amid COVID-19

New York City, New York, United States

 The collateral damage of the COVID-19 pandemic had a disproportionate impact on women. As of November 2020, six out of 10 unemployed workers in the United States were women; violence against women rose by 25 percent around the world; and women have experienced reduced access to reproductive and female health services. In her body of work, Yana Paskova documents an all-female medical crew in New York City's Hasidic community, revealing how this brave team of women filled a crucial gap in health services.

YOPPY PIETER

Transgender Women Face New Challenges Amid COVID-19

Jakarta, Indonesia

 Although transgender women have long been a part of Indonesia's multicultural society, this marginalized community nevertheless faces widespread discrimination. Yoppy Pieter documents how this community's complex struggles were affected in the wake of COVID-19, including rising poverty rates, economic challenges due to community-wide job loss, and the damaging effects of stigma and discrimination.

ENCARNACIÓN PINDADO GONZÁLEZ AND MADELEINE WATTENBARGER

Prisons and COVID-19

Mexico City, Mexico

The COVID-19 fatality rate within the Mexican prison system is double the country's overall rate, which was the highest in the world as of December 2020. As the pandemic rages on, Mexico's prisons have become more crowded, and access to

the system is more limited, making social distancing and access to hygienic products difficult. Encarnación Pindado González and Madeleine Wattenbarger document how COVID-19 has compounded struggles and threatened the lives of those inside Mexican jails.

FAUSTO PODAVINI

How COVID-19 Created a Family
Rome, Italy

 Faced with the impending COVID-19 pandemic, Fausto Podavini and his partner, Anna, began living together earlier than they'd planned; he abruptly became a stepfather figure to her two sons. Podavini tells the story of their growth, struggles, and acceptance of one another amid the pandemic, documenting how the challenges of lockdown provided them with a silver lining: the opportunity to form a new family.

JÚLIA PONTÉS

The Impact of Environmental Deregulation
Belo Horizonte, Brazil

As of September 2020, the Brazilian government had issued 12 times more environment-related legislation over a three-month period than it had throughout the entire 2019 calendar year. Much of the legislation has been criticized as harmful to the environment, and came amid reports that a deregulating environmental protections was achieved while the media was focused on COVID-19. In this body of work, Júlia Pontés investigates the social and environmental repercussions of deregulation in a region known as the Iron Quadrangle, which contains the world's highest concentration of open-pit mines.

LISETTE POOLE

Asylum Seekers Navigate COVID-19 Policy Changes
Ciudad Juárez, Mexico

 In this searing series of images, Lisette Poole tells the story of a community of Cuban asylum seekers in Ciudad Juárez, Mexico, as they navigate asylum policy changes, including those enacted in response to COVID-19 and changing U.S. administrations.

ANITA POUCHARD SERRA

Keeping the Tango Alive During COVID-19
Buenos Aires, Argentina

 The tango, one of Argentina's most important cultural emblems, represents everything that the COVID-19 pandemic has prevented: closeness, intimacy, and bringing unknown people together. The tango is not only a cultural passion but also a multibillion-dollar industry, and for many it's their primary source of income. Anita Pouchard Serra explores how those whose livelihoods depend on the tango coped financially and emotionally during the COVID-19 outbreak—and how they are preserving the living culture of tango through the pandemic.

MÓNICA QUESADA CORDERO

Migrant Coffee Workers: Health Challenges Appear as an Economic Driver Returns
San José, Costa Rica

 Mónica Quesada Cordero examines how Costa Rica's substantial flow of migrant coffee workers emerged as both a public health challenge and an essential economic force during COVID-19. She also examines how the arrival of these workers during the pandemic has driven creative public-private partnerships that could shape the future.

ANNALISA QUINN

Politicizing a Pandemic: The Fallout of Political Messaging Around COVID-19
Munich, Germany

 In the wake of the 2020 elections in the United States and Germany, Annalisa Quinn compared efforts by far-right political leadership in both countries to co-opt the pandemic to gain political support. Quinn's reporting explores the fallout of these efforts, including how political views are affecting vaccination efforts.

ALAINA RAJAGOPAL

The Emergency Docs Podcast
Orange, California, United States

 Due to the wealth of information—and misinformation—in the complicated world of medicine and health care, it is easy to become overwhelmed, misinformed, scared, and uncertain. To educate and empower listeners about medicine and diseases, Dr. Alaina Rajagopal, an emergency medicine physician, virologist, and global health specialist, founded *The Emergency Docs* podcast. It covers vaccine hesitancy and other key topics related to COVID-19.

MIORA RAJAONARY

Can Home Gardens Combat Rising Food Insecurity?
Johannesburg, South Africa

In South Africa the outbreak of COVID-19 and government-imposed quarantine measures have led to severe economic repercussions, including an increase in food insecurity. Over the past several years, urban farming has been posed as a sustainable solution to this issue. Though it has largely remained a marginal movement, the urgency of the pandemic could foster change. Miora Rajaonary documents the efforts of a volunteer group that developed an emergency food security model in

Johannesburg—including starter kits for those wanting to establish their own home gardens—as an answer to rising food insecurity in the wake of COVID-19.

ESPEN RASMUSSEN

Pregnancy in the Time of a Pandemic
Oslo, Norway

 In his body of work, Espen Rasmussen chronicles his wife's pregnancy and the birth of his newest child through the COVID-19 pandemic and quarantine in Oslo, told through the prism of his family members' daily lives through isolation and social distancing. Rasmussen's work highlights the challenges and fears of pregnancy and delivery, along with the adaptations of family life, amid a global crisis.

ANDREA ELLEN REED

Black Families and COVID-19 Loss
Minneapolis, Minnesota, United States

By highlighting a death from COVID-19 within her own family, Andrea Ellen Reed explores the impact and aftermath of pandemic mortality within the Black community, including the breakdown of family structure, inequities in health care, neglect from the federal government, and the fight to live after loss. Through photographic portraits and first-person audio interviews, Reed portrays 20 midwestern Black families who are experiencing these issues, giving Black voices a platform to discuss concerns around the pandemic.

REMESHA

Preparing Burundian Refugees for COVID-19
Kigali, Rwanda

Remesha, a collective of young Burundian refugee journalists, has worked to reach Burundian refugees in East Africa with critical information about COVID-19, including

methods for personal protection and recognizing symptoms, as well as coping strategies for economic downturns. Remesha's reporting explores the social consequences of the disease on this group and documents lessons learned from local pandemic responses that could be applied to other large-scale challenges, including climate change, other refugee crises, or future public health issues.

HANNAH REYES MORALES

Plants and Humans During COVID-19
Baguio, Philippines

 The Philippines is one of the world's megadiverse countries for flora: one of 17 countries that together are thought to contain 70 percent of the world's plant biodiversity. As the COVID-19 pandemic drove an economic collapse and revealed failures of infrastructure, people in urban centers looked to plants and community gardens for traditional medicines, food security, and livelihoods. While this trend has benefited many, a spike in plant poaching, endangering some species, occurred. Hannah Reyes Morales explores the human relationship with plants during the COVID-19 pandemic, how gardens have helped people heal, and the costs of plant consumption to the environment.

SARAH RICE

Take Action! Renewing Commitments and Providing Help for the Most Vulnerable
Michigan, United States

 With the onset of fall and winter, dropping temperatures eliminated outdoor gatherings and increased social isolation. More people gathered inside, increasing the risk from COVID-19, which for those with preexisting conditions—an estimated 92.6 million people in the United States—presents an especially high burden of disease. Sarah Rice investigates the thoughts and fears of this population through photographic portraiture and interviews. Her work fosters community, sparks a renewed commitment to the most vulnerable, and creates guidelines for caring for those who need it most.

LORENA RÍOS TREVIÑO AND ARMANDO VEGA

Those Left Behind: Migrant Families Lost to COVID-19
Xierra Mixteca, Mexico

 As of July 2020, at least 1,500 Mexican migrants had died from COVID-19 in the United States. Lorena Ríos Treviño and Armando Vega document the impact the disease is having on the families of the deceased who remain in Mexico, thousands of miles away. They also investigate the complexities of the relationships—including financial support—between families and their loved ones who leave in search of a better life.

HALEY RITCHIE

Remoteness of Indigenous Communities Challenges Vaccine Rollout
Old Crow, Yukon, Canada

In January 2021 the Yukon received enough COVID-19 vaccines to inoculate 75 percent of all adults in the Canadian territory. But distributing the vaccine to remote Indigenous communities presented a steep logistical challenge. By documenting the mobile vaccination team that administered the vaccination efforts here, Haley Ritchie illuminates health inequities, how Indigenous people have coped with COVID-19, and the logistical challenge of the vaccine rollout.

DYNA ROCHMYANINGSIH

Learning From Indigenous Public Health Strategies
Bukit Dua Belas National Park, Indonesia

 Dyna Rochmyaningsih explores how the Orang Rimba, Indigenous people who live in Bukit Dua Belas National Park in Indonesia's Sumatran rainforest, responded to the COVID-19 pandemic using their own public health strategy. Over the past several decades, massive deforestation and increased contact with the outside world have led to many outbreaks among the group. And so the Orang Rimba developed their own coping response: minimal travel to other communities, appointing envoys to outside communities, self-quarantining, social distancing, and special procedures for burying their dead. Understanding this approach to outbreak containment will reinforce the recommendations the rest of the world is attempting, including social distancing and quarantining measures.

ARTURO RODRÍGUEZ

When Is It Time to Revive Tourism?
Tenerife, Canary Islands

Largely due to prompt measures taken to contain its few early cases of COVID-19, Spain's Canary Islands remain one of the least affected part of the country. Despite exceptionally low levels of COVID-19 and a desire for tourism to return, the region must follow the same strict measures as the rest of Spain. Arturo Rodríguez explores how this has created an unprecedented economic disruption in an island territory that generates 40 percent of its GDP from the tourism industry, and how the lack of demand has rippled throughout its other industries and affected its residents.

JAMES RODRIGUEZ

Eruption: COVID-19 Threatens a Community Displaced by a Volcano
Escuintla City, Guatemala

 On June 3, 2018, the eruption of the Fuego Volcano in Guatemala killed hundreds in surrounding villages and displaced thousands subsequently placed in hastily built transitional shelters in Escuintla. Two years after the tragedy, hundreds still lived without electricity in these wooden shacks, fearing that such close quarters would place them at extremely high risk for contracting COVID-19. James Rodriguez documents their struggle for safe housing and economic and medical security.

CAMILLE RODRÍGUEZ MONTILLA

In the Wake of COVID-Fueled Depression, Mental Health Treatment Is a Critical First Step
Mérida, Venezuela

According to the Venezuelan Violence Observatory, the COVID-19 pandemic spurred an alarming rise in suicide rates, which during the first quarter of 2021 were double that of the previous year. Depression was identified as a major contributing factor—and in Venezuela, that condition was worsened by the fear of lost work, soaring poverty rates, concern over contracting COVID-19, and difficulty receiving mental health treatment. Through the stories of people from affected communities, Camille Rodríguez Montilla produced a three-part documentary series to raise awareness about depression and the importance of mental health—and to spur change in public policies.

ISADORA ROMERO
Delivery in a Time of COVID-19
Quito, Ecuador

📷 There are close to 5,000 delivery drivers in Ecuador. Many belong to migrant communities, and many continued to perform essential duties amid COVID-19-induced quarantining and social practices. Their work is not regulated by a state entity and is generally carried out in precarious conditions. In this series of images, Isadora Romero tells their story, highlighting numerous social inequities within the country.

RUDA COLLECTIVE: FABIOLA FERRERO, LUJÁN AGUSTI, MAYELI VILLALBA, KORAL KARBALLO, GABI PORTILHO, ÁNGELA PONCE, MORENA JOACHIN, WARA VARGAS LARA, PAZ OLIVARES-DROGUETT, XIMENA VÁSQUEZ, AND ISADORA ROMERO
The Human Side of Food Production
Argentina, Bolivia, Brazil, Chile, Colombia, Ecuador, Guatemala, Mexico, Paraguay, Peru, Venezuela

📷 Ruda Collective, a transnational network of women and nonbinary photographers, documents how vulnerable communities in Latin America's food production economy—including women, migrant populations, and informal workers—adapted during the pandemic. The photographers explore the impact of COVID-19 on workers in food industries, who are not able to work from home, highlighting the human and economic consequence of the global crisis.

JAKUB RYBICKI
What Happens to Plastic Waste Generated by COVID-19?
Poznań, Poland

📷 In his series of images, Jakub Rybicki investigates the monumental increase in plastic trash necessitated by the COVID-19 pandemic, including plastic personal protective equipment such as masks,

gloves, and medical gowns and single-use plastics like restaurant takeout containers and bottled water—all initially assumed to be safer than alternatives. His work explores the steep rise in single-use plastics being processed and integrated into the waste-management system.

HAILEY SADLER AND DARIAN WOEHR
Navajo Nation Confronts COVID-19
Flagstaff, Arizona, United States

▷ As the Navajo Nation faced intersecting public health and housing crises amid the COVID-19 pandemic, Hailey Sadler and Darian Woehr document how 300 "tiny homes" are being deployed to empower the Diné (Navajo) community to protect their elders from the virus. Since their initial storytelling trip in January 2021, a number of Diné elders have been vaccinated. Sadler and Woehr returned in March 2021 to explore how vaccine distribution impacted dynamics within the tribe's multigenerational homes.

HAILEY SADLER AND DARIAN WOEHR
Tiny Homes: Lifesaving for Indigenous Communities
Flagstaff, Arizona, United States

▷ The Navajo Nation has higher levels of substandard housing than any other tribal lands in the United States. In May 2020 the group had a higher per capita COVID-19 death rate than any U.S. state, mainly due to overcrowded, multigenerational, and insufficient housing. In their body of work, Hailey Sadler and Darian Woehr document an initiative pioneered by Community Organized Relief Effort and Johns Hopkins Center for American Indian Health to provide families in multigenerational living situations with "tiny homes"—8-by-15-foot (2.4 x 4.6 m) houses, modeled after traditional

Navajo *chaha'oh* structures—to protect their elders and provide a space to prevent the spread of COVID-19.

SÉVERINE SAJOUS
A Site of Pilgrimage and Healing Reinvents Itself Amid COVID-19
Lourdes, France

📷 The Sanctuary of Our Lady of Lourdes, an important Catholic pilgrimage site, saw a 95 percent drop in visitors during 2020, leaving it deserted even on its most important celebration days. Faced with the first historical closure of the sanctuary, in July 2020 its leadership initiated Lourdes United, the first e-pilgrimage in the world, broadcast in 10 languages and reaching 80 million people. Séverine Sajous documents how the sanctuary reinvented itself to stay connected with its faithful—and the economic consequences for the surrounding town.

JORDAN SALAMA
At the Epicenter of the World: A Portrait of Queens Through the COVID-19 Pandemic
New York City, New York, United States

▷ Hundreds of thousands of immigrants from diverse communities around the world call Queens home, making this borough of New York City one of the most culturally diverse neighborhoods on Earth. A home to many essential and frontline workers, bustling thoroughfares, and overcrowded housing, Queens became known as the "epicenter of the epicenter" of the U.S. outbreak when the COVID-19 pandemic took hold in March 2020. Jordan Salama tells the story of Queens during the pandemic; how joblessness and isolation caused seemingly irreparable social, economic, and cultural devastation; and how the experience of this multicultural borough echoes around the world.

RUBÉN SALGADO ESCUDERO
Mariachi Resilience
Mexico City, Mexico

 The mariachi musician is one of Mexico's most iconic symbols. But with group gatherings eliminated and tourism at a standstill, Mexico City's once widely visited Plaza Garibaldi, also known as Mariachi Mecca, has been silenced. Appreciative crowds once provided income so that these musicians could support and feed their families. Now some mariachi musicians have turned to the digital space to share their culture, playing tributes and serenades commissioned online. Rubén Salgado Escudero's images capture the new realities of the pandemic for these celebrated figures of Mexican culture and his videos record their performances for posterity.

MARTIN SAN DIEGO
Rediscovering Their Roots
Lake Sebu, Philippines

📷 For the Indigenous peoples of the Philippines, the COVID-19 pandemic has provided a portal to the past: a time before the dawn of infrastructure, budget travel, and social-media-inspired sightseeing brought flocks of tourists to their ancestral lands. In his moving body of work, Martin San Diego explores how the tourism void caused by the COVID-19 pandemic is providing space for Indigenous peoples to rediscover their fading roots—and why this gateway may be out of balance with the needs of the present.

MARTIN SAN DIEGO

Worship in Isolation

Manila, Philippines

 Does enforced isolation bring Muslim communities to God, or does it lead to anxiety and loneliness? In April 2020 millions of Muslims around the world were gearing up for Islam's holiest month. In Manila about 200,000 Muslim Filipinos spent Ramadan confined in their homes. This body of work documents the pandemic's effect on minorities—specifically, the Muslim population in the Philippines—by following different groups in Manila who experienced Ramadan in different ways.

VIOLETA SANTOS MOURA

COVID-19 Poised to Devastate Portugal's Rural Interior

Porto, Portugal

 Among the sparsely populated and aging communities of Portugal's northern interior, COVID-19 was seemingly nonexistent—that is, until fall 2020, when the second wave began closing in on the small, remote villages. The virus's late arrival is rooted in long-standing societal inequalities within these remote communities, including isolation, poverty, low birth rates, and emigration. Violeta Santos Moura examines how the pandemic, compounded by preexisting disconnection, threatens these overlooked, centuries-old communities, whose inhabitants are often the last living practitioners of ancient traditions.

JOSÉ SARMENTO MATOS

A Segregated African Diaspora Community Tells Its Own COVID-19 Stories

Lisbon, Portugal

 In Seixal, a town on the outskirts of Lisbon, the COVID-19 pandemic deepened poverty and isolation in Jamaica, a community of primarily African migrants or African

descendants that has been historically marginalized. José Sarmento Matos highlights this community during the pandemic and helped five individuals from Jamaica tell their own stories via video and photography. This intimate perspectives go beyond standard narratives, featuring police interventions, urban decay, and substandard living conditions.

SHONE SATHEESH

Amid Soaring COVID-19 Cases, Vaccines Remain Out of Reach for Marginalized Castes

Mumbai, India

 By May 2021 India had managed to fully vaccinate just 1.8 percent of its population against COVID-19, as cases there exceeded 400,000 a day, due to the prevailing Delta variant. The pursuit of herd immunity was threatened by unsound centralized policy, as well as pricing and technological barriers that largely excluded marginalized groups. Shone Satheesh investigates how India's vaccine program excludes its historically disadvantaged castes while highlighting the stories of individuals from these communities.

DAVID SAVELIEV, ALEXEY VASILYEV, AND DIMITRI SIMES, JR.

Indigenous Reindeer Herders Face COVID-19

Yakutsk, Sakha Republic, Russia

 For centuries, and through numerous geopolitical earthquakes, Indigenous reindeer-herding tribes have thrived in the frosty tundra of Russia's northern Siberia. But COVID-19 has proved to be a unique challenge, exposing major inequalities between these nomadic communities and the rest of Russian society, including lack of infrastructure, fragile livelihoods, ethnic tensions, and access to COVID-19 vaccines. David Saveliev, Alexey Vasilyev, and Dimitri

Simes, Jr., document how COVID-19 has affected these unique communities and their traditional way of life.

BRADLEY SECKER

The New Normal

Istanbul, Turkey

In this body of work, Bradley Secker uses thermal imaging to highlight how the perceived threat of the novel coronavirus can come from everyone and everywhere—and how our familiar habits and surroundings have suddenly become potential sources of anxiety.

RONNY SEN

Countering Mucormycosis

Mumbai, India

As the COVID-19 pandemic raged across India, mucormycosis, a fungal infection that can cause blindness and death, threatened a startling number of recovering COVID-19 patients. Ronny Sen tells the story of this disturbing spread and its effect on those blinded by the disease. His reporting sounds the alarm on his devastating infection, helping governments, health-care facilities, and individuals safeguard their COVID-19 treatment protocols against its potential hazards.

MANUEL SEOANE

Lacking Assistance, Indigenous Communities Educate Themselves on COVID-19

La Paz, Bolivia

Faced with inadequate health care and public safety information, Indigenous communities in the Bolivian Amazon organized themselves to disseminate COVID-19 safety information through Indigenous radio networks in their own languages. Manuel Seoane supports Indigenous community members in the production of these broadcasts to help publicize safety and health best

practices. He also documents the process of these broadcasts through photography to illuminate how community organizing has been essential to Indigenous communities since many government resources and policies do not reach or include them.

FAHAD SHAH

COVID-19 and India's Employment Crisis

Uttar Pradesh, India

It is estimated that the COVID-19 pandemic will threaten the livelihoods of 400 million informal laborers in India, including the 139 million internal migrants who left their homes to work in big cities. Fahad Shah documents the country's labor crisis, which has pushed millions into poverty and unemployment without basic health care and has caused tens of thousands of laborers to return to their hometowns.

ISHAN SHARMA

How COVID-19 Tourism Shutdowns May Foster a Poaching Resurgence

Panna National Park, India

With the implementation of strict conservation laws over the past several decades, the Adivasi communities of central India gradually shifted from forest-dependent livelihoods via hunting and poaching to their present-day occupations. With an increase in wildlife tourism, many found work in the tourism industry—until COVID-19 brought tourism to a standstill around the world. Ishan Sharma documents the narratives of the Adivasi people amid the pandemic, exploring the impact COVID-19 has had on their communities—and the future of conservation in central India.

VICTOR HUGO SILVA

Debunking Brazil's "Early Treatment" for COVID-19
Goiania, Brazil

 In his body of work, Victor Hugo Silva investigates the "COVID Kit," a so-called early treatment not yet proved to counteract the virus but nonetheless prescribed by doctors and embraced by Brazilian authorities. Silva's reporting investigates the origins and efficacy of this regimen as well as potential influence by drug manufacturers. He also reveals how a network of high-profile doctors have promoted the kit—and the larger repercussions it may have on Brazil's COVID struggle.

VEDRANA SIMICEVIC

The Impact and Future of the COVID-19 Pandemic
Opatija, Croatia

Vedrana Simicevic examines the impact and future of the COVID-19 pandemic in Croatia, investigating how the Istria peninsula has managed to control the pandemic better than other Croatian counties, whether enough COVID-19 vaccines will reach Croatia, and how the virus is rapidly breaching nursing homes. Simicevic's investigation helps determine whether malpractices or failures in governmental strategy allow the virus to infiltrate these communities—and if they might be easily prevented in the future.

STEPHANIE SINCLAIR

The Front Line Is Female: Portraits of Women in Health Care
Cortlandt, New York, United States

 Women make up 91 percent of nurses and 76 percent of all U.S. health-care workers—people who risk their health and their families' health to lead the frontline fight against COVID-19. Stephanie Sinclair compiles intimate portraits of this group, telling their stories and highlighting their challenges. The series shows the stark realities of the current health-care landscape, including overrepresentation of women and people of color in health-care positions—and how these workers were both underpaid and disproportionately impacted by the virus.

VALENTINA SINIS

The Front Lines of Their Minds: COVID-19 and Obsessive Compulsive Disorder
Sardinia, Italy

For many of the one million people in Italy diagnosed with an obsessive-compulsive disorder, the outbreak of COVID-19 exacerbated fears of contamination, as well as corresponding ritualistic hygienic and sanitation practices. As the world fought against the spread of the pandemic, Valentina Sinis tells the story of this population, whose battle also took place within their own minds.

MICHAELA SKOVRANOVA

COVID-19 and Long-Term Health Care
Sydney, Australia

Nearly half of Australians suffer from chronic disease, and First Nations people experience higher rates than other groups. The pandemic has resulted in the cancellation of elective surgeries, long waiting lists to see specialists, and a general lack of access to medical care. For vulnerable communities, this reduced access can be fatal. Michaela Skovranova's reporting sheds light on the complex needs of people suffering from long-term health conditions during the pandemic and beyond—and why a successful vaccine rollout is crucial not only for countering COVID-19 but also for those whose health depends on a functioning medical system.

GARETH SMIT

My Community Fridge: The Intersection of Social Justice and Food Security
New York City, New York, United States

 In New York City, organizers came together to combat food insecurity spurred by the COVID-19 pandemic by creating community refrigerators to provide fresh food items for free at any hour of the day. Gareth Smit's short film focuses on a community fridge in his neighborhood on the border of Brooklyn and Queens, serving as a prism through which to explore the intersection of social justice and food security—and how simple acts of kindness can have a resounding impact.

CHERYL SMITH

The Essentiality of Black-Owned Small Businesses
Dallas, Texas, United States

Cheryl Smith documents the impact of COVID-19 on small, Black-owned businesses in northern Texas. With the advent of the pandemic, many small businesses suffered large losses in revenue, and many closed down temporarily or permanently. Smith examines the challenges these entrepreneurs have faced, including coping with lost customers and the impact that the loss of small businesses can have on communities—especially in low-income neighborhoods and food deserts.

RB SMITH

COVID-19 Brings Inequalities Into Focus
Bering Strait, Alaska, United States

The Bering Strait region of Alaska is one of the most isolated and underserved areas of the United States; the area relies on plane and helicopter service from Nome to meet community needs. As positive COVID-19 cases in Nome and some nearby villages ticked slowly upward, RB Smith investigates the systemic inequities that are now being brought into sharp focus: the historic trauma left by the 1919 influenza outbreak; overcrowded housing; a lack of basic water and sewer infrastructure; and deficient health care, economic, and educational systems, all exacerbated by the pandemic.

SHIRLEY SMITH

COVID-19's New Orphans
Byram, Mississippi, United States

 As of February 2021, an estimated 40,000 children in the United States had lost a parent due to COVID-19, placing them at risk for prolonged grief, depression, weaker performance in school, and long-term economic insecurity. Although only 14 percent of children in the United States are Black, it is estimated that Black children make up 20 percent of all the children in this harrowing circumstance. Shirley Smith investigates how these tragic losses have impacted the family structure, and how children—particularly Black children—who have lost one or both parents to COVID-19 might receive adequate assistance.

ALVA SOLOMON

COVID-19 and Indigenous Communities
Georgetown, Guyana

In his work, Alva Solomon explores the impact of COVID-19 on Indigenous communities in Guyana—including Carib, Arawak, and Akawaio villages, which have experienced hundreds of cases and face economic and social breakdown. Solomon's reporting helps disseminate critical public health information and stories of successful tactics for resilience among these communities while highlighting the need for interventions by both the government and nongovernmental health organizations.

ANA E. SOTELO

Las Truchas: Inspiring Pandemic Resilience Through Open-Ocean Swimming
Lima, Peru

 In her body of work, Ana E. Sotelo tells the story of Las Truchas, an all-female open-water swimming group that has promoted physical and mental health during the COVID-19 pandemic. Amid political turmoil and a foundering health-care system, Las Truchas has shown resilience even during the pandemic's hardest phases, creating a community and a coping mechanism while complying with safety protocols and local laws.

SOUTHERLY

COVID-19 Compounds Existing Disparities in the American South
Durham, North Carolina, United States

 Southerly, a nonprofit independent media organization that covers the intersection of ecology, justice, and culture in the American South, explores how rural communities handled COVID-19, on top of existing risks including air and water pollution, sea-level rise, natural disasters, and lack of access to health care.

GAIA SQUARCI

Psychological Domestic Violence Amid COVID-19-Induced Isolation
New York City, New York, United States

Natalia, a woman living in New York City, was forced to move out of her home and seek a divorce after quarantining with a verbally and psychologically abusive husband. Through Natalia's story, Gaia Squarci sheds light on the sharp increase in domestic violence amid the COVID-19 pandemic, helping audiences recognize and react to the type of violence that does not leave marks on the skin.

ANDREW STELZER, JEAN ROSE, KATIE ROSE, AND SARAH SHOURD

Is Decarceration in Response to COVID-19 a Model for Prison Alternatives?
Alameda, California, United States

As of May 2020, decarceration efforts across the United States in response to the COVID-19 pandemic had not led to a discernible rise in crime. Many incarcerated people die from preventable causes—by suicide, brutality, and medical neglect—and these risks have continued during the pandemic. Through the stories of three currently or formerly incarcerated people, Andrew Stelzer, Jean Rose, Katie Rose, and Sarah Shourd examine the alternatives to imprisonment, including scalable programs that may prevent a post-pandemic return to business as usual.

AKOS STILLER

How COVID-19 Widened the Education Gap for Lower-Income Students
Budapest, Hungary

 As the COVID-19 pandemic made online learning an everyday reality for schoolchildren across Europe, students from families who struggle to afford equipment like laptops, or utilities like energy and internet access, are falling behind. This cohort includes many families in Hungary, for whom energy poverty is a tragic reality. Akos Stiller documents how the pandemic is dramatically widening the education gap between rich and poor students, and how this circumstance may impact the future of the workforce here.

ALISON STINE

Masks and Remote Learning Bring New Challenges to the Deaf and Hard of Hearing
Denver, Colorado, United States

Alison Stine examines how COVID-19 has exacerbated education inequalities for the deaf and hard of hearing community; mask

mandates, for example, have made communication difficult for people who rely on lip reading. Stine investigates the long-term effects of the pandemic, which has prevented in-person education, on development, including potential psychological impacts of wearing masks, lower graduation rates, and increases in mental health issues.

ANNA STITT

COVID-19's Threats to the Incarcerated
Minneapolis, Minnesota, United States

Anna Stitt provides an in-depth look at how the COVID-19 outbreak affected incarcerated people through the prism of the Arkansas prison system. The project explores limited access to testing and safety equipment for prisoners and correctional officers, the perspectives of incarcerated people and their families, and the lawsuits and ensuing debate over freeing prisoners to avoid their increased exposure to COVID-19.

KASIA STREK

The Elderly Confront COVID-19
Warsaw, Poland

 In her revealing series of images, Kasia Strek documents the impact of COVID-19 on the elderly in Poland's capital, portraying their access to medical care, food, and housing security, and their social well-being. Strek's reporting showcases stories of the strong intergenerational bonds that formed between volunteers and seniors, yielding purpose and connection during a time of social distancing.

JASON STROTHER

COVID-19's Risk to the Institutionalized
Seoul, South Korea

In his work, Jason Strother investigates the human rights concerns of institutionalized people with disabilities during the COVID-19 pandemic and explores ways that this

system might be reformed to accommodate them. Throughout the pandemic, this group was one of the most at-risk populations; in April 2020 the Office of the United Nations High Commissioner for Human Rights cited preliminary studies revealing that between 42 and 57 percent of all deaths in 22 countries that reported deaths linked to COVID-19 occurred at these homes. Strother reports on this situation in South Korea, which at the onset of the pandemic suffered a widespread COVID-19 outbreak inside a psychiatric hospital, as well as at smaller full-time-care group homes.

ASHA STUART

The Alarming Increase of Domestic Abuse in Quarantine
Atlanta, Georgia, United States

 Asha Stuart documents how COVID-19 affected domestic violence against women in the state of Georgia, where the Atlanta Police Department reported a 58 percent increase in related 911 calls between March and April 2020, compared with the same time frame in 2019. Through the prism of personal narratives and community initiatives in women's shelters, hotels, and apartment-relocation services, Stuart gives a rare glimpse into the lives and strength of domestic violence survivors, especially in light of COVID and the economic strain and unemployment it has wrought.

ADRIENNE SURPRENANT

Social Refuge During COVID-19
Montréal, Canada

 As Montréal entered quarantine in response to a second wave of COVID-19 in October 2020, the city's alleyways, which have long been a part of its social DNA, became the last place where the social fabric of each neighborhood could remain intact. Adrienne Surprenant documents

scenes from the city's 4,300 alleys as they became a last stronghold of human contact during the pandemic.

DIANA TAKACSOVA

COVID-19 Leaves Migrant Workers Trapped Outside the System
Beja, Portugal

 Over the years, Portugal's agricultural sector has increasingly come to rely on undocumented migrant workers, primarily from African countries, who are willing to work long hours for low pay in inadequate living conditions. The COVID-19 pandemic halted much of their seasonal work, leaving large numbers without income, and dangerously muddled the procedures for receiving residency status and social benefits. Diana Takacsova explores the social and economic consequences of COVID-19 on this group, who were trapped outside the system yet made essential contributions to Portuguese society.

CELIA TALBOT TOBIN

COVID-19 Threatens Community-Led Conservation of the Sea of Cortez
La Paz, Mexico

 For several years, fishermen in the city of La Paz partnered with the government to sustainably manage the collection of scallops, clams, and mussels in their adjacency to the Sea of Cortez. They have been able to avoid overfishing by balancing fishing income with revenue from tourism. But the latter quickly evaporated with the onset of the COVID-19 pandemic, forcing some fishermen to reevaluate their sustainability commitment in the face of decreasing incomes. Celia Talbot Tobin explores how the pandemic affected the fishing community in La Paz—and the health of the larger ecosystem that sustains it.

ANASTASIA TAYLOR-LIND, KRISTEN CHICK, AND SARA KHOJOYAN

COVID-19 Fuels New Risk of Violence
Nagorno-Karabakh, Azerbaijan

 Conflict in Nagorno-Karabakh over the disputed region between Azerbaijan and Armenia in 2020 brought new risks for civilians living there—not only in terms of violence but also in terms of COVID-19. The overlap of these two crises has been especially deadly. Rates of COVID-19, which had been low, spiraled out of control when the fighting began in October 2020. Anastasia Taylor-Lind, Kristen Chick, and Sara Khojoyan document how the pandemic compounded the effects of the conflict for its most vulnerable people, shedding light on this underreported situation. Taylor-Lind received extended funding for this project in 2020.

REFIK TEKIN

COVID-19 Reaches Refugee Population
Diyarbakır, Turkey

 Refik Tekin documents how the COVID-19 outbreak is affecting Syrian, Iranian, and Afghan refugee and immigrant communities living in the Kurdish region of eastern Turkey. Even before the crisis, these groups lived in low-income districts, struggled to build livelihoods, and were informally employed, earning very little income. Tekin tracks how the pandemic made an already precarious situation worse for these vulnerable communities.

JESSICA TICKTIN

How COVID-19 Created Critical New Challenges for New Mothers
Burlington, Vermont, United States

 Throughout the COVID-19 pandemic, expectant mothers have been kept isolated during prenatal care. In many cases their partners have been barred from deliveries, and new mothers must stay distanced from supporting family members and friends. Many women have also returned to work from maternity leave with limited options for childcare. In her body of work, Jessica Ticktin explores how the COVID-19 pandemic affected the mental health and lives of pregnant and postpartum women from diverse socioeconomic and racial backgrounds as they have been isolated during what can, even in normal times, be a challenging process.

JOANA TORO

Times Square's Street Performers Amid COVID-19
New York City, New York, United States

 In her body of work, Joana Toro documents the impact of COVID-19 on the street performers who dress as Hello Kitty, Mickey Mouse, Batman, and other entertainment icons to pose with tourists in Times Square. As that normally crowded, hectic area of New York City emptied of tourists in early 2020, these performers, mostly Latin American migrants, found their meager incomes drying up. Toro's series of portraits portray these workers, dressed in their costumes in their homes, as they endure economic hardship and anxiety while waiting for tourism to return to New York City.

NHAN TRAN

Between the Silent Eyes: COVID-19 Drives Child Marriage
Ha Giang, Vietnam

The COVID-19 pandemic has led to the highest increase in child marriages in 25 years; in many communities across Vietnam, these unions have doubled. In "Between the Silent Eyes," a visual documentation of Hmong child brides in Ha Giang, Nhan Tran shows how school closures, economic pressure, and disrupted health care for girls in the wake of the pandemic have increased the likelihood that they will join the estimated 650 million women today who married before their 18th birthday.

IRINA UNRUH

Breaking the Silence of Domestic Violence
Warendorf, Germany

Every hour, 16 Germans become victims of domestic violence; one out of four German women has experienced physical or sexual abuse at the hands of a current or previous partner. This circumstance has made it difficult for this group to stay safely at home during the COVID-19 pandemic. In her moving series of images, Irina Unruh tells the stories of these victims to highlight the complexity of domestic violence and to illuminate how those affected can cope with their circumstances—especially amid a nationwide quarantine.

YUNANTO UTOMO

Virion: Webtoons to Help Youth Cope With COVID-19
Jakarta, Indonesia

Yunanto Utomo produced a series of nonfiction webtoons, known as "Virion," which provides important information to children and teenagers about the social impact of COVID-19. "Virion" helps young people understand the complexity of the disease and its social impacts and imparts valuable lessons that will help them become the leaders of the future.

HARSHA VADLAMANI

Volunteer Hospitals Counter COVID-19's Devastating Impact
Chhattisgarh, India

When COVID-19 struck rural India, health-care resources were diverted to fight the virus, but lockdown measures made it virtually impossible for residents from remote villages to travel for medical treatment. Given an already

insufficient rural health-care infrastructure, addressing other diseases became a dangerously low priority. In this body of work, Harsha Vadlamani documents how volunteer doctors and health-care workers set up rural hospitals to counter the devastating impact of COVID-19 on rural India's medical system.

GAYATHRI VAIDYANATHAN

The Downside of Technology-Based Contact Tracing
Chennai, India

 Over the course of the COVID-19 pandemic, India has employed a concerted door-to-door effort to collect medical data. Each citizen is required to download a mobile application called Aarogya Setu, which enables contact tracing, issues "immunity certificates," and diagnoses COVID-19 via algorithm. Those found to be positive for the disease or at a high risk for exposure are monitored or moved into quarantine—but can be ostracized because of their disease status. Gayathri Vaidyanathan investigates how using technological surveillance to track and determine COVID-19 exposure changes how people relate to one another—and impacts the 500 million Indians who do not have smartphones.

NEELIMA VALLANGI

Are Local Communities Ready for the World's Highest Mountain to Reopen?
Lukla, Nepal

 With the outbreak of the COVID-19 pandemic, Nepal's tourism sector came to a grinding halt. Thousands were left unemployed, including the guides and porters who lead attempts on Mount Everest. In spring 2021 the Everest region opened for business again, and the climbing season was back in full swing. Neelima Vallangi explores the impact of reopening on communities within the Everest region, including their economic situation, hopes, fears, and challenges as outsiders begin to reenter the region.

WARA VARGAS LARA

Seeing Their Struggle: Blind Street Performers in the Time of COVID-19
La Paz, Bolivia

In this body of work, Wara Vargas Lara documents the challenges the COVID-19 outbreak has posed to a community of blind street performers in La Paz, Bolivia, whose meager income from singing vanished along with the crowds; without an audience to sing for, these individuals struggled to earn a basic income. Vargas's work highlights the compounded risks and unique experiences of this community, whose perceptions of the pandemic are fundamentally different from those of the sighted.

KYLE VASS

The Cost of Social Isolation in Recovering Addict Communities
Huntington, West Virginia, United States

Many recovering from narcotic addictions rely on the support of social connections to avoid relapses. In Huntington, West Virginia, a community with alarmingly high rates of drug abuse, Kyle Vass investigates the effects of social isolation on the recovery and sobriety of individuals battling addiction from the confines of their own homes in the wake of COVID-19.

MALAIKA VAZ

Goa's Migrant Laborers Face a Different World
Margao and Vasco de Gama, Goa, India

 As they traveled home amid shutdowns to slow the spread of COVID-19, India's historically underserved and marginalized community of migrant laborers faced turbulent economic instability and jeopardized health conditions. Malaika Vaz examines the impact of the pandemic and the efforts to control the outbreak on these communities in India's state of Goa, as well as the solutions needed to protect this group.

MIRKO VIGLINO

Through Our Eyes: A Parent and Child Face Italy's COVID-19 Outbreak
Rome, Italy

 In this body of work, Mirko Viglino tells the story of family fears amid Italy's alarming COVID-19 outbreak. He approaches this story from a personal angle, documenting his relationship with his young daughter through his photography and her pandemic-inspired art.

RAFAEL VILELA

The New Poor: COVID-19 Pushes Previously Stable Communities Toward Poverty
São Paulo, Brazil

 In Brazil, the COVID-19 pandemic and resulting economic downturn are driving new communities toward food insecurity and jeopardizing their access to such basic human needs as water, housing, and health care. At the same time, communities previously living below the poverty line now face dire food insecurity. Rafael Vilela documents how the pandemic is affecting both new and existing vulnerable populations in São Paulo.

RAFAEL VILELA

Will the Next Pandemic Be Cooked in Brazil?
Mato Grosso, Brazil

In his body of work, Rafael Vilela investigates how the growth of animal farming and industrial soy production in Mato Grosso, Brazil, led to deforestation, resulting in climate change and a loss of habitat that affects biodiversity. Vilela also examines how these factors are intensifying the pandemic in the country, increasing its chances of becoming host to the next zoonotic outbreak.

PAU VILLANUEVA

Inside the Bakwit School: Indigenous Filipino Groups Respond to COVID-19
Manila, Philippines

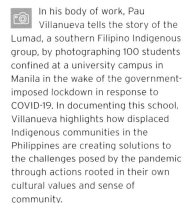 In his body of work, Pau Villanueva tells the story of the Lumad, a southern Filipino Indigenous group, by photographing 100 students confined at a university campus in Manila in the wake of the government-imposed lockdown in response to COVID-19. In documenting this school, Villanueva highlights how displaced Indigenous communities in the Philippines are creating solutions to the challenges posed by the pandemic through actions rooted in their own cultural values and sense of community.

DANIELLE VILLASANA

COVID-19 Compounds Challenges for Transgender Asylum Seekers
Tijuana, Mexico

 Kataleya Nativi Bac is a transgender woman who fled Honduras after her brother, a gang member, attacked her. She was in the process of seeking asylum in the United States when COVID-19 erupted across the world and asylum measures everywhere froze. By highlighting Bac's story and those of other transgender migrants and asylum seekers, Danielle Villasana documents how COVID-19 has exacerbated their already precarious journey, as well as the pandemic's impact on U.S. immigration policy.

SARAH WAISWA

Rethinking Mental Health Access Amid COVID

Nairobi, Kenya

Although the Kenyan government acknowledges the increase of mental health issues over the course of the COVID-19 pandemic, there has been no formal mental health response plan. Mental health itself is seen as taboo here, often leading people to go without the proper care and treatment. Through her moving series of images, Sarah Waiswa tells the stories of people living in Nairobi with mental health conditions—with and without access to proper care—amid COVID-19. Her work helps to change the stigma surrounding mental health and starts conversations about access to mental health care and treatment.

TSHEWANG WANGCHUK

Can Adaptability Be a Model for Pandemic Response?

Thimphu, Bhutan

Bhutan's strong response to the COVID-19 outbreak—including closing its borders—resulted in only six cases nationwide as of April 2020. But since tourism is Bhutan's second highest revenue source, more than 50,000 people were suddenly unemployed, and food imports stopped. The country's leadership used these challenges as an opportunity to sustainably increase domestic food production and combat youth unemployment. Tshewang Wangchuk covers these stories to document successful approaches to pandemic adaptability and resilience.

ROSE WANGUI

The Causes and Costs of School Closings

Baringo County, Kenya

In Baringo County, Kenya, heavy rainfall caused an unprecedented rise in the water levels of Lake Baringo and Lake Bogoria, cutting off villages, health centers, and schools. At least 17 schools serving about 5,000 students were flooded, and many have been destroyed, vandalized, or robbed. Rose Wangui investigates how school closures in the wake of COVID-19 affected students, especially young girls subjected to female genital mutilation at home—and how these students will continue to learn when the Kenyan government reopens schools.

LYNSEY WEATHERSPOON

Alabama's First Incorporated African American City Faces COVID-19

Hobson City, Alabama, United States

 The COVID-19 pandemic has disproportionately impacted Black communities—and Hobson City, Alabama, has faced challenges both preparing for and coping with it. Residents have experienced difficulty attaining federal funding, and thanks to historical oppression, mistrust of the government is high. Lynsey Weatherspoon creates a portrait of Hobson City, a community of fewer than 750 residents and Alabama's first incorporated African American city, during the pandemic.

ALEXIA WEBSTER

Projecting Our Losses: Surviving Shuttered Family Businesses

New York City, New York, United States

Since the start of the COVID-19 pandemic, more than 6,000 small businesses, including family-run shops, grocery stores, bars, and restaurants, in New York City have closed or gone bankrupt; many had been part of their communities for generations. Alexia Webster tells the story of these neighborhood hallmarks, helping communities take stock of what was lost during this time by projecting archival and contemporary images and videos onto the storefronts that they once occupied. Webster's reporting and installation documents and publicly memorializes the loss of small family businesses that characterize New York City.

MÉLANIE WENGER

Family Physicians: A Personal Account of Rural Doctors

Isère, France

Inspired by W. Eugene Smith's "Country Doctor," Mélanie Wenger's intimate photo essay portrays the daily challenges of an indefatigable family doctor at the front line of a global pandemic in rural France. Wenger's project illuminates the scarcity of physicians in rural areas while revealing the flaws of one of the strongest health systems in the world.

IRINA WERNING

International Surrogacy in a Global Pandemic

Buenos Aires, Argentina

Irina Werning tells the stories of six couples in Buenos Aires, Argentina, who became parents through international surrogacy but were barred from seeing or bringing home their newborn babies because of COVID-19 travel restrictions. Werning documents their daily lives in waiting, portraying their efforts to lobby government agencies and work with lawyers to bring home their children. Meanwhile, many painful questions arose, including, Who will look after their children and when will they be able to bring them home?

MATIKA LORRAINE WILBUR AND ADRIENNE KEENE

All My Relations: How Native Americans Can Stay Safe During COVID-19

La Conner, Washington, United States

Native Americans are particularly susceptible to the spread of COVID-19, given that they are more likely to live in overcrowded and intergenerational housing, lack access to running water, and experience health conditions that increase their risk of hospitalization. Matika Lorraine Wilbur and Adrienne Keene examine the effects of COVID-19 on tribal communities, encouraging them to return to traditional knowledge structures that encourage healthy lifestyles.

RACHEL WISNIEWSKI

The Difference a Year Makes: Portraits of Senior Living Before and After the COVID-19 Pandemic

East Norriton, Pennsylvania, United States

Before the COVID-19 pandemic, Rachel Wisniewski documented the lives of residents at Brandywine Living at Senior Suites, an assisted living facility in East Norriton, Pennsylvania. Residents there were actively engaged, dedicating themselves to new hobbies and activities, building platonic and romantic relationships, and even conducting a yearly "senior prom." Returning to Brandywine in March 2021, Wisniewski began documenting the physical, social, and psychological toll that the previous year of isolation had on its residents. Each set of photos illuminates the detriments of social isolation on the elderly, as well as their resilience and strength despite it.

HANNAH YOON

Released Early, Formerly Incarcerated People Adjust to Life During a Global Pandemic

New Jersey, United States

 In November 2020 New Jersey released more than 2,000 inmates to help slow the spread of COVID-19 among the prison population. By March 2021 an additional 1,000 inmates were released early. Hannah Yoon explores the barriers that formerly incarcerated people face on being released—barriers that have been greatly amplified for Black Americans—as they adjust to living outside prison, search for employment, and reacclimate to society amid a global pandemic.

DANIELLA ZALCMAN

How the Jewish Community Is Observing Faith During Quarantine

Nevada, United States

 The Jewish holiday of Passover is fundamentally rooted in family gathering, sharing, and human connection. Amid the outbreak of COVID-19, Jewish people around the world sought alternatives to in-person seder gatherings, including video-conferencing, in order to comply with stay-at-home orders while maintaining tradition. As a multiracial Jewish photojournalist, Daniella Zalcman documents virtual seder gatherings to highlight adaptations of life and faith during the pandemic.

ELISABETTA ZAVOLI

The Pandemic Through the Eyes of Independent Theaters

Milan, Italy

 The COVID-19 pandemic devastated Italy's small and private theaters, home to the country's artistic avant-garde. After losing nearly all their revenue during closures of a year or more, many of the remaining theaters feared that reopening would not be enough to save them, even with safety measures in place. In her body of work, Elisabetta Zavoli documents the lives of the actors, dancers, directors, and staff who work in Italy's independent theaters, including moments of sadness, joy, hope, and uncertainty for the future.

VICTOR ZEA AND SHARON CASTELLANOS

Reverse Migration: Reconnecting with the Land for Pandemic Resiliency

Cusco, Peru

 In recent years, Peru has seen a migration from rural areas to large cities like Lima and Cusco as people seek new opportunities. With the outbreak of COVID-19 and a resulting quarantine that lasted months, Peruvians are now reversing course, fleeing cities and poor job prospects for the resiliency and dependency of rural agriculture. Through the stories of former tourism professionals, artisans, and entrepreneurs, Victor Zea and Sharon Castellanos highlight the challenges of adaptation and reconnection with the land—and the rediscovered value of work in the fields.

MAKAFUI ZIMRANI

Stigmatization and the New Front in the Fight Against COVID-19

Obuasi, Ghana

Ever since Obuasi, a mining community in the Ashanti region of Ghana, was reported as the epicenter of the region's COVID-19 cases in May 2020, stigmatization and discrimination has hit its residents; some have even refused testing. Through the stories of the Obuasi residents, Makafui Zimrani explores how this sense of shame is impacting the fight against COVID-19 in Ghana.

ACKNOWLEDGMENTS

First and foremost, we would like to extend our most heartfelt thanks to our grantees, who were the soul of this project, often putting themselves at risk to create an indelible mark upon history and who together created one of the defining documents of this time.

Thank you to the generous funders who supported the COVID-19 Emergency Fund for Journalists, making this book possible, as well as our foundations and corporate sponsors: Cigna Corporation, the Howard Hughes Medical Institute, and the Rita Allen Foundation.

We also deeply appreciate the contributions of our individual donors: Roberta L. Adams, Christy S. Anderson, Rosemary B. Bay, Robert A. Bilko, Barbara Brewster and Henry Brewster, Mary Lou Buck, Diana K. Carey, Tom Church, Carol A. Cleave, Karen Danski, Marilyn A. Ellsworth and Dr. Robert Ellsworth, James H. Feit, Bruce F. Fest and Beverly T. Fest, Charlotte A. Fowler, Nicholas V. Galuzzi, Dr. Cornelia C. Haag-Molkenteller, William J. Hannon and Paul M. Harding, T. Norman Hardy, Zainool Ibrahim, Michael E. Jacobson and Wanda L. Olsen, Jeri L. Jarvis, Emily G. Kahn, Dr. Andrew Kao, Dr. Adel B. Korkor, Dr. Feng-Yang Kuo, Stephanie M. Leal, Nikki L. Lowry and J. Scott Lowry, Eddington Lyda, Roger I. MacFarlane and Ruth MacFarlane, Diane M. McCutcheon, Douglas D. McDowall and Judith C. McDowall, Lisa McGonigle, Jim Mitchell, Barbara S. Moffet, Dr. Mary L. Morgan, Barbara Moss and Sheldon Moss, Dane A. Nichols, William O'Neill and Jean O'Neill, Suzanne P. Polen, Douglas Raybeck, Ritta G. Rosenberg, Lynda Sayre, Dr. Marion J. Siegman, Dorami Sierra, Victor E. Skloff, Robert E. Smiser, Dr. Robert L. Smith, John L. Speredelozzi, Sara Carter Staples, Ronald S. Stone, Virgil H. Swadley, Elysia Tan, Dr. James W. Truman and Dr. Lynn M. Riddiford, Robin A. Vince and Liselotte J. Vince, Christy Walton, Thomas K. Washburn and Eileen Washburn, Nancy Willetts, Susan Yakutis, Hiroaki Yonahara, and Audre A. Zembrzuski.

Enormous thanks also go to the creators of this book: National Geographic Books editorial director Lisa Thomas and executive editor Hilary Black, who saw its potential from the beginning and helped make it the best it could be. Thanks, too, to our talented publishing team: graphic designer David Griffin, creative director Elisa Gibson, production editor Michael O'Connor, and project manager Kristina Reznikov.

At the National Geographic Society, Kaitlin Yarnall had the brilliant idea to launch the fund that supported the work you see in this book. Jill Tiefenthaler and Mike Ulica had the vision to support the program through its entire cycle, which includes the creation of this book. Rachael Strecher led the team that made it all—the fund and the book—happen. So many NGS staff contributed their time and expertise to making the fund and book happen; and special thanks go to Jess Elfadl and Will Thompson, whose quiet and diligent work is woven throughout these pages.

Other staff who provided critical support include but are not limited to Gael Almeida, Doug Bailey, Summer Bingham, Danielle Cales, Matt Campbell, Betty Chu, Chloe Cipolletta, Amelia Cormier, Jeanne Fink, Rob Flynn, Todd Georgelas, Aditya Kandada, Kathryn Keane, Chelsea Kopta, Yannick Kuehl, David Y. Lee, Amanda McDonald, Claire McNulty, Chelsey Perry, Andrew Rasner, Dustin Renwick, Angela Sanders, Jason Southern, Andrea Stahlmann, Agnes Tabah, Sana Ullah, Briona Vennie, and Jenn Wallace. Additionally, Xaquín G.V. dedicated his significant time and expertise to creating and maintaining a beautiful interactive map representing each project on our website (in addition to the one on pages 24-25 of this book, which was created by Sam Guilford).

Finally, enormous thanks go to curator and photo editor extraordinaire Claudi Carreras, who interviewed hundreds of applicants, looked through thousands of images, and masterfully created order out of chaos.

ABOUT THE NATIONAL GEOGRAPHIC SOCIETY

The National Geographic Society is a global nonprofit that uses the power of science, exploration, education, and storytelling to illuminate and protect the wonder of our world.

Since 1888, the National Geographic Society has driven impact by identifying and investing in a global community of Explorers: leading changemakers in science, education, storytelling, conservation, and technology. National Geographic Explorers help bring our mission to life by defining some of the most critical challenges of our time, uncovering new knowledge, advancing new solutions, and inspiring transformative change in our world.

To learn more about the Explorers we invest in and the efforts we support, visit *natgeo.com/impact*.

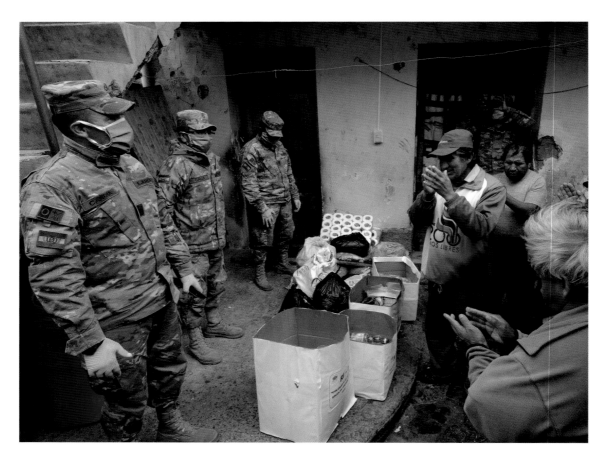

JUST IN TIME: Bolivian armed forces bring supplies to the homes of people with visual impairments during mandatory quarantine to combat the spread of COVID-19. Restrictions on gatherings, visits to public places, and in-person work left many participants of the informal economy struggling to find employment or generate money for food during the pandemic.

WARA VARGAS LARA | LA PAZ, BOLIVIA | APRIL 2020

Since 1888, the National Geographic Society has funded more than 14,000 research, conservation, education, and storytelling projects around the world. National Geographic Partners distributes a portion of the funds it receives from your purchase to the National Geographic Society to support programs including the conservation of animals and their habitats.

Get closer to National Geographic Explorers and photographers, and connect with our global community. Join us today at nationalgeographic.org/joinus

For rights or permissions inquiries, please contact National Geographic Books Subsidiary Rights: bookrights@natgeo.com

Front cover: Musuk Nolte

Back cover: Mark Leong (four corner portraits); Réginald Louissaint, Jr./ Kolektif 2D (other color portraits); Cédric Gerbehaye (black-and-white portraits)

Financially supported by the National Geographic Society.

ISBN: 978-1-4262-2307-5

Printed in South Korea

22/SPSK/1

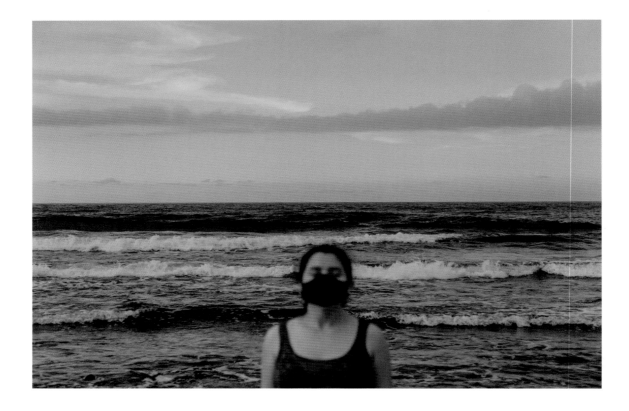

MARICEU ERTHAL/AYÜN FOTÓGRAFAS | VERACRUZ, MEXICO | JULY 2020

A portrait of the photographer's sister taken at a beach near Veracruz, Mexico, during their first trip away from home following mandatory quarantine. During this outing, the two practiced writing haiku as a way of reconnecting with nature after so much time spent away from it. One reads:

Donde es el viento
Yo grito a mar abierto
Aliento mío

Approximate translation:

Where the wind blows
I cry out to the open sea
My breath